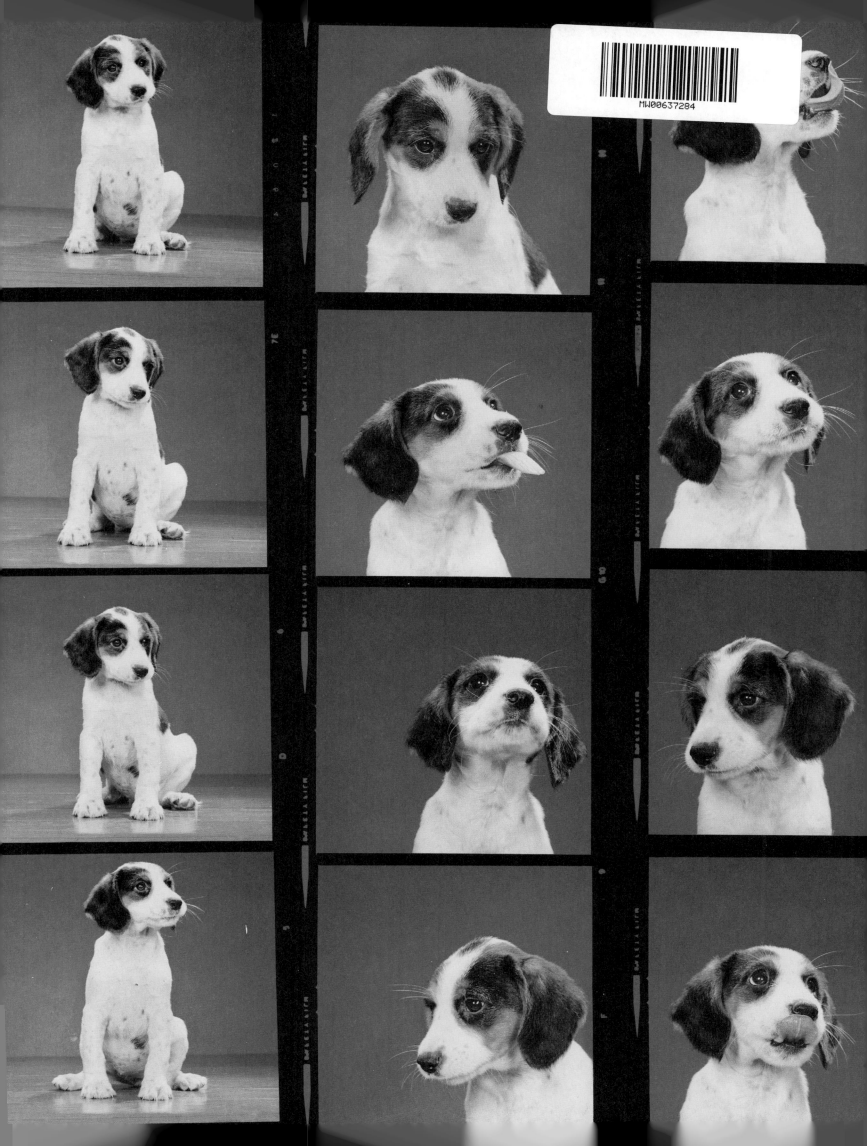

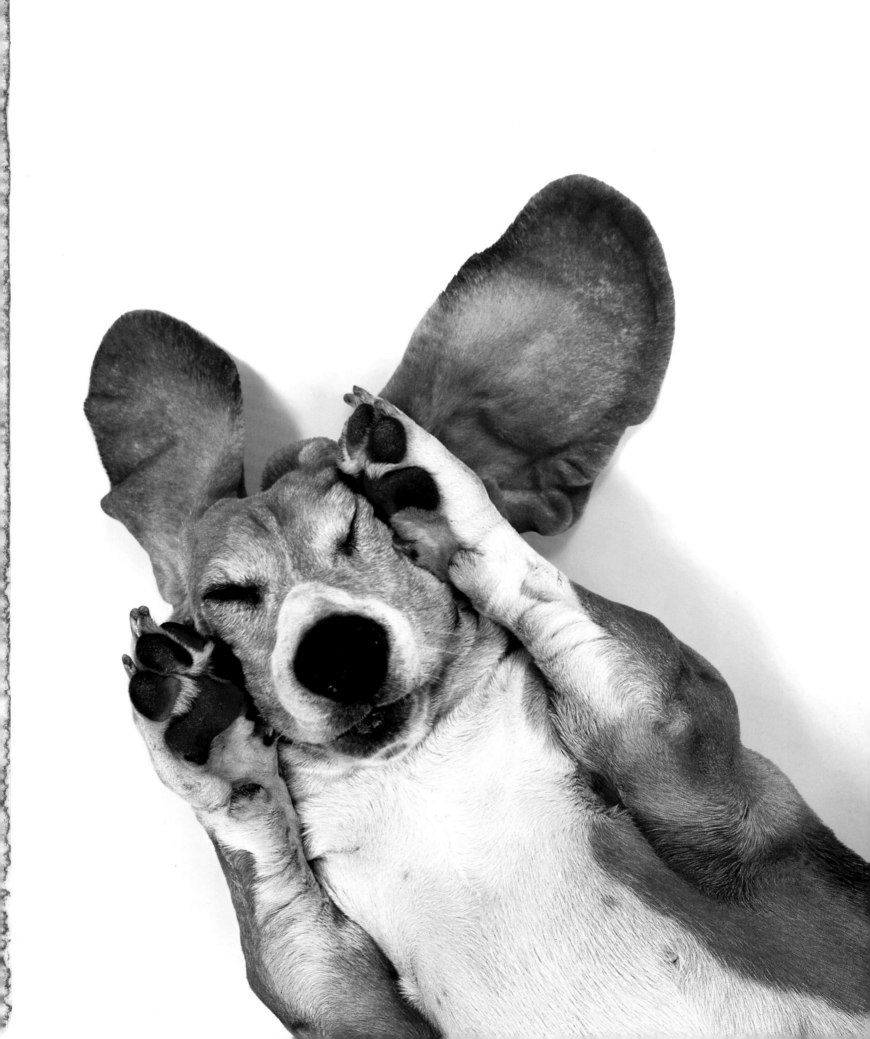

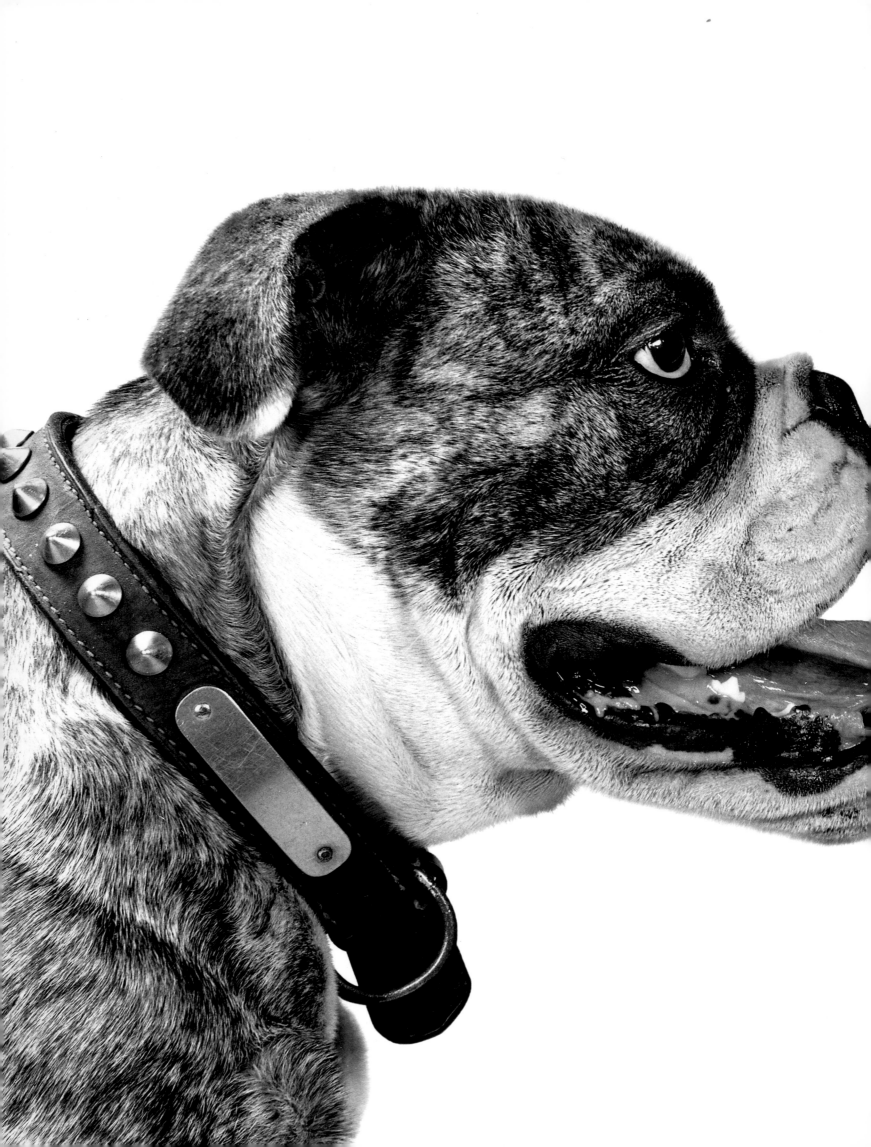

WALTER CHANDOHA

DOGS

PHOTOGRAPHS 1941–1991

TASCHEN

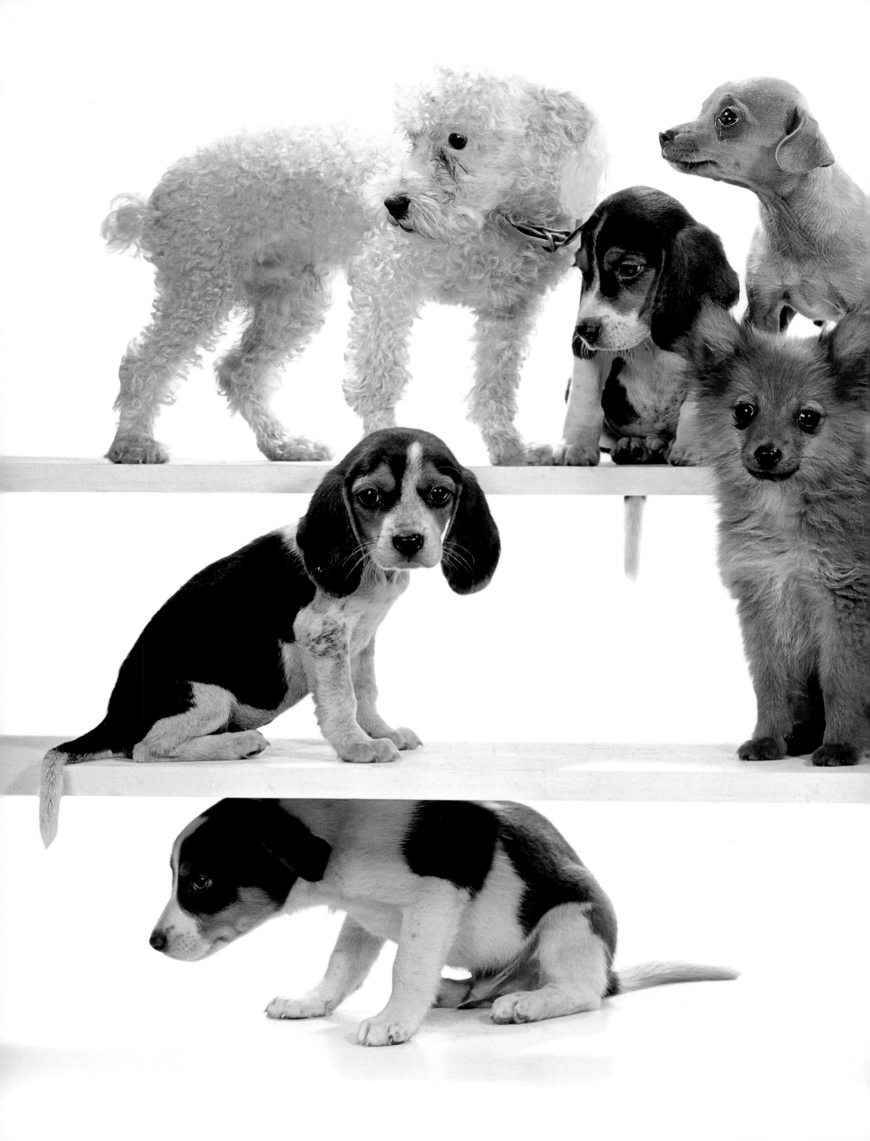

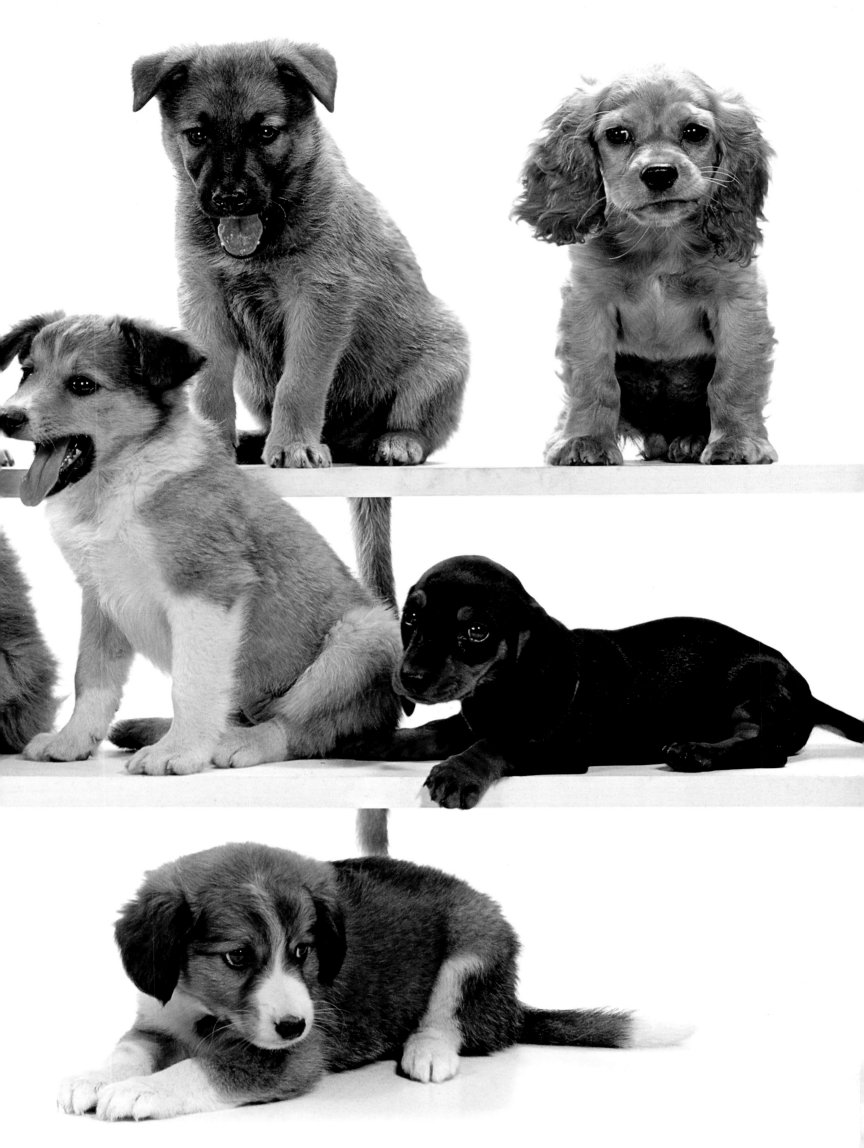

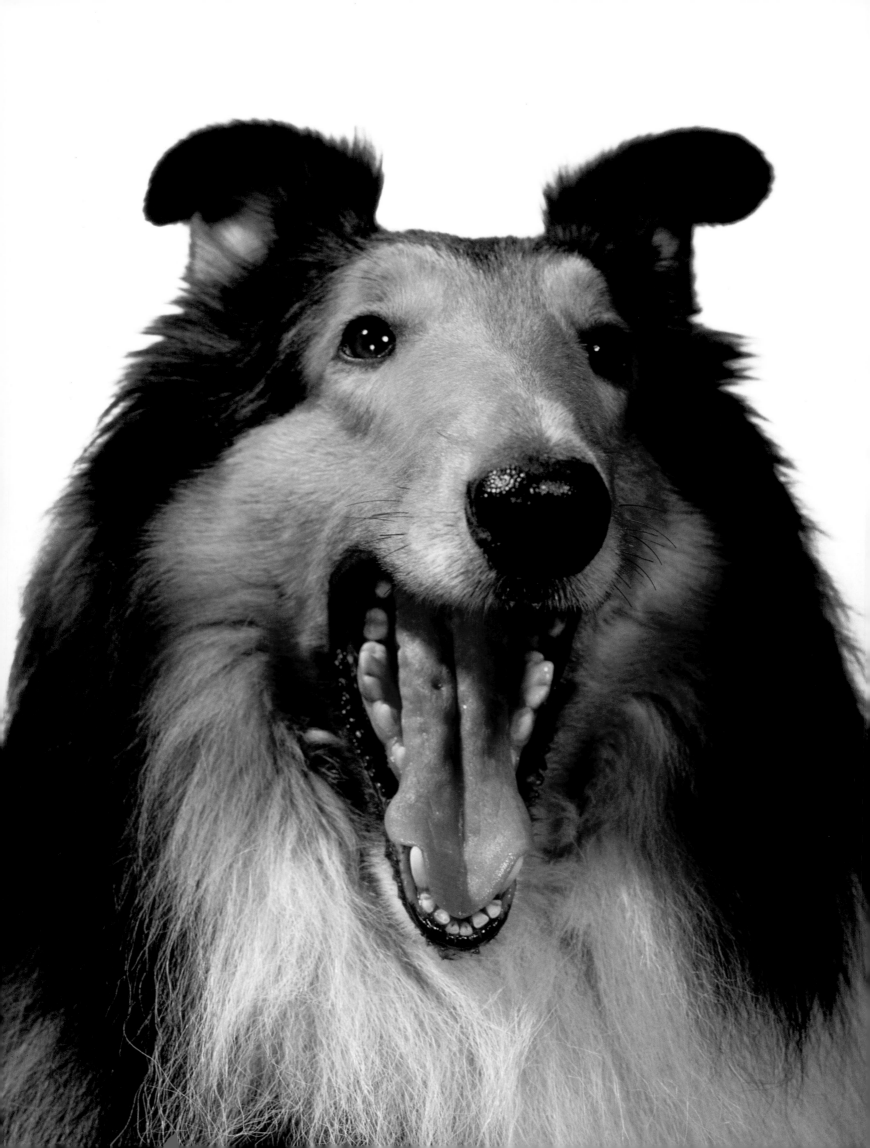

INTRODUCTION

A PHOTOGRAPHER OF PEDIGREE
8

EIN FOTOGRAF FÜR ALLE FELLE
20

UN PHOTOGRAPHE DE BEAU PEDIGREE
34

IN THE STUDIO
46

STRIKE A POSE
124

OUT AND ABOUT
174

BEST IN SHOW
202

TAILS FROM THE CITY
222

COUNTRY DOGS
236

BIOGRAPHY

A PORTRAIT
288

EIN PORTRÄT
290

UN PORTRAIT
292

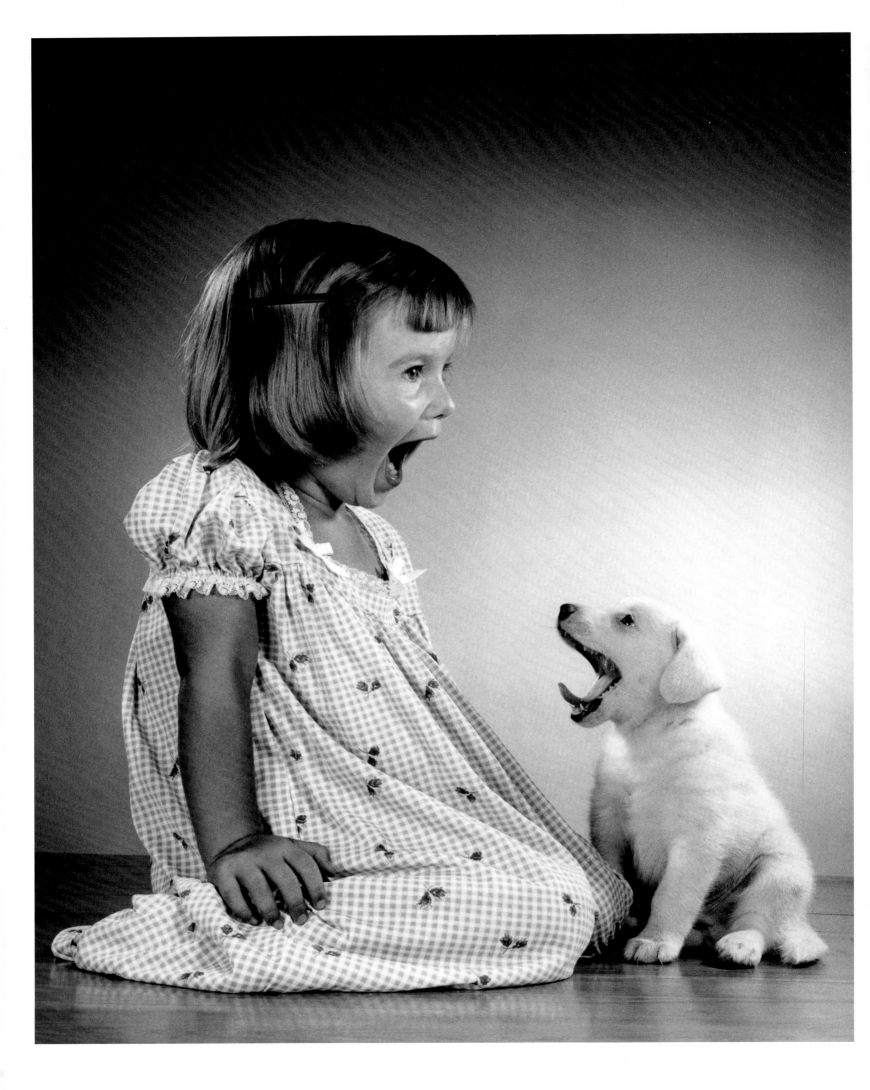

A PHOTOGRAPHER OF PEDIGREE

BY JEAN DYKSTRA

WALTER CHANDOHA'S PHOTOGRAPHS OF DOGS ARE COMPELLING NOT JUST BECAUSE DOGS HAVE AN INHERENT CHARM, BUT BECAUSE THE PERSON BEHIND THE CAMERA WAS A MASTER OF HIS CRAFT. He knew how to get the shot he wanted, how to light it, how to compose it, how to capture a particular expression or gesture: a Great Dane puppy sprawled over his half-asleep sibling; a pair of pugs, side by side, their expressions deeply concerned; or three white West Highland terriers against a tomato-red background, tipping over like dominoes. These shots require experience, judgment, deep reservoirs of patience, and a keen eye. But Walter Chandoha made it look easy.

There are several black-and-white photographs in the following pages that feature an exceedingly charming fuzzy white puppy and Chandoha's daughter Maria, aged four. In one (page 103), the pair lay side by side on their bellies, facing the camera, the setting minimal—wood floor, pale wall, dog and girl centered in the frame. Another (page 34) is set outdoors, and Chandoha has caught Maria holding the puppy by its armpits as she traipses barefoot across a sunny spot of grass. In a third (opposite), he's captured the instant at which both girl and dog, facing each other with mouths wide open, appear to laugh at an inside joke.

These three photographs of the same two subjects say a lot about his reputation as one of the greatest domestic animal photographers of all time. They speak to his affection for his children (Maria was one of six), but also for the animals he chose as his lifelong subjects. And they point to his versatility: Within a career focused primarily on photographing cats and dogs, he mastered the formal studio portrait, the *plein air* action shot, and a delightful sort of decisive moment. The images also convey the profound attachment and the emotional bond between dogs and humans.

Chandoha began honing his craft when he was a child in Bayonne, New Jersey, where he was born in 1920 to Ukrainian-immigrant parents, taking photographs with the family Kodak. He eventually joined the Lens Club of Bayonne, one of the many camera clubs that flourished in the 1930s, '40s, and '50s. Camera clubs were places for photographers to print and share work and learn from other members, and they were enormously influential in terms of providing a community, connections, and an education in the medium before the establishment of college photography departments. Chandoha returned the favor years later by visiting camera clubs to give lectures to standing-room-only audiences on how to photograph animals.

Mixed-breed and the photographer's daughter Maria, Long Island, New York, 1956

In 1942, Chandoha was drafted into the U.S. Army during World War II and assigned to Fort Dix. A photograph from the time shows him with the barracks mutt, the aptly named Hypo (the term for the chemical mixture used to fix a print in the darkroom). Eventually, he was shipped out and served in the Signal Corps as a combat photographer in the South Pacific until 1946. He attended NYU on the GI Bill, and he never stopped taking photographs. In between classes, he wandered the city taking pictures of the shadows cast by elevated trains or boys splashing through a fire hydrant or a taxicab caught in a shaft of sunlight, beautifully composed images that recall street photographs by Walter Rosenblum or Louis Stettner.

All along, though, Chandoha was regularly taking photographs of cats and dogs — a respite, perhaps, and

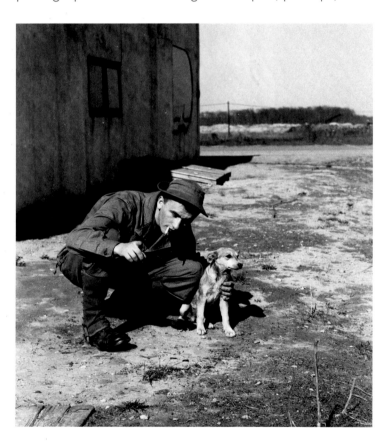

a comfort, as animals can be. His daughters Fernanda, Chiara, and Paula all recall that he almost never spoke of his wartime experiences, and when the subject arose in later years, tears came to his eyes. He may have surrendered the photographs he took during the war, but the horrors of what he saw surely stayed with him. His photography, suggested Fernanda, was a salve. "I think something about it healed his heart," added Paula.

His photographs were also attracting wider attention and winning him prizes. He regularly submitted to contests and exhibitions held by newspapers, magazines, camera clubs, and camera companies, and just as regularly won. If the prizes were often only $25 or so, the exposure meant that he was developing a reputation as the go-to animal photographer. In December of 1955, his photograph of a button-nosed silky terrier appeared on the cover of *Popular Photography*, having won 2nd place in the magazine's annual contest. Silky terriers, according to subsequent newspaper accounts of the time, promptly became a wildly popular breed.

Meanwhile, Chandoha had gotten married to Maria Ratti, who became an integral part of the artistic team, as Walter himself said many times in interviews over the years. She was, among others things, an expert animal wrangler, and they worked together until her death in 1992 (Chandoha passed away in 2019). The Chandohas started out in Astoria, Queens, then lived for a time on Long Island before moving out to a charming 18th-century farmhouse in New Jersey, with a surplus of land, light, and a big barn that they converted to a studio. Chandoha's interest in art and design did not stop with photography: Before buying the farmhouse, he had reached out to none other than architect Frank Lloyd Wright to inquire whether he would design a house for Chandoha and his growing family. Wright agreed, but he died before the plans were completed. The fact that Chandoha contacted Wright, though, is just one indication of his broader aesthetic interests, something he advised budding photographers to cultivate. In his

Walter Chandoha and companion, Fort Dix, New Jersey, 1943

German shorthaired pointer, Long Island, New York, 1953

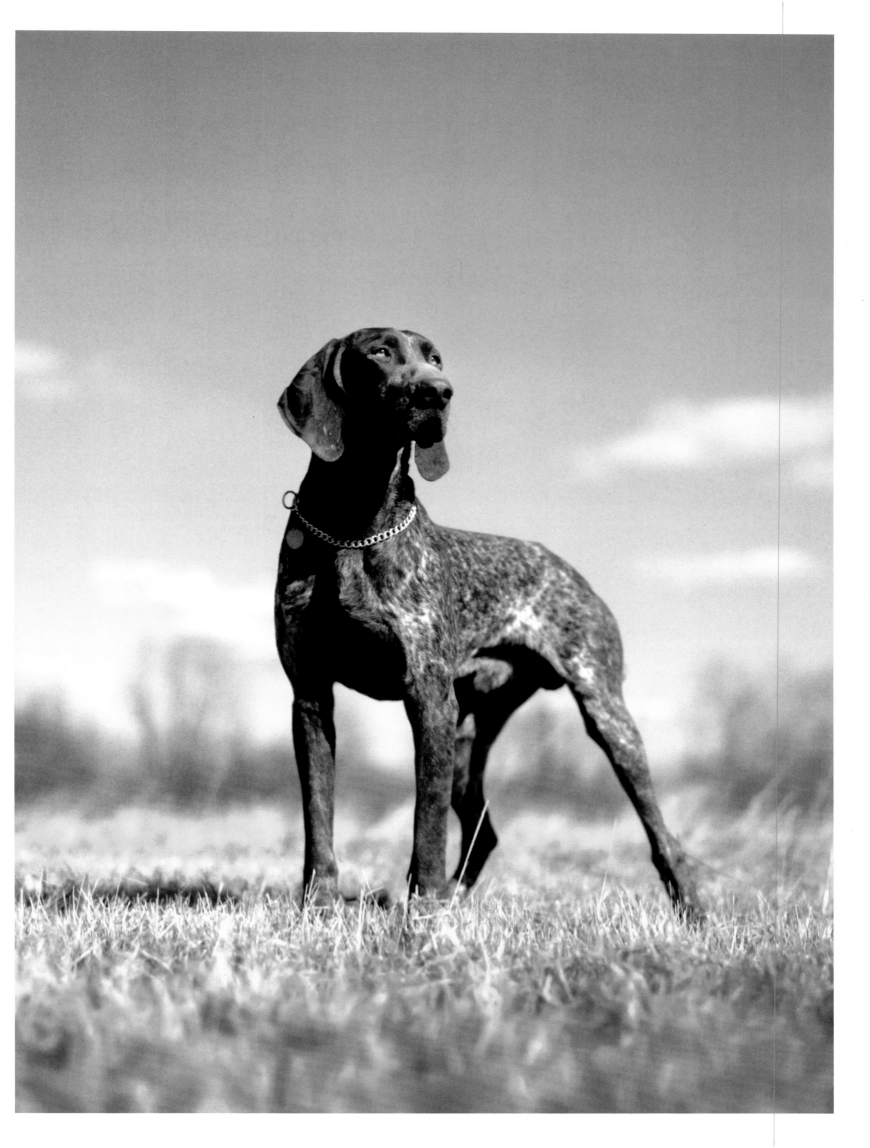

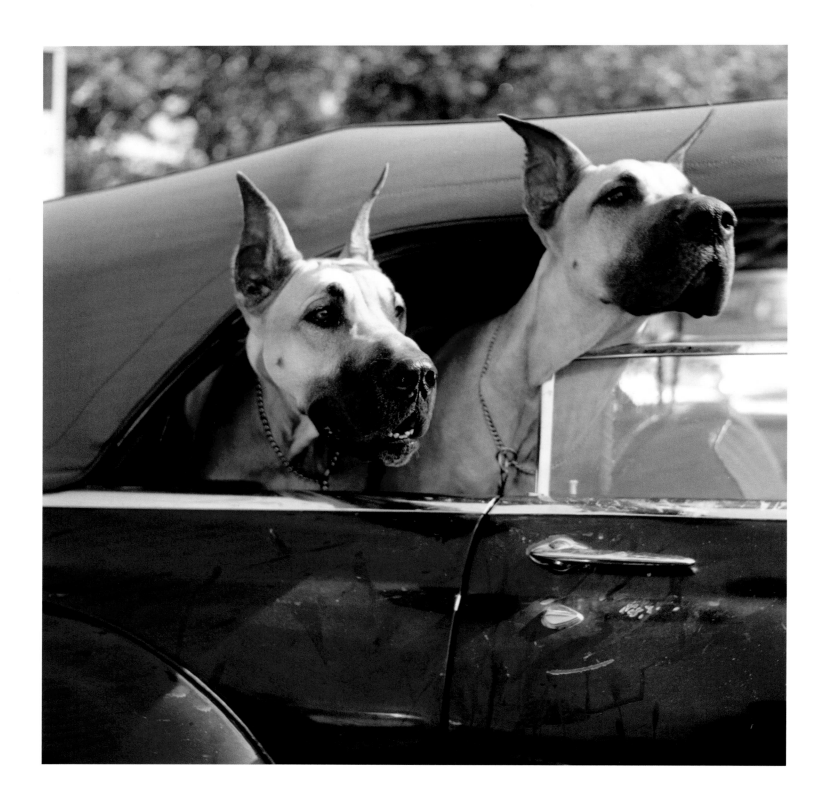

Great Danes, Long Island, New York, 1958

1973 book, *How to Photograph Cats, Dogs, and Other Animals*, before he gets to the chapters on equipment, film and paper, and shooting techniques, Chandoha advises photographers to expose themselves to as many different art forms as possible: "Go to the theatre, the movies, concerts, ballet; watch TV selectively, and most important of all, read, read, read!...Through

reading and constant exposure to all forms of art," he added, "you will become more observant of the world about you. You will subconsciously learn to see more."

Chandoha's own ability to see more — to absorb the lessons of art as well as advertising — enabled him to become a highly versatile photographer. He was adept at the Hollywood-style studio portrait (like his

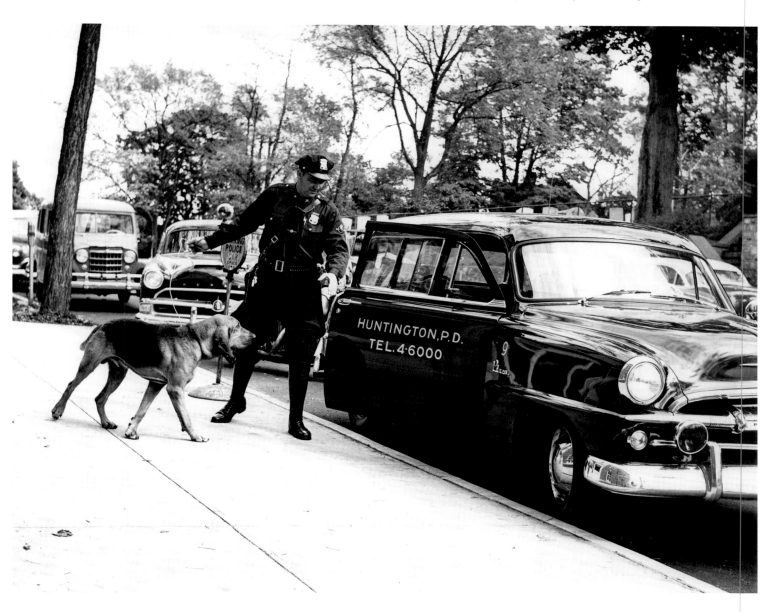

Bloodhound, Long Island, New York, 1954

13

photograph of a pair of regal Afghan hounds, long locks flowing, posed against a soft pink background (page 25), but he could also adopt a photojournalistic style he likely developed as a war photographer and later as a student taking street photographs in New York City. He regularly photographed dogs at work, for example: a bloodhound working with a policeman (page 13), a cocker spaniel carrying a pheasant (page 263) or a guide dog helping his owner disembark from a bus (opposite).

Chandoha was also intrigued by the rituals and pageantry of dog shows, and they became a personal, social documentary project that he returned to again and again. At the Westminster Dog Show in New York City, the people were as much his focus as the

dogs—like the handlers gripping the muzzles of four dogs in a straight line of springer spaniels (page 23), or the group of people crowding the entryway to the main floor, the dog in their midst an apparent after-thought (page 216). But he also loved local dog shows, which were popular community events in the 1950s and '60s, and his photographs offer a glimpse into a slice of upper-middle-class life in mid-century America. Although they were held outdoors, a certain decorum was evidently expected, because people dressed for those events—men in suits and ties, women in skirts and pumps, all of whom arrived in big American cars that wait in the background of many of Chandoha's pictures. In several photographs, the dogs are in the ring, being put through their paces, but in others, he focused on what happened in the wings, so to speak, like the ill-at-ease Chihuahua whose leash appears to be wrapped around the ankle of a woman in high-heeled pumps (page 196). It's a photograph with the wit of an Elliott Erwitt picture, but a touch less irony.

Like the anxious Chihuahua, the dogs in Chandoha's pictures are eminently relatable, one of the reasons his pictures were sought after by such a wide range of brands. Gaines, Milk Bone, Ken-L Ration, and Purina, for example, but also Old Gold cigarettes, Genesee beer, General Mills' Cheerios, and Ohrbach's department store as well as film and camera companies, including Kodak, Hasselblad, Polaroid, and Graflex. His photo-graphs were regularly featured in the picture magazines like *Life* and *Look* and their equivalents around the world, on the covers of the numerous popular magazines of the time, as well as the many Sunday newspaper magazines such as *Parade*, *This Week*, and *Weekend* that were commonplace. Thirty-five books of his work, including this one, have been published since 1951.

Despite his success, Chandoha remained his own boss, photographing creatures he loved, with the people he loved—his wife, of course, but also their children, who were frequent subjects and collaborators, and

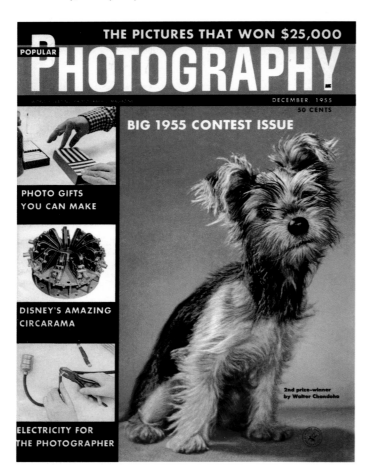

Popular Photography, 1955

Guide dog, Long Island, New York, 1956

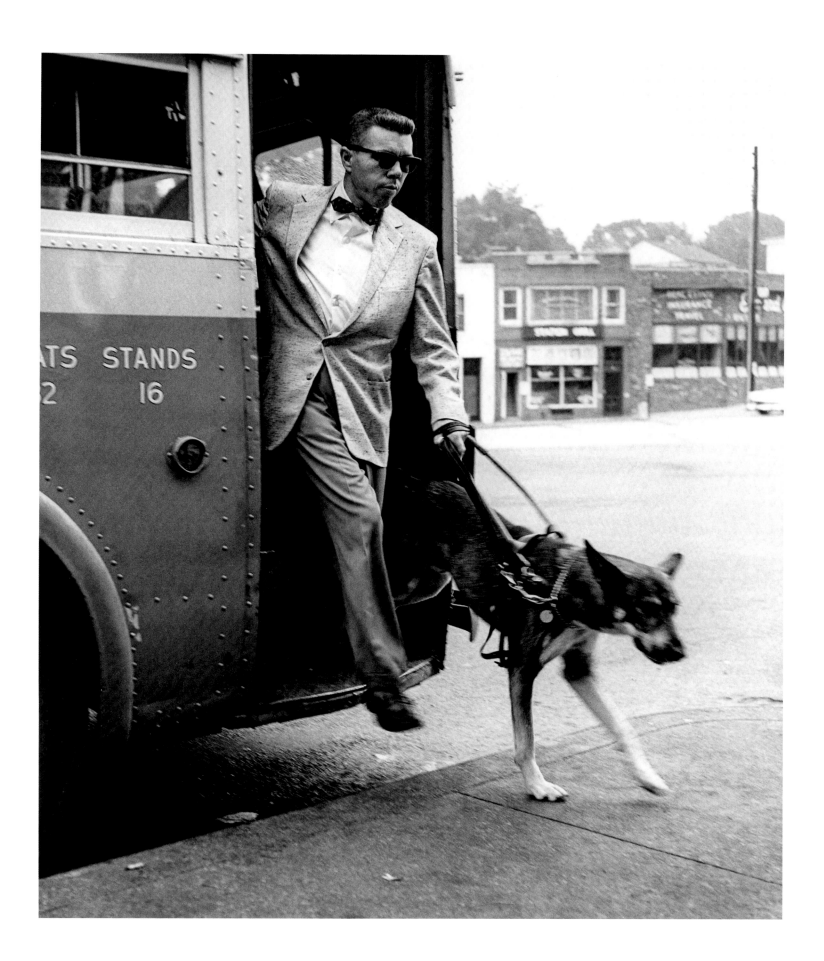

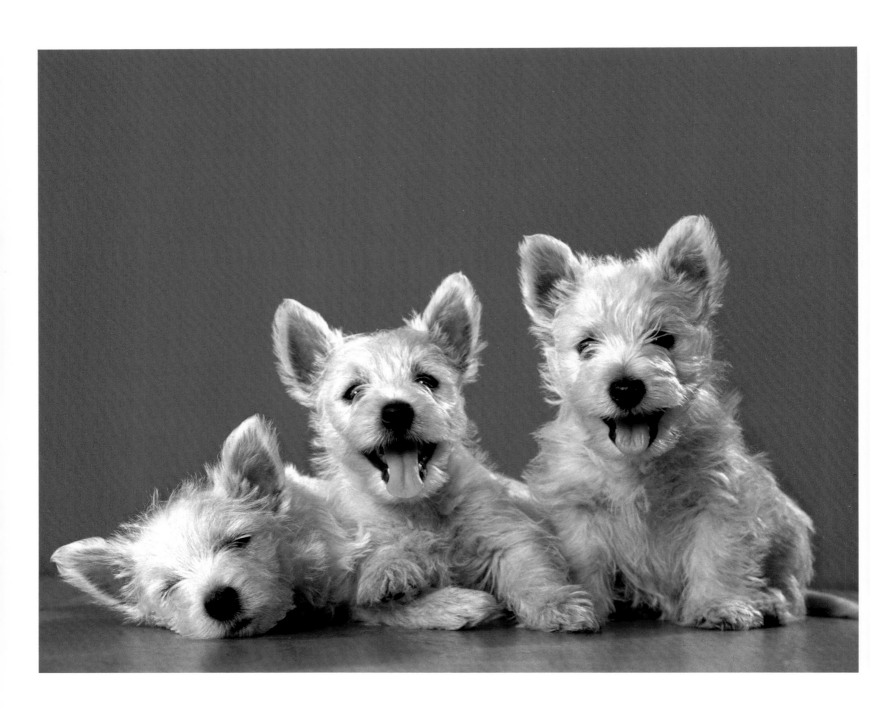

West Highland terriers, New Jersey, 1974

their pets. Many cats roamed the family farm, and in addition to their family dogs, Chandoha regularly borrowed rescue dogs from the Greenwich Village humane league, the North Shore Animal League, and other shelters, or occasionally put ads in the local newspapers, particularly if he had a specific type of dog in mind. According to Fernanda, her father intentionally sought out as many different breeds and types as possible to photograph, for the creative possibilities they provided. "The various characteristics and personalities of the different breeds and mixed breeds often contributed to what he envisioned for each shot," she said. "The different dogs themselves were a large part of his inspiration and his creative process."

His daughter Chiara recalls jumping off the school bus at the end of the day, eager to see which animals might be there to play with. There was no reticence on the part of the six children about being around the animals, who quickly became part of the Chandoha clan. The first family dog was a Bouvier named Kitty Dog, and a photograph of Chiara and Kitty Dog (page 29) attests to how comfortable the animals and the children were with each other. The Bouvier stands protectively over Chiara, who is a year old at most, while she peers up into her face. Like many of Chandoha's portraits, the photographs show the two in a spare, simple setting, so the focus is entirely on the pair. Even in his color photographs, he often posed the dogs in front of minimal color backdrops, a precursor to the aesthetic Neil Winokur incorporated — in an amped up version — some 30 years later in his supersaturated color portraits of animals.

Chandoha's photographs benefitted as well from his reserves of patience and his impeccable timing. Like Henri Cartier-Bresson, he was attuned to the decisive moment, commonly understood as the perfect instant to press the shutter. In his introduction to his book *The Decisive Moment*, Cartier-Bresson wrote, "Photography is the simultaneous recognition, in a fraction of a second, of the significance of an event as well as of a precise organization of forms which give that event its proper expression." For Chandoha, it was not just capturing the moment when a German shepherd stands with his paws on the shoulders of a girl (his daughter Paula), so that the two are face-to-face (page 37), but the compositional elements — "the precise organization of forms" — that fell into place in that moment: the triangular shape formed by the pair, the parked cars in the background that look like toys at the feet of the girl and the dog, the trees that line the frame, and the low vantage point from which the photograph was taken (Chandoha was probably lying on his stomach in the grass to get the shot) that gives the pair a formidable presence.

Family Weekly, 1959

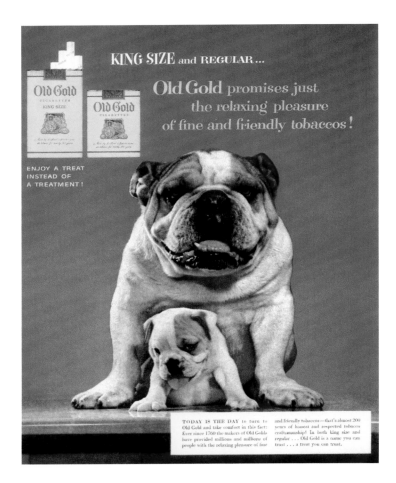

that dogs have a unique capacity not just to communicate with humans, but to love them. They are "hyper social," according to Wynne, which seems evident in the number of artists whose affection for their dogs have translated into portraits of them, from Thomas Gainsborough's 1877 painting of a Pomeranian and her puppy; to Alex Katz's 1971 portrait of a long-haired sheepdog Sunny, red tongue hanging out; to William Wegman's numerous cooperative Weimaraners. Dogs' loyalty and devotion is, to some degree, built into their genome, according to Wynne — they experience pleasure in the presence of humans.

It's no wonder that sense of pleasure is reciprocal, and Chandoha's photographs convey that simple delight. In a larger sense, suggests Fernanda, they also remind us that humans have bonds with (and responsibilities to) other living creatures with whom they share the planet. She recalls that her father mostly photographed the dogs with minimal props, if any, in order to photograph them *as dogs*, rather than anthropomorphizing them. Indeed, whether they were used to advertise dog biscuits or to illustrate a magazine story or whether they were for his own projects, Chandoha's photographs conveyed real affection for and affinity with his canine subjects. Regularly photographing them at (their) eye level, he put them on an equal footing, so to speak.

Take his photograph of a mutt resting in the inside of a screen door on a sunny day (page 41). It takes a beat to notice that outside, looking in, are a cat and another dog, a large Kitty Dog, perhaps, though it's hard to tell, because the animal is mostly in shadow. The doorframe, as well as a perpendicular post outside, give the photograph a solid geometry, and the screen slightly conceals two of the subjects, adding a sense of depth, and the hint of a secret. Then there's that oddball trio of animals, who seem blithely unaware of how unmatched they are. It's a classic Chandoha photograph, sweet but not saccharine, with a quiet undercurrent of affection.

He also, though, emphasized the importance of pressing the shutter at just the right second, and he recommended developing "a quick trigger finger." Pretend to hold a camera, he suggested to aspiring photographers in *How to Photograph Cats, Dogs, and Other Animals*, and "shoot" imaginary pictures wherever you are to sharpen your timing, so that when you're actually holding a camera, your reaction time will be second nature. How else to get the shot of a dalmatian, mid leap, as it jumps over a stick held out by a young boy (Chandoha's son Enrico) on the beach (page 38), or the frame-filling face of a Weimaraner barking, mouth open wide (page 117)?

In the 2019 book *Dog Is Love*, Clive D. L. Wynne, a psychologist who specializes in dog behavior, found

Old Gold advertisement, 1954

Pugs, Long Island, New York, 1957

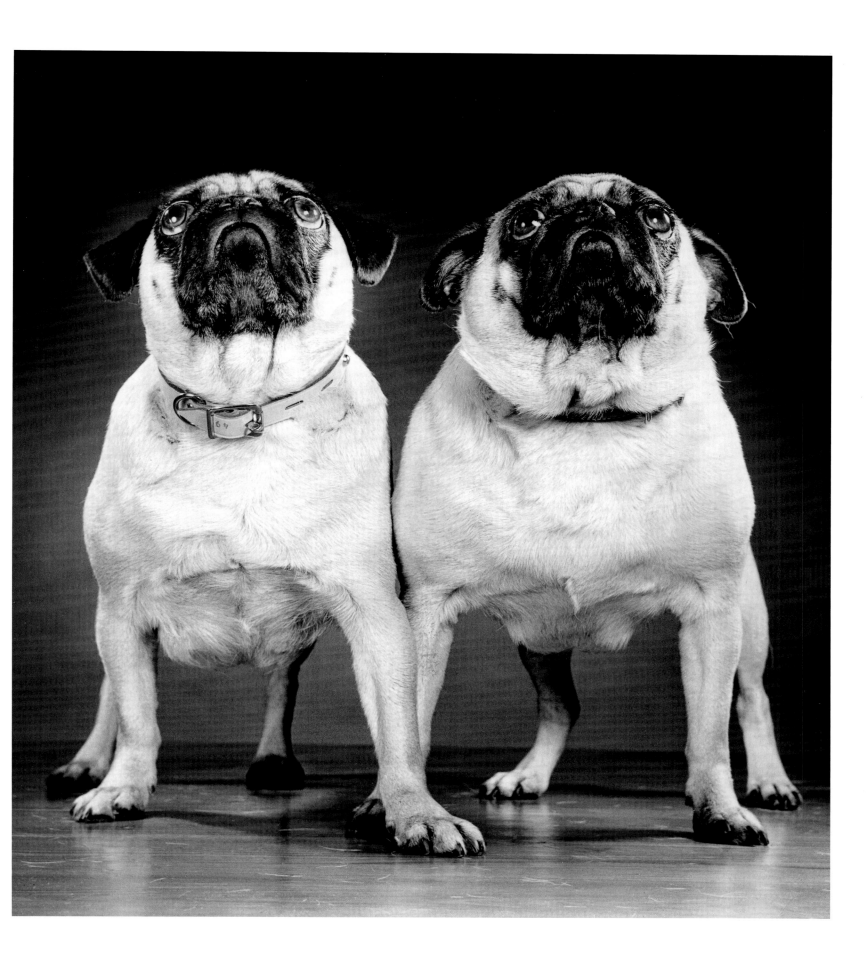

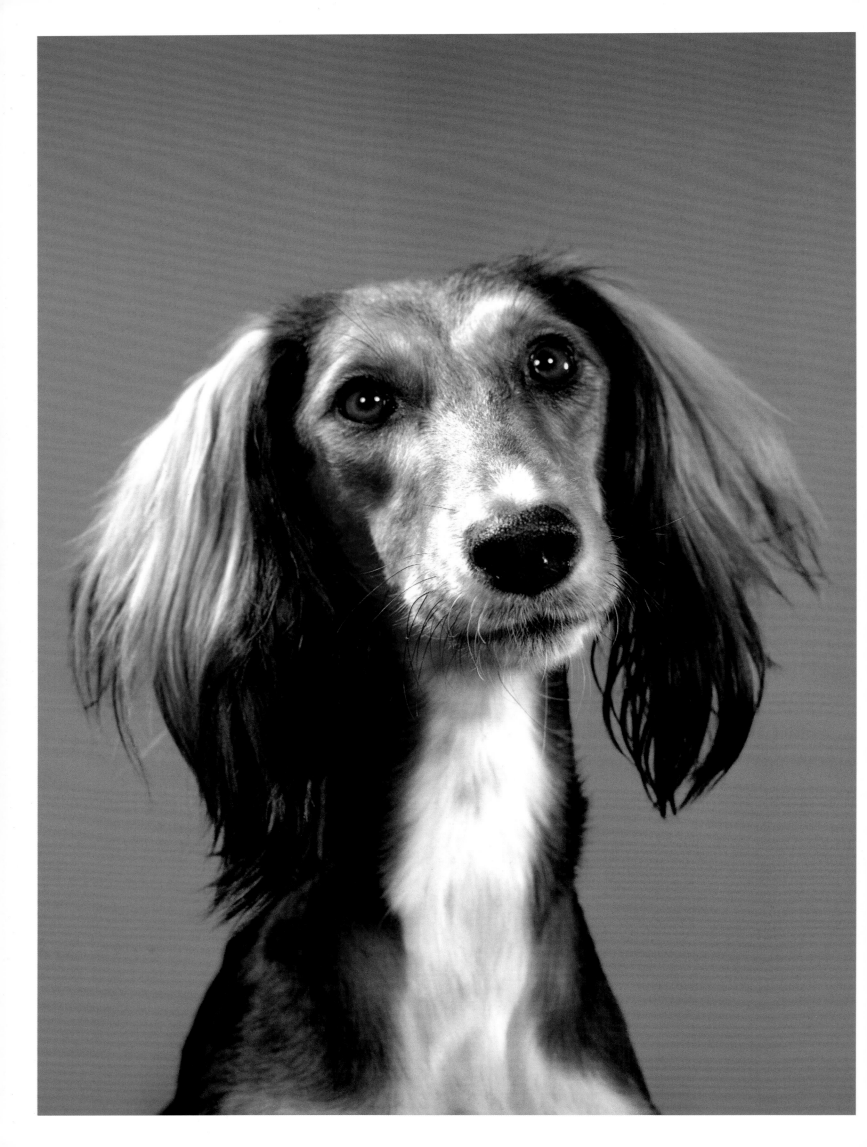

EIN FOTOGRAF FÜR ALLE FELLE

VON JEAN DYKSTRA

WALTER CHANDOHAS FOTOGRAFIEN VON HUNDEN FASZINIEREN NICHT ALLEIN DESHALB, WEIL HUNDE AN SICH BEZAUBERND SIND, SONDERN WEIL DER MENSCH HINTER DER KAMERA SEIN HANDWERK BEHERRSCHTE. Er wusste, was zu tun war, um das gewünschte Bild zu bekommen — wie man es ausleuchtet, komponiert, einen bestimmten Ausdruck oder eine Haltung einfängt: einen Doggenwelpen, der sich auf seinem halb schlafenden Geschwisterchen ausbreitet, zwei Möpse Seite an Seite mit tief besorgten Mienen oder drei weiße West-Highland-Terrier vor tomatenrotem Hintergrund, die wie Dominosteine umzukippen scheinen. Solche Aufnahmen erfordern Erfahrung, Urteilskraft, Unmengen an Geduld und ein scharfes Auge. Doch Walter Chandoha ließ es leicht aussehen.

Auf den folgenden Seiten finden sich einige Schwarz-Weiß-Aufnahmen, die einen überaus entzückenden, flaumig weißen Welpen und Chandohas vierjährige Tochter Maria zeigen. Einmal liegen die beiden nebeneinander auf dem Bauch, die Köpfe Richtung Kamera, spartanische Kulisse — Dielenboden, bleiche Wand —, Hund und Mädchen im Bildmittelpunkt (Seite 103). Ein anderes Foto entstand im Freien: Chandoha erwischte Maria, als sie, den Welpen unter den Achseln gepackt, barfuß über ein sonniges Rasenstück tappt (Seite 34). In einem dritten Bild fing er den Moment ein, in dem Mädchen und Hund, einander zugewandt, Mund und Maul weit aufreißen, als lachten sie über einen privaten Witz (Seite 8). Diese drei Aufnahmen desselben Motivpaares sagen viel über seinen Ruf als einer der größten Heimtierfotografen der Welt aus. Sie zeugen von der Liebe zu seinen Kindern (es waren insgesamt sechs), aber auch zu den Tieren, die er lebenslang fotografierte. Und sie belegen seine Vielseitigkeit: Das Repertoire seiner hauptsächlich auf Katzen- und Hundefotografie fokussierten Kunst umfasste das formelle Studioporträt, das Actionfoto unter freiem Himmel und eine wunderbare Form des entscheidenden Augenblicks. Außerdem vermitteln die Bilder die innige Zuneigung und emotionale Verbindung zwischen Hunden und Menschen.

Chandoha kam 1920 als Sohn ukrainischer Einwanderer in Bayonne, New Jersey, zur Welt und unternahm seine ersten Schritte in der Kunst der Fotografie als Kind mit der Kodakkamera der Familie. Später trat er dem Lens Club of Bayonne bei, einem von vielen Kameraklubs, die in den 1930er-, 40er- und 50er-Jahren aufblühten. Kameraklubs waren Orte, an denen Fotografen Abzüge machen, sich austauschen und von anderen Mitgliedern lernen konnten. Sie spielten eine überaus wichtige Rolle,

Saluki, Long Island, New York, 1954

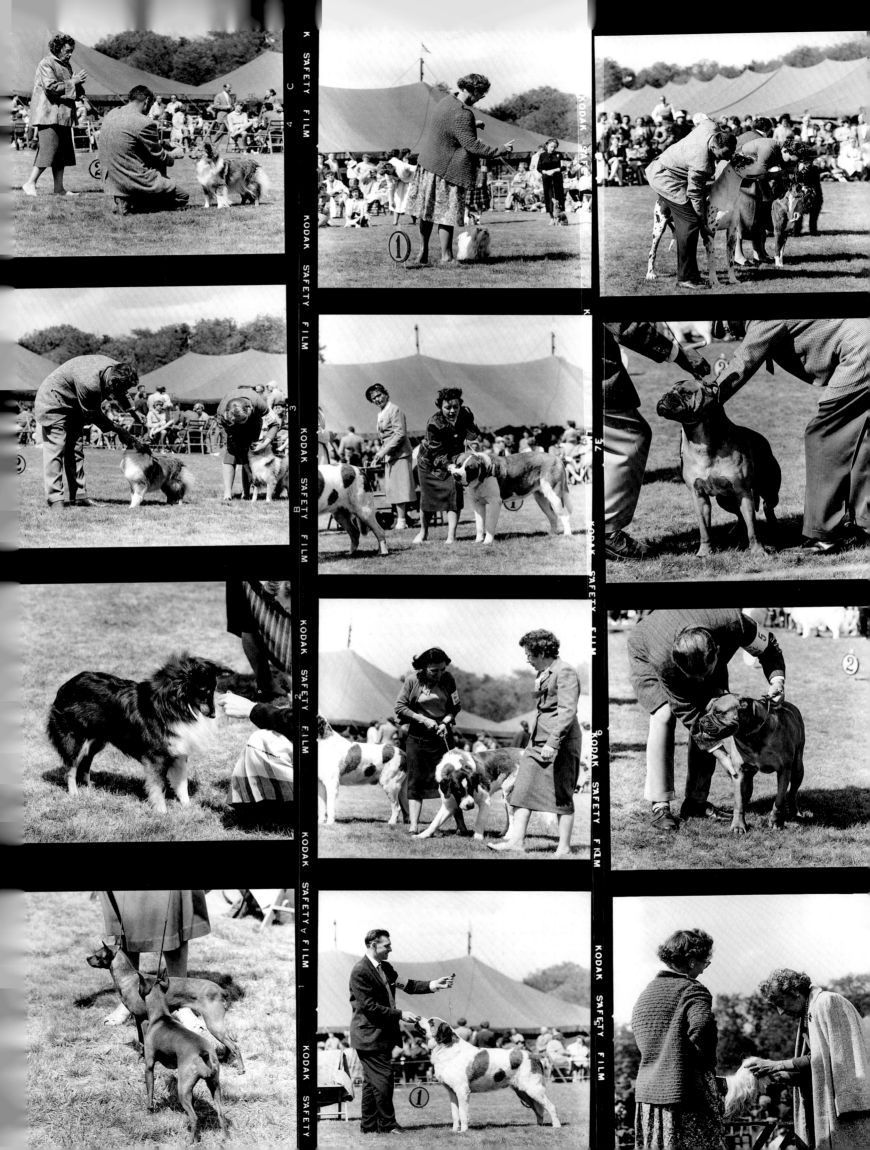

da sie eine Gemeinschaft, Beziehungen und eine fachliche Ausbildung boten, als Fotografie noch nicht an Hochschulen unterrichtet wurde. Jahre später revanchierte sich Chandoha dafür mit Vorträgen über Tierfotografie in Kameraklubs, die sich vor Zuhörern kaum retten konnten.

1942 wurde Chandoha einberufen und als Pressefotograf in Fort Dix stationiert. Eine Fotografie aus dieser Zeit zeigt ihn mit dem Kasernenhund, der den passenden Namen Hypo trug (die Bezeichnung für das chemische Gemisch, das zum Fixieren von Abzügen verwendet wurde). Schließlich wurde er als Truppenfotograf einer

Fernmeldeeinheit in den Südpazifik versetzt, wo er bis 1946 diente. Mit GI-Berechtigung studierte er an der New York University und hörte nicht auf zu fotografieren. Zwischen den Vorlesungen durchstreifte er die Stadt und fotografierte die Schatten von Hochbahnzügen, im Strahl eines Feuerhydranten planschende Kinder oder ein von Sonnenlicht eingekeiltes Taxi – wunderbar komponierte Bilder, die an Straßenfotografien von Walter Rosenblum oder Louis Stettner erinnern.

Aber nebenbei fotografierte Chandoha immer wieder Katzen und Hunde – vielleicht zur Erholung und zum Trost, wie Tiere ihn spenden können. Seine Töchter

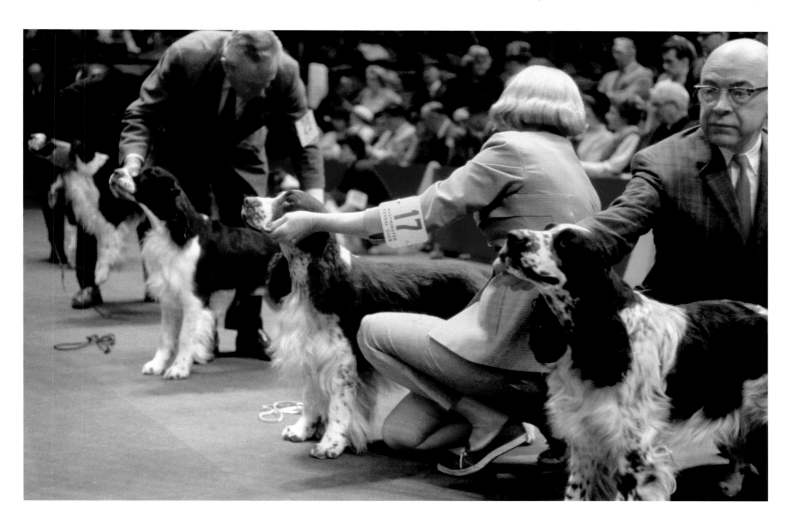

Dog show, New York, 1959

Westminster Dog Show, New York City, 1972

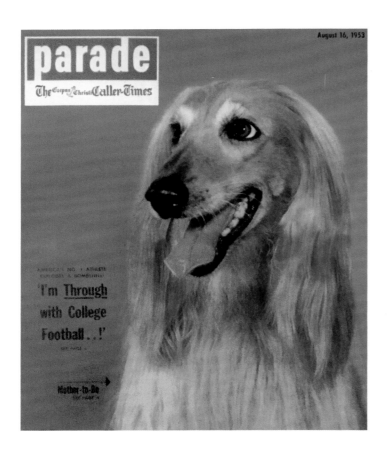

Fernanda, Chiara und Paula erinnern sich, dass er fast nie von seinen Kriegserlebnissen sprach, und wenn das Thema in späteren Jahren aufkam, stiegen ihm Tränen in die Augen. Die Bilder, die er während des Kriegs aufgenommen hatte, mochte er wohl abgeliefert haben, doch die Schrecken des Gesehenen verließen ihn sicher nicht. Die Fotografie war, wie Fernanda vermutet, seine Rettung. „Ich glaube, etwas an ihr heilte sein Herz", wie Paula ergänzt.

Zudem erregten seine Fotografien immer größere Aufmerksamkeit und trugen ihm Preise ein. Regelmäßig reichte er sie bei Wettbewerben ein, die Zeitungen, Zeitschriften und Kameraklubs ausschrieben, und ebenso regelmäßig gewann er. Auch wenn das Preisgeld oft nur um die 25 Dollar betrug, machte ihn das Zurschaustellen seiner Arbeit als Tierfotograf bekannt und begehrt. Im

Dezember 1955 erschien seine Aufnahme eines knopfnasigen Silky-Terriers auf dem Cover der Zeitschrift *Popular Photography*, in deren alljährlichem Wettbewerb er damit den zweiten Platz belegte. Laut damaliger Zeitungsberichte wurde der Silky-Terrier anschließend prompt zum heiß begehrten Modehund.

Chandoha hatte mittlerweile Maria Ratti geheiratet, die zum festen Bestandteil des Kreativteams wurde, wie er selbst in Interviews immer wieder sagte. Sie war unter anderem eine erfahrene Tiertrainerin und arbeitete bis zu ihrem Tod im Jahr 1992 mit Walter zusammen (der 2019 starb). Nach ihren Anfängen in Queens, New York, lebten die Chandohas einige Zeit in Long Island und zogen schließlich nach New Jersey in ein entzückendes Bauernhaus aus dem 18. Jahrhundert mit reichlich Grund, Licht und einer großen Scheune, die sie zum Studio umfunktionierten. Chandohas Interesse an Kunst und Design blieb nicht auf die Fotografie beschränkt: Vor dem Kauf des Bauernhofs hatte er keinen Geringeren als den Architekten Frank Lloyd Wright gebeten, ein Haus für ihn und seine wachsende Familie zu entwerfen. Wright willigte ein, starb jedoch vor Fertigstellung der Pläne. Dass Chandoha sich an Wright wandte, ist nur ein Indiz für die große Spannweite seines ästhetischen Interesses, was er auch angehenden Fotografen zu kultivieren riet.

In seinem 1973 erschienenen Buch *How to Photograph Cats, Dogs, and Other Animals* rät Chandoha den Fotografen — bevor er auf die Kapitel Ausrüstung, Film, Papier und Aufnahmetechniken zu sprechen kommt —, sich mit so vielen verschiedenen Kunstformen wie nur möglich auseinanderzusetzen: „Geht ins Theater, Kino, Ballett, geht in Konzerte, seht selektiv fern und am allerwichtigsten: Lest, lest, lest!" Und er ergänzt: „Wer liest und sich ständig mit allen Formen der Kunst auseinandersetzt, wird die Welt um sich herum aufmerksamer wahrnehmen. Er wird unbewusst lernen, mehr zu sehen."

Chandohas eigene Fähigkeit, mehr zu sehen — die Lektionen der Kunst und auch der Werbung zu

Parade magazine, 1953

Afghans, Long Island, New York, 1956

24

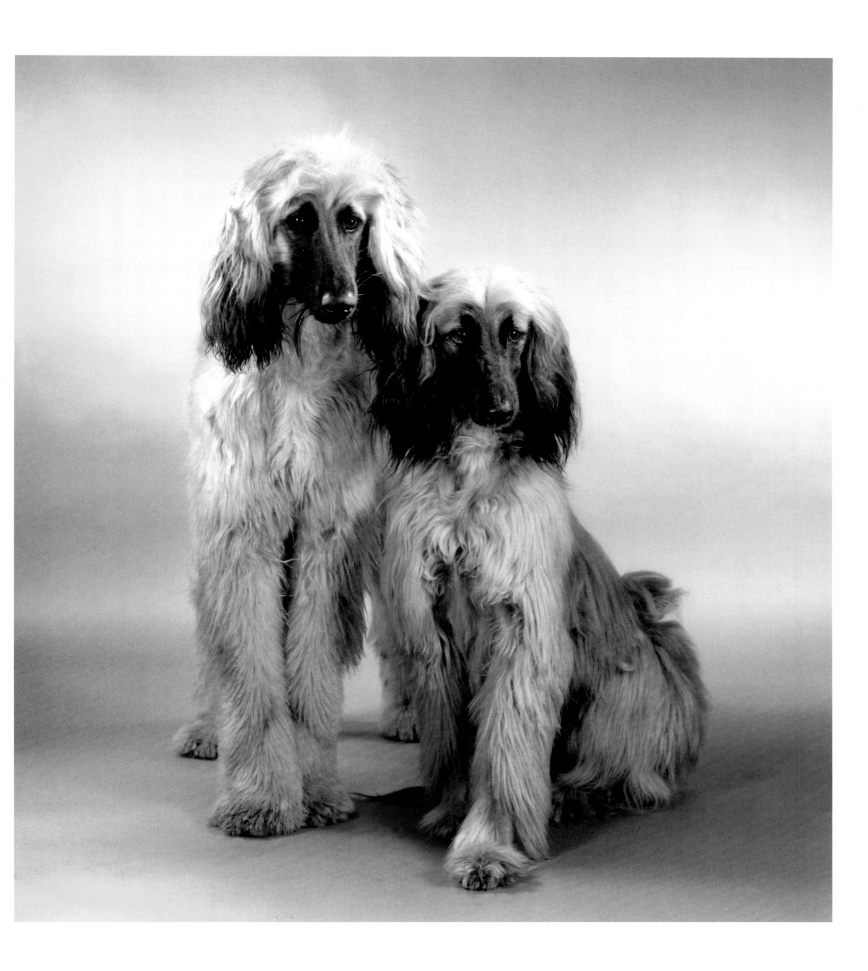

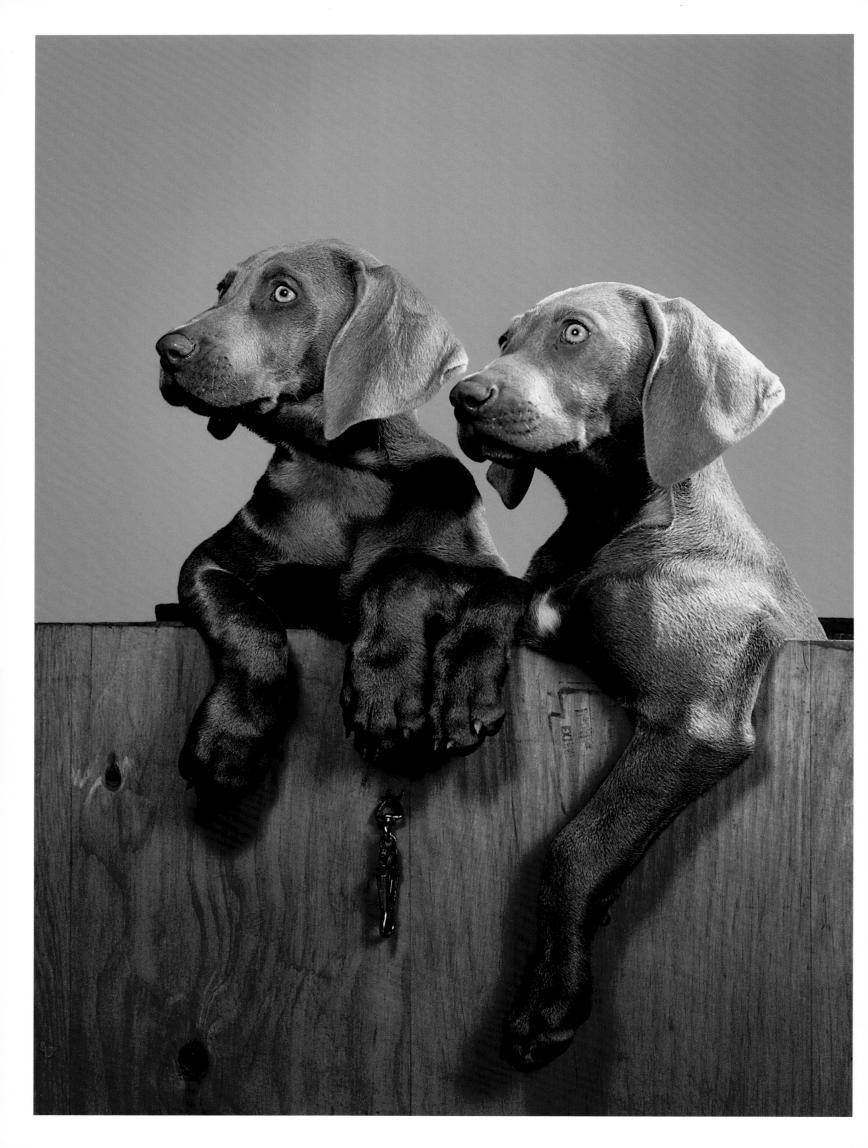

verinnerlichen —, ermöglichte ihm, ein ungemein vielseitiger Fotograf zu werden. Er war ein Meister des Studioporträts im Hollywoodstil (wie bei der Aufnahme des majestätischen Afghanenpaares mit wallendem Haar vor zartrosafarbenem Hintergrund, Seite 25), konnte sich jedoch auch eines fotojournalistischen Stils bedienen, den er wahrscheinlich als Kriegsfotograf und später als Student bei seinen Fotostreifzügen durch die Straßen von New York entwickelt hatte. So fotografierte er beispielsweise immer wieder Hunde bei der Arbeit: einen Bloodhound im Einsatz mit einem Polizisten (Seite 13), einen Golden Retriever, der einen Fasan apportiert (Seite 263), oder einen Führhund, der seinem Besitzer beim Aussteigen aus dem Bus hilft (Seite 15).

Auch Hundeausstellungen mit ihrem Pomp und Zeremoniell faszinierten Chandoha und wurden zu einem persönlichen Projekt, einer Gesellschaftsdokumentation, an der er immer wieder arbeitete. Bei der Westminster Dog Show in New York nahm er die Menschen genauso in den Fokus wie die Hunde — etwa die Vorführer, die die Schnauzen ihrer in Reih und Glied angetretenen vier Springer-Spaniel in Position halten (Seite 23), oder die Menschengruppe, die sich im Eingang zur Hauptarena drängt und in der der Hund in ihrer Mitte offensichtlich nur Randfigur ist (Seite 216). Aber auch regionale Hundeausstellungen, wie sie Mitte des letzten Jahrhunderts beliebt waren, lockten Chandoha, und seine Bilder zeigen uns einen kleinen Ausschnitt aus dem Lebensalltag der oberen Mittelschicht im Amerika der 1950er- und 60er-Jahre. Auch wenn diese Veranstaltungen im Freien stattfanden, war offensichtlich eine gewisse Etikette erwünscht, denn man warf sich dafür in Schale — die Männer trugen Anzug und Krawatte, die Frauen Rock und Pumps —, und alle fuhren in großen amerikanischen Autos vor, die auf vielen von Chandohas Fotos im Hintergrund warten. Einige Bilder zeigen, wie die Hunde im Ring genauestens geprüft werden, andere aber konzentrieren sich auf das, was sozusagen hinter den Kulissen passierte, etwa auf den unglücklichen Chihuahua,

dessen Leine sich offenbar um die Fessel einer Frau in hohen Pumps gewickelt hat (Seite 196). Es ist ein Bild mit dem Witz einer Elliott-Erwitt-Fotografie, aber etwas weniger ironisch.

So wie der verschreckte Chihuahua sprechen die Hunde in Chandohas Bildern uns ungemein an — einer der Gründe, weshalb ein breites Spektrum an Unternehmen damit seine Produkte bewarb: die Hundefuttermarken Gaines, Milk Bone, Ken-L Ration und Purina zum Beispiel, aber auch Old Gold (Zigaretten), Genesee (Bier), General Mills' (Frühstücksflocken) oder die Kaufhauskette Ohrbach's, außerdem Film- und Kamerahersteller wie Kodak, Hasselblad, Polaroid und Graflex. Seine Fotos erschienen regelmäßig in Magazinen wie

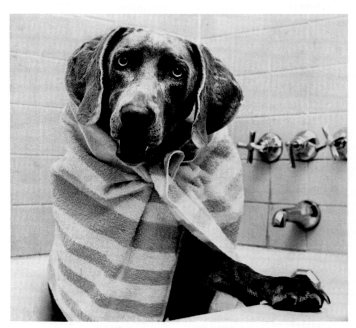

Dry skin? When I'm still soaking wet?

Could be, boy. Baths alone can't give pets healthy skin and a bright, glowing coat. Good nutrition is vital...and new easy-to-add PET'M Daily Food Supplement can help.

Grooming's great, as far as it goes. But most pets need something more basic . . . for the lasting, lustrous look of good health. Even canned and packaged foods may lack certain nutrients . . . enough fatty acids and vitamins . . . which help to prevent dull coats and itchy skin.

Now it's easy to make sure your pet's diet includes them. Get PET'M Daily Food Supplement . . . the new secret of sound pet nutrition.

Simply squirt it on your dog's or cat's dinner every day, with the push-button dispenser. Makes food more appetizing, too, even for finicky eaters.

Poly-unsaturated fatty acids, sorbitans that make them easy to assimilate, plus essential vitamins A, D₂, and E. They all should be in your pet...that's why they're all in this healthful new product.

...for the Blue Ribbon coat that starts inside. Now at your drug store.

Weimaraners, Long Island, New York, 1955

Pet'm advertisement, 1962

Life, Look und deren Pendants in aller Welt, aber auch auf den Titelseiten der damals so zahlreichen Illustrierten und in Sonntagsbeilagen wie *Parade, This Week* und *Weekend*. 35 Bücher, diesen Band miteingerechnet, haben sich seit 1951 seinem Werk gewidmet.

Allem Erfolg zum Trotz blieb Chandoha sein eigener Herr und fotografierte Tiere, die er liebte, mit Menschen, die er liebte — seine Frau natürlich, aber häufig auch die gemeinsamen Kinder, die zugleich seine Helfer waren, und die Haustiere der Familie. Auf dem Bauernhof streunten viele Katzen umher, und zusätzlich zu den eigenen Hunden lieh Chandoha sich oft Pflegehunde bei Tierheimen und Tierschutzvereinen wie der

WALTER CHANDOHA
FAMOUS ANIMAL PHOTOGRAPHER

MR. CHANDOHA WILL SPEAK ON HIS SPECIALTY

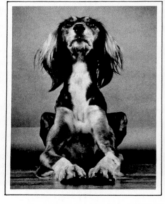
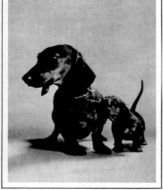

KODAK CAMERA CLUB THEATRE
FRIDAY FEB. 18th at 7:30

TICKETS AVAILABLE FREE AT K.C.C. BLDG. 28 K.P. and KORC K.O.

Kodak Camera Club announcement, 1955

Greenwich Village Humane League oder der North Shore Animal League. Gelegentlich inserierte er auch in der Lokalpresse, vor allem dann, wenn ihm ein bestimmter Hundetyp vorschwebte. Laut Fernanda versuchte ihr Vater ganz bewusst so viele verschiedene Rassen und Typen wie nur möglich vor die Kamera zu bekommen, weil sich so mehr kreative Möglichkeiten boten. „Oft lieferten die unterschiedlichen Eigenschaften und Charaktere der verschiedenen Rassen und Mischlinge seiner Idee für die jeweilige Aufnahme zusätzliche Anregungen", erzählte sie. „Die Hunde selbst in ihrer Verschiedenheit waren ein wichtiger Teil seiner Inspiration und seines kreativen Prozesses."

Tochter Chiara erinnert sich, am Ende des Tages immer aus dem Schulbus gesprungen zu sein, voller Neugier, welche Tiere zum Spielen da sein mochten. Seitens der sechs Kinder gab es keinerlei Berührungsängste mit den Tieren, die bald fest zum Chandoha-Clan gehörten. Der erste Hund der Familie war ein Bouvier namens Kitty Dog, und eine Aufnahme von Chiara und Kitty Dog bezeugt, wie wohl sich Kinder und Tiere miteinander fühlten (Seite 29). Der Bouvier steht beschützend über dem höchstens einjährigen Mädchen, das zu ihm aufblickt. Der Aufbau ist wie bei vielen Chandoha-Porträts sparsam und schlicht, sodass der Fokus ganz auf dem Paar liegt. Selbst bei seinen Farbfotografien platzierte er die Hunde oft vor einfachste Farbhintergründe, ein Vorläufer der Ästhetik, die Neil Winokur gut 30 Jahre später in seinen ultrafarbsatten Tierporträts auf die Spitze trieb.

Chandohas Gabe der Geduld kam seinen Fotografien ebenso zugute wie sein unfehlbares Timing. Wie Henri Cartier-Bresson ging es auch ihm um den entscheidenden Augenblick, so die gebräuchliche Bezeichnung für den perfekten Moment, um auf den Auslöser zu drücken. In der Einleitung zu seinem Buch *The Decisive Moment* schrieb Cartier-Bresson: „Fotografie heißt, im Bruchteil einer Sekunde die Bedeutung eines Ereignisses zu erkennen und gleichzeitig eine präzise Organisation

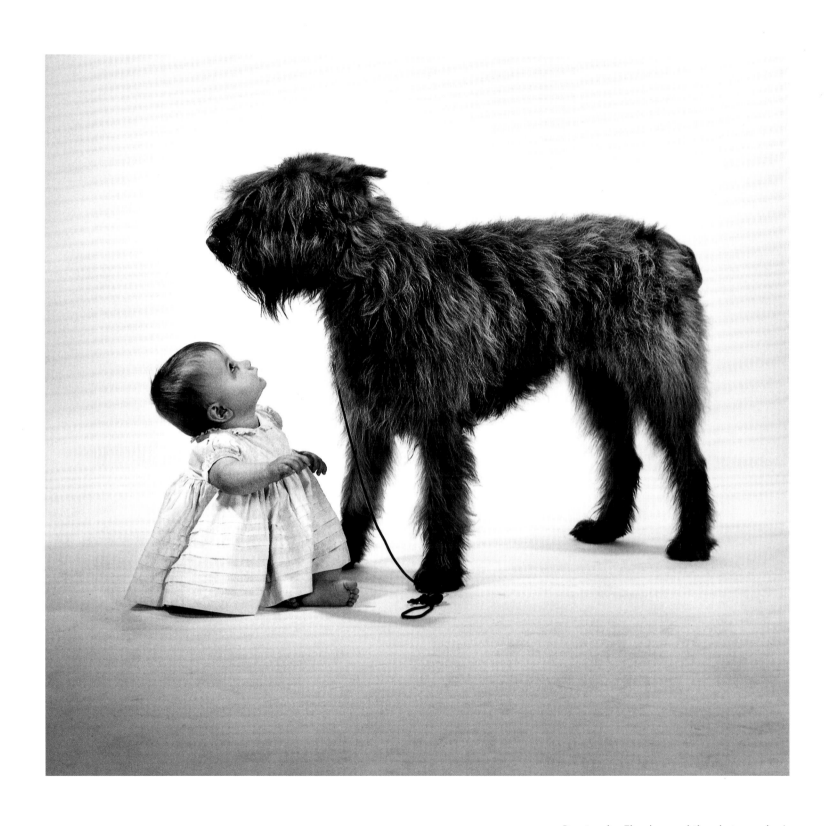

Bouvier des Flandres and the photographer's
daughter Chiara, New Jersey, 1961

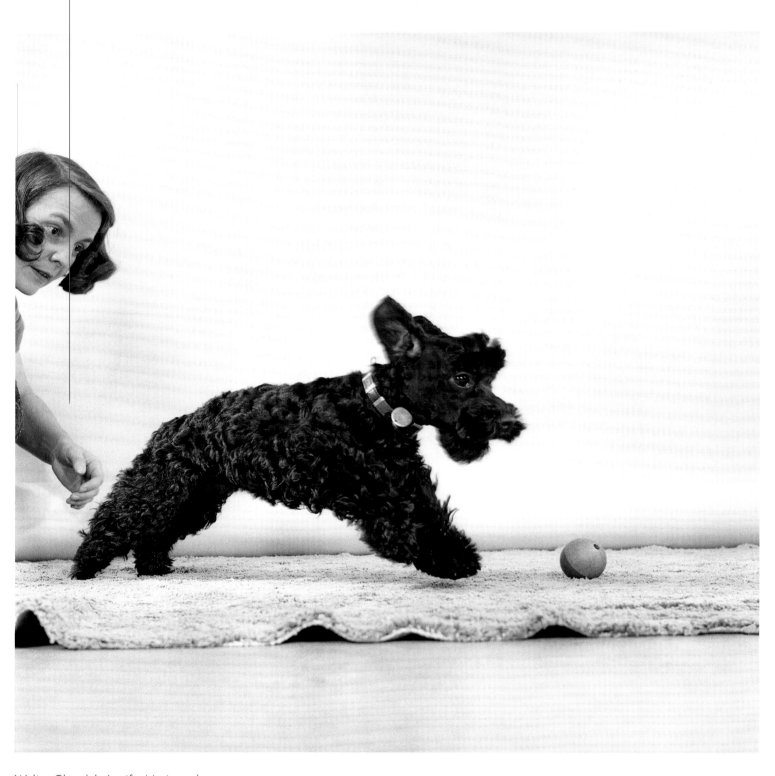

Walter Chandoha's wife, Maria and
mixed-breed, Long Island, New York, 1957

The American Weekly, 1959

von Formen zu finden, die diesem Ereignis den ihm angemessenen Ausdruck verleiht." Chandoha ging es nicht nur um das Festhalten des Augenblicks, in dem ein Deutscher Schäferhund mit seinen Pfoten auf den Schultern eines Mädchens (seiner Tochter Paula) steht, sodass beide einander in die Augen blicken (Seite 37), sondern auch um die Kompositionselemente – die „präzise Organisation von Formen" –, die sich in diesem Moment zusammenfügten: das Dreieck, das Hund und Mädchen bilden, die parkenden Autos im Hintergrund, die wie Spielzeug zu Füßen der beiden wirken, der Baum, der von links in den Bildausschnitt hineinragt, und der niedrige Aufnahmewinkel (Chandoha lag dabei vermutlich bäuchlings im Gras), der dem Paar eine eindrückliche Präsenz verleiht.

Doch er betonte auch, wie wichtig es sei, genau in der richtigen Sekunde auf den Auslöser zu drücken, und empfahl, sich einen „schnellen Finger am Abzug" anzutrainieren. Tut so, als hieltet ihr eine Kamera, riet er angehenden Tierfotografen in *How to Photograph Cats, Dogs, and Other Animals*, und „schießt" imaginäre Fotos, wo immer ihr seid, um euer Timing zu perfektionieren, sodass eure Reaktion wie im Schlaf abläuft, wenn ihr dann wirklich eine Kamera in Händen habt. Wie sonst wäre es möglich, einen Dalmatiner frei in der Luft zu fotografieren, mitten im Sprung über einen Stock, den ihm ein Junge am Strand hinhält (Chandohas Sohn Enrico, Seite 38), oder den bildfüllenden Kopf eines Weimaraners, der mit weit aufgerissenem Maul bellt (Seite 117)?

Der auf das Verhalten von Hunden spezialisierte Psychologe Clive D. L. Wynne stellte in seinem 2019 erschienenen Buch ... *und wenn es doch Liebe ist?* fest, dass Hunde mit Menschen nicht nur kommunizieren können, sondern die einmalige Fähigkeit besitzen, sie zu lieben. Sie sind, so Wynne, „hypersozial", was die Zahl der Künstler zu bestätigen scheint, deren Hundeliebe sich in Porträts ihrer Vierbeiner niederschlug, von Thomas Gainsboroughs 1877 gemaltem Zwergspitz

samt Welpen über Alex Katz' 1971 entstandenes Porträt von Sunny, einem langhaarigen Schäferhund mit rot aus dem Maul hängender Zunge, bis zu William Wegmans Aufnahmen vieler williger Weimaraner. Nach Ansicht Wynnes sind Loyalität und Ergebenheit bis zu einem gewissen Grad bei Hunden genetisch verankert – sie empfinden Freude in der Gegenwart von Menschen.

Es wundert nicht, dass dieses Gefühl von Freude gegenseitig ist, und Chandohas Fotografien vermitteln dieses schlichte Glück. In weiterem Sinn gemahnen sie nach Auffassung Fernandas auch daran, dass der Mensch mit den anderen Lebewesen, mit denen er diese Erde teilt, verbunden ist (und Verantwortung für sie trägt). Wie sie sich erinnert, benutzte ihr Vater beim Fotografieren meist nur wenige Requisiten, wenn

überhaupt, um die Hunde als Hunde zu fotografieren, anstatt sie zu vermenschlichen. In der Tat sprechen aus Chandohas Fotografien, ob für Hundekuchenwerbung oder als Zeitschriftenillustration oder für eines seiner eigenen Projekte gedacht, echte Zuneigung und Affinität zu seinen kaninen Motiven. Er fotografierte sie zumeist auf (ihrer) Augenhöhe, stellte sie also sozusagen gleich.

Nehmen wir nur seine Aufnahme eines Mischlingshundes, der an einem sonnigen Tag vor einer Fliegengittertür rastet (Seite 41). Erst auf den zweiten Blick bemerkt man die Katze und einen weiteren Hund –

vielleicht ein großer Kitty Dog, es lässt sich schwer sagen, da er halb im Schatten ist –, die von draußen hinter der Türe durch das Gitter hineinblicken. Der Türrahmen und ein senkrechter Balken im Hintergrund geben dem Bild eine stabile Geometrie, und das Gitter, das die beiden Tiere dahinter leicht verschleiert, verleiht ihm zusätzliche Tiefe und einen Hauch von Geheimnis. Und schließlich ist da noch dieses merkwürdige Vierbeinertrio, das wohl nicht ahnt, wie unvergleichlich es ist. Es ist ein klassisches Chandoha-Bild, süß, aber nicht zuckrig, mit einem leisen, liebevollen Unterton.

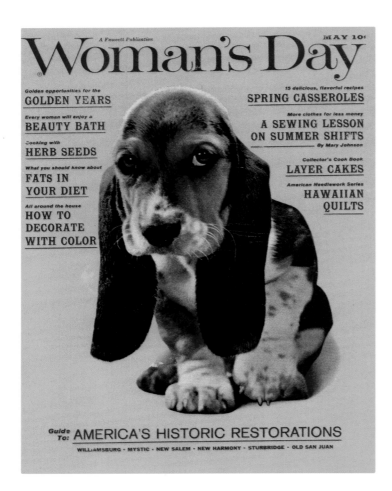

Woman's Day magazine, 1963

Beagles and Chandoha, Long Island, New York, 1955

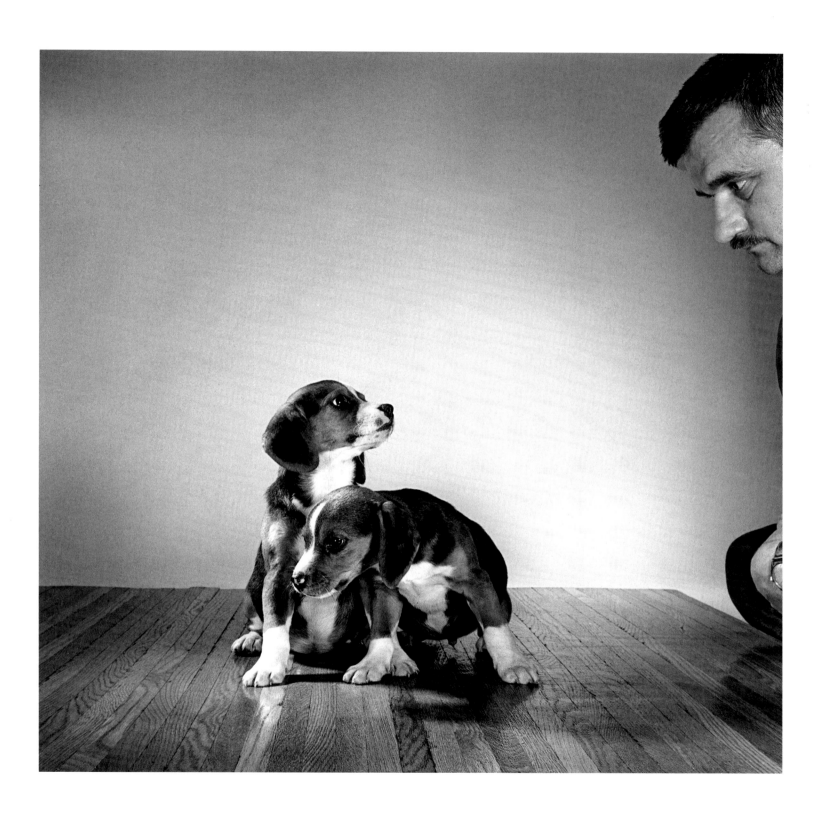

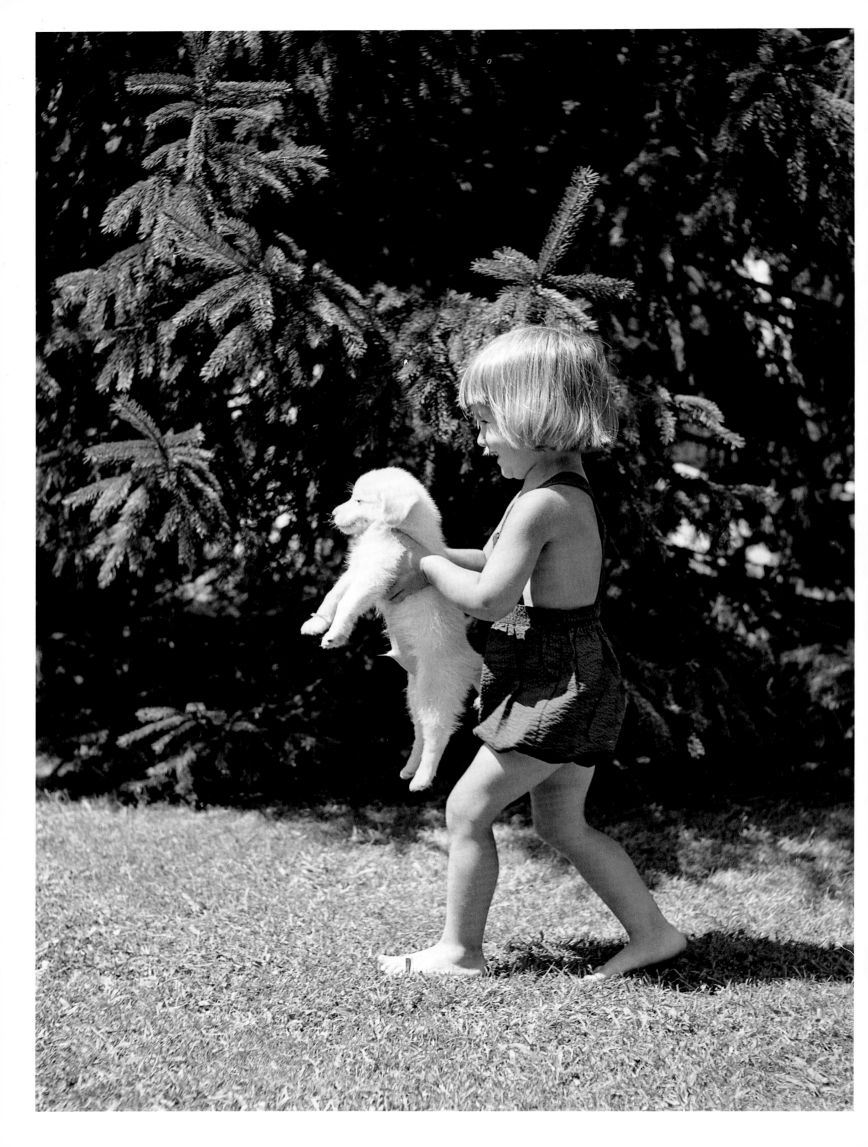

UN PHOTOGRAPHE
DE BEAU PEDIGREE

PAR JEAN DYKSTRA

SI LES PHOTOS DE CHIENS DE WALTER CHANDOHA SONT CAPTIVANTES, CE N'EST PAS SEULEMENT GRÂCE AU CHARME INDÉNIABLE DE CES BÊTES, MAIS AUSSI PARCE QUE CELUI QUI TENAIT L'APPA-REIL CONNAISSAIT SON MÉTIER. Il savait comment obtenir l'image qu'il voulait, comment l'éclairer, la composer, comment saisir au vol une expression ou une attitude particulière : un bébé dogue allemand vautré sur son frère à moitié endormi, deux carlins côte à côte, la mine très préoccupée, ou trois Westies blancs posés devant un fond rouge tomate qui s'affaissent les uns contre les autres comme des dominos. Obtenir de tels clichés exige de l'expérience, un jugement sûr, une patience infinie et un œil affûté. Pourtant Walter Chandoha donne l'impression que ce fut facile.

Les pages qui suivent comptent plusieurs photos en noir et blanc d'un adorable chiot à la fourrure blanche duveteuse avec Maria, la fille de Chadoha alors âgée de quatre ans. Sur une d'entre elles, ils sont allongés sur le ventre côte à côte, face à l'objectif, dans un décor réduit au strict minimum — parquet, mur clair, chiot et fillette au centre du cadre (page 103). Une autre montre Maria qui traverse pieds nus un bout de pelouse ensoleillée en tenant le chiot sous les pattes avant (page 34). Une troisième immortalise un instant où l'enfant et le chien se font face, bouche et gueule grandes ouvertes, comme s'ils riaient à une même blague d'initiés (page 8). Ces trois clichés du même duo de choc en disent long sur ce qui fit sa réputation de photographe des animaux domestiques le plus doué de tous les temps. Ils témoignent de son affection pour ses enfants (Maria avait cinq frères et sœurs), mais aussi pour les animaux qui furent ses modèles pendant toute sa carrière. Ils démontrent aussi sa capacité d'adap-tation : il a beau n'avoir photographié quasiment « que » des chats et des chiens, Chandoha maîtrisait l'art du portrait en studio et de la photo de mouvement en plein air, et savait saisir, avec une joie et un talent évidents, le « moment décisif ». Ces images commu-niquent aussi l'attachement profond, émotionnel, qui lie les chiens aux humains.

Né en 1920 à Bayonne, dans le New Jersey, de parents immigrés ukrainiens, il commença son appren-tissage dès son enfance en prenant des photos avec le Kodak familial. Il s'inscrivit bientôt au Lens Club de la ville, un des innombrables clubs de photo locaux qui ouvrirent un peu partout dans les années 1930, 1940 et 1950. Les photographes amateurs pouvaient y déve-lopper leurs clichés, montrer leur travail et apprendre des autres membres. Ces clubs jouaient un rôle capital

Mixed-breed and Maria, Long Island, New York, 1956

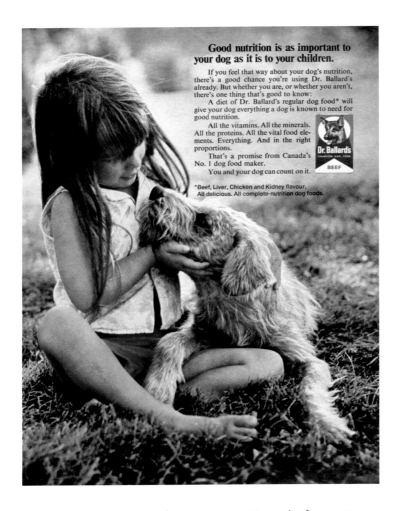

Good nutrition is as important to your dog as it is to your children.

If you feel that way about your dog's nutrition, there's a good chance you're using Dr. Ballard's already. But whether you are, or whether you aren't, there's one thing that's good to know:

A diet of Dr. Ballard's regular dog food* will give your dog everything a dog is known to need for good nutrition.

All the vitamins. All the minerals. All the proteins. All the vital food elements. Everything. And in the right proportions.

That's a promise from Canada's No. 1 dog food maker.

You and your dog can count on it.

*Beef, Liver, Chicken and Kidney flavour. All delicious. All complete-nutrition dog foods.

Dr. Ballard's
CHAMPION. DOG. FOOD
BEEF

en termes de réseau, de communauté et de formation, à une époque où les universités ne proposaient pas encore de cursus en photographie. Chandoha renvoya l'ascenseur des années plus tard, en faisant la tournée des clubs pour donner des conférences sur ses techniques pour photographier les animaux.

En 1942, Chandoha fut mobilisé et envoyé à Fort Dix comme photographe de presse. Une photo de l'époque le montre avec le corniaud de la caserne, le bien nommé Hypo (terme qui désigne le bain chimique utilisé pour fixer l'image en chambre noire). Il embarqua finalement pour le Pacifique Sud, où il servit comme photographe de guerre au service des transmissions jusqu'en 1946. À

son retour, le GI Bill lui permit de suivre les cours de la New York University et il ne cessa jamais de prendre des photos. Entre les heures de classe, il parcourait la ville, immortalisant les ombres portées du métro aérien, des garçons s'aspergeant avec l'eau d'une bouche à incendie dégoupillée, un taxi sur lequel tombe un rayon de soleil, des images admirablement composées qui rappellent la photographie de rue d'un Walter Rosenblum ou d'un Louis Stettner.

Pendant tout ce temps, Chandoha ne délaissa jamais les chats et les chiens — un répit, peut-être, ce refuge réconfortant que représentent souvent les animaux. Ses filles Fernanda, Chiara et Paula se souviennent qu'il ne parlait presque jamais de la guerre et que lorsque le sujet fut abordé, vers la fin de sa vie, les larmes lui montaient encore aux yeux. Il avait laissé derrière lui ses photos des combats, mais les horreurs dont il fut témoin ne le quittèrent jamais vraiment. D'après Fernanda, la photo était pour lui comme un baume. « Je crois qu'elle a aidé son cœur à guérir », renchérit Paula.

Ses photos séduisirent un public large et lui valurent divers prix. Il proposait régulièrement ses clichés dans les concours organisés par les journaux, les magazines ou les clubs et l'emportait tout aussi régulièrement. La récompense dépassait rarement les 25 dollars, mais la visibilité qu'ils lui apportaient fit croître sa réputation de photographe animalier. En décembre 1955, son cliché d'un terrier australien au museau en bouton de bottine fit la Une de *Popular Photography*, pour s'être classé deuxième au concours annuel organisé par le magazine. À en croire la presse de l'époque, les terriers à poil soyeux devinrent ensuite LA race à la mode.

Entretemps, Chandoha s'était marié avec Maria Ratti, rapidement devenue partie intégrante de l'équipe artistique, comme Walter le répéta maintes fois dans les interviews qu'il donna au fil des années. Elle excellait notamment dans l'art de « diriger » les animaux et ils travaillèrent ensemble jusqu'à son décès en 1992 (Walter nous a quittés en 2019). Les Chandoha

Dr. Ballard's advertisement, 1973

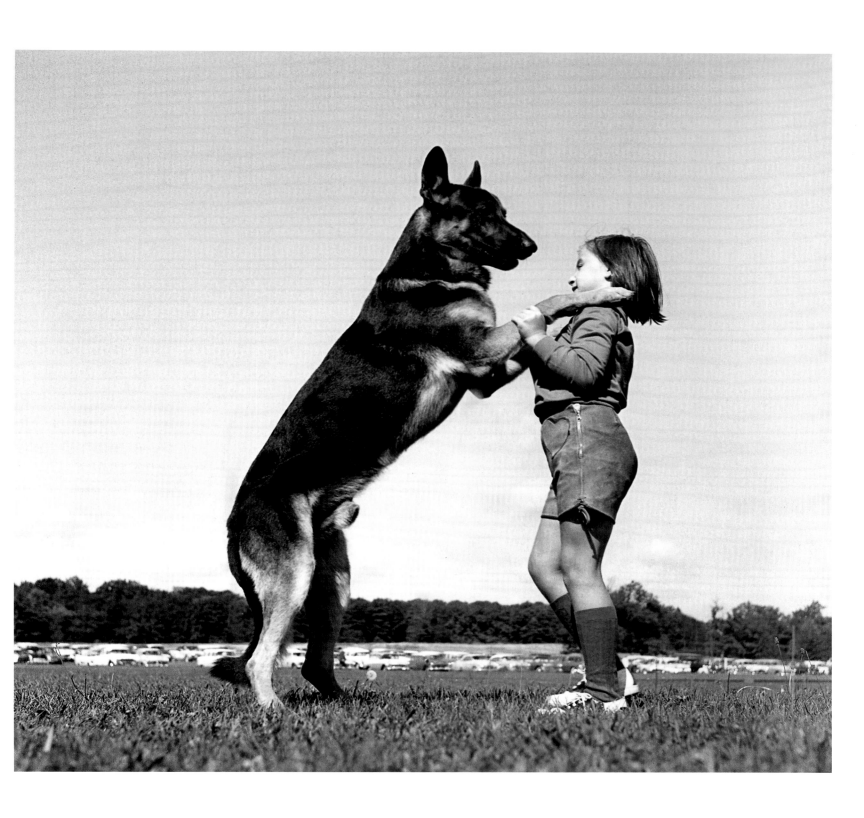

German shepherd and daughter
Paula, Long Island, New York, 1958

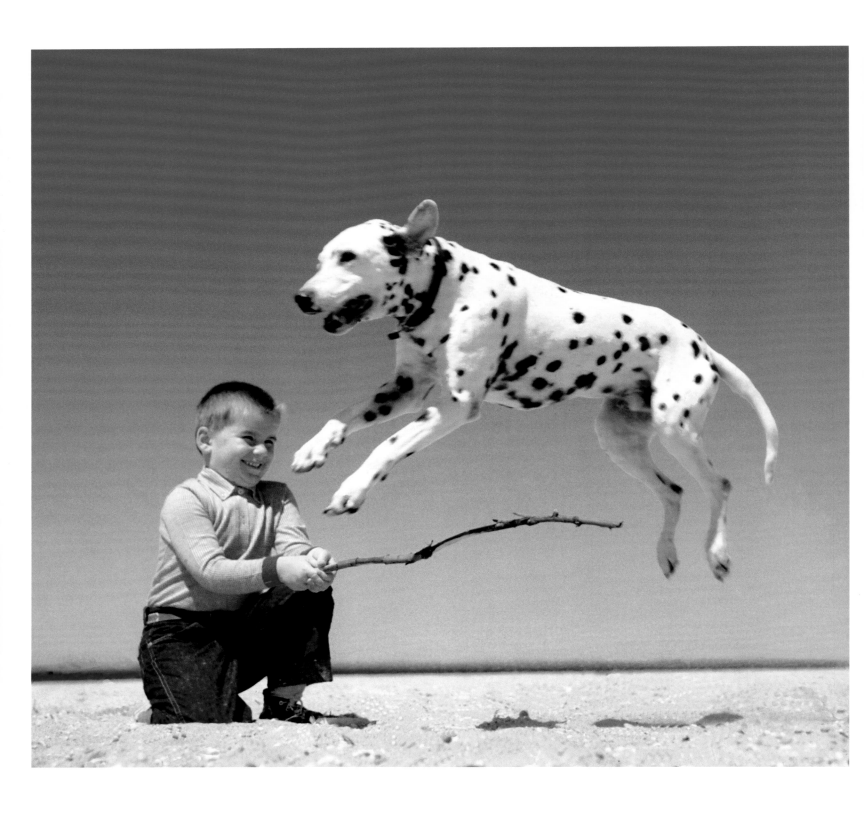

Dalmation and the photgrapher's son Enrico,
Long Island, New York, 1958

vécurent d'abord à Astoria, dans le Queens, puis un temps à Long Island, avant de s'installer dans une jolie ferme du VIIIᵉ siècle dans le New Jersey, avec des terres et de la lumière à foison et une immense grange convertie en studio. Le goût de Chandoha pour l'art et le design ne s'arrêtait pas à la photo : avant d'acquérir la ferme, il demanda à l'architecte Frank Lloyd Wright, rien de moins, de concevoir une maison pour sa famille de plus en plus nombreuse. Wright accepta, mais il mourut avant d'avoir achevé les plans. Le fait que Chandoha ait contacté Wright indique combien il s'intéressait à l'esthétique au sens large, une curiosité qu'il conseillait aux photographes en herbe de cultiver. Dans son livre de 1973 *How to Photograph Cats, Dogs, and Other Animals*, avant d'évoquer le matériel, la pellicule, le papier et les techniques de prise de vue, Chandoha encourage les photographes à explorer autant de disciplines artistiques que possible : « Allez au théâtre, au cinéma, écouter des concerts, assister à des ballets, regardez la télévision de façon sélective et surtout, lisez, lisez, lisez ! » Et il ajoute : « Grâce à la lecture et à la fréquentation de toutes les formes d'art vous deviendrez un observateur plus fin du monde qui vous entoure. Vous apprendrez, inconsciemment, à voir plus. »

La propre capacité de Chandoha à voir plus — à absorber les leçons tirées de l'art comme de la publicité — a fait de lui un photographe hautement polyvalent. Adepte du portrait en studio pratiqué à Hollywood (comme sa photo d'un couple de majestueux lévriers afghans, leur longues mèches ondulant contre un arrière-plan d'un rose pâle, page 25), il savait aussi adopter le style journalistique qu'il acquit sans doute pendant la guerre et plus tard, étudiant, dans les rues de New York. Il aimait par exemple photographier les chiens au travail : le limier coéquipier d'un policier (page 13), un golden retriever rapportant un faisan (page 263), ou un chien guide aidant son maître à descendre d'un bus (page 15).

Chandoha était également intrigué par le barnum ritualiste des concours canins, sujet d'un projet documentaire social personnel auquel il revint souvent. Au Westminster Dog Show de New York, il s'intéressa autant aux maîtres qu'aux chiens — comme ces dresseurs qui serrent les muselières de quatre chiens dans une rangée impeccable de Springers anglais (page 23), ou les gens qui se pressent à l'entrée du hall principal, dos tournés au chien comme perdu parmi eux (page 216). Il adorait aussi les concours locaux, rendez-vous très populaires dans les petites villes des années 1950 et 1960, et ses photos donnent à voir une facette de la classe moyenne supérieure américaine de l'époque.

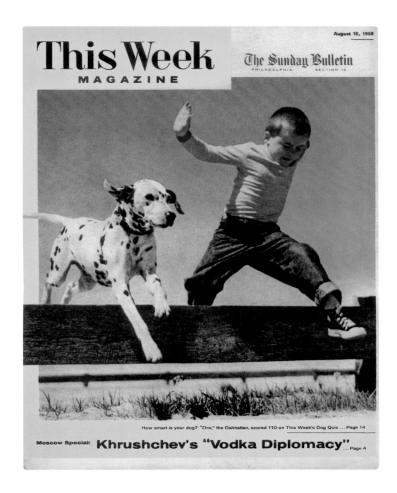

This Week magazine, 1958

Ces événements se tenaient en plein air mais n'étaient pas dépourvus de décorum : les messieurs portaient costume et cravate, les dames jupe et escarpins, tout ce petit monde arrivait à bord d'énormes Américaines qui patientent souvent à l'arrière-plan des photos de Chandoha. Sur plusieurs, les chiens sont sur la piste et font leur numéro sagement, mais sur d'autres il s'est concentré sur la marge, pour ainsi dire, comme ce chihuahua embarrassé dont la laisse est enroulée autour de la cheville d'une femme en hauts talons (page 196). L'image est aussi malicieuse qu'un instantané d'Elliott Erwitt, avec un peu moins d'ironie.

Dr. Ballard's advertisement, 1972

Mixed-breed, Bouvier des Flandres, and domestic shorthair cat, New Jersey, 1965

Comme l'anxieux chihuahua, les chiens des photos de Chandoha sont des créatures auxquelles il est facile de s'identifier, raison pour laquelle tant de marques différentes ont sollicité ses talents : Gaines, Milk Bone, Ken-L Ration et Purina, par exemple, mais aussi les cigarettes Old Gold, la bière Genesee, les Cheerios de General Mills et le grand magasin Ohrbach's, ou des marques de pellicules et d'appareils photo, notamment Kodak, Hasselblad, Polaroid et Graflex. Ses photos ont paru dans des titres prestigieux comme *Life* et *Look* et leurs équivalents à l'étranger, en couverture d'innombrables magazines populaires en son temps, ainsi que de suppléments du dimanche aussi connus que *Parade*, *This Week* et *Weekend*. Trente-cinq livres, dont celui-ci, ont été consacrés à son travail depuis 1951.

Malgré son succès, Chandoha demeura son propre patron tout au long de sa carrière, qu'il consacra presque exclusivement à photographier les êtres qu'il aimait — son épouse, bien sûr, ses enfants, tour à tour sujets et collaborateurs, et leurs animaux. La ferme familiale était fréquentée par de nombreux chats plus ou moins indépendants et en plus des chiens de la maisonnée, Chandoha empruntait des chiens dans divers refuges, dont celui de la Humane League à Greenwich Village et de l'Animal League de North Shore ; il passait parfois des petites annonces dans la presse locale, notamment s'il recherchait une race particulière. D'après Fernanda, son père tenait à photographier autant de types de chiens que possible, pour toutes les possibilités créatives qu'offrait cette diversité. « Les caractéristiques et la personnalité de chaque race ou croisement jouaient souvent un rôle important dans l'idée qu'il se faisait de chaque image, se souvient-elle. Les différents chiens eux-mêmes étaient sa principale source d'inspiration, une part déterminante de son processus créatif. »

Sa fille Chiara se revoit bondissant du bus scolaire en fin de journée, impatiente de voir quels animaux seraient là pour jouer avec elle. Les six enfants étaient

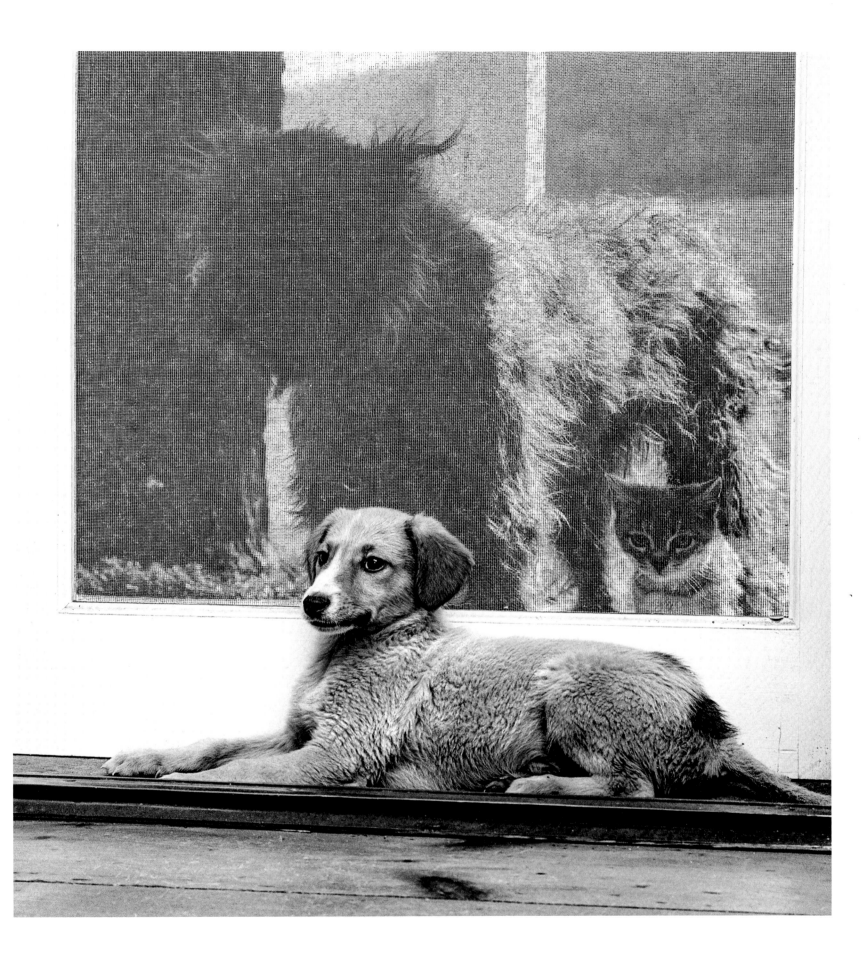

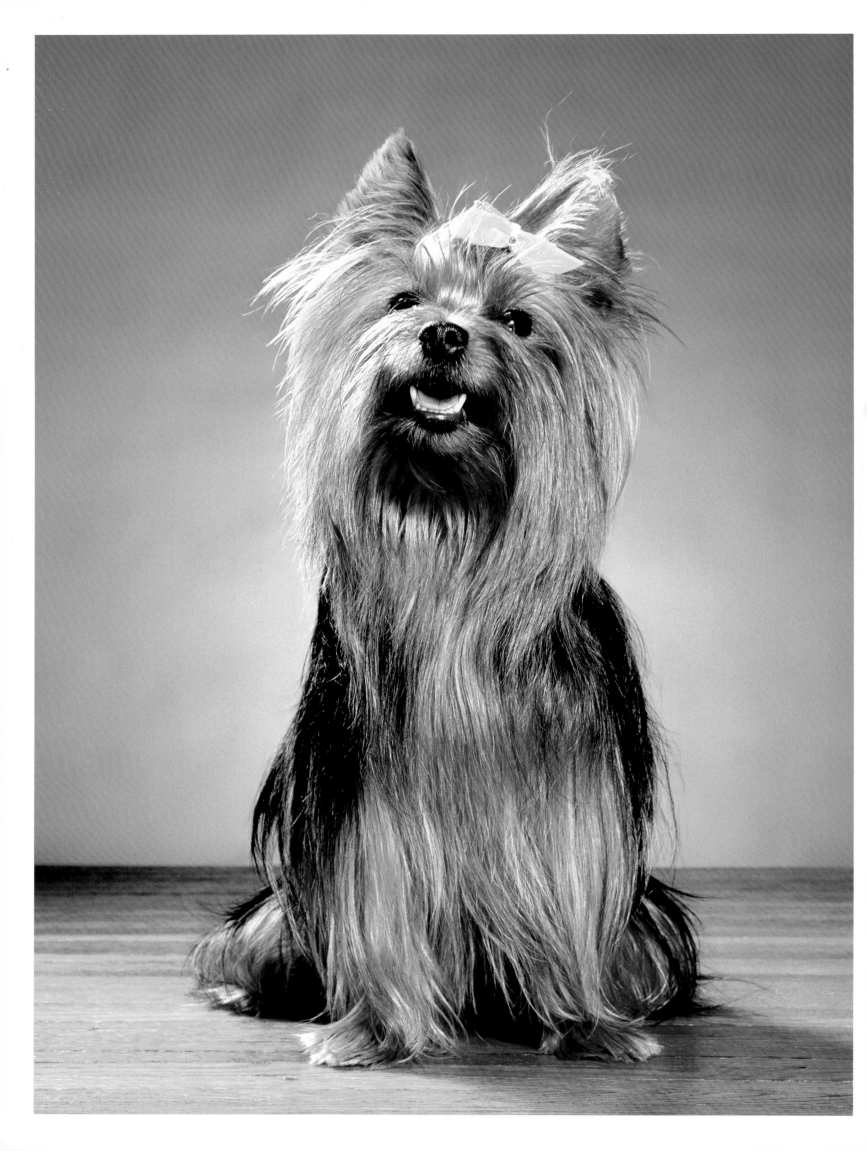

ravis d'être entourés de toutes ces bêtes, qui s'inté-graient rapidement au clan Chandoha. Le premier chien de la famille fut un bouvier nommé Kitty Dog et une photo de Chiara et lui montre combien les animaux et les enfants étaient à l'aise ensemble (page 29). Le bouvier couve de sa carrure protectricese une Chira âgée d'à peine un an, qui lève les yeux vers sa grosse tête. Comme la plupart des portraits de Chandoha, ces clichés montrent les deux protagonistes dans un décor simple et dépouillé, pour que l'attention ne soit pas dispersée. Même dans ses photographies en couleur, il pose souvent les chiens devant un fond monochrome minimaliste ; un parti-pris annonciateur de l'esthétique développée 30 ans plus tard par Neil Winokur, avec ses portraits animaliers aux couleurs saturées.

Les photos de Chandoha profitent aussi de sa patience infinie et de son sens inné du timing. Comme Henri Cartier-Bresson, il sait sentir l'instant précis où il faut appuyer sur l'obturateur. Dans son introduction à son livre *Images à la Sauvette*, Cartier-Bresson écrit : « Une photographie est pour moi la reconnaissance simultanée, dans une fraction de seconde, d'une part de la signification d'un fait, et de l'autre d'une organi-sation rigoureuse des formes perçues visuellement qui expriment ce fait. » Pour Chandoha, il ne s'agissait pas seulement de saisir le moment où un berger allemand se dresse et pose ses pattes sur les épaules d'une fil-lette (sa fille Paula, page 37), de façon à ce qu'ils se trouvent face à face, mais aussi de veiller aux éléments compositionnels — cette « organisation précise des formes » — qui se mettaient en place à cet instant : combinés, le triangle que forment leurs silhouettes rapprochées, les voitures garées en arrière-plan qui évoquent des jouets aux pieds de l'enfant et du chien, l'arbre penché qui entre dans le cadre à gauche et l'effet de contreplongée (Chandoha prit sans doute sa photo à plat ventre dans l'herbe) confèrent au duo une présence formidable.

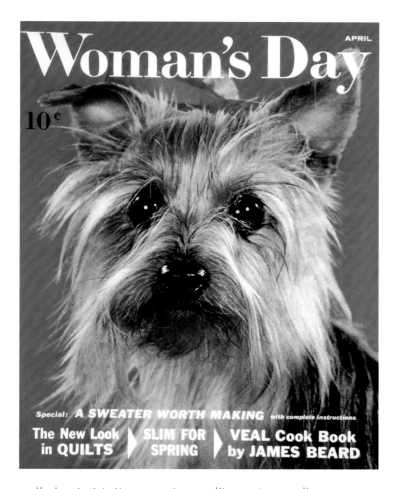

Il n'en insistait pas moins sur l'importance d'appuyer sur le déclencheur pile au bon moment et de travailler ses réflexes pour devenir un « pro de la gâchette ». Faites comme si vous teniez un appareil photo, conseille-t-il ainsi à ses lecteurs dans *How to Photograph Cats, Dogs, and Other Animals*, et où que vous soyez, cadrez des photos imaginaires et cliquez pour affûter votre temps de réaction. Quand vous aurez vraiment un appa-reil dans les mains, cette réactivité sera devenue une seconde nature. C'est le seul moyen de saisir un dalmatien en plein élan, tandis qu'il saute par dessus un bâton que tient un garçon sur la plage (Enrico, le fils de Chandoha, page 38), ou le gros plan d'un braque de Weimar en train d'abboyer, gueule grande ouverte (page 117).

Yorkshire terrier, New Jersey, 1975

Woman's Day magazine, 1960

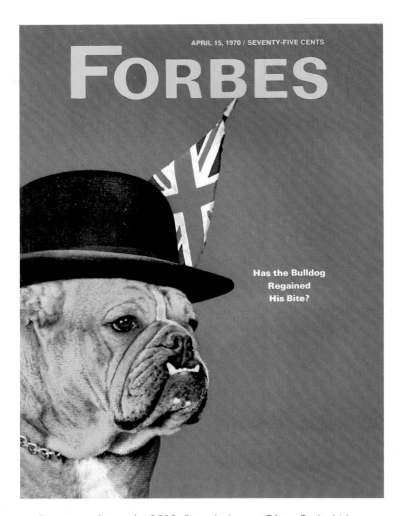

APRIL 15, 1970 / SEVENTY-FIVE CENTS

FORBES

Has the Bulldog
Regained
His Bite?

Dans son livre de 2019 *Dog Is Love*, Clive D. L. Wynne, psychologue spécialiste du comportement canin, explique que les chiens, « hyper-sociaux », ont la capacité unique, non seulement de communiquer avec les humains, mais de les aimer. Nombre d'artistes ont exprimé l'affection qu'ils vouaient à leurs chiens dans des portraits : de la Spitz naine avec son petit peints par Thomas Gainsborough en 1877, à Sunny le terrier à poils longs d'Alex Katz en 1971, en passant par William

Wegman et ses flegmatiques braques de Weimar. La loyauté et le dévouement des chiens sont d'une certaine façon inscrits dans leurs gênes, d'après Wynne — ils ont plaisir à fréquenter les humains.

Pas étonnant que ce plaisir soit réciproque et les photos de Chandoha communiquent ce ravissement simple. Plus généralement, Fernanda estime qu'elles nous rappellent que les humains sont liés aux autres créatures vivantes avec lesquelles ils partagent la planète et qu'ils ont des responsabilités à leur égard. Elle se souvient que son père photographiait le plus souvent les chiens avec un minimum d'accessoires, voire aucun, afin de ne surtout pas céder à l'anthropomorphisme. De fait, qu'elles aient été utilisées pour vendre des biscuits pour chiens ou pour illustrer un article de magazine, ou qu'elles s'inscrivent dans des projets plus personnels, les photos de Chandoha sont imprégnées de la tendresse réelle qu'il éprouvait pour les chiens et de la complicité qui les liait. Soucieux de se placer à hauteur de (leurs) yeux, il se met en quelque sorte sur un pied d'égalité avec eux.

Voyez, par exemple, ce corniaud allongé dans l'embrasure d'une porte à moustiquaire un jour de grand soleil (page 41). Il faut une seconde pour remarquer les deux compères qui l'observent de l'extérieur, un chat ronchon et un chien qui, bien que dans l'ombre, évoque un Kitty Dog plus grand. Le chambranle de la porte et le tronc d'arbre qui se dresse dehors confèrent au cliché une géométrie robuste ; la moustiquaire dissimule légèrement deux des sujets, ce qui ajoute à la composition de la profondeur, une pointe de mystère. Et puis il y a ce trio animal improbable, qui semble se moquer allègrement d'être si mal assorti. C'est une photo typique de Chandoha : douce sans être mielleuse, traversée par un paisible élan d'affection.

Forbes magazine, 1970

Bulldog, New Jersey, 1969

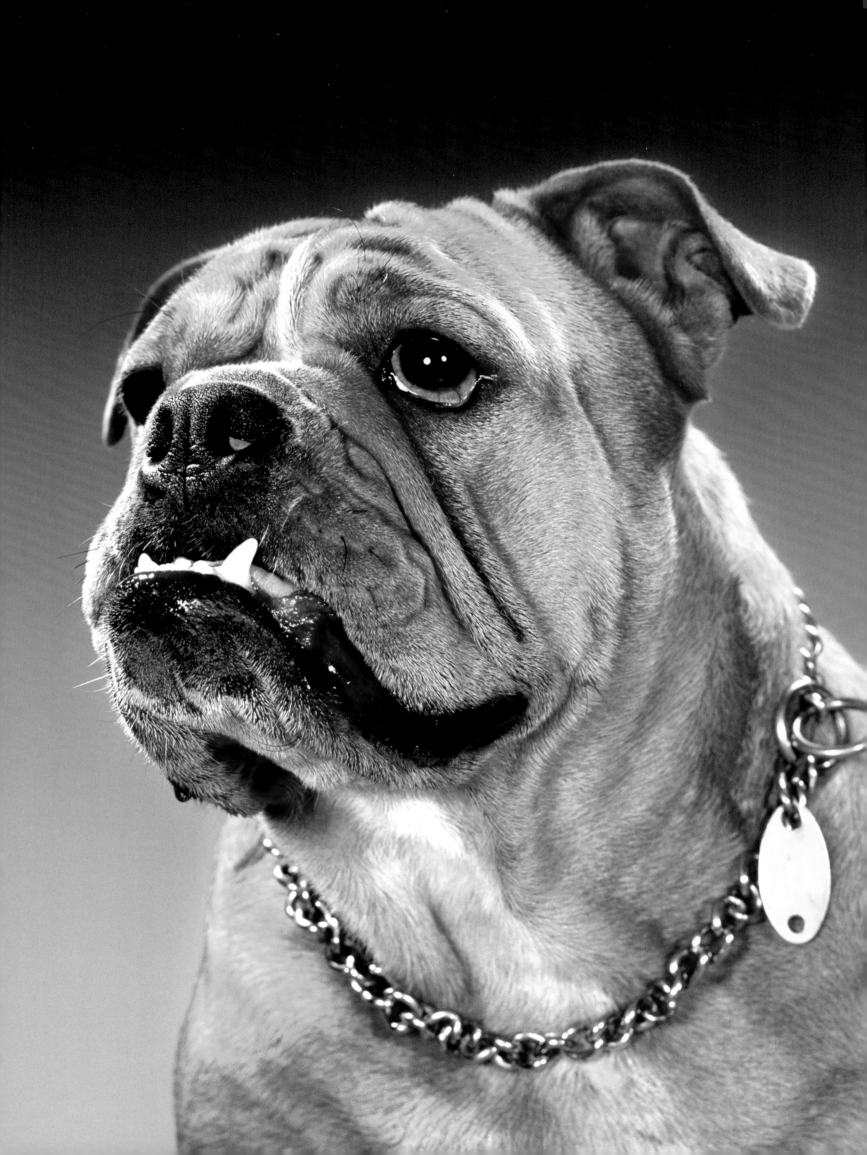

IN THE STUDIO

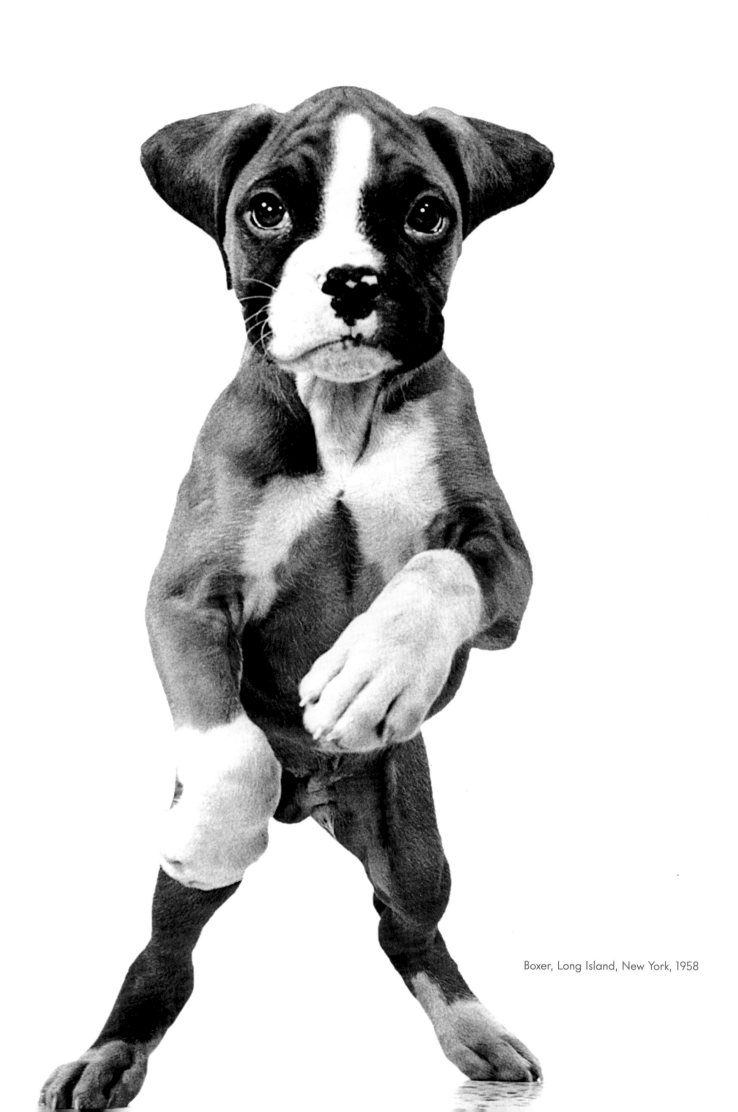

Boxer, Long Island, New York, 1958

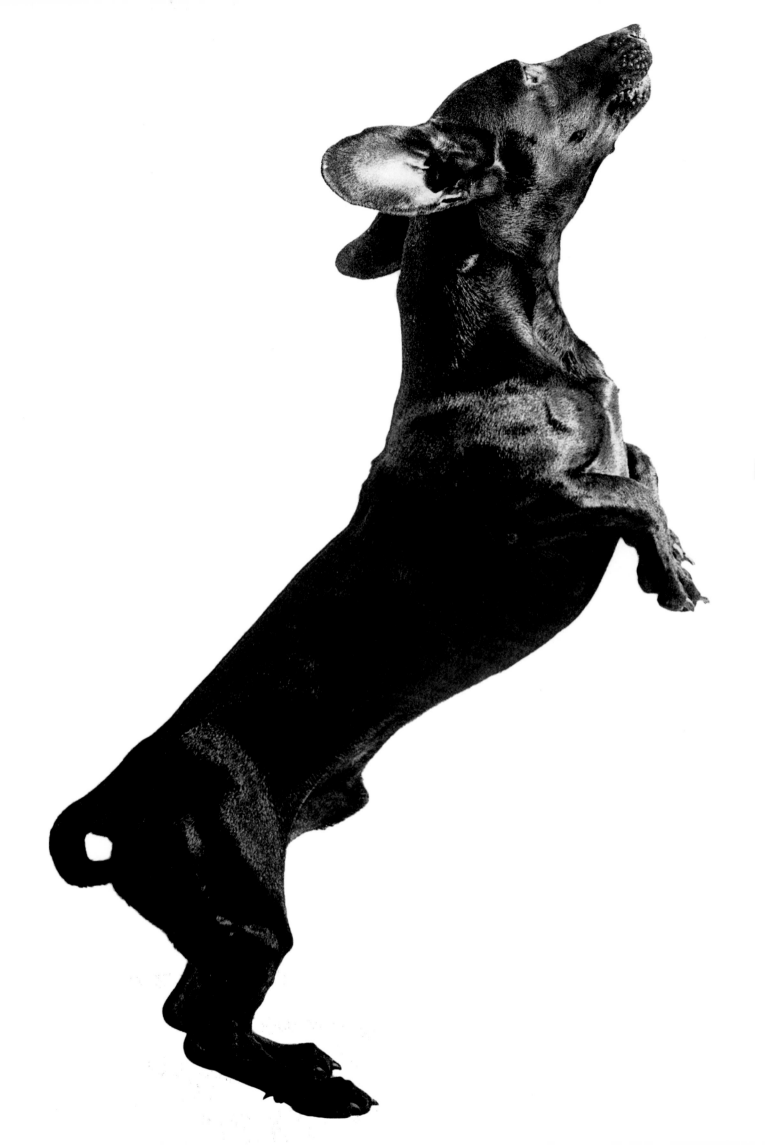

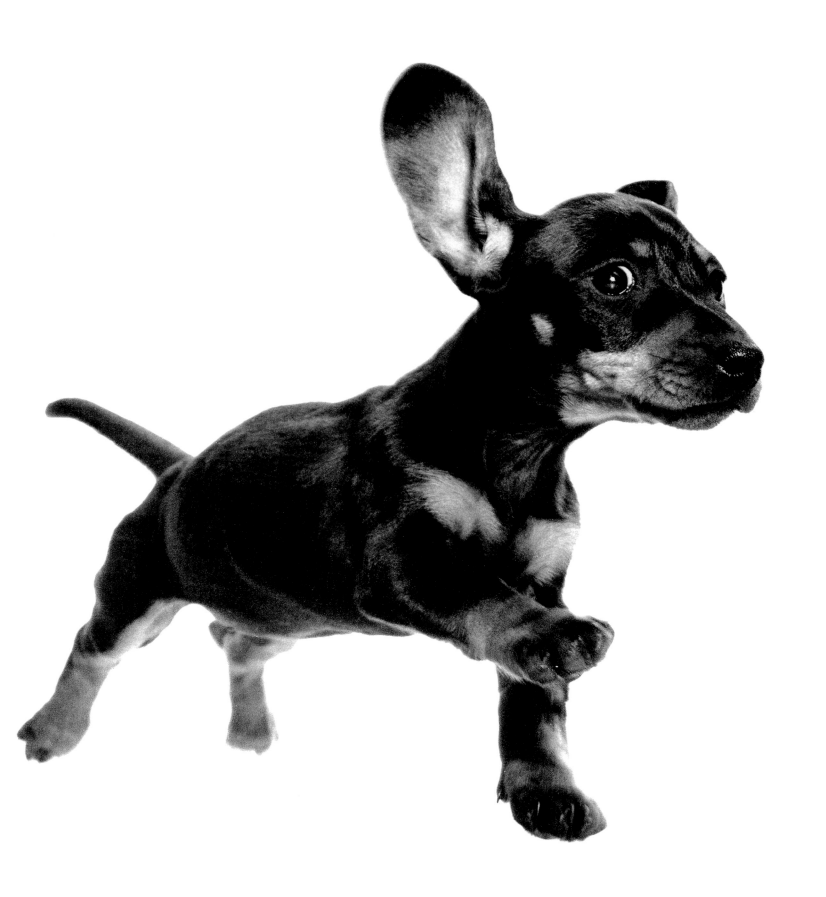

Dachshund, Long Island, New York, 1953 & 1959

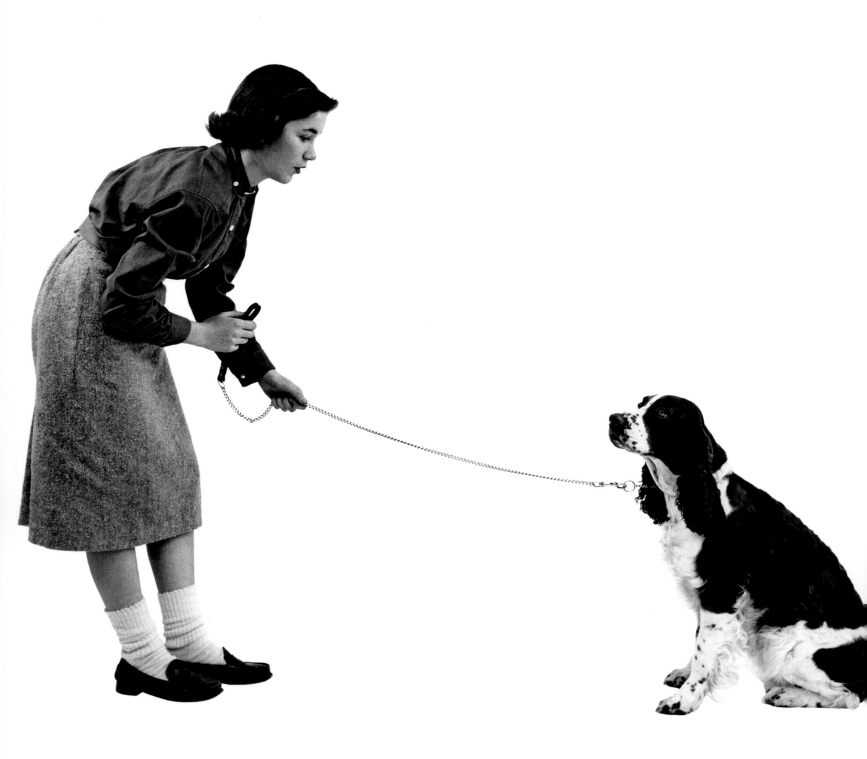

Springer spaniel, Long Island, New York, 1954

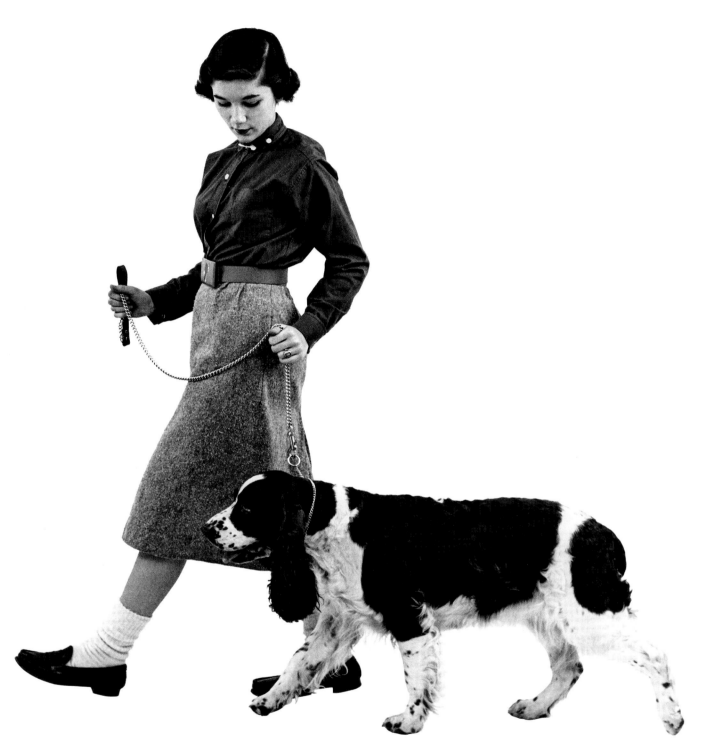

Page 52: Boston terrier, Long Island, New York, 1953

Page 53: Basset hound, Long Island, New York, 1954

Pages 54–55: German shepherd, New Jersey, 1965

51

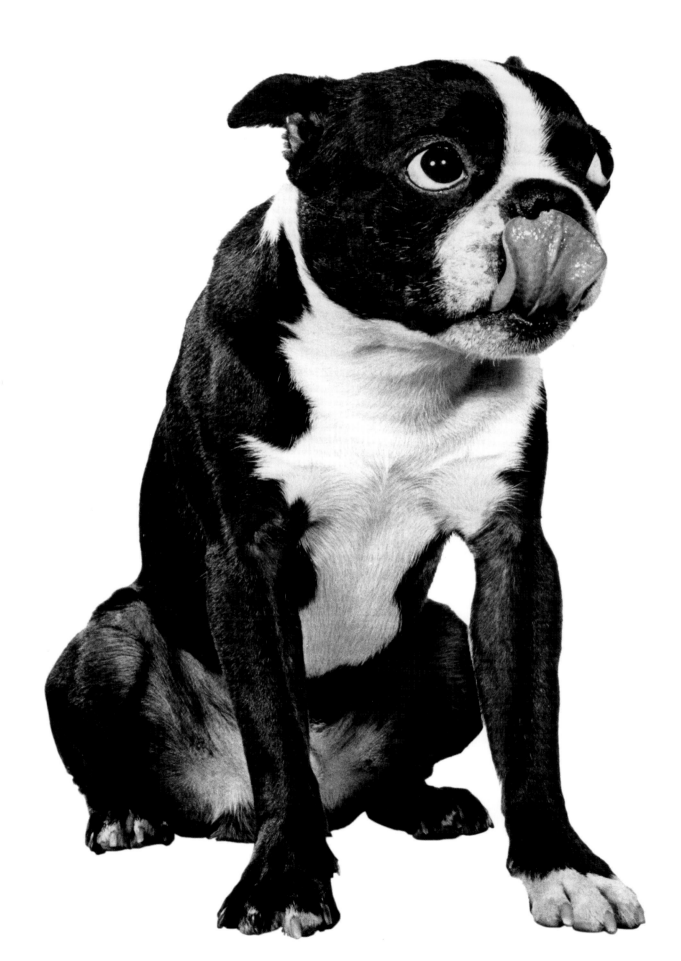

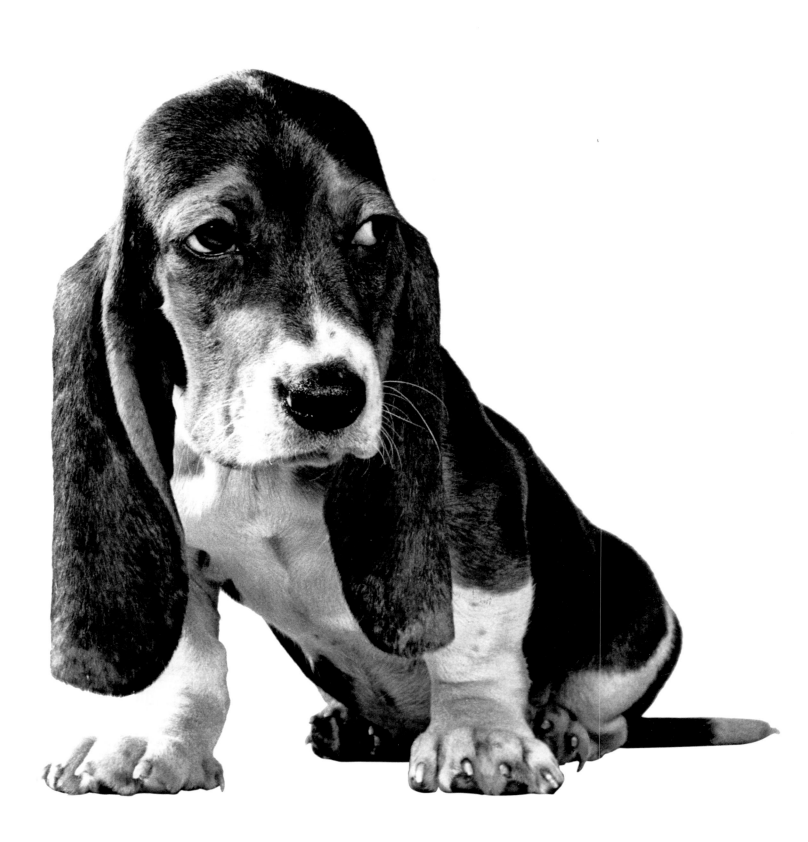

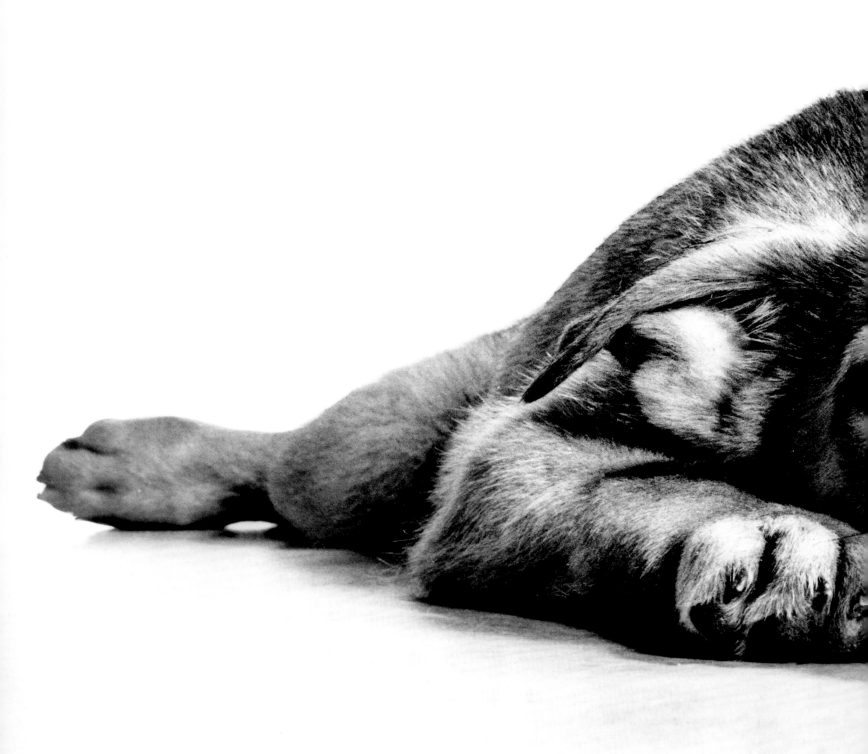

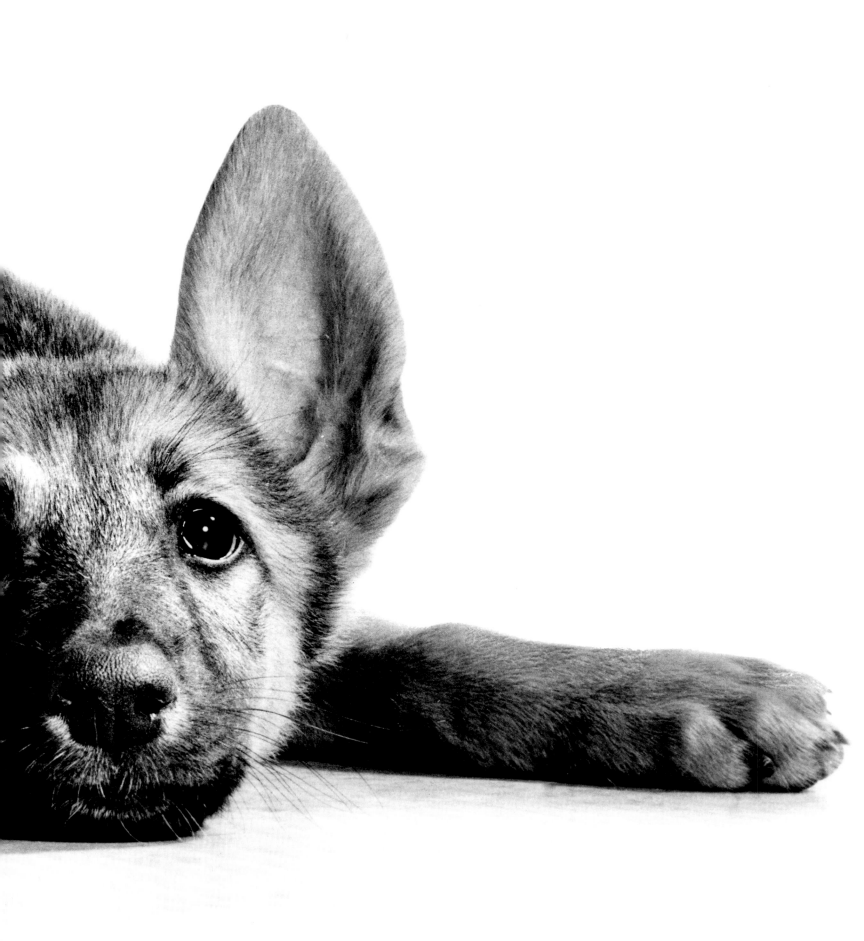

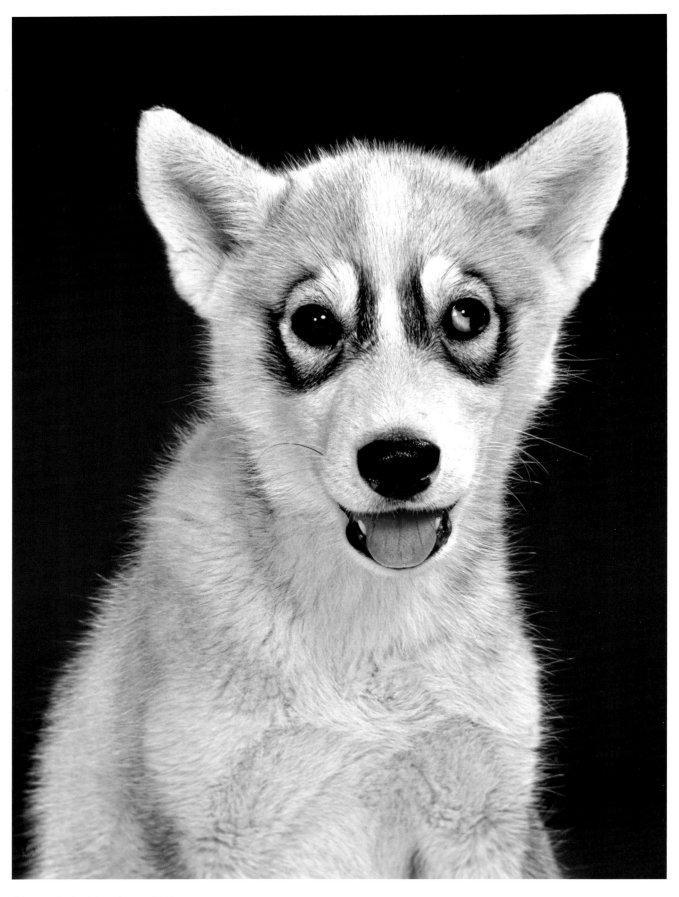

Siberian husky, New Jersey, 1962

Golden retriever, Long Island, New York, 1956

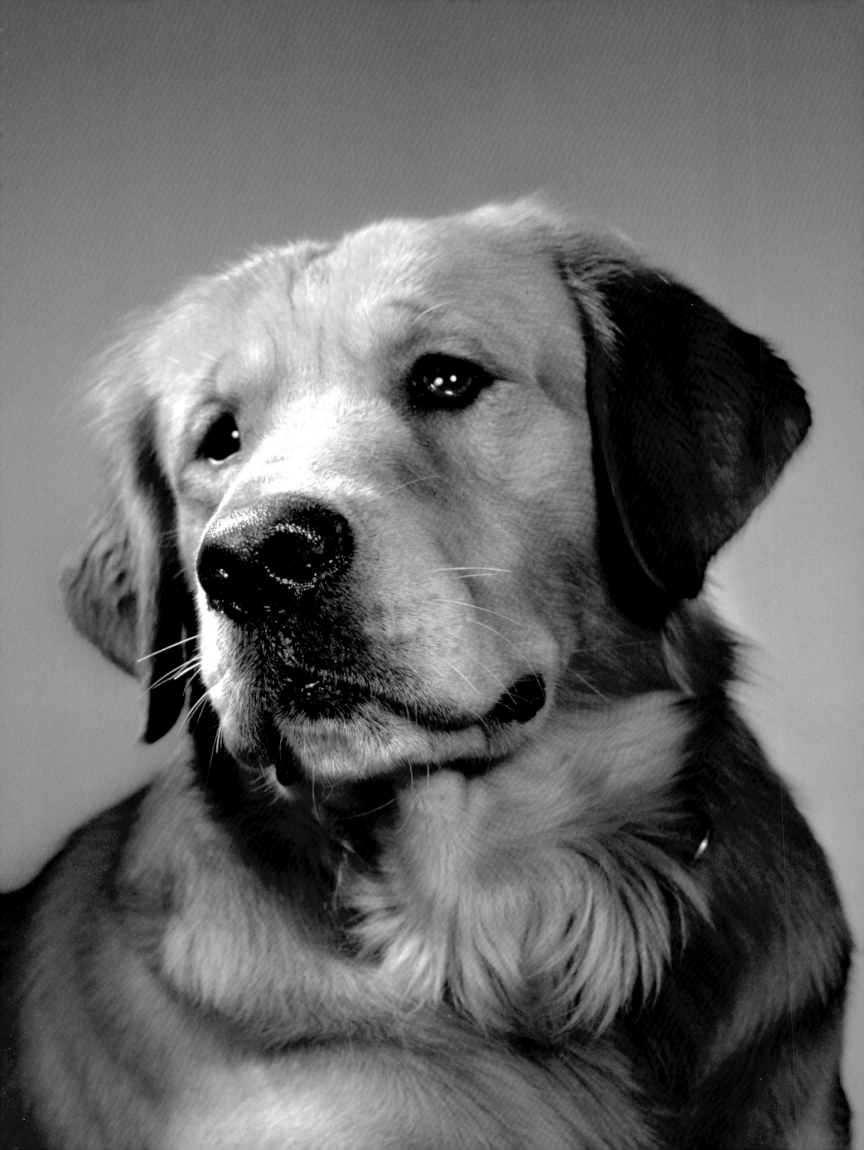

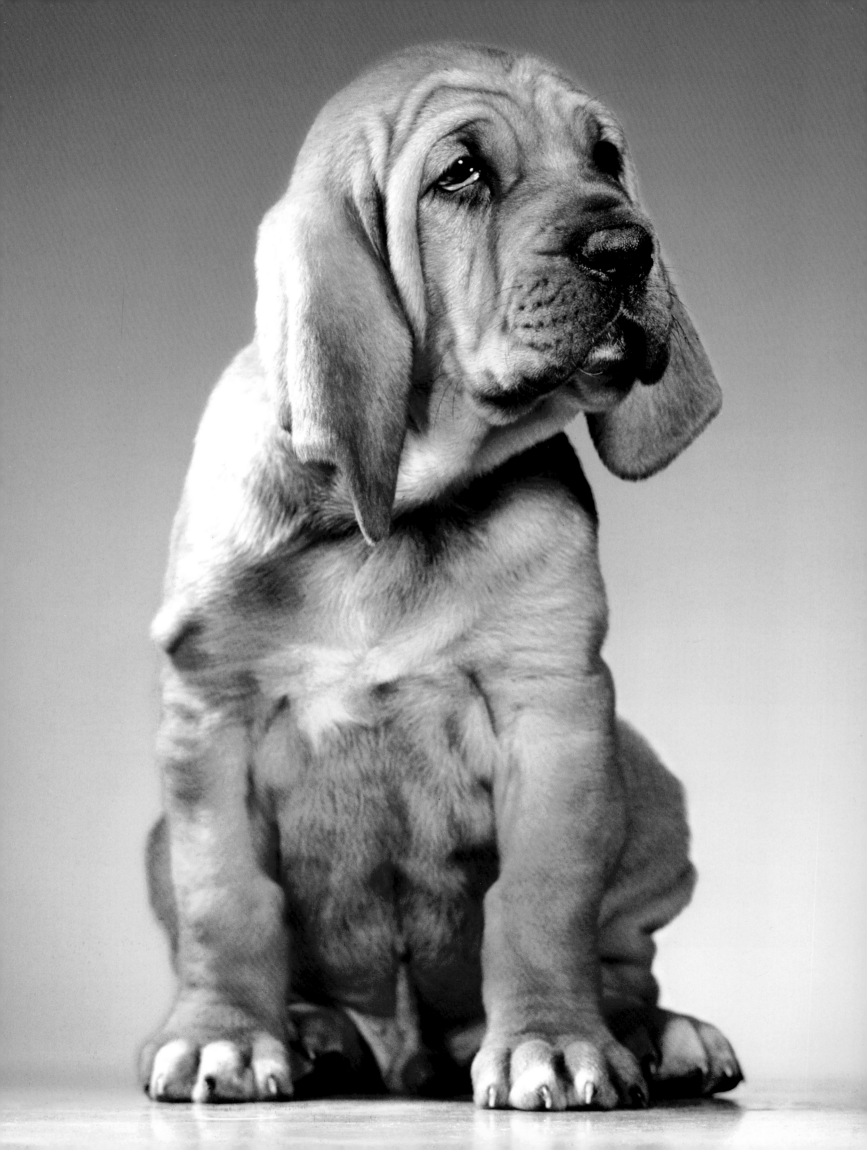

Bloodhound, Long Island, New York, 1953

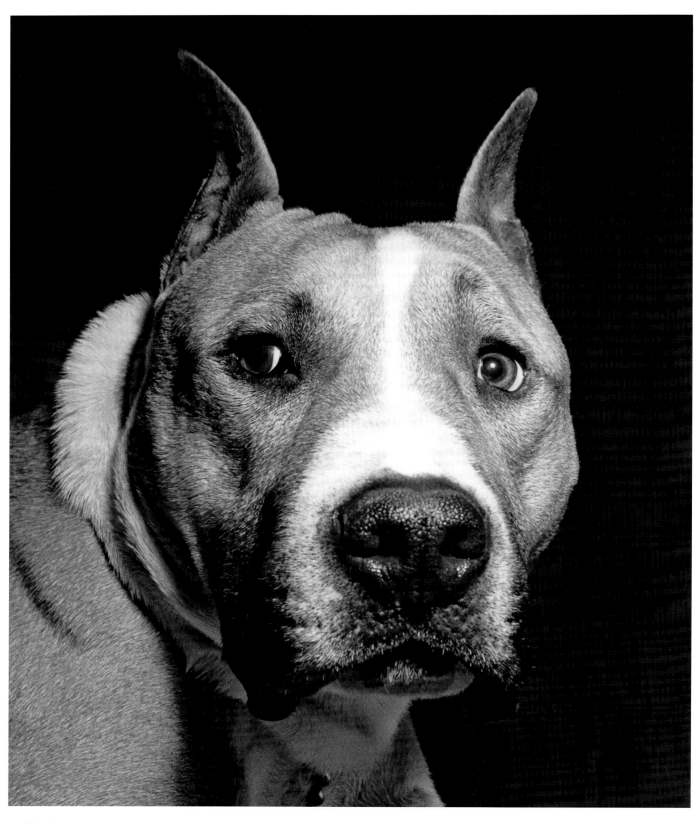

Staffordshire terrier, Long Island, New York, 1957

Malinois, Long Island, New York, 1954

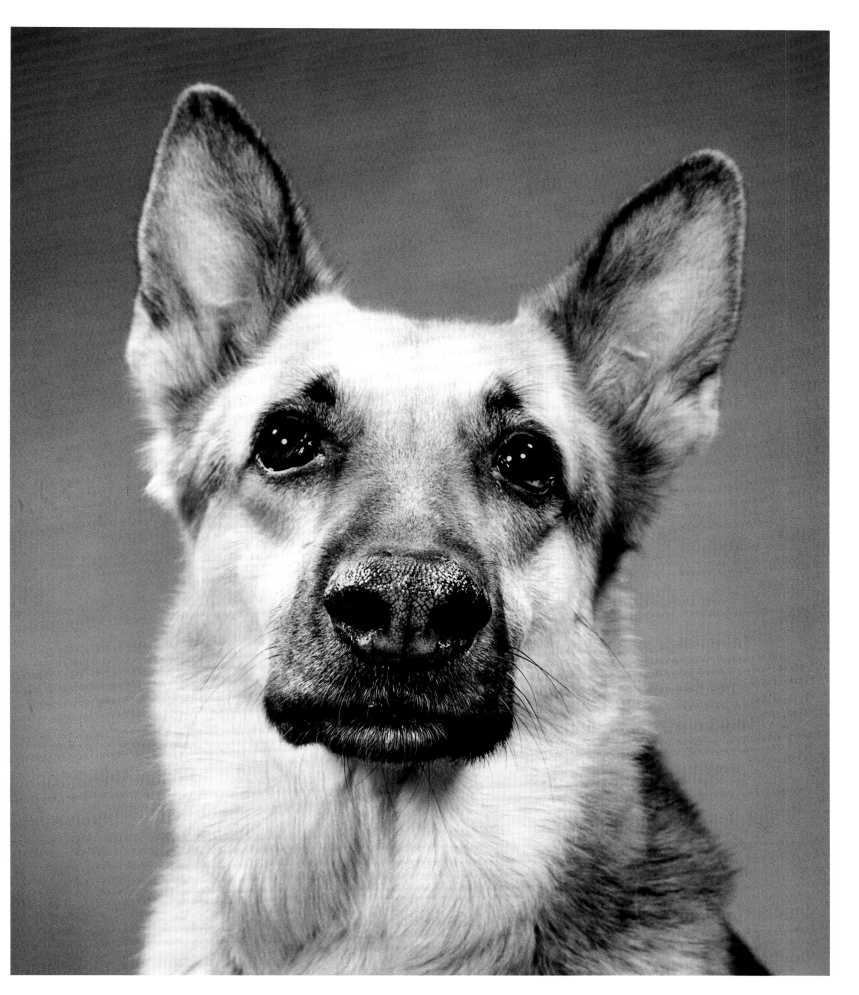

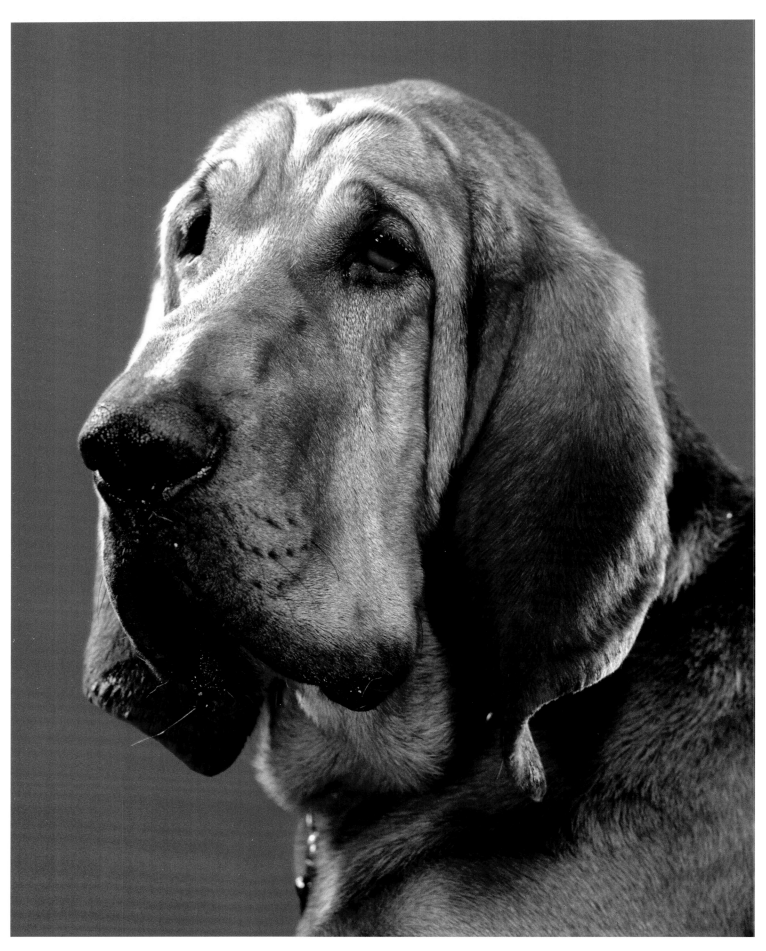

Bloodhound, Long Island, New York, 1954

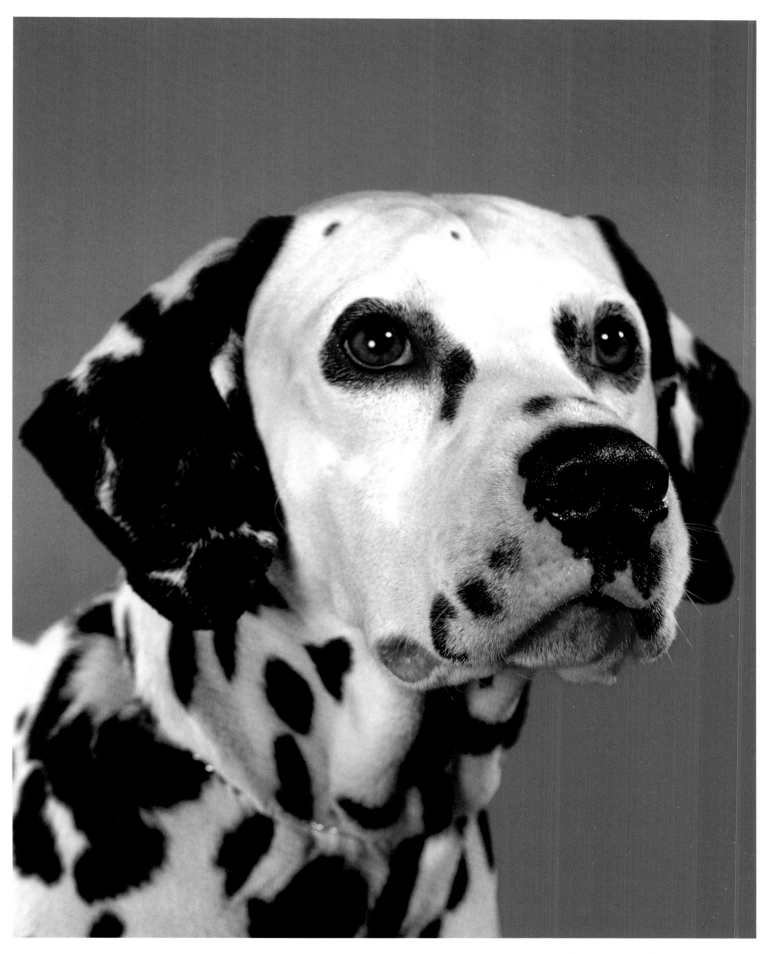

Dalmatian, Long Island, New York, 1957

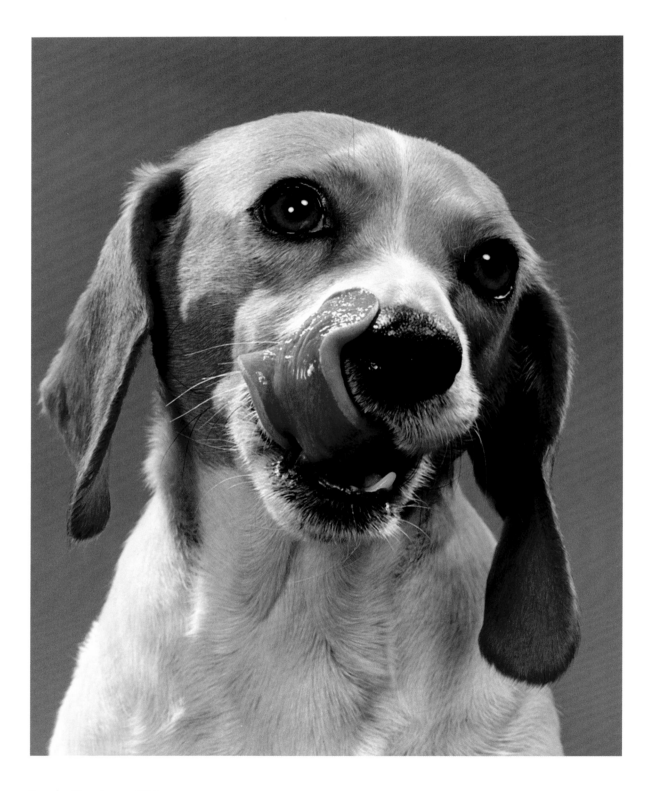

Beagle, New Jersey, 1966

German shorthaired pointer, New Jersey, 1974

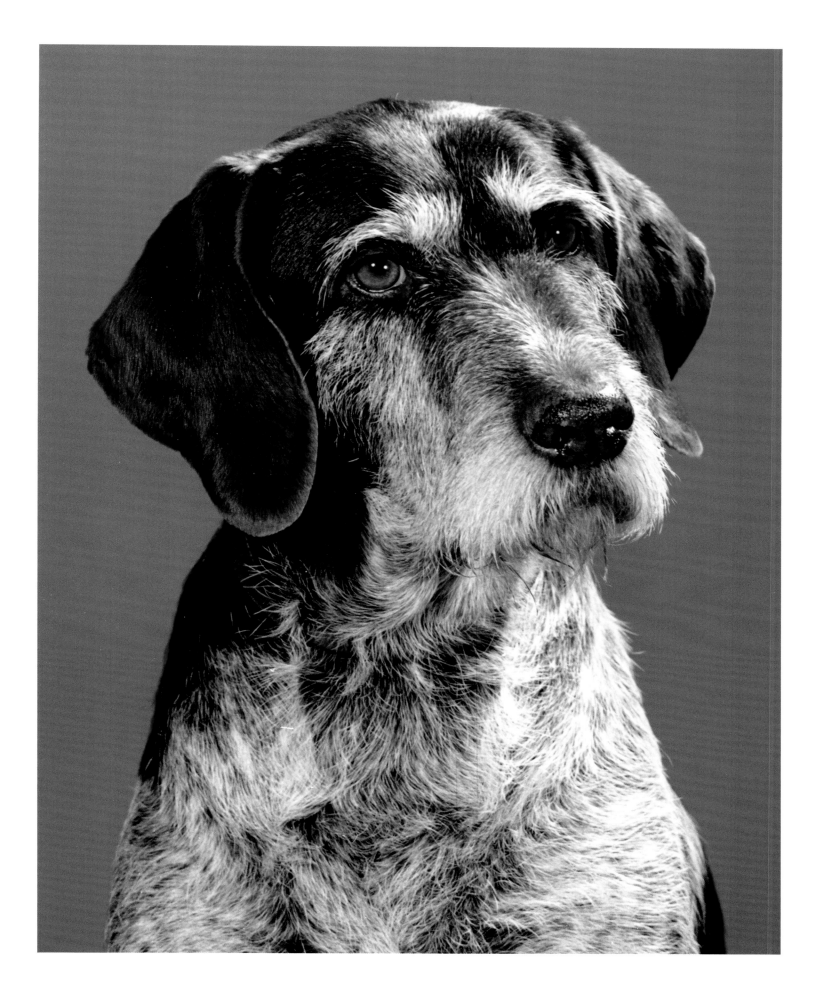

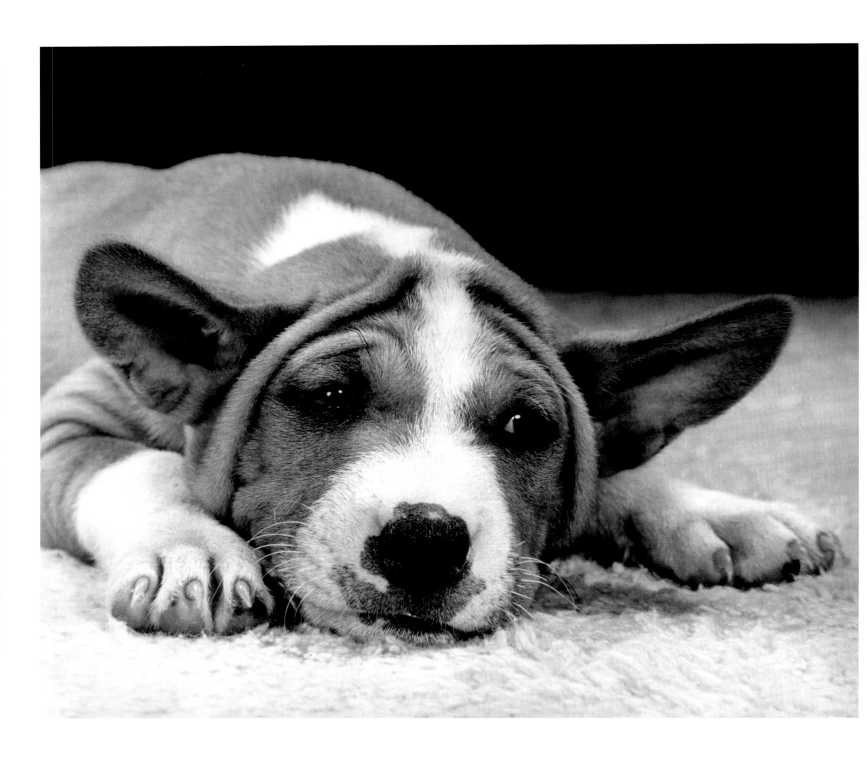

Basenji, New Jersey, 1966

Basset hound, Long Island, New York, 1959

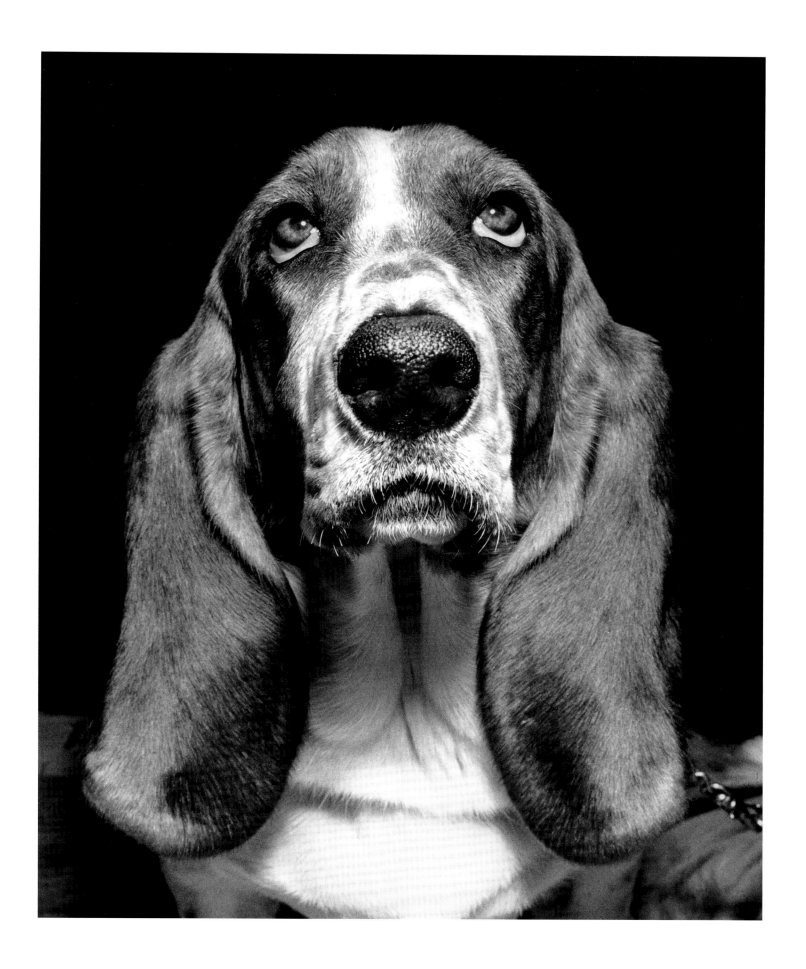

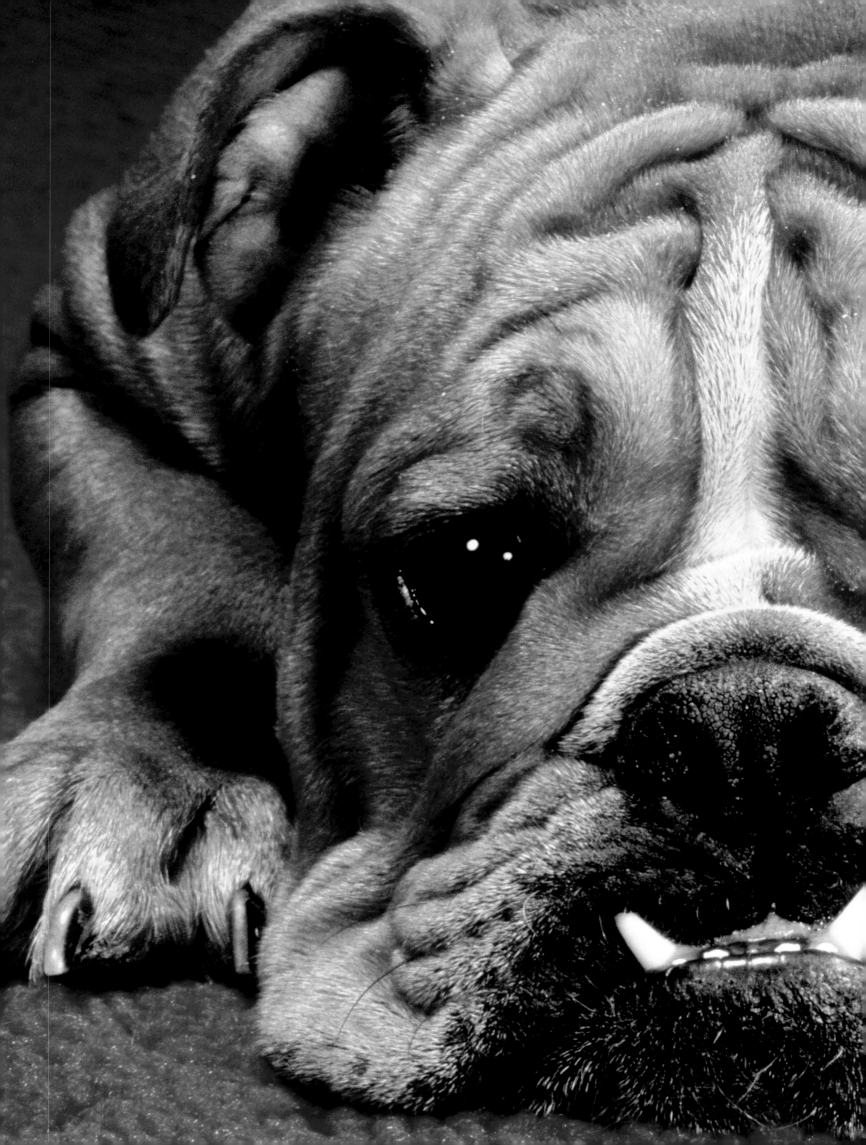

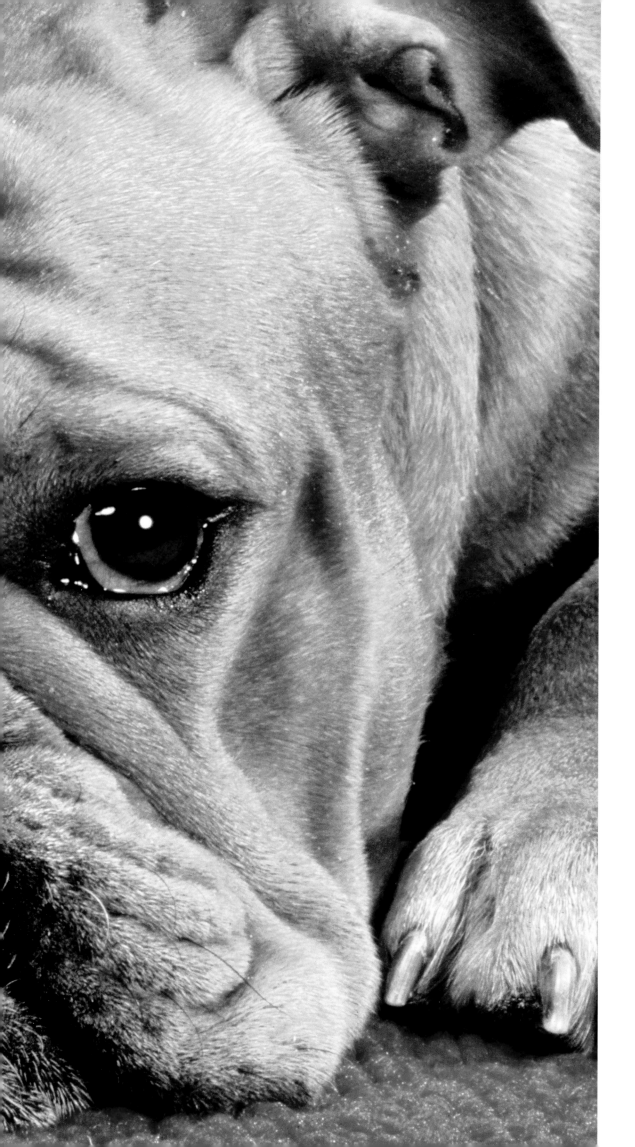

Bulldog, New Jersey, 1970

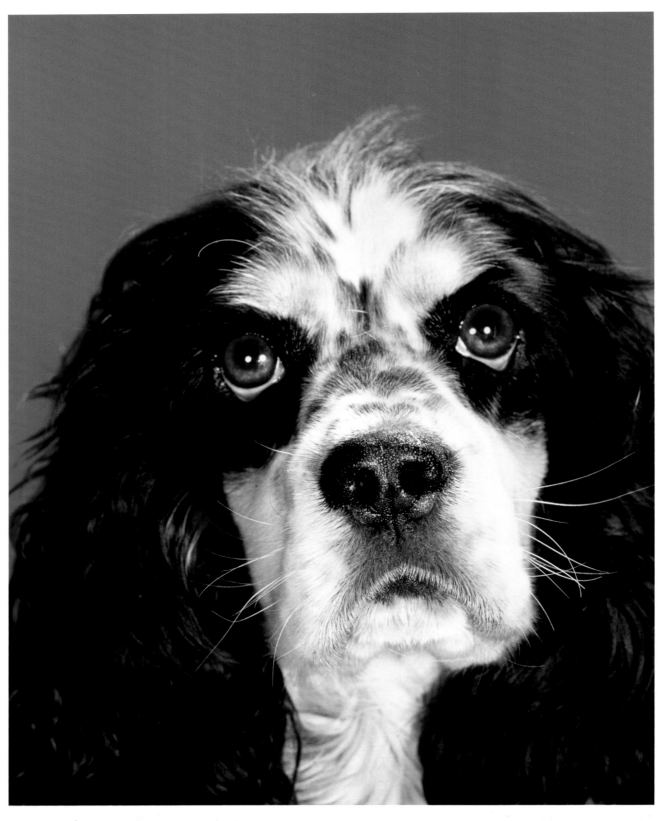

Cocker spaniel, New Jersey, 1967

English setter, New Jersey, 1974

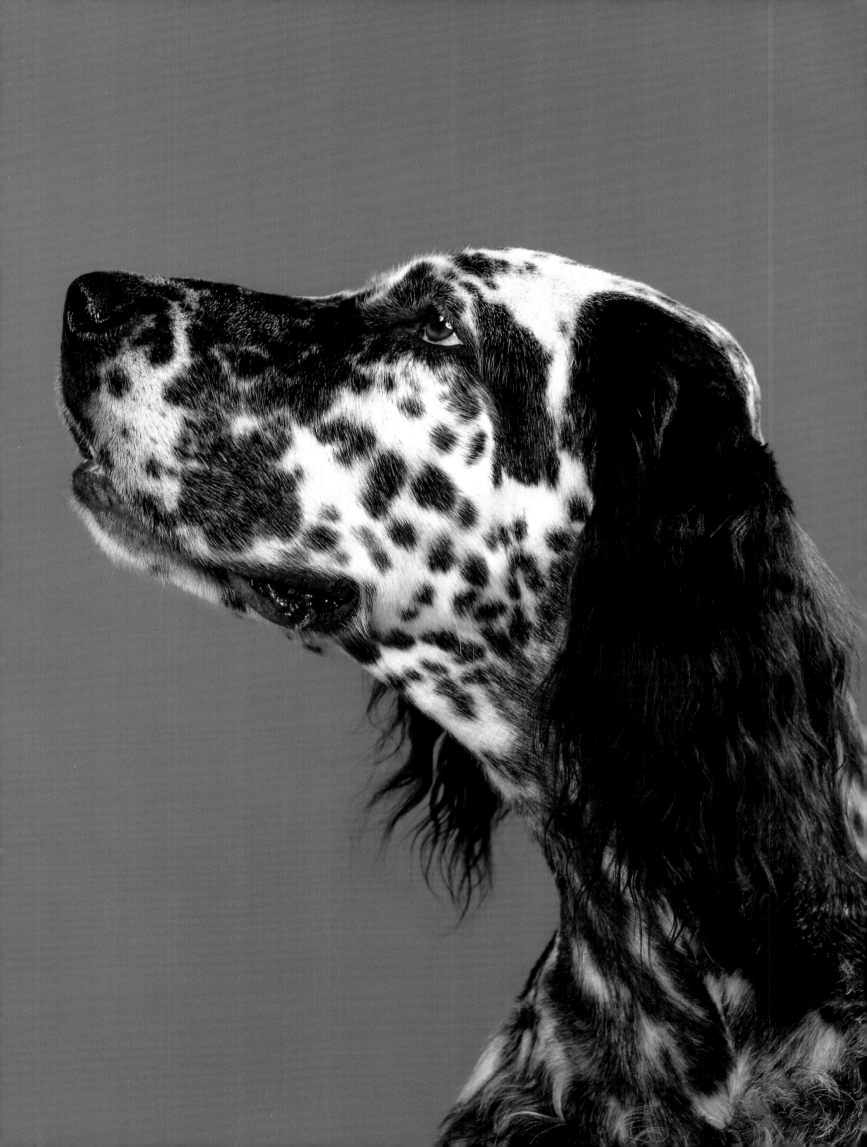

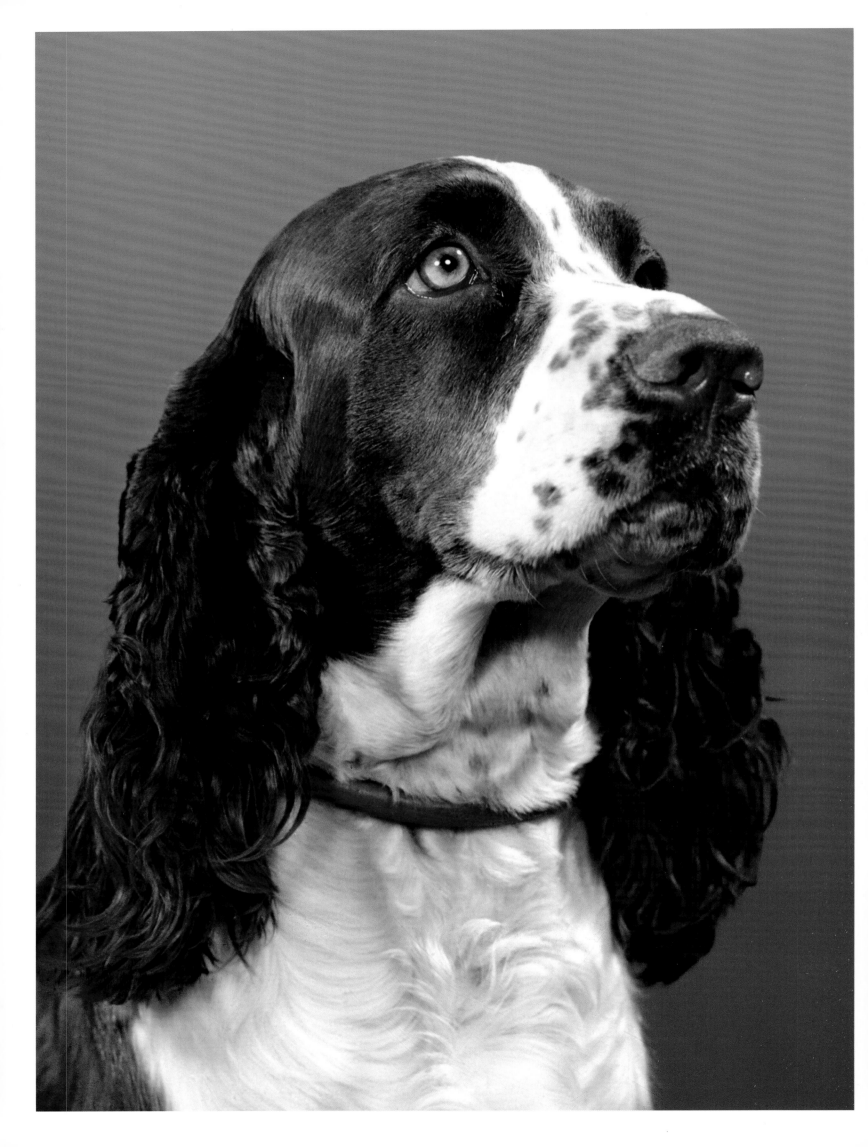

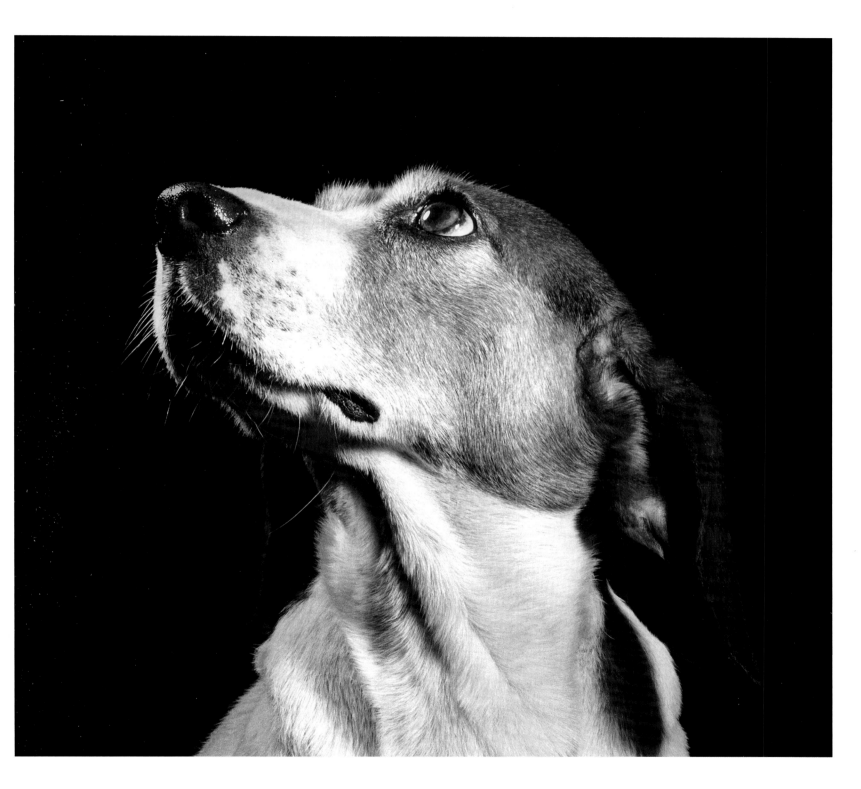

Springer spaniel, Long Island, New York, 1953

Beagle, New Jersey, 1941

Weimaraner, Long Island, New York, 1955

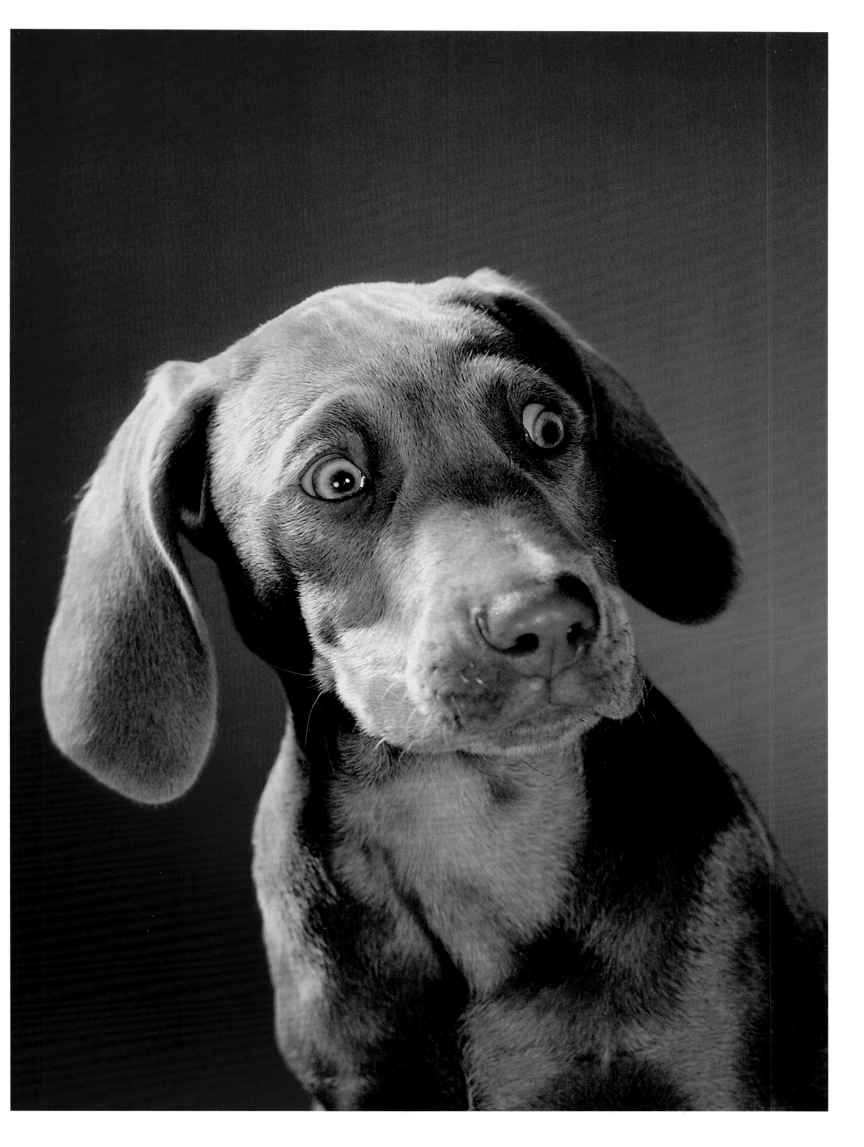

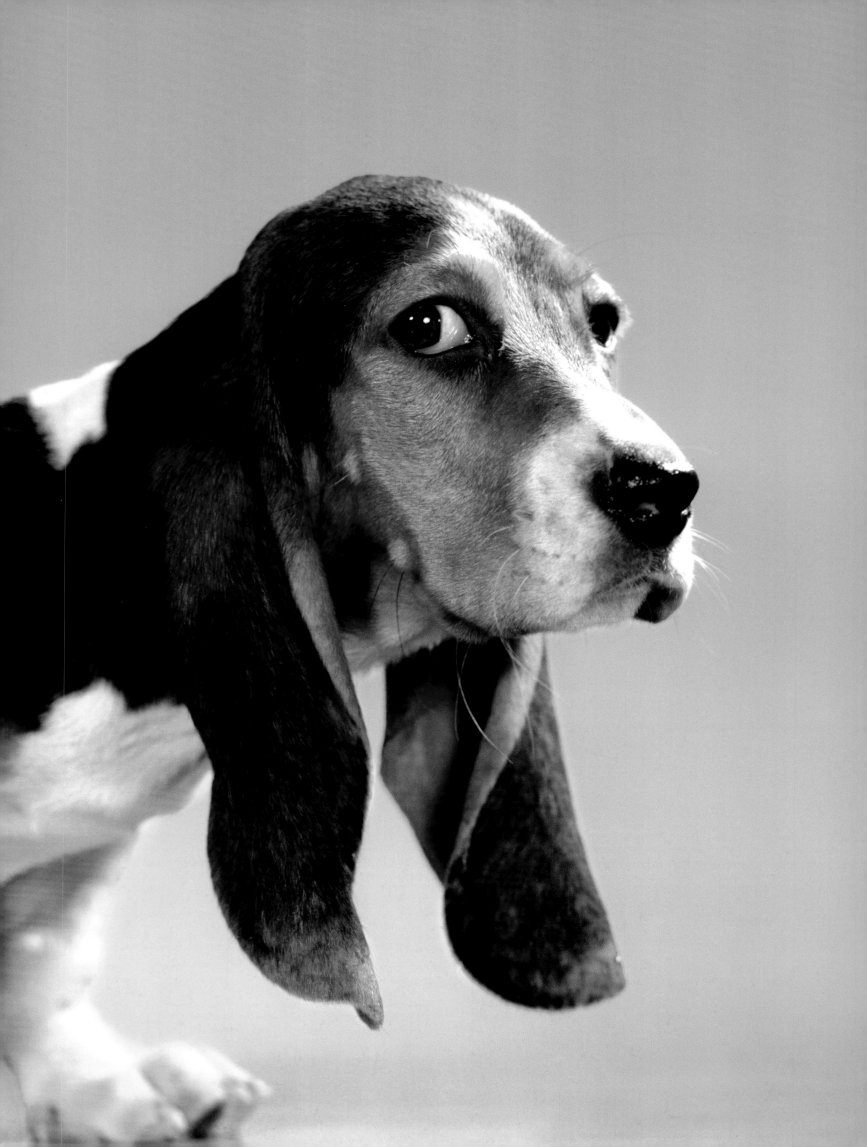

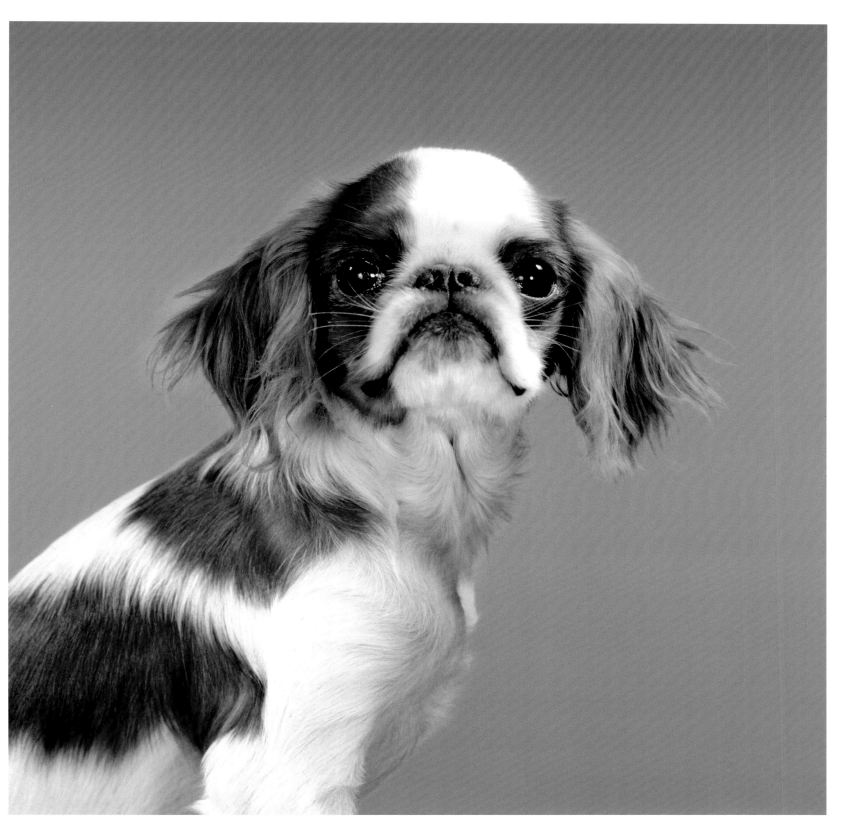

Basset hound, Long Island, New York, 1954

King Charles spaniel, Long Island, New York, 1956

Scottish terrier, Long Island, New York, 1953

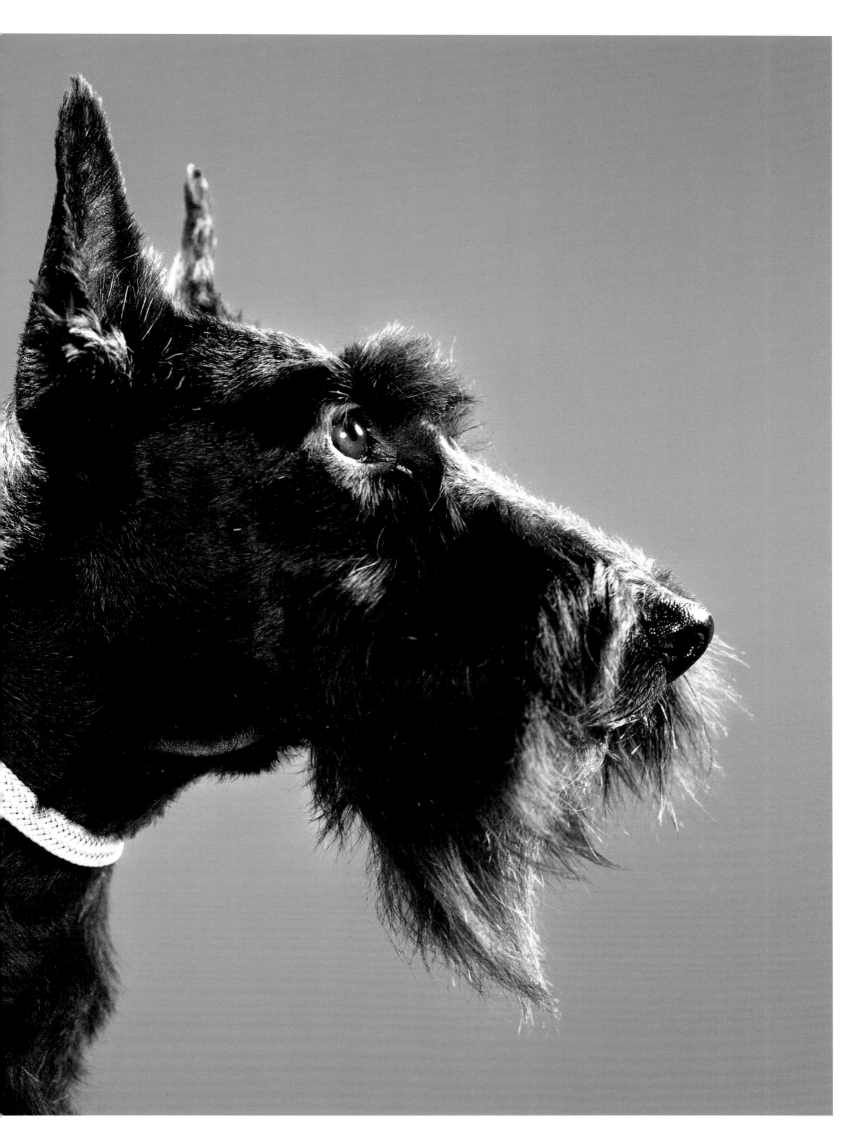

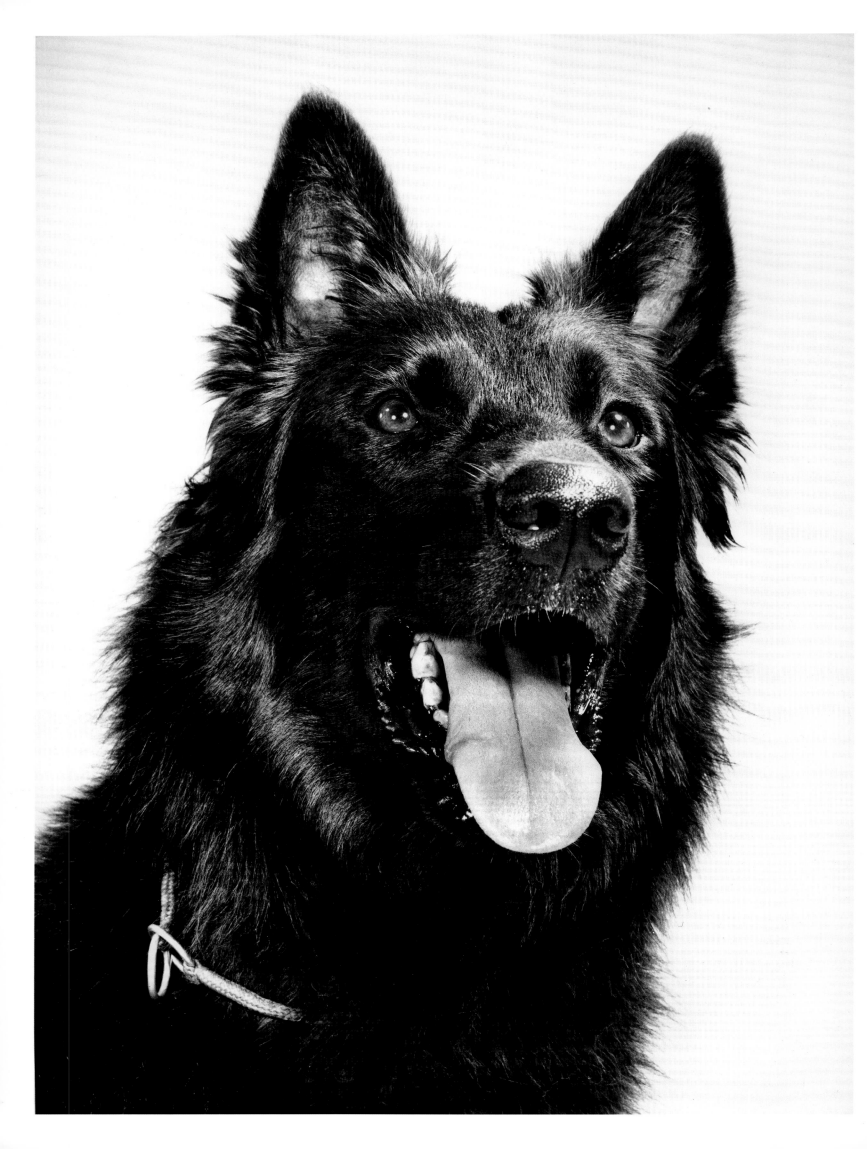

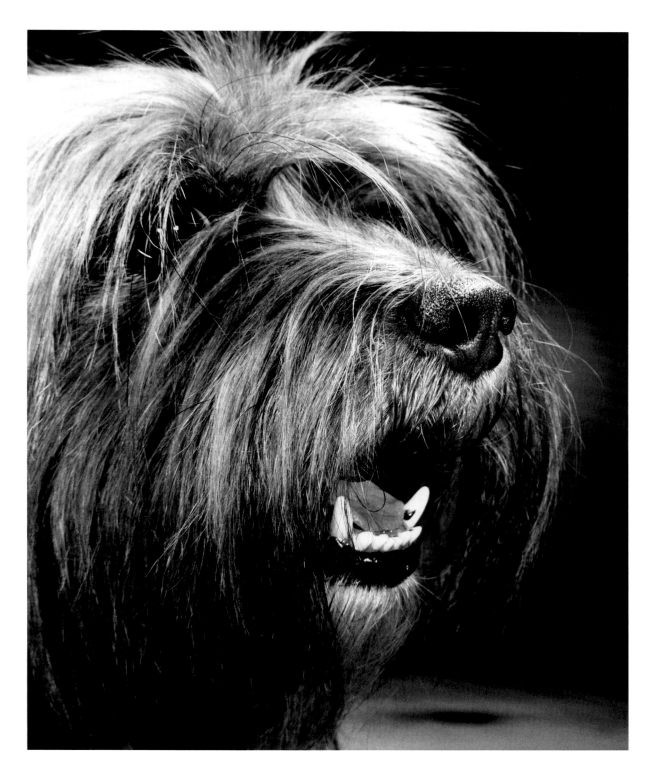

Groenendael, Long Island, New York, 1958

Mixed-breed, New Jersey, 1960

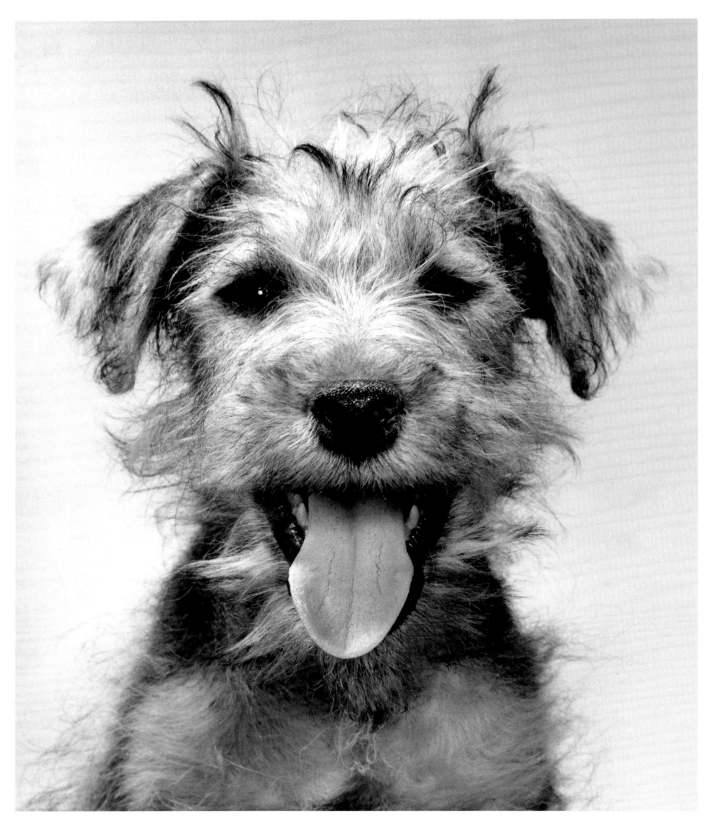

Welsh terrier, New Jersey, 1965

Pekingese, Long Island, New York, 1960

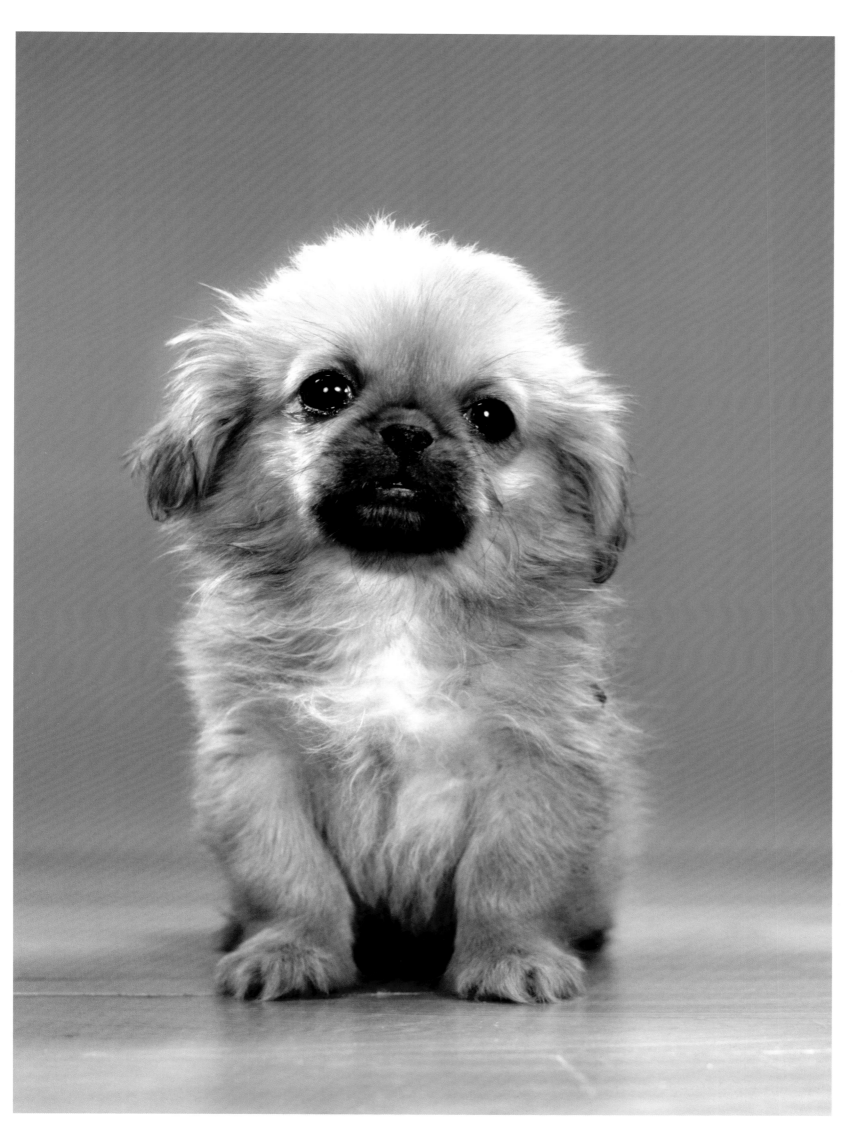

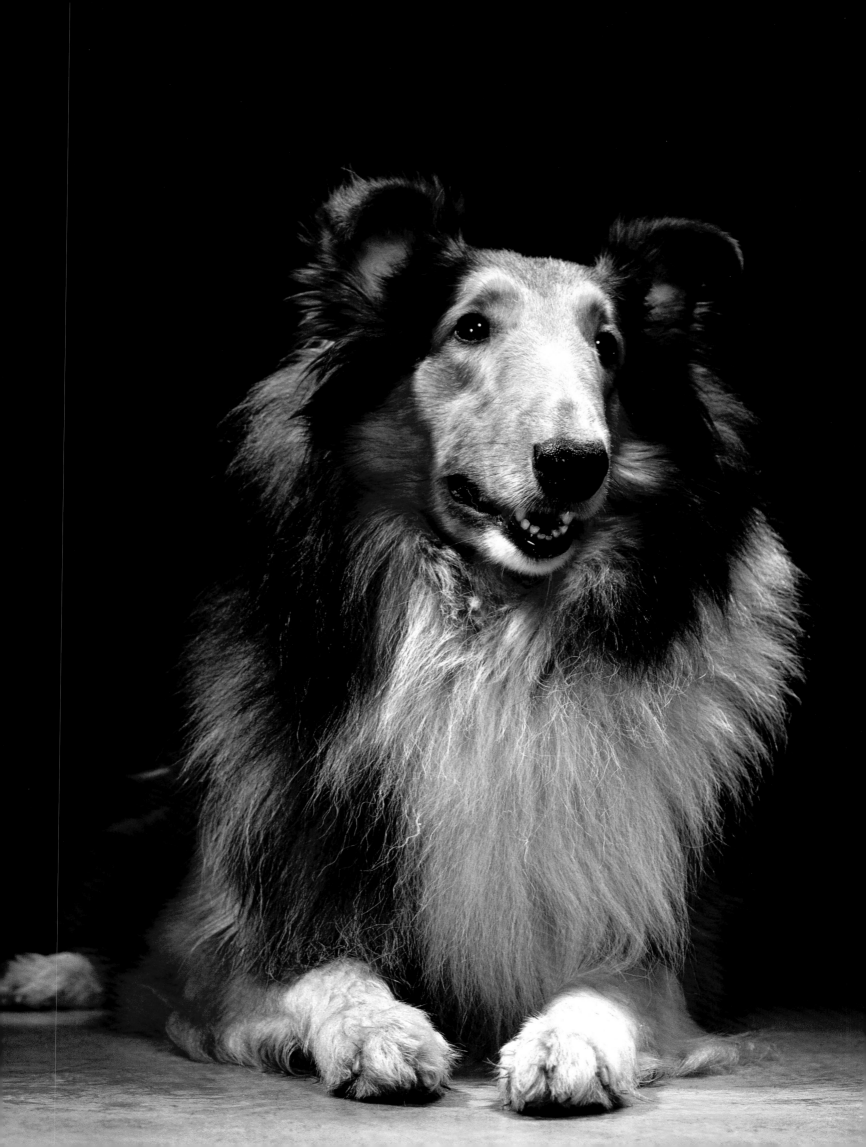

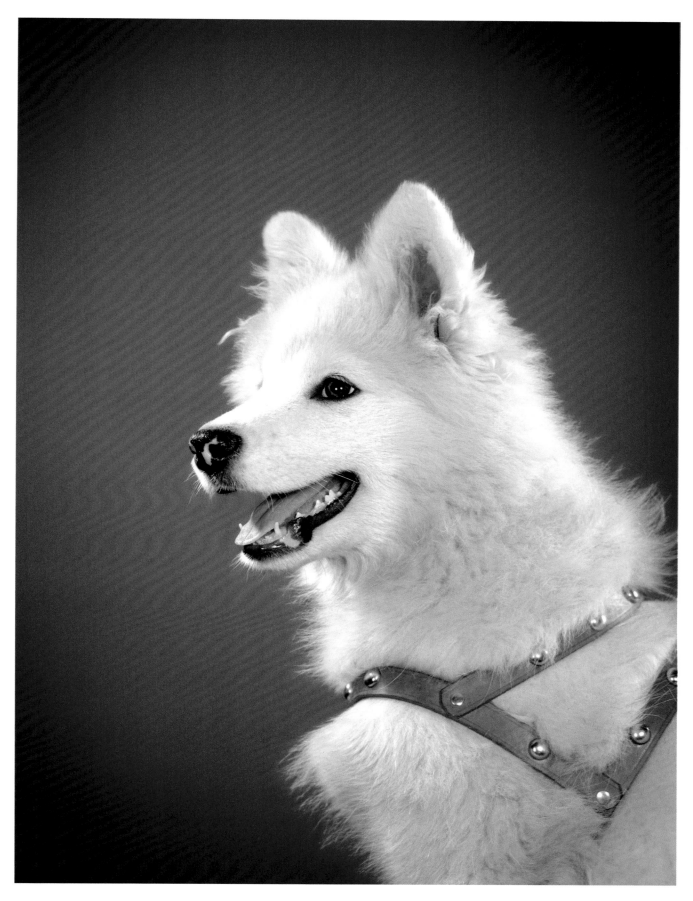

Collie, New Jersey, 1961

Samoyed, Long Island, New York, 1954

Saint Bernards, Long Island, New York, 1955

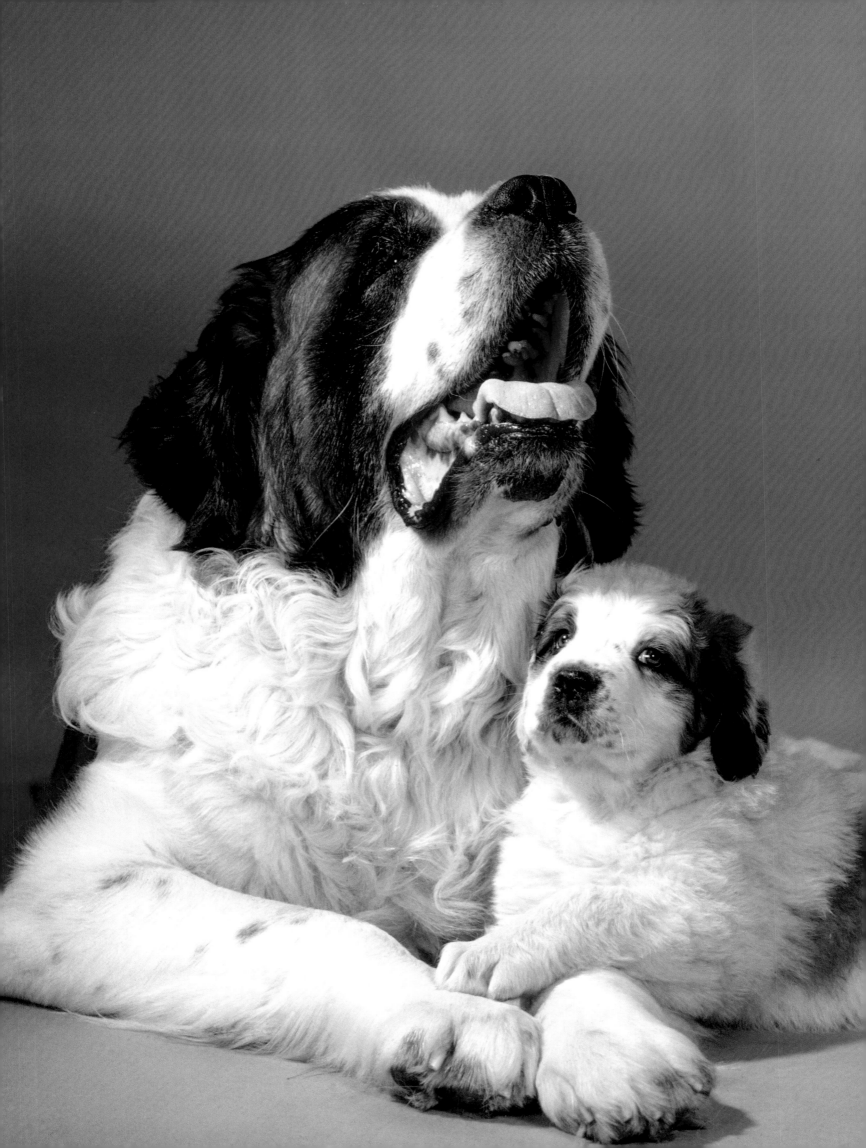

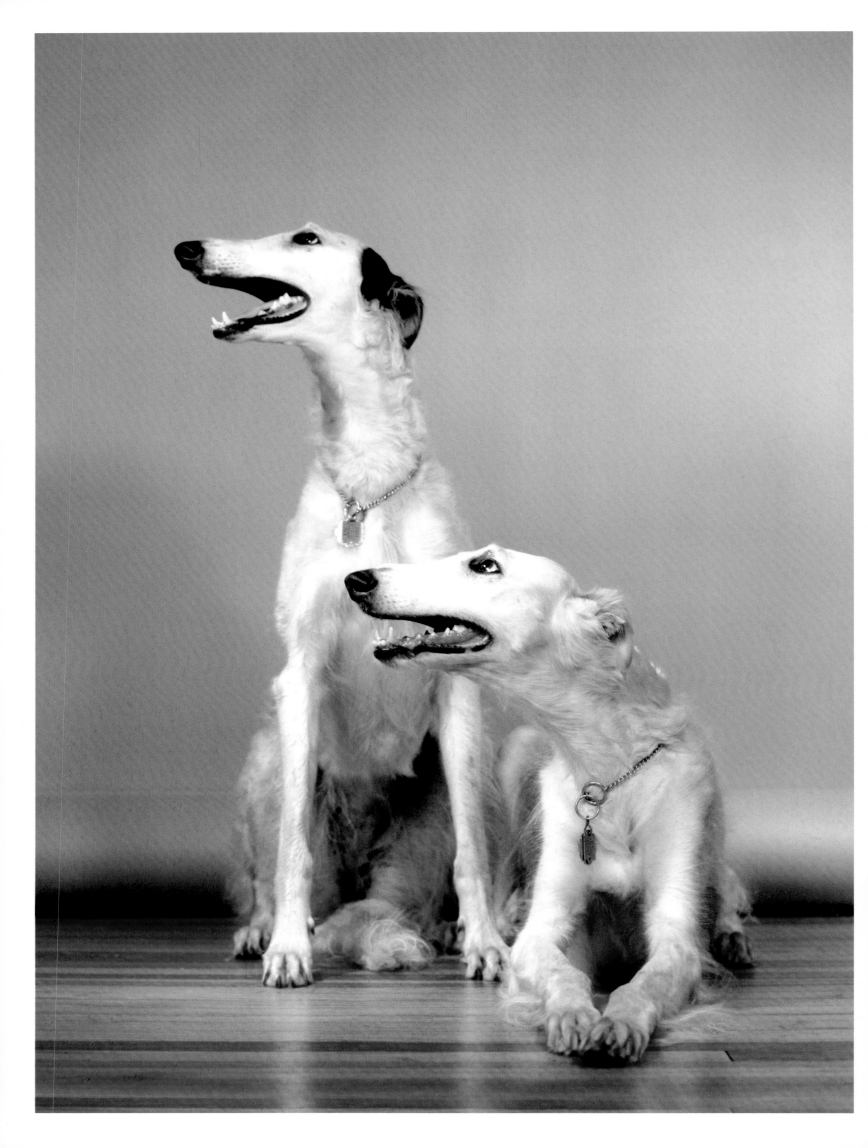

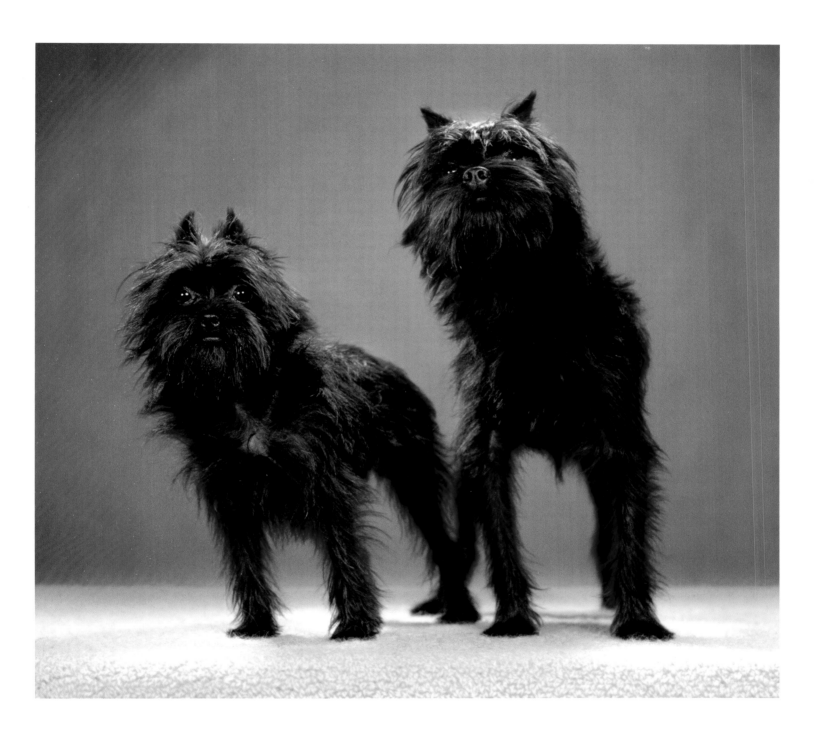

Borzois, Long Island, New York, 1953

Affenpinschers, New Jersey, 1965

Pages 90–91: Dachshunds, New Jersey, 1963

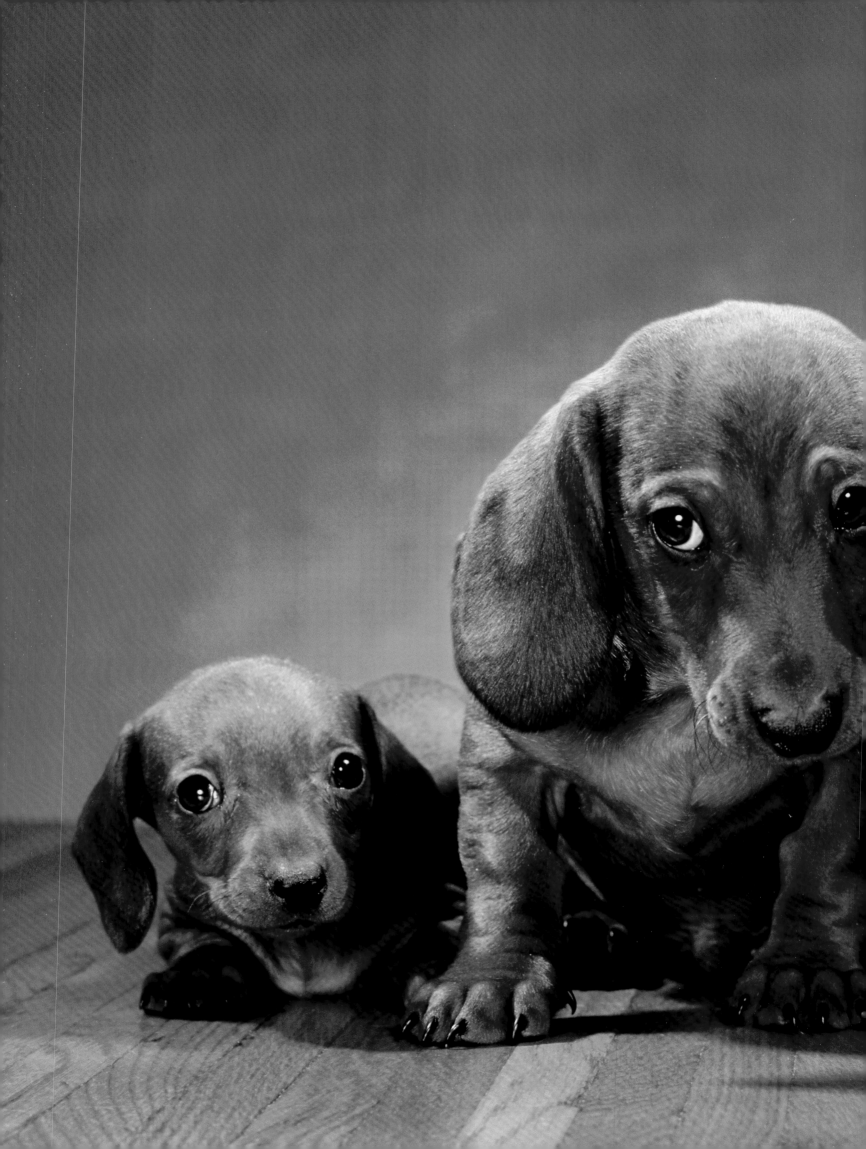

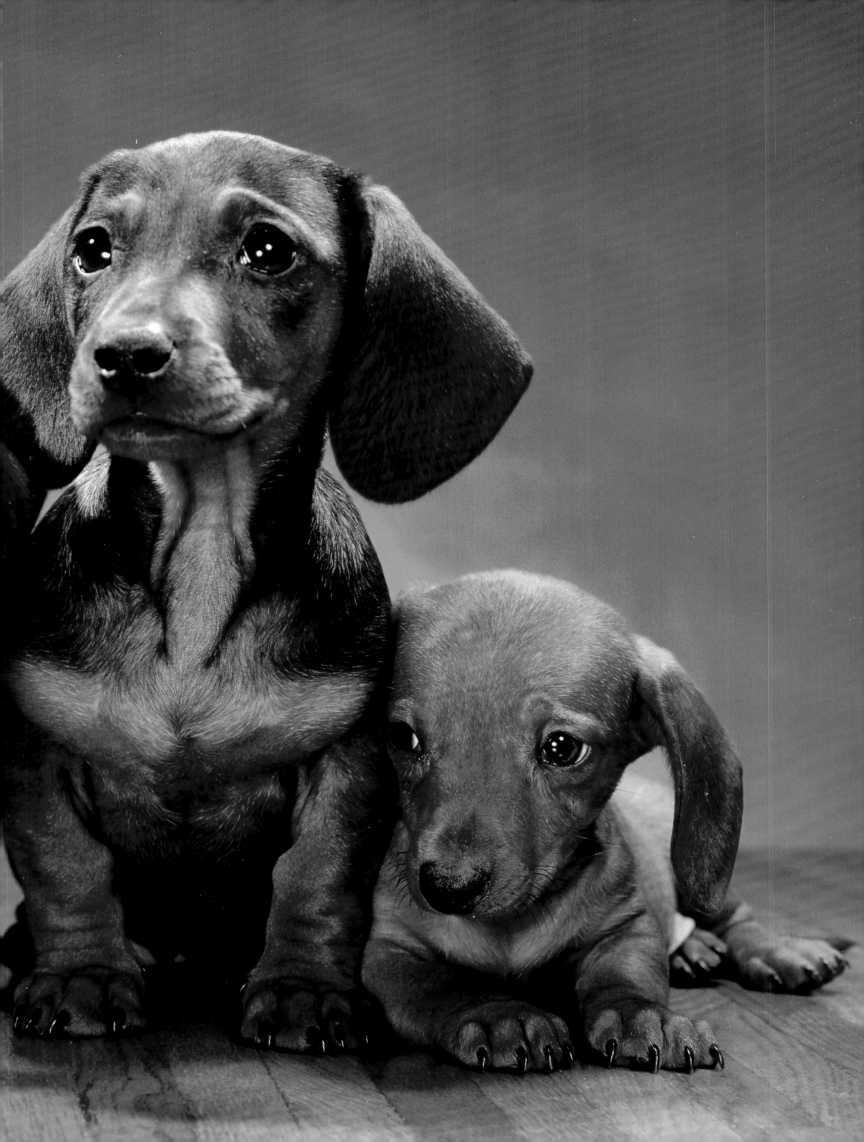

Basset hounds, New Jersey, 1964

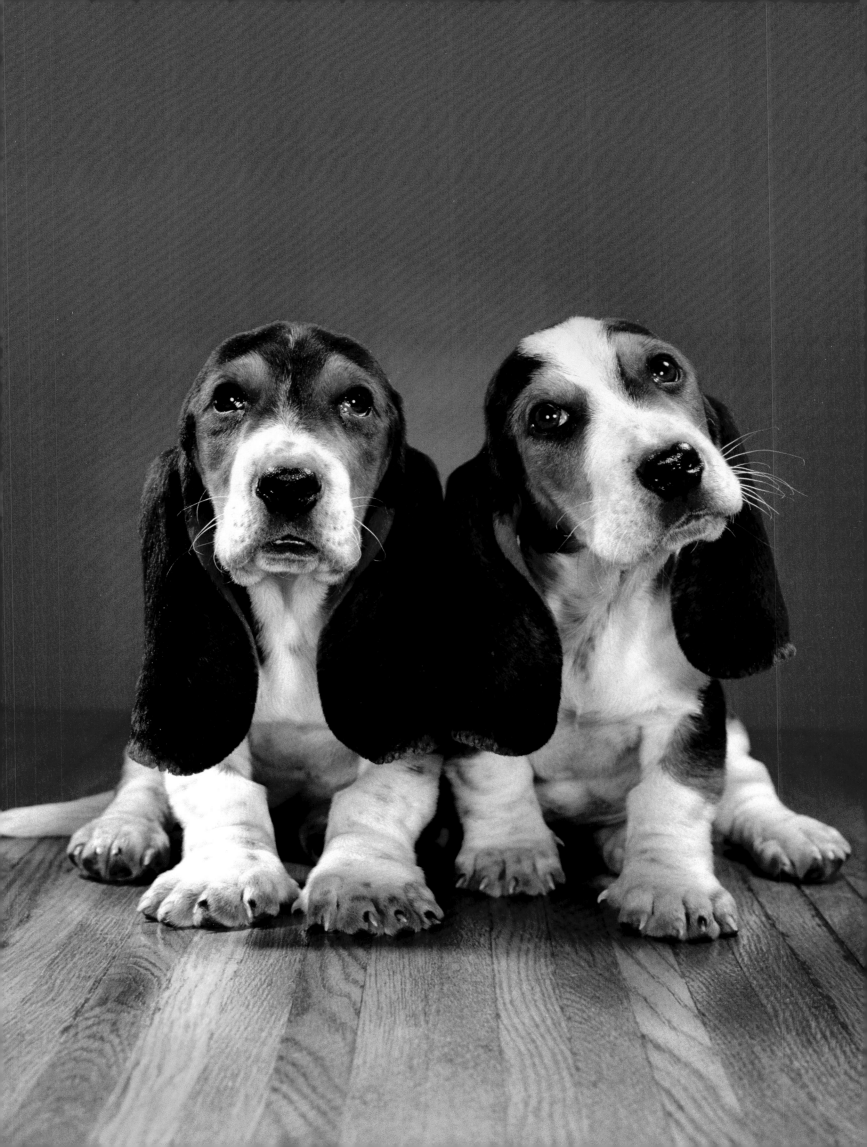

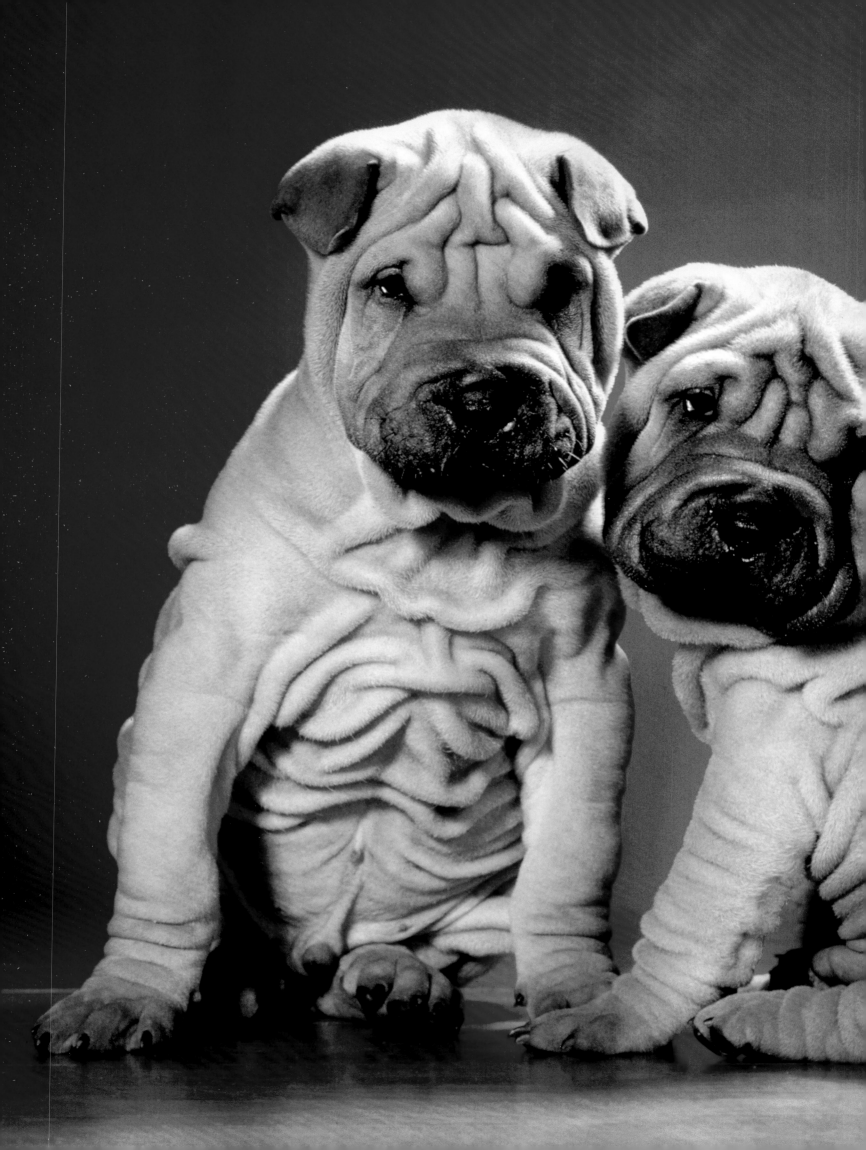

Shar-Pei, New Jersey, 1981

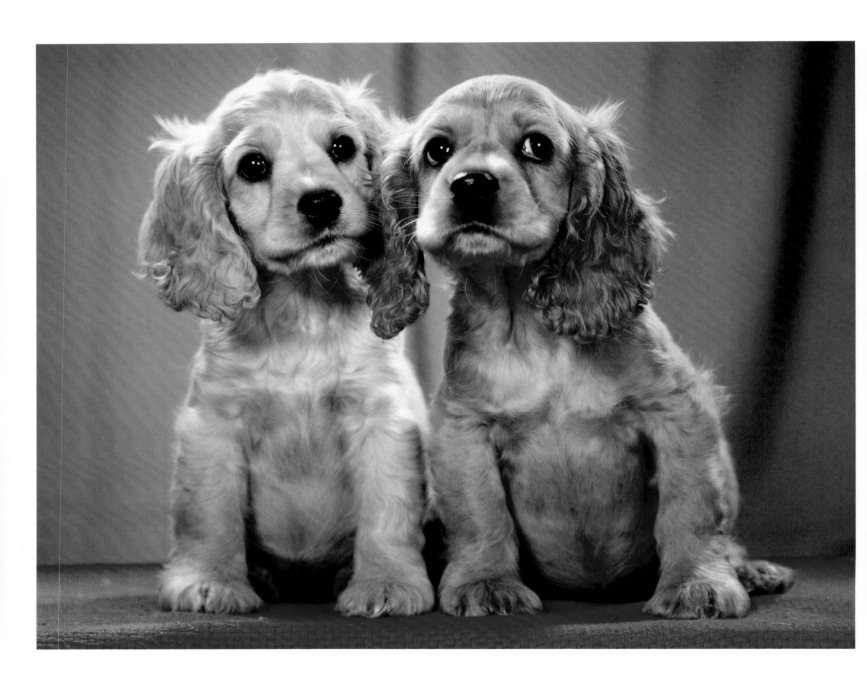

Cocker spaniels, Long Island, New York, 1959

Dalmatians, Long Island, New York, 1957

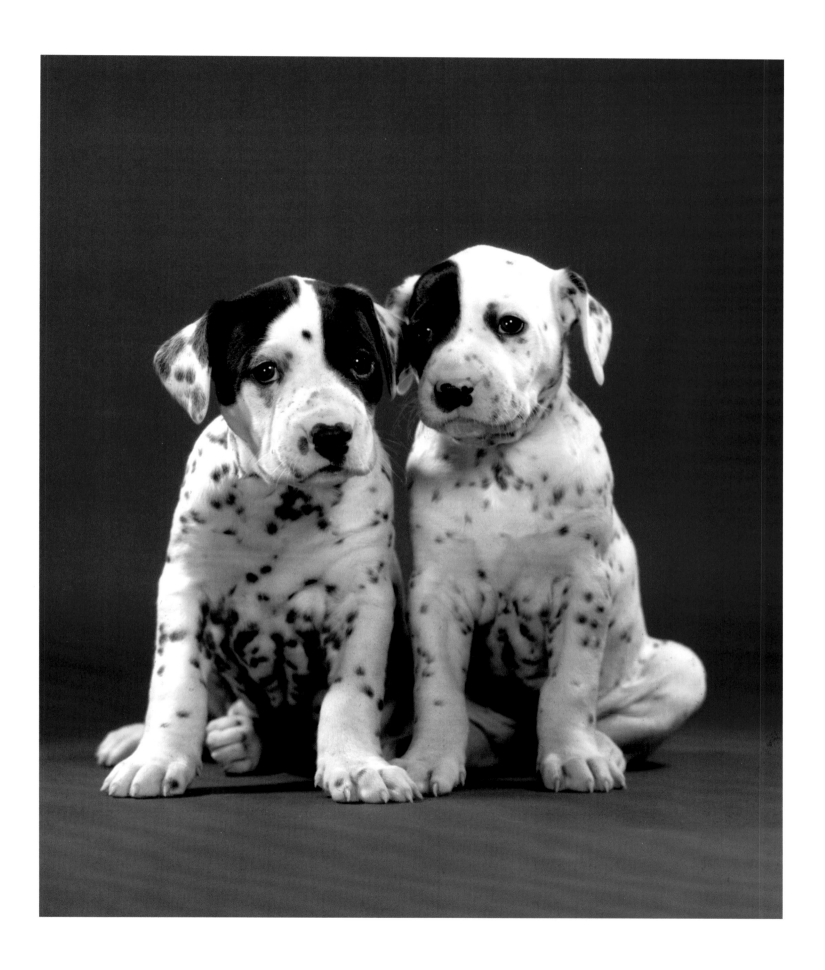

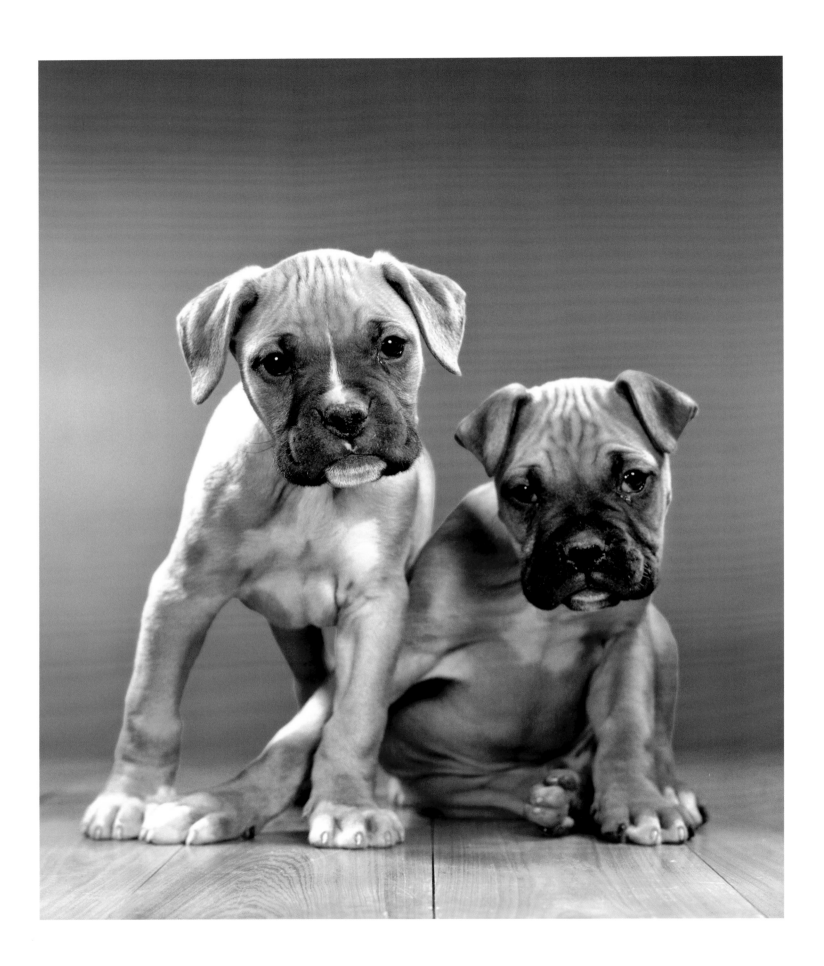

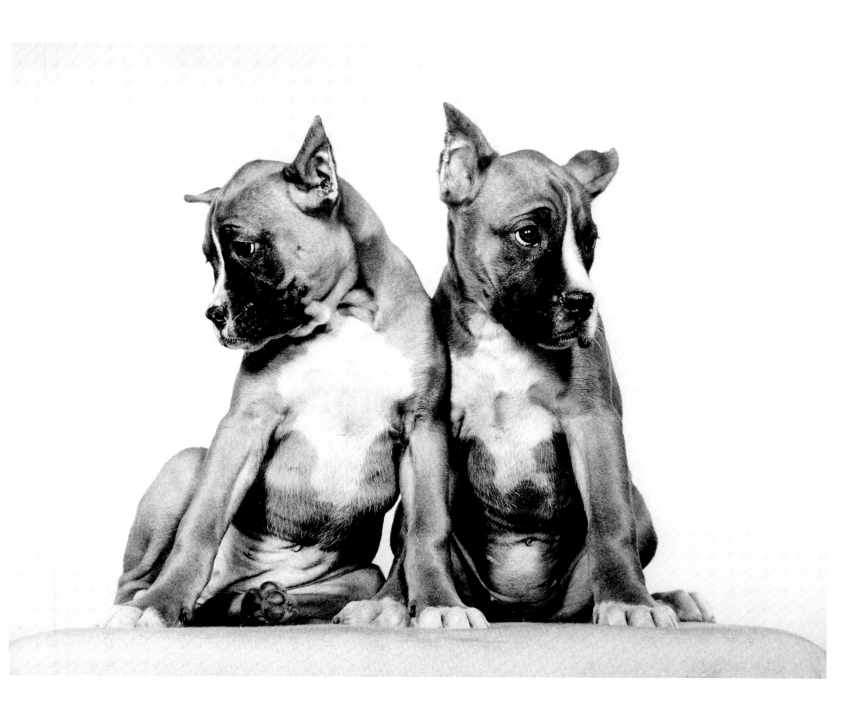

Boxers, New Jersey, 1960

Boxers, Long Island, New York, 1953

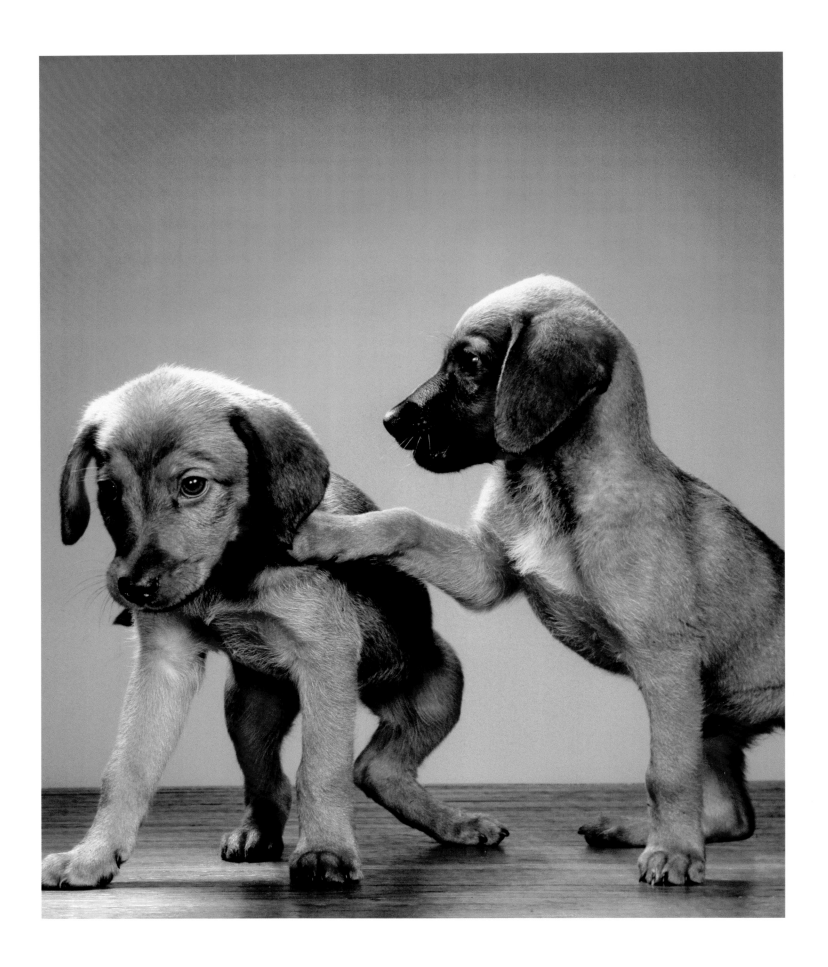

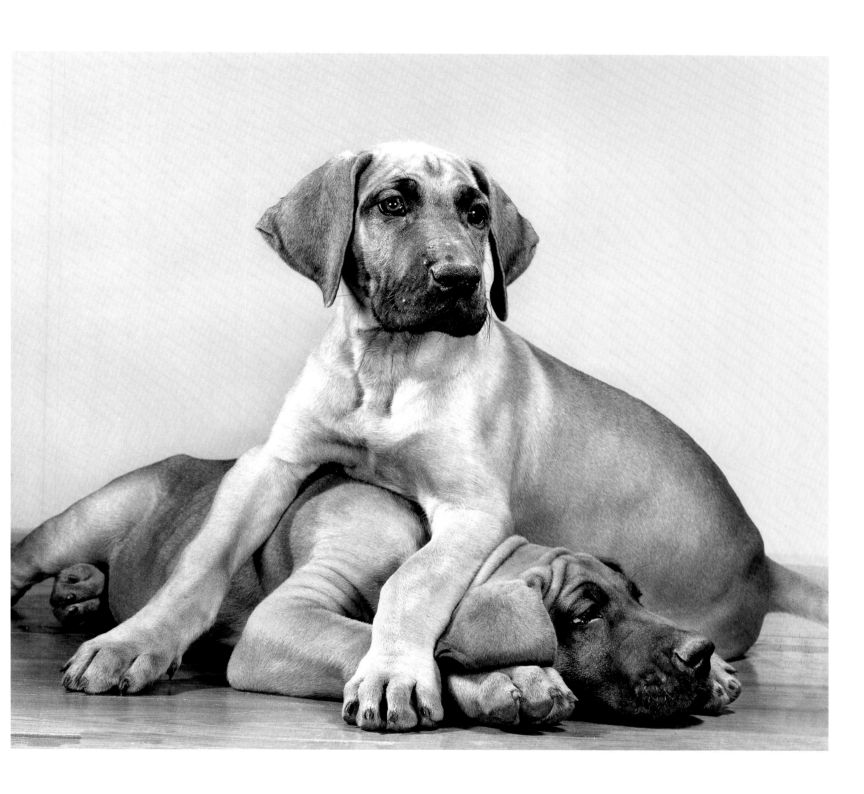

Mixed-breeds, New Jersey, 1991

Great Danes, New Jersey, 1960

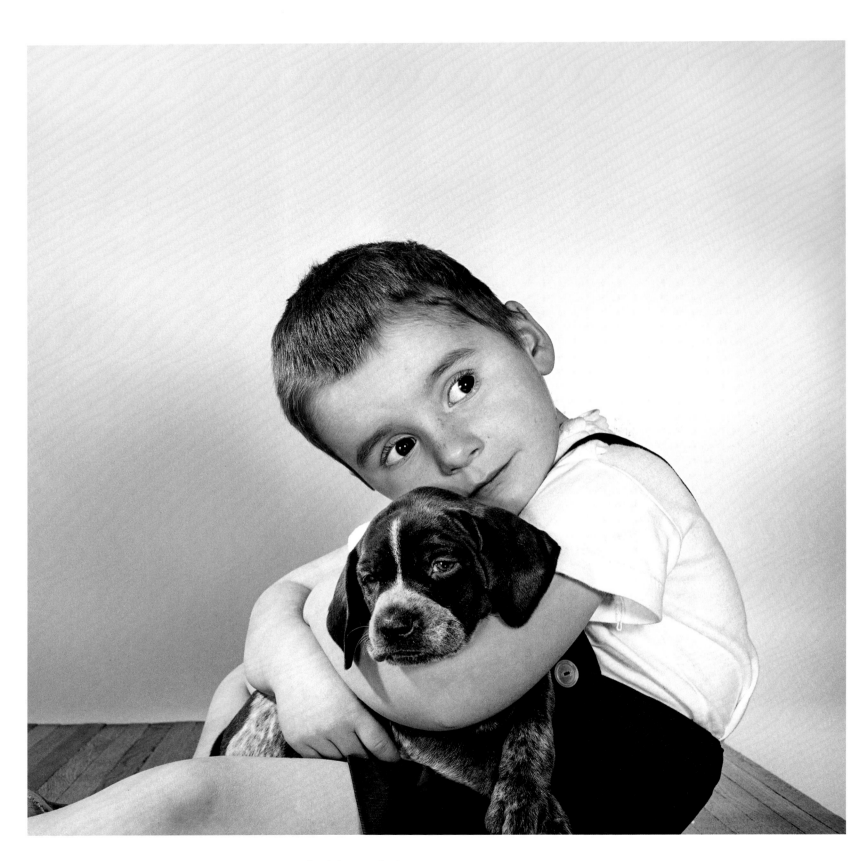

German shorthaired pointer and Enrico, Long Island, New York, 1955

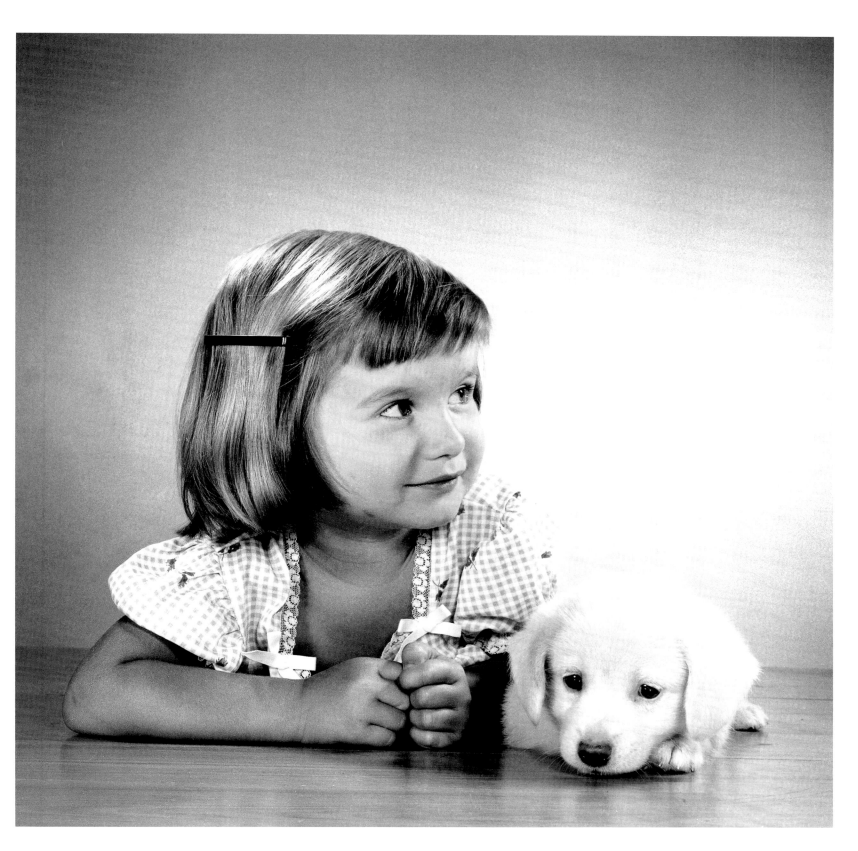

Mixed-breed and Maria, Long Island, New York, 1956

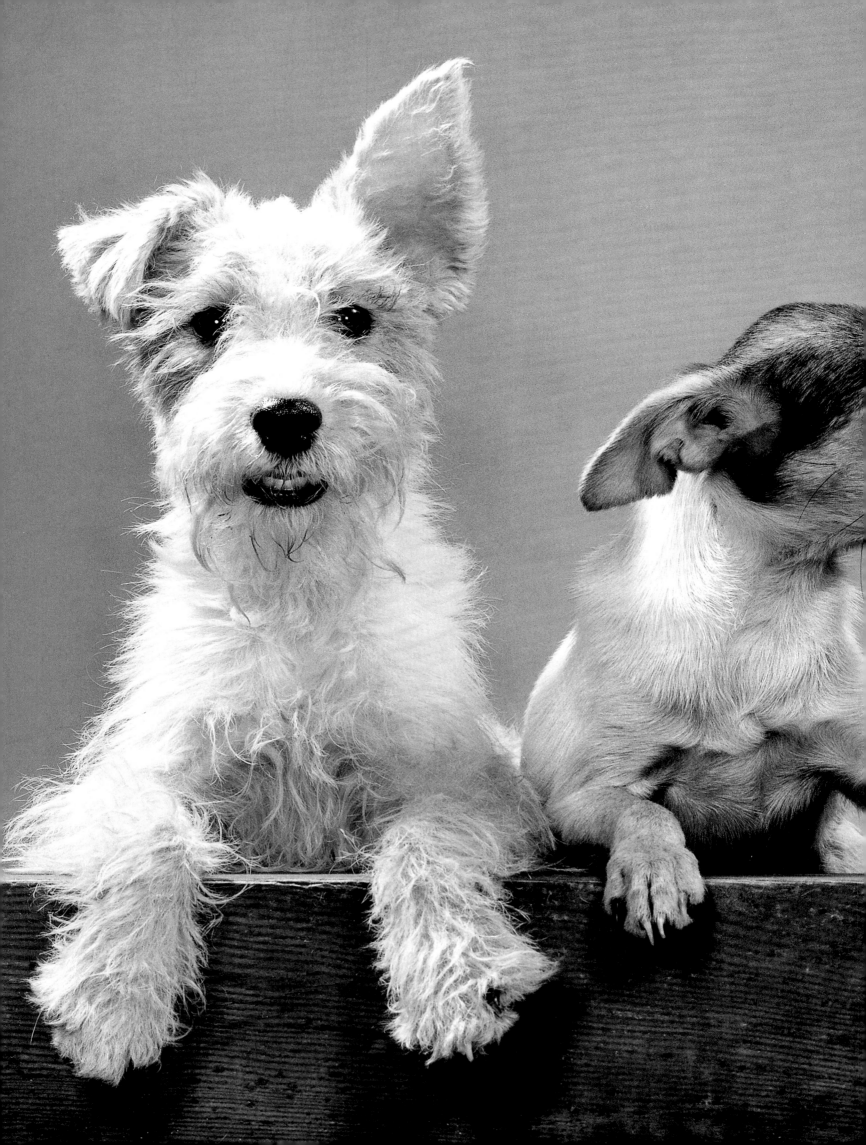

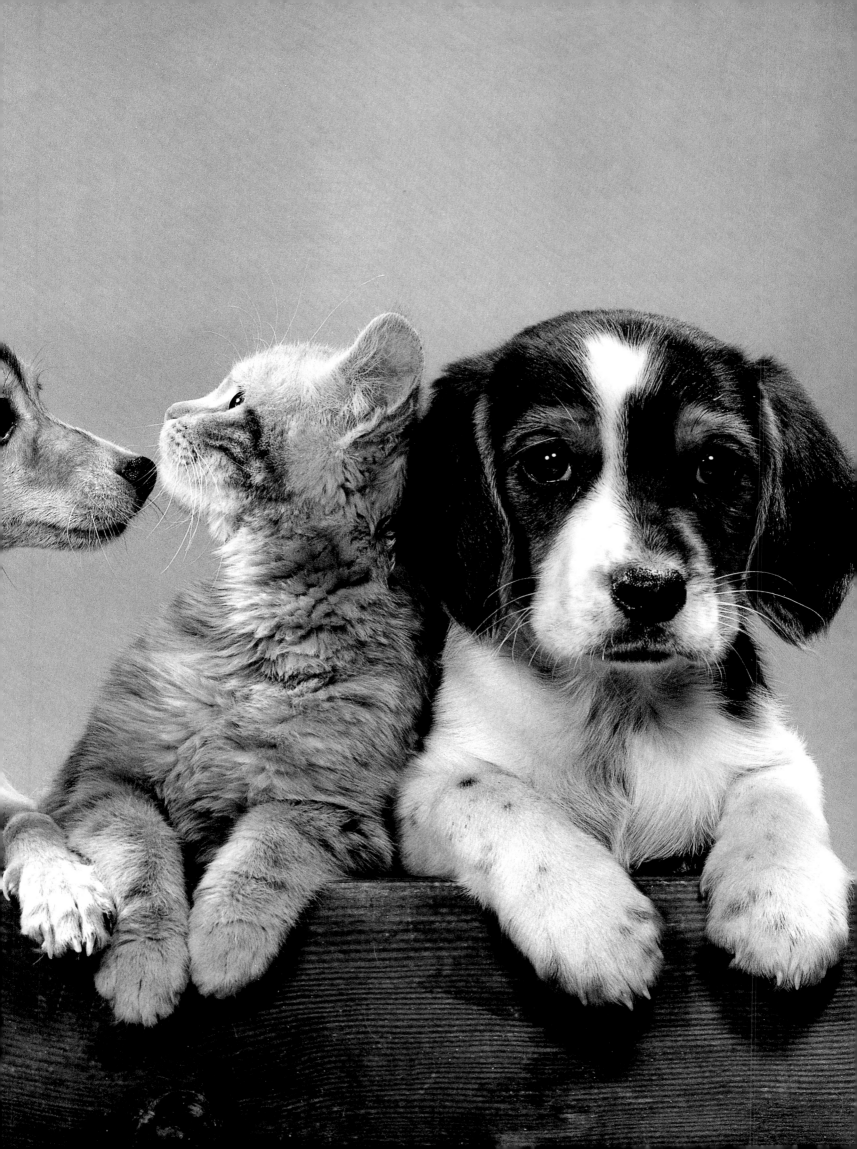

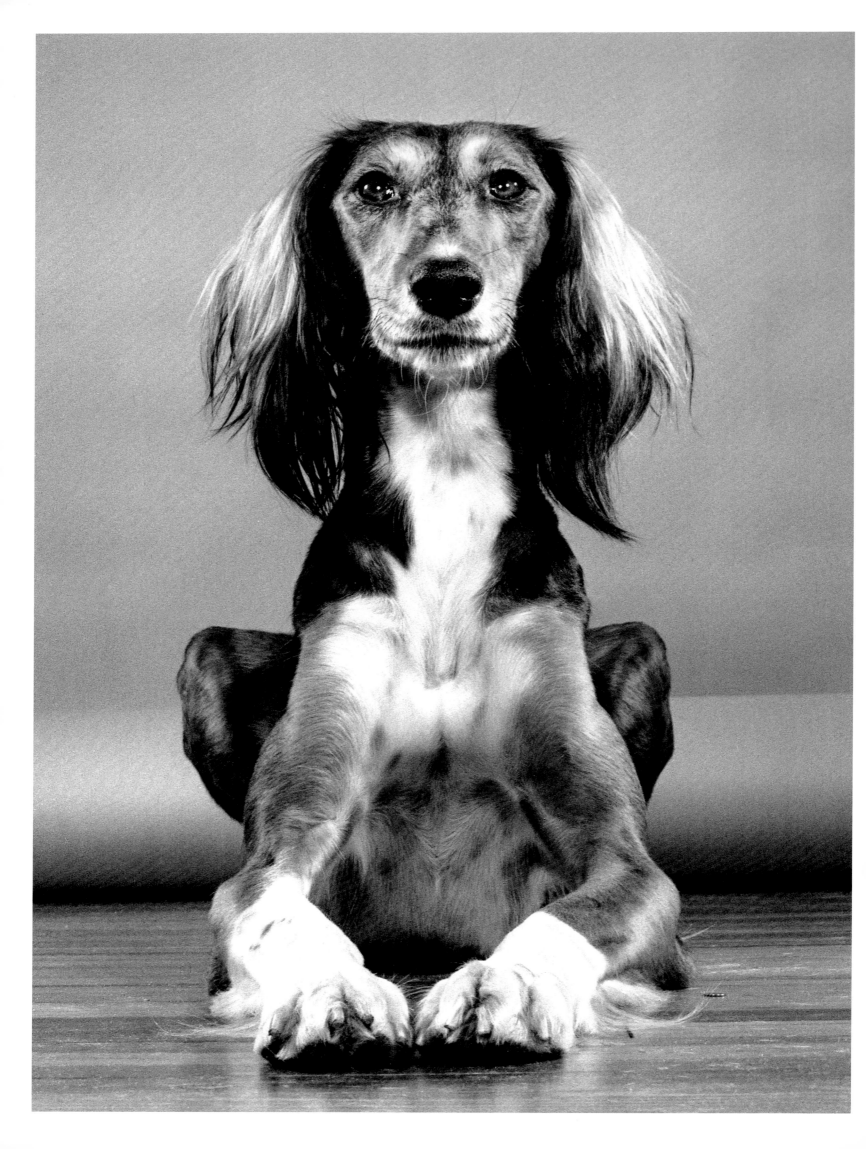

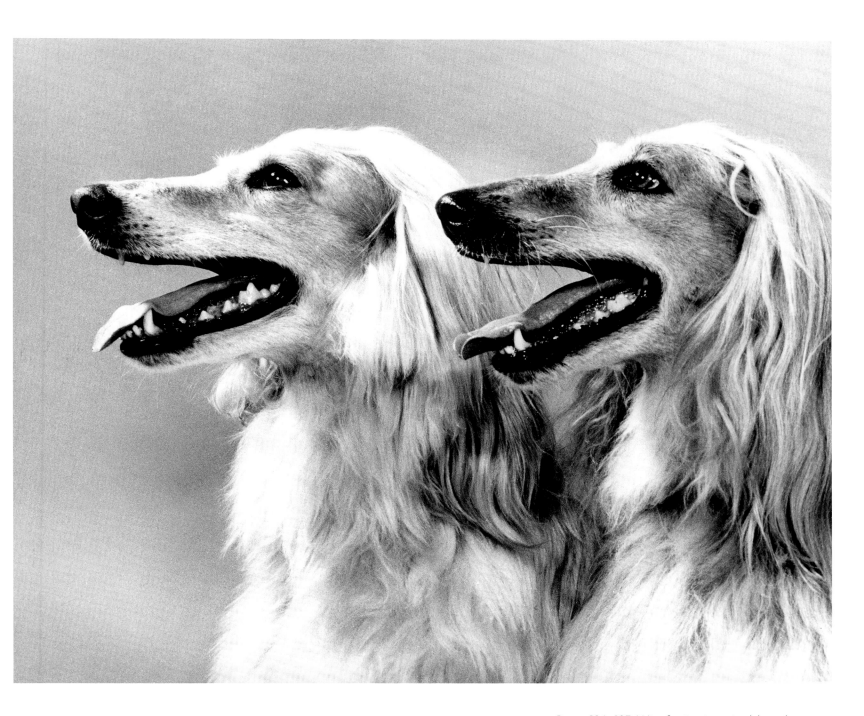

Pages 104–105: Wire fox terrier, mixed-breeds, and domestic shorthair cat, New Jersey, 1965

Saluki, Long Island, New York, 1954

Afghans, Long Island, New York, 1956

French poodle, New Jersey, 1961

Page 110: Dalmatians, Long Island, New York, 1952

Page 111: Bulldogs, Long Island, New York, 1952

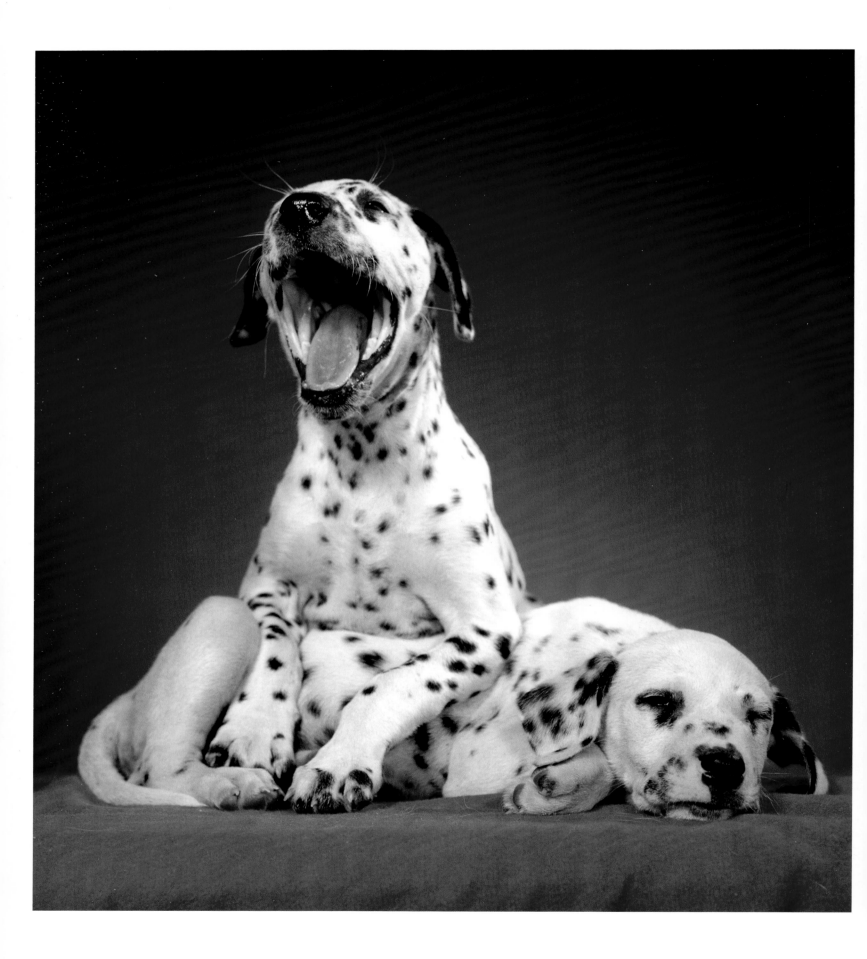

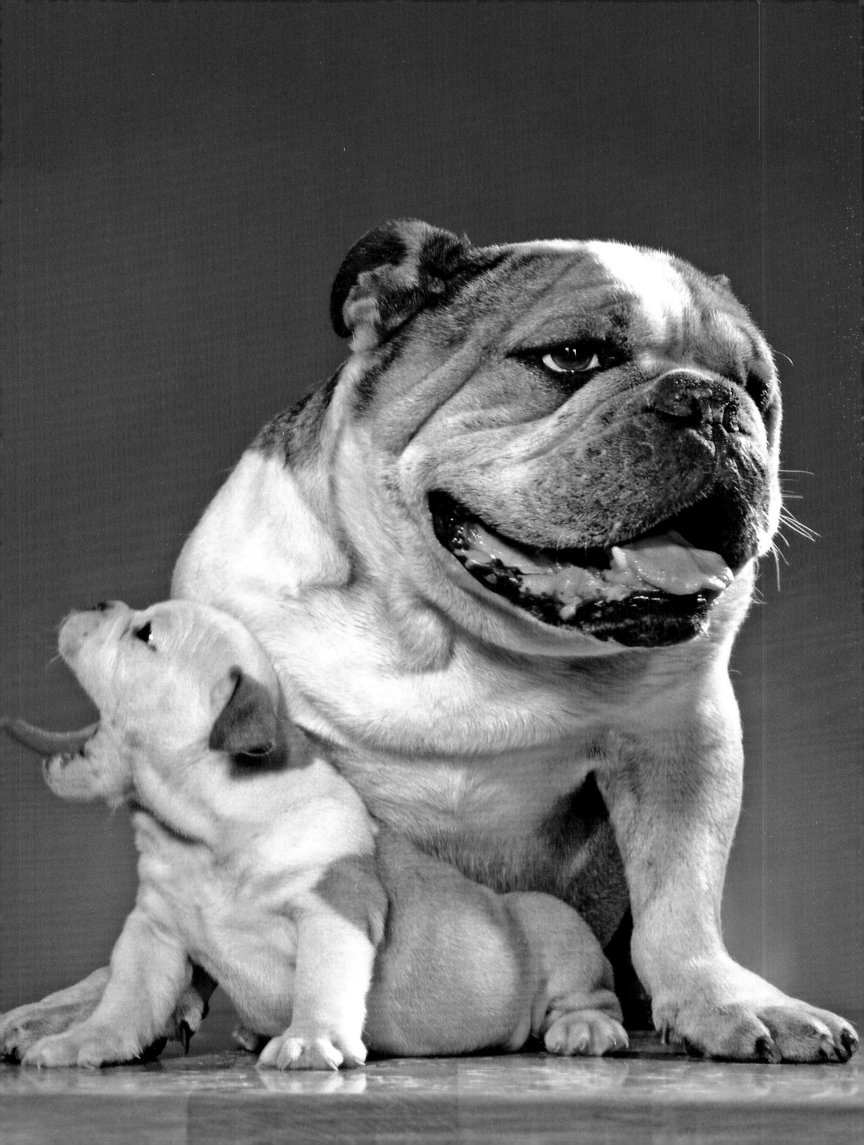

Mixed-breeds,
Long Island,
New York, 1954

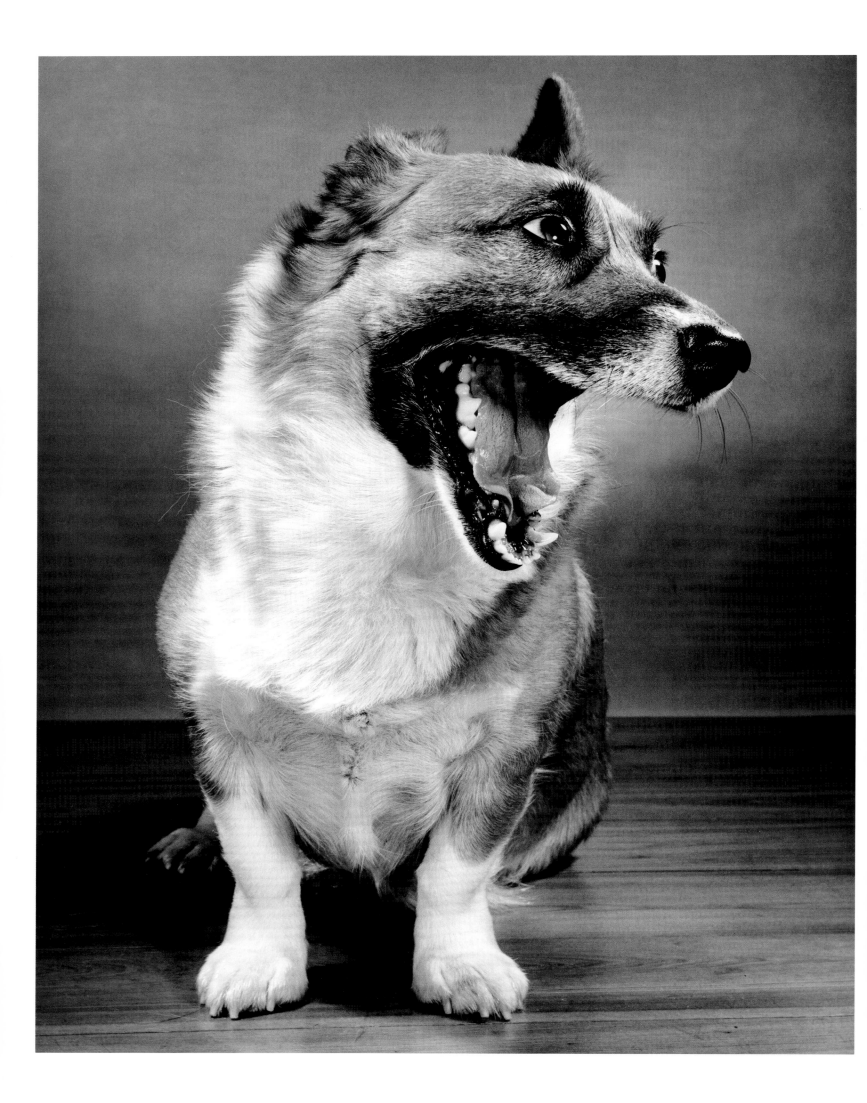

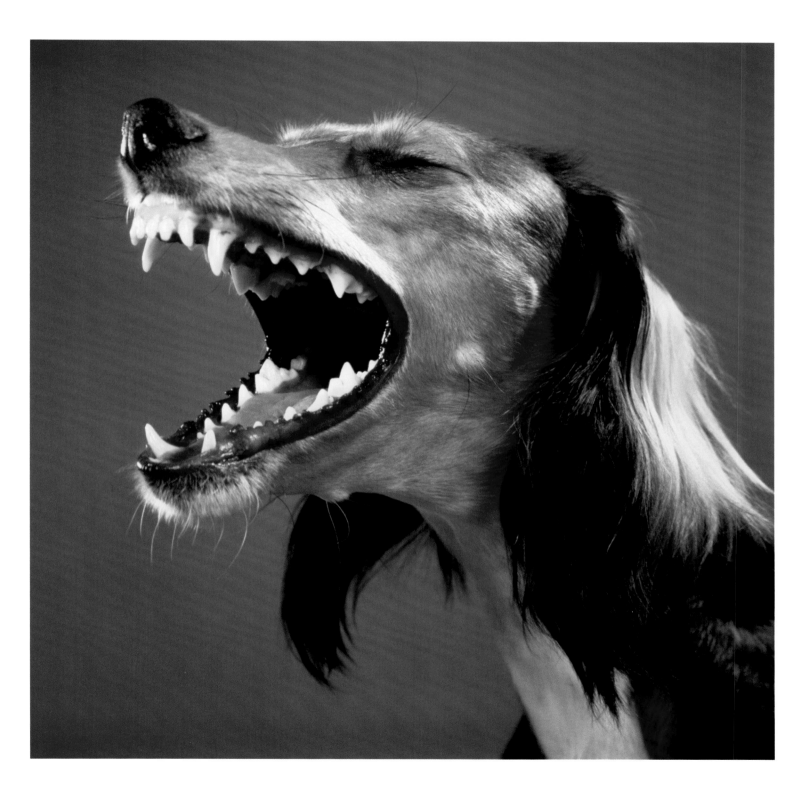

Welsh corgi, Long Island, New York, 1958

Saluki, Long Island, New York, 1954

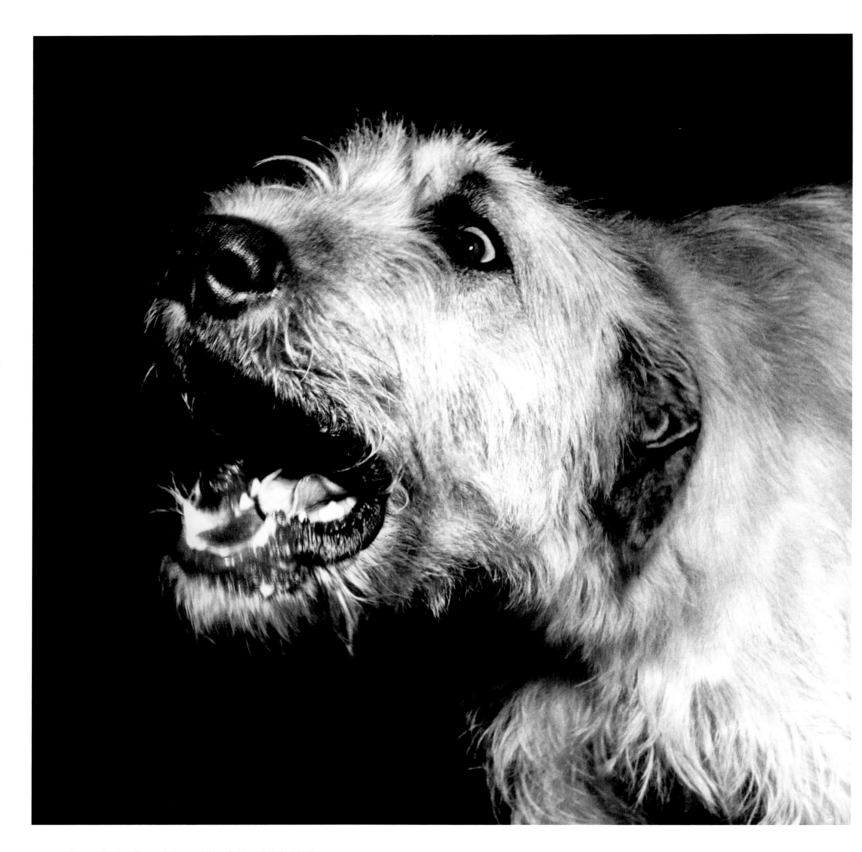

Scottish deerhound, Long Island, New York, 1953

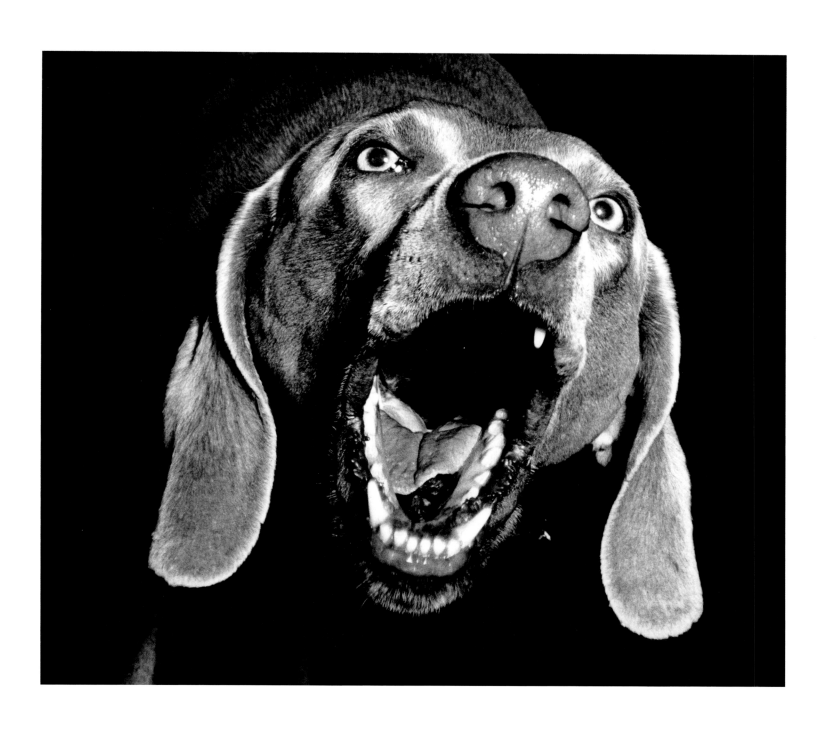

Weimaraner, Long Island, New York, 1954

Page 118: Beagle, Long Island, New York, 1954

Page 119: Irish setters, New Jersey, 1960

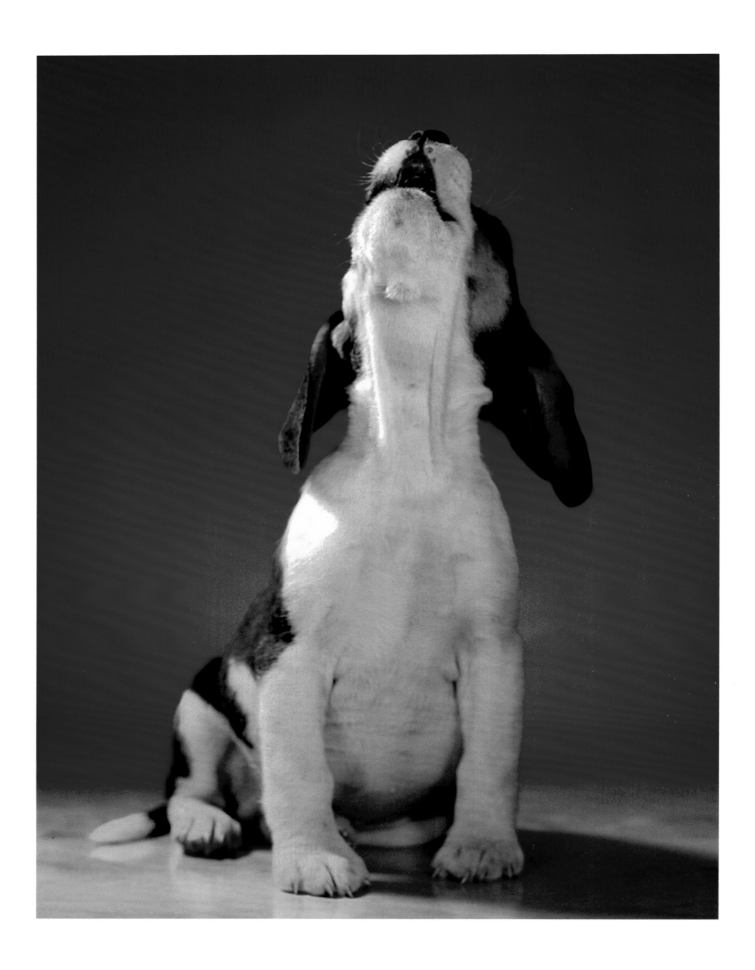

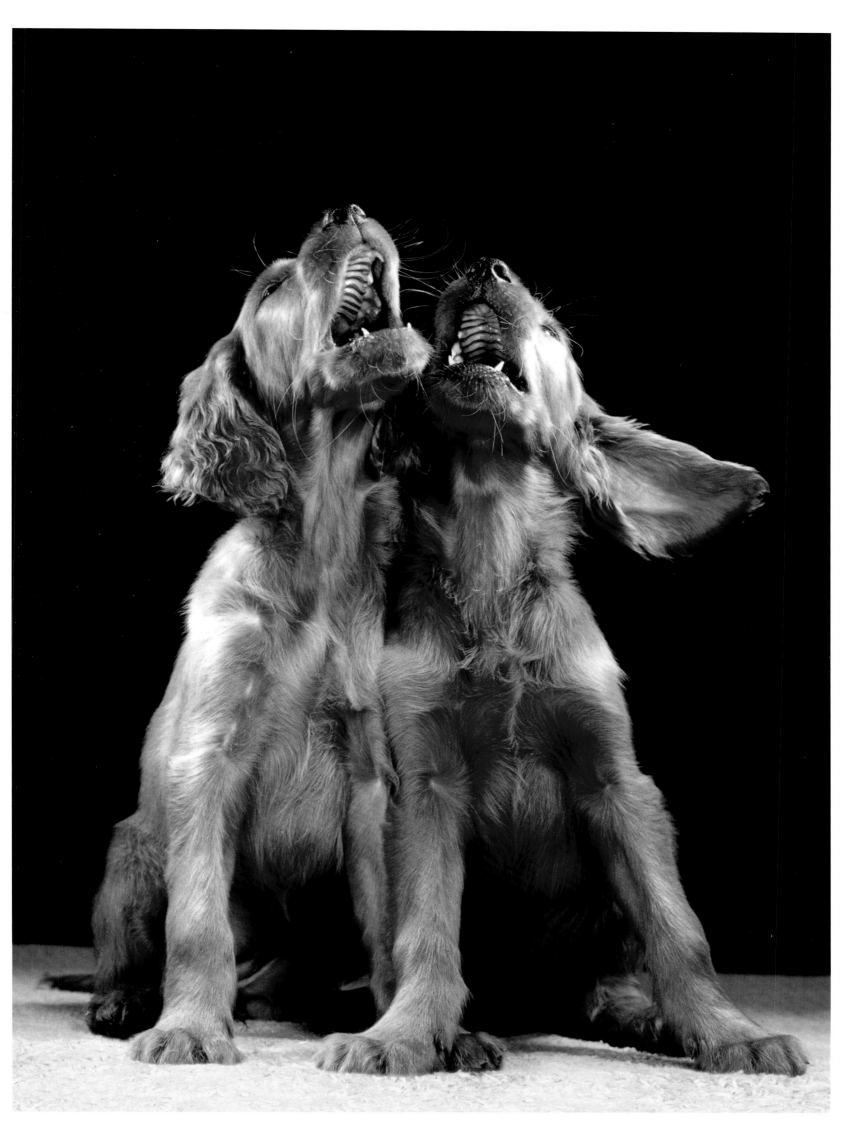

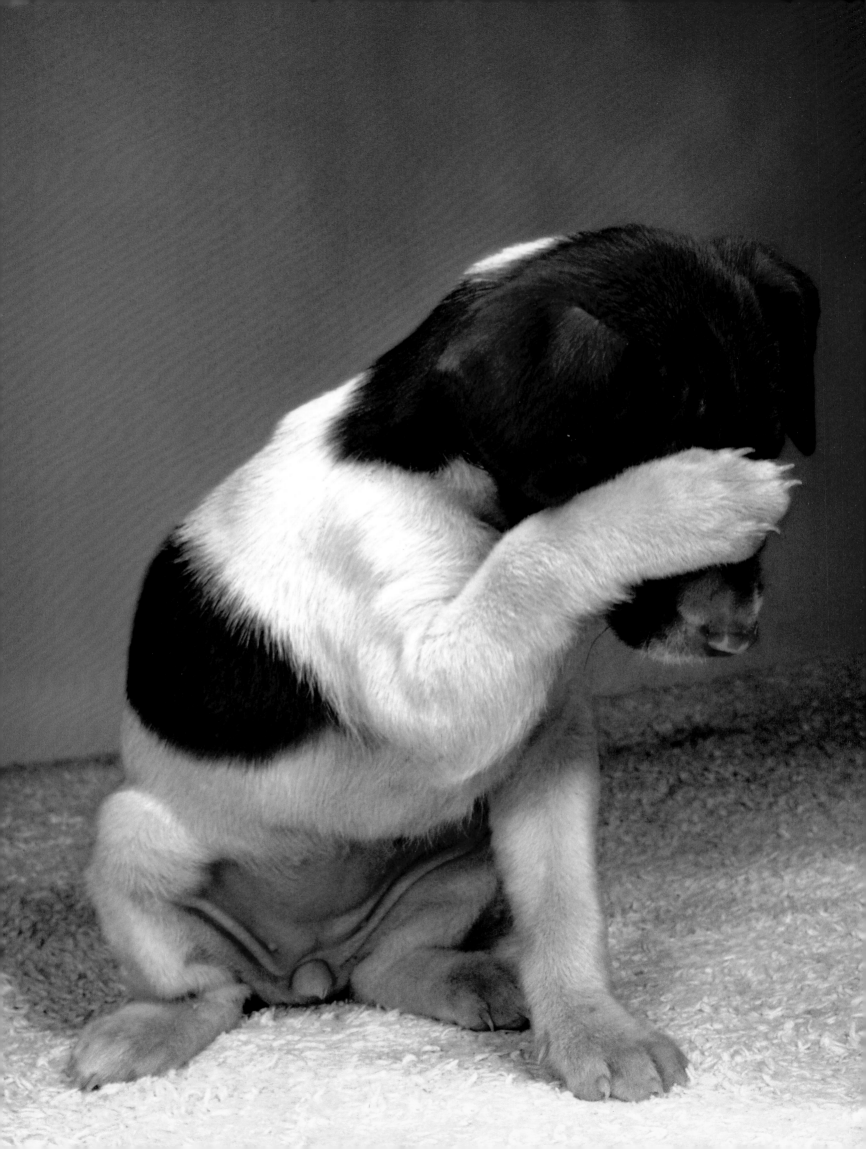

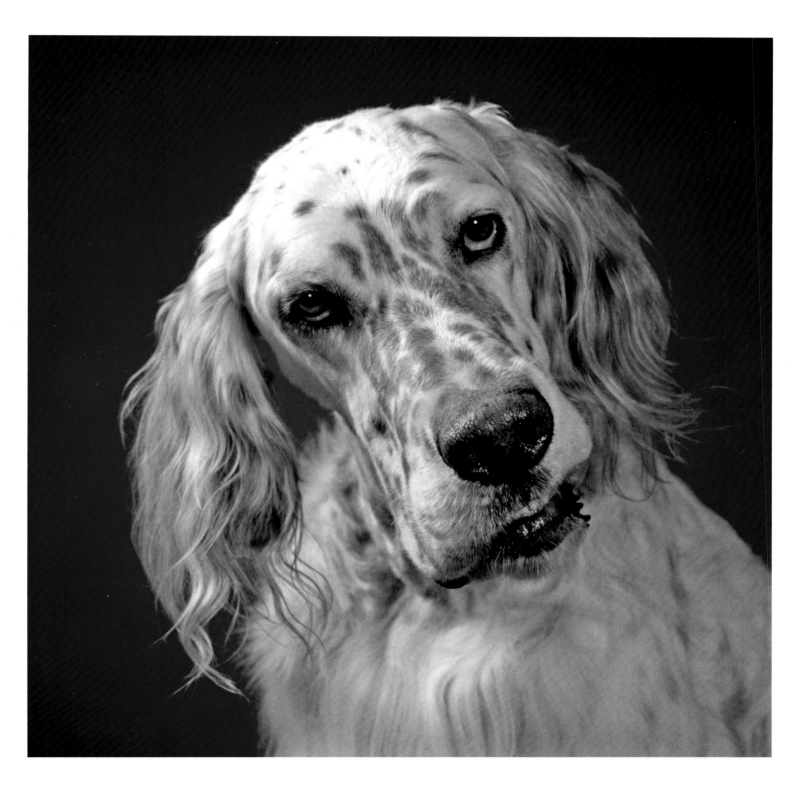

Fox terrier, New Jersey, 1980

English setter, New Jersey, 1981

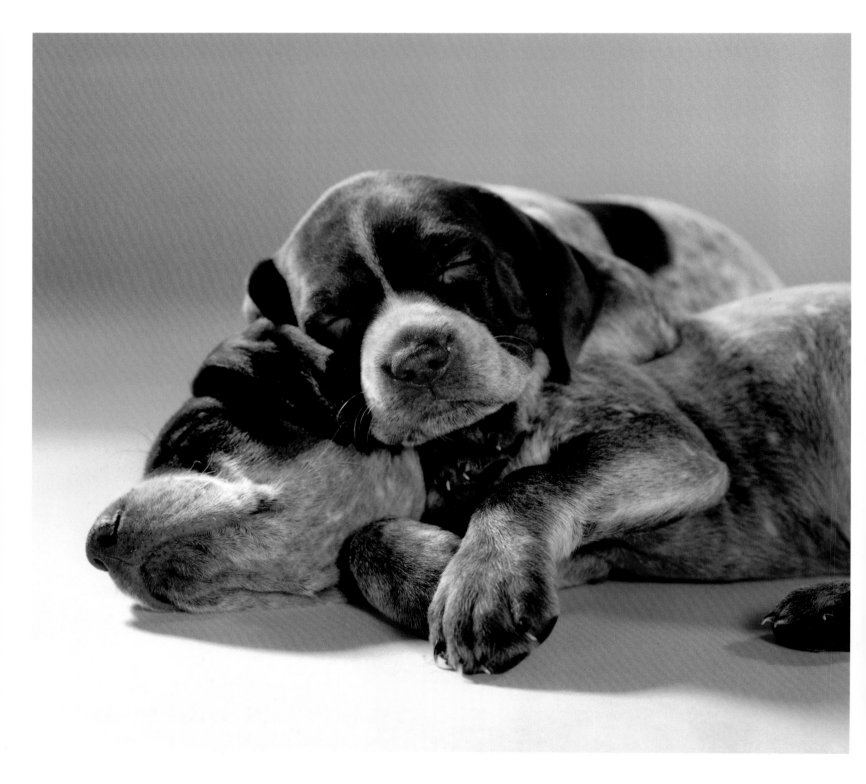

German shorthaired pointers, Long Island, New York, 1955

Dachshunds, Long Island, New York, 1959

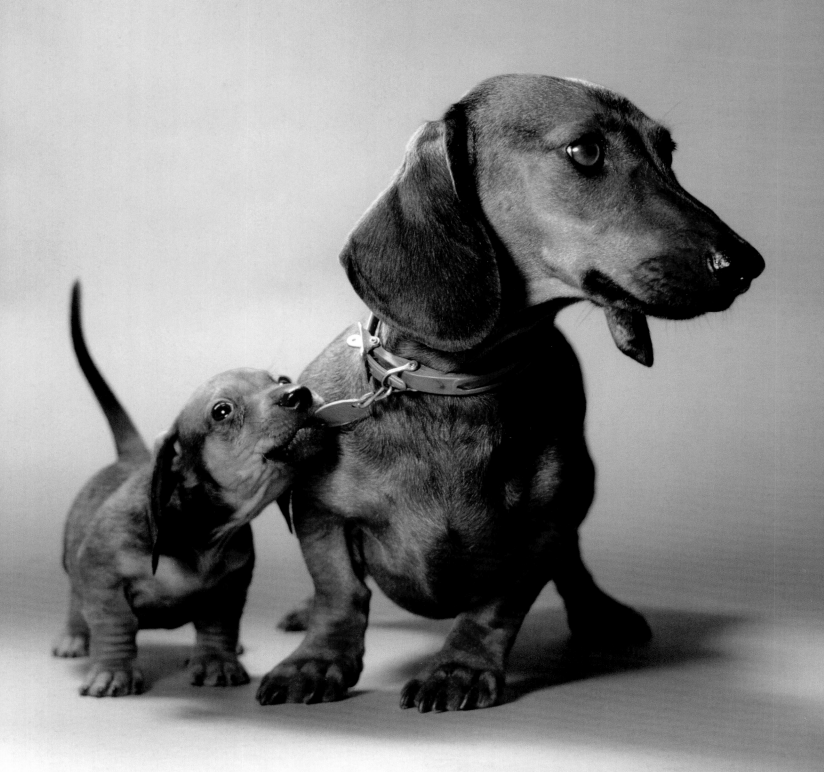

STRIKE
A POSE

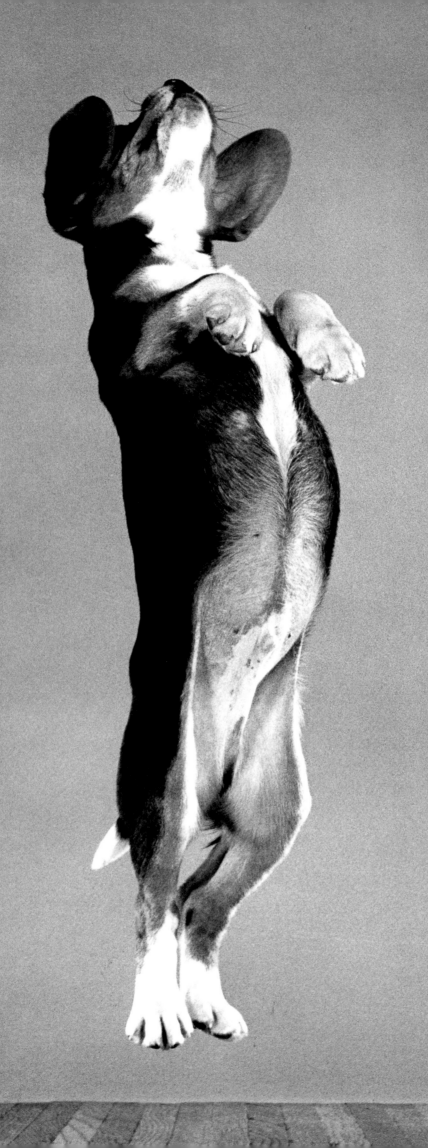

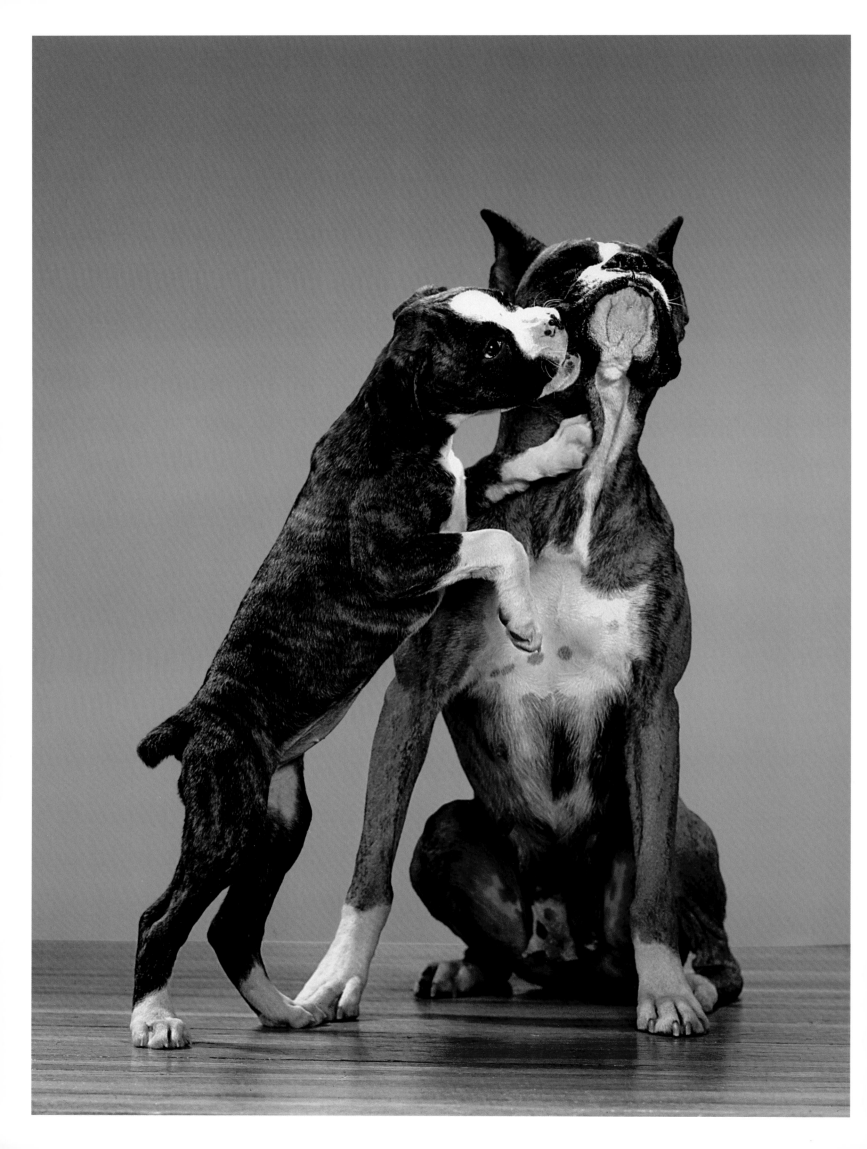

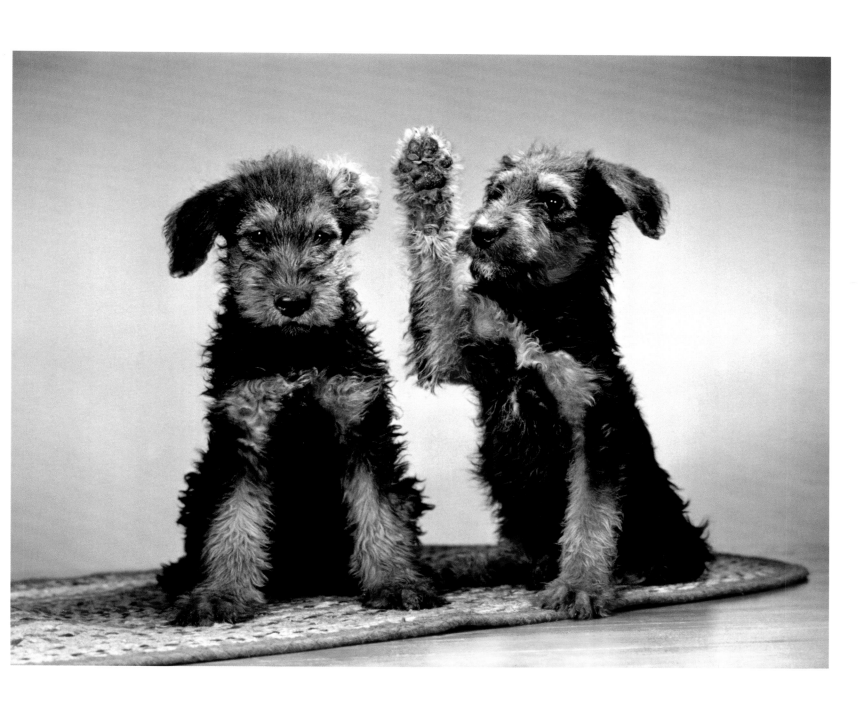

Pages 124–125: Beagle, Long Island, New York, 1955

Boxers, Long Island, New York, 1958

Airedale terriers, New Jersey, 1960

127

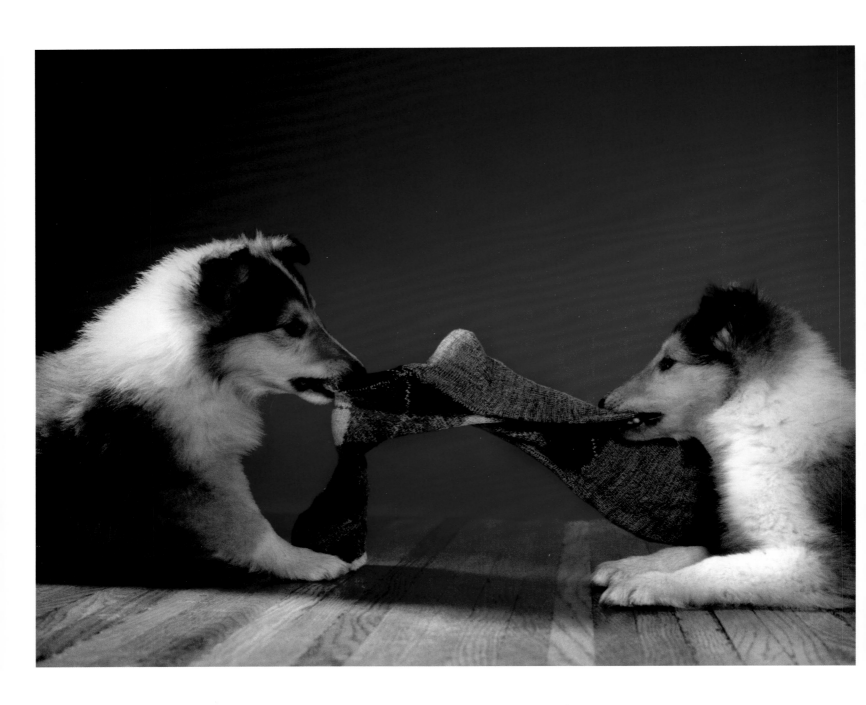

Collies, Long Island, New York, 1955

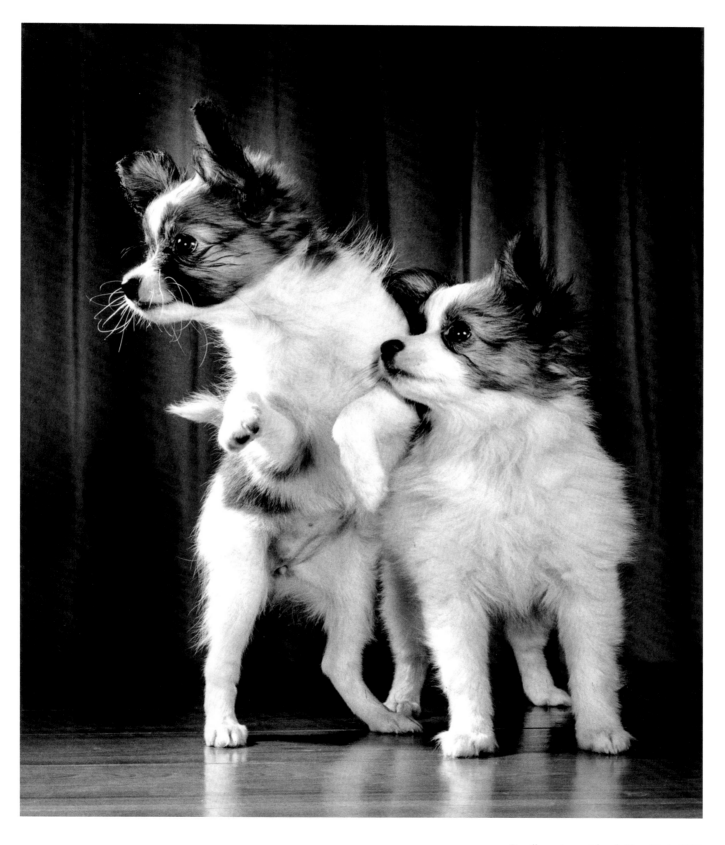

Papillons, Long Island, New York, 1956

Dachshund, Long Island, 1959

Pages 132–133: Bedlingtons,
Long Island, New York, 1954

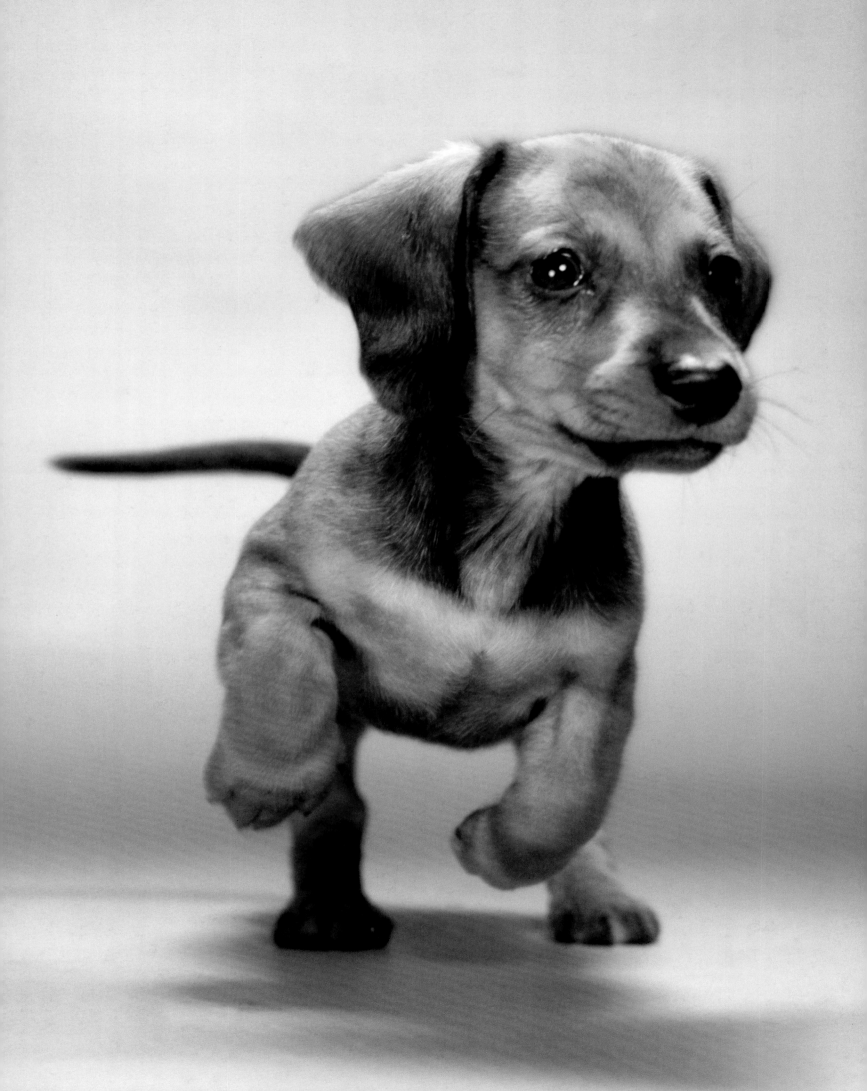

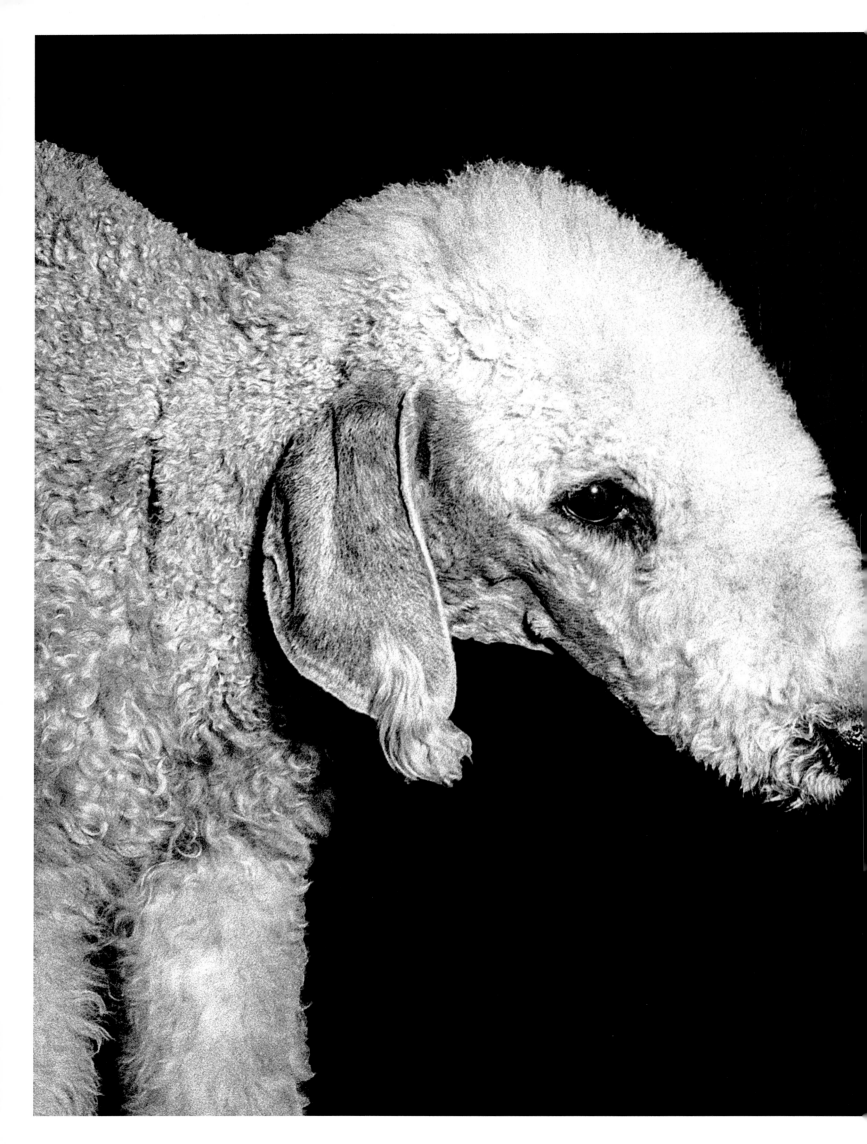

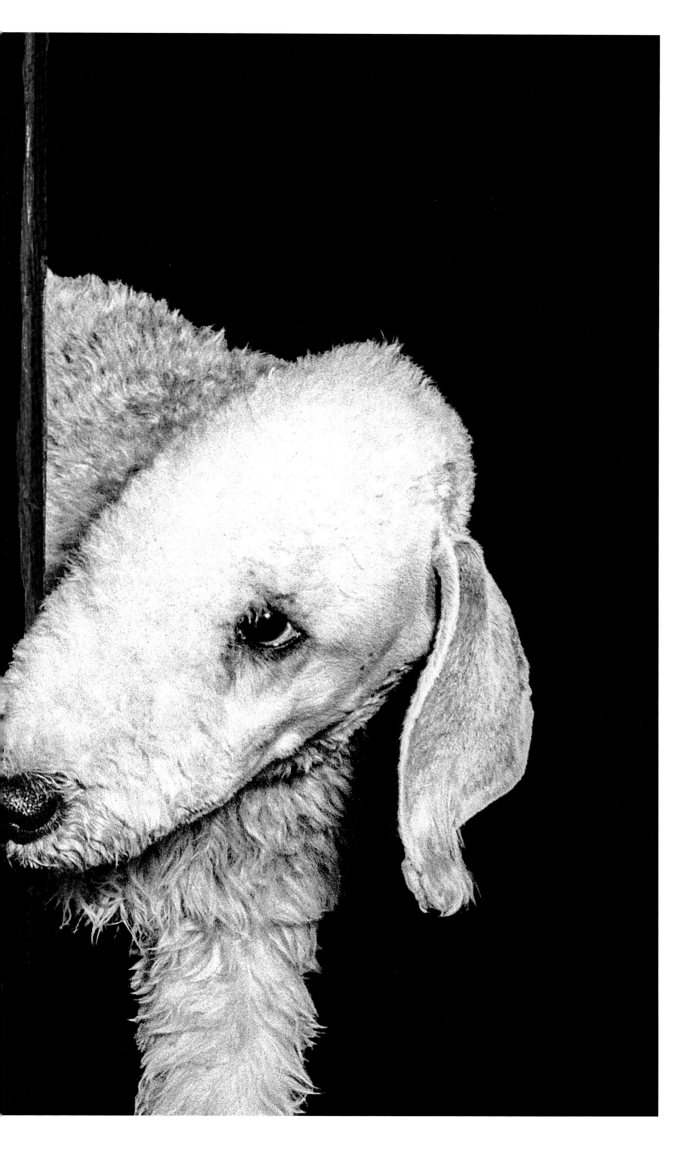

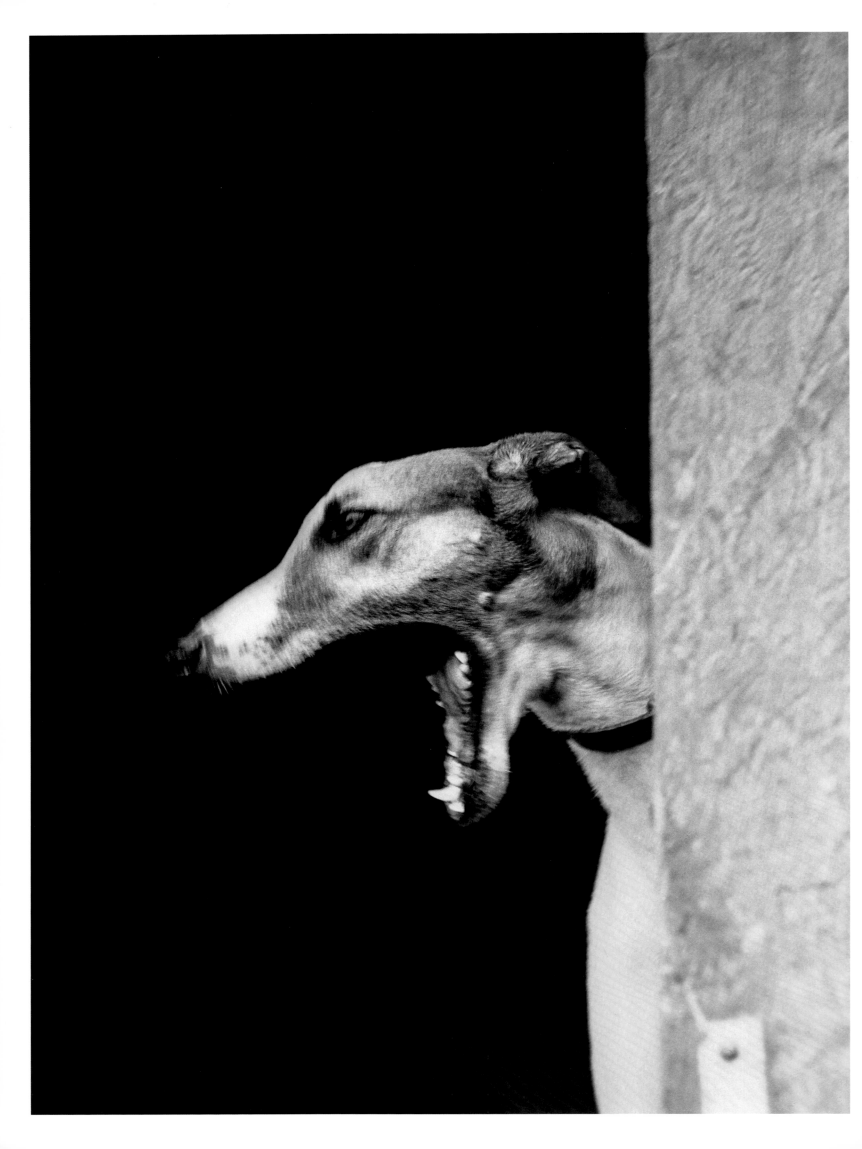

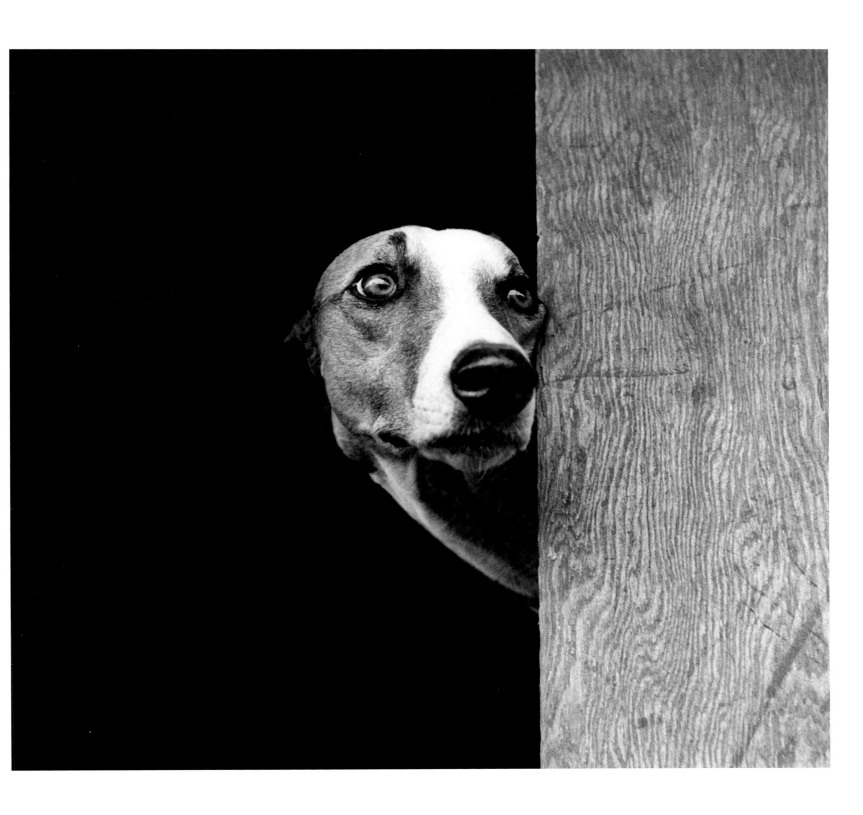

Greyhound, New York, 1952

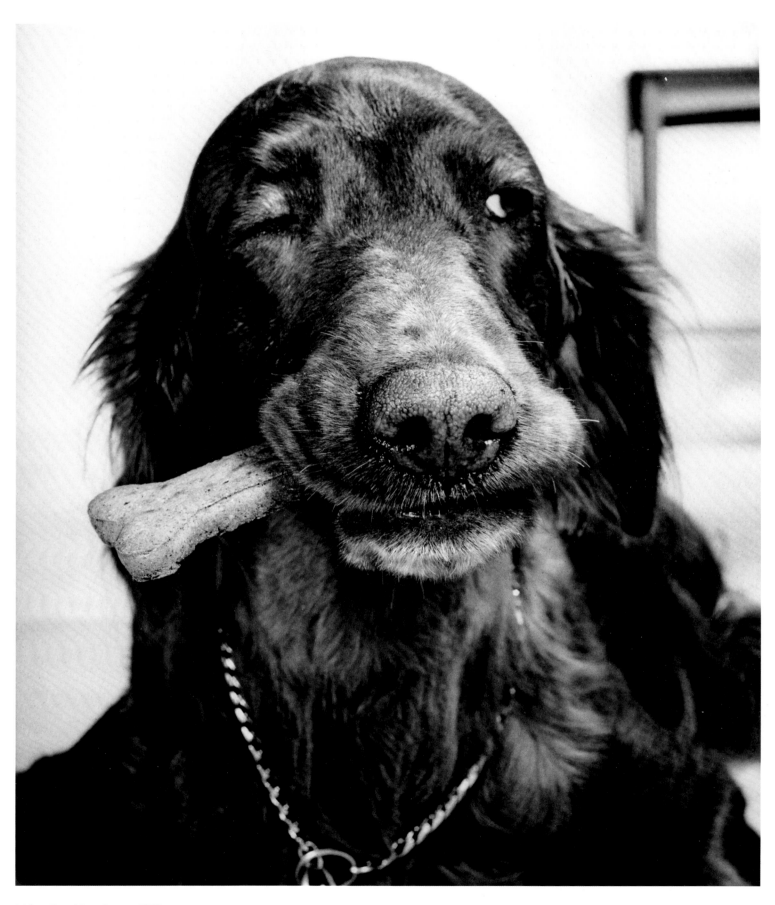

Irish setter, New Jersey, 1960

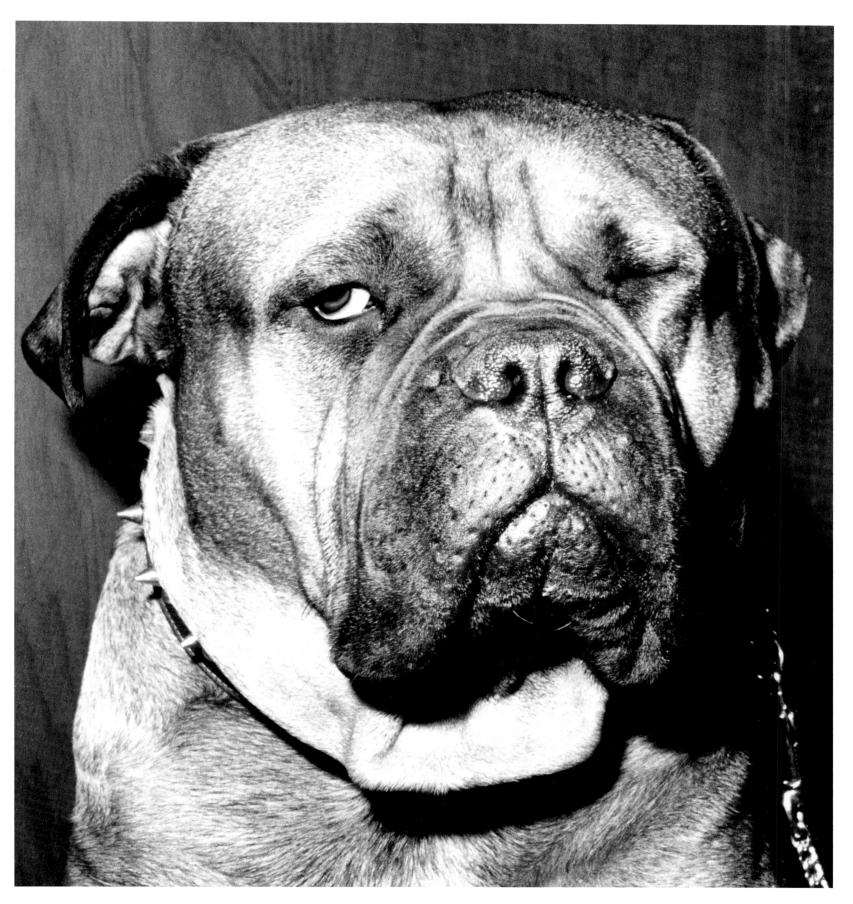

Bull mastiff, Long Island, New York, 1955

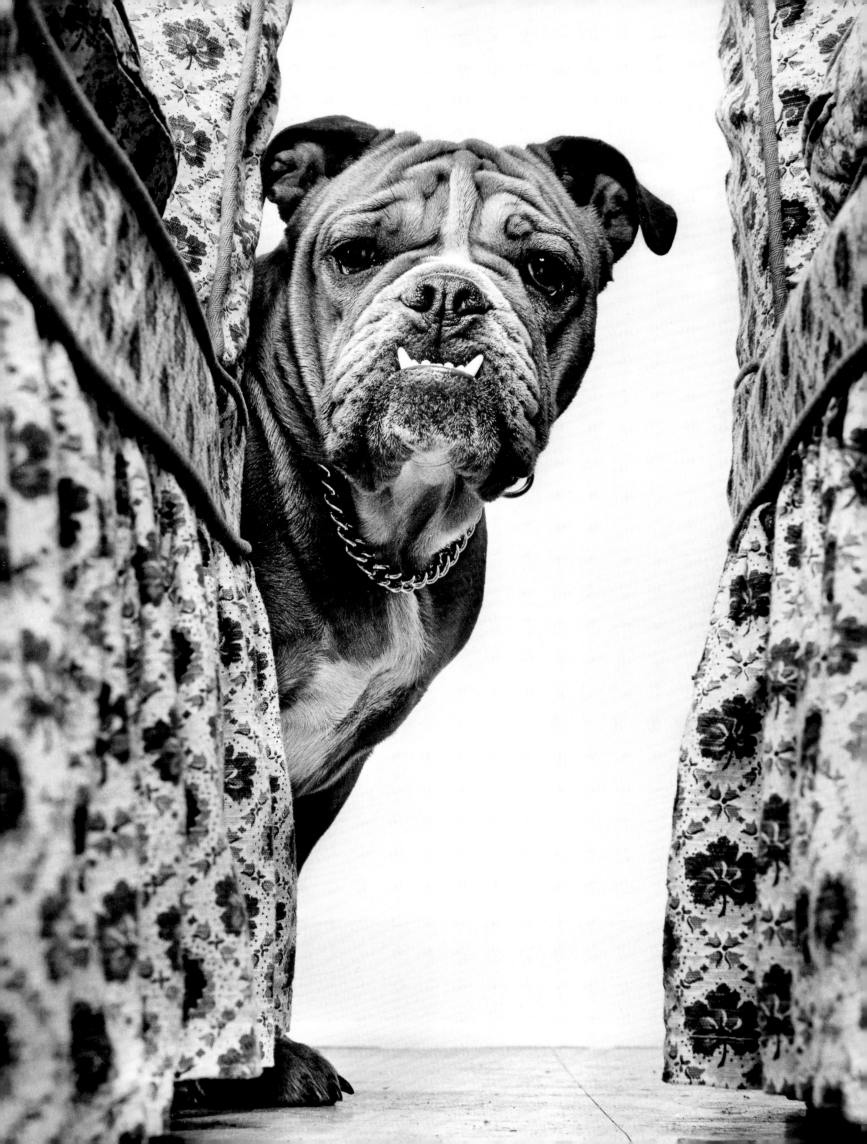

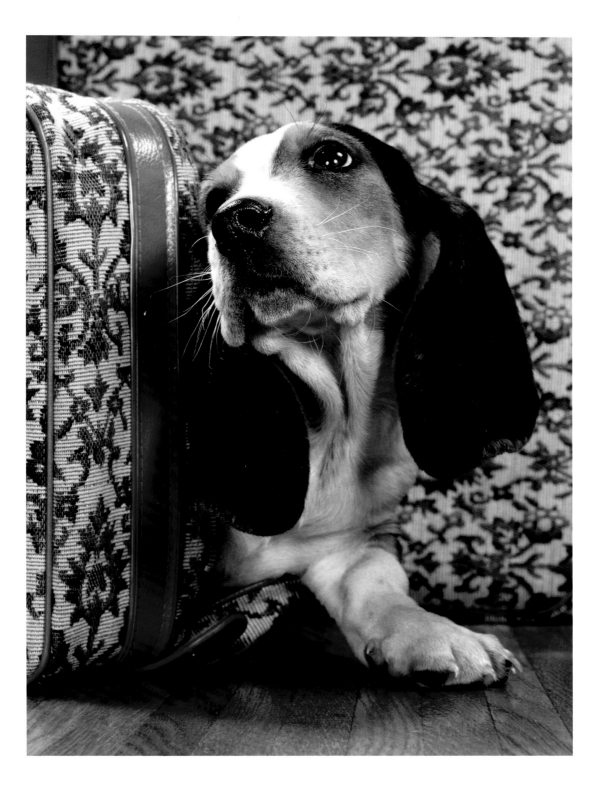

Bulldog, New Jersey, 1973

Basset hound, New Jersey, 1964

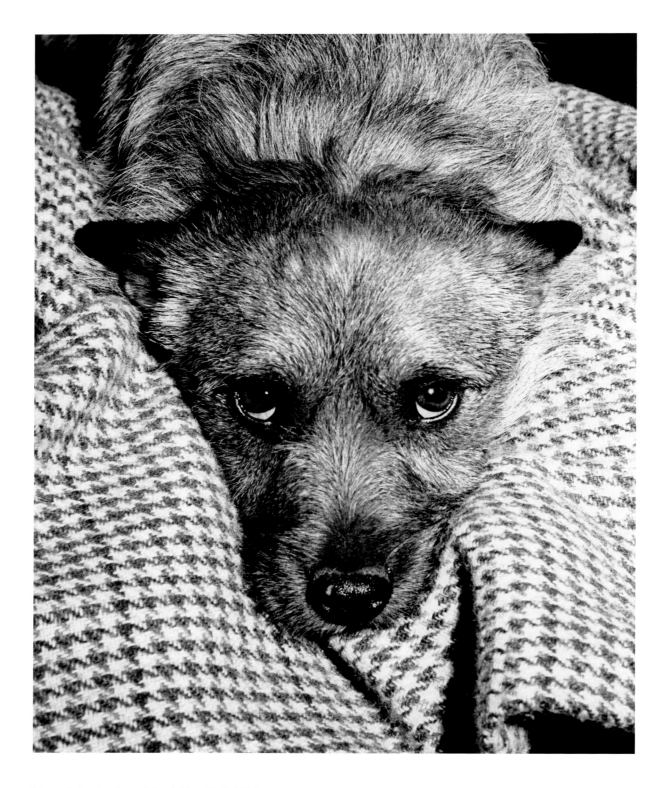

Norwich terrier, Long Island, New York, 1954

Great Dane, Long Island, New York, 1952

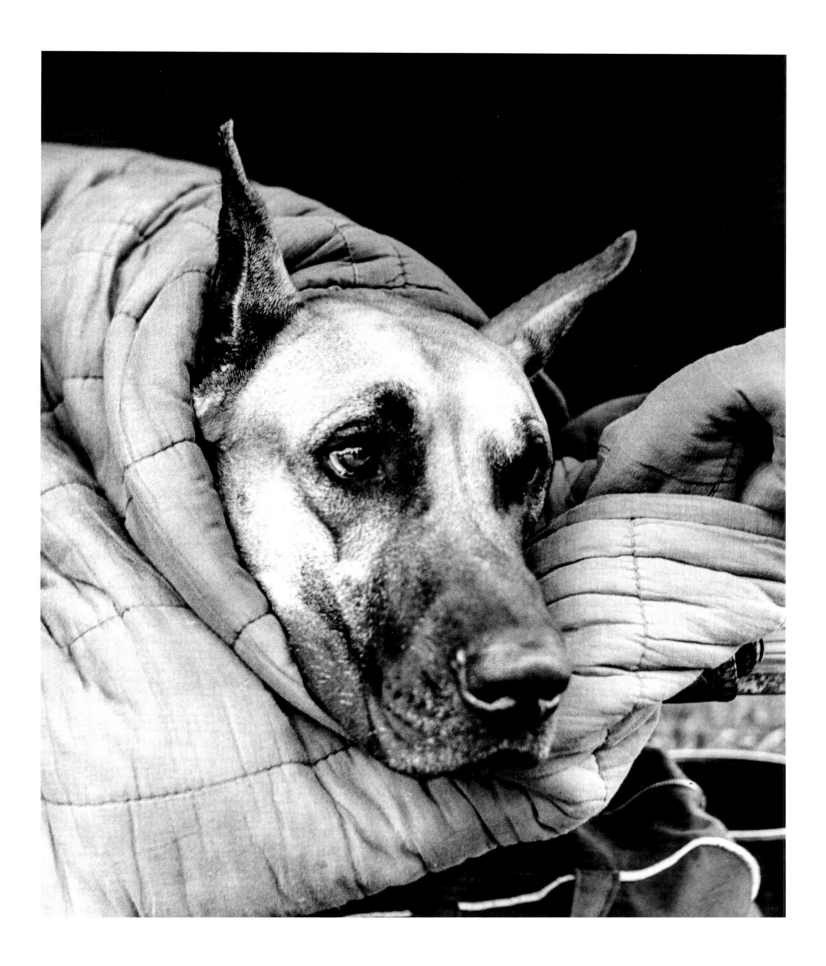

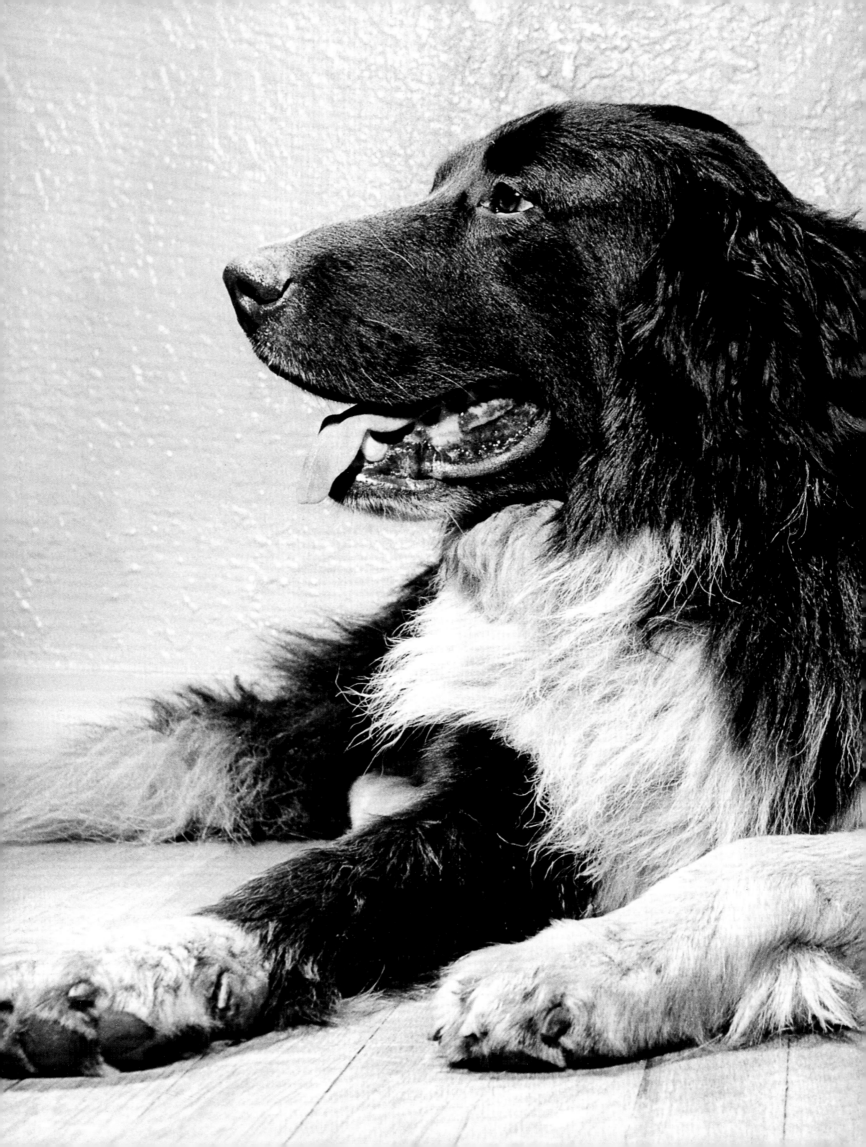

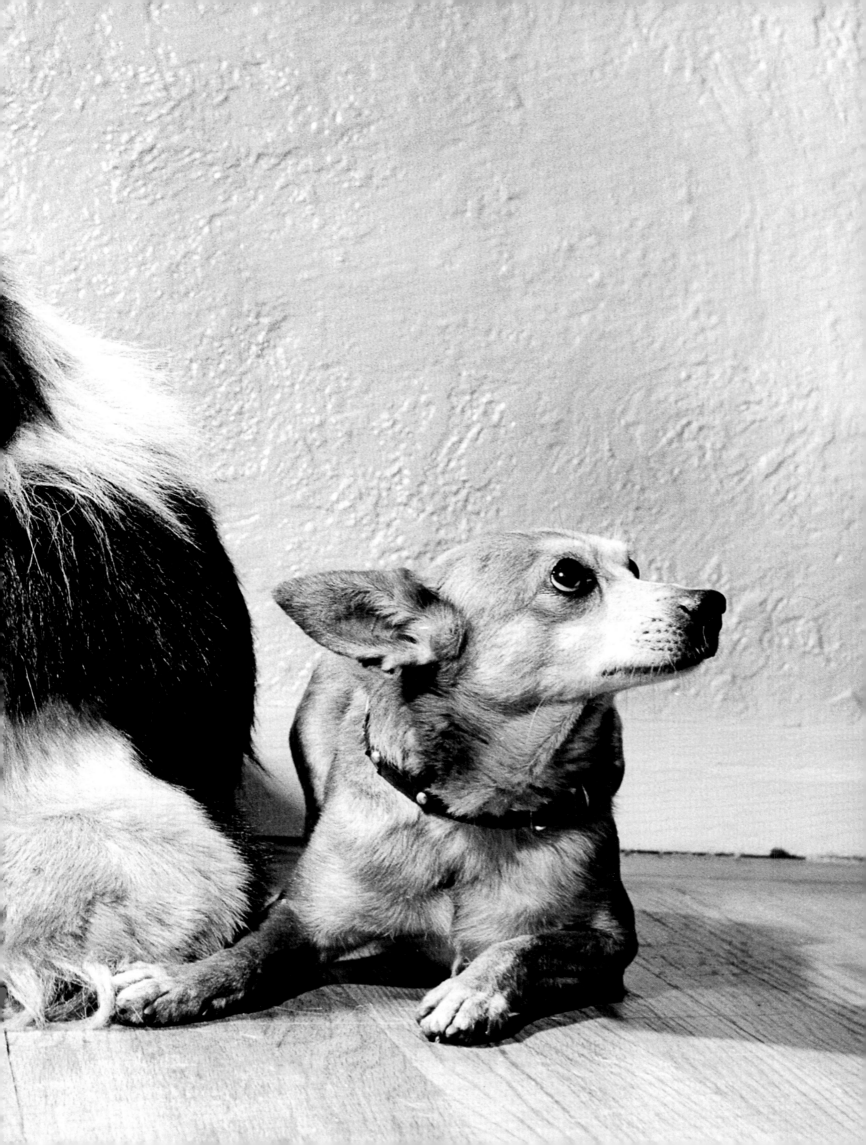

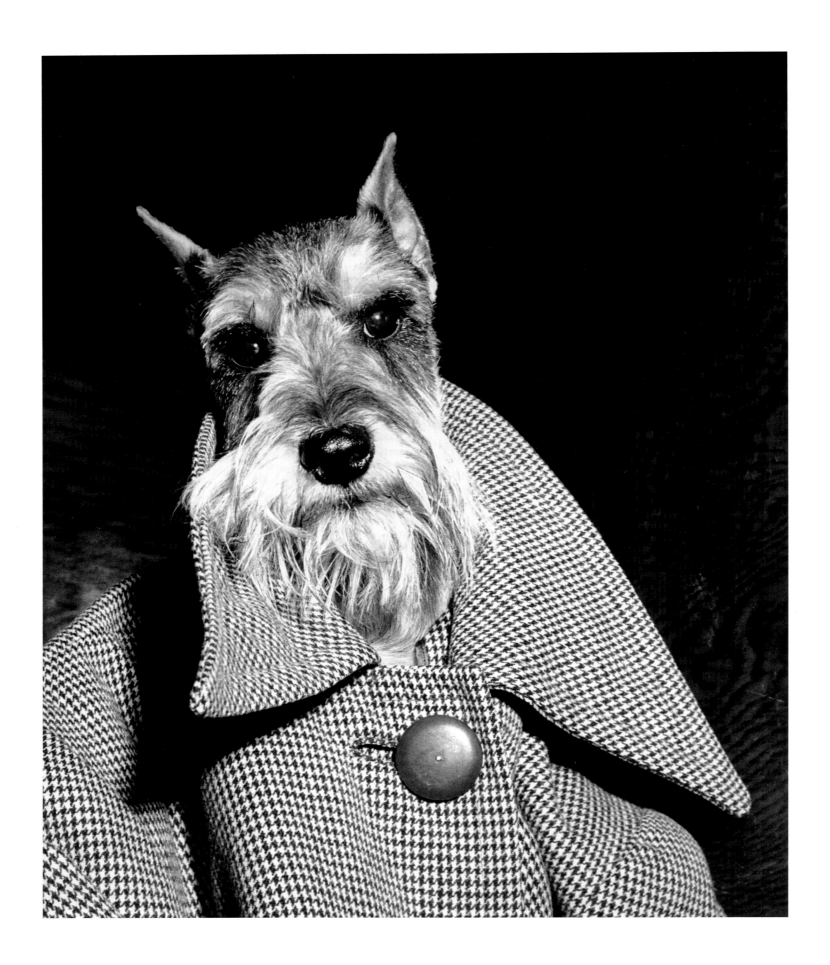

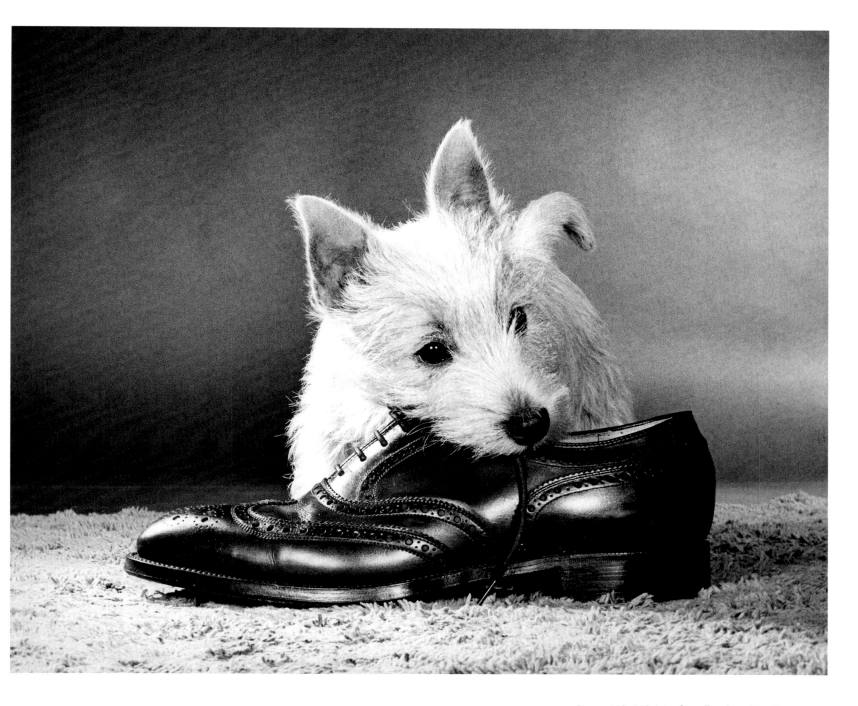

Pages 142–143: Newfoundland and terrier,
Long Island, New York, 1953

Schnauzer, New York, 1952

West Highland terrier, Long Island, New York, 1952

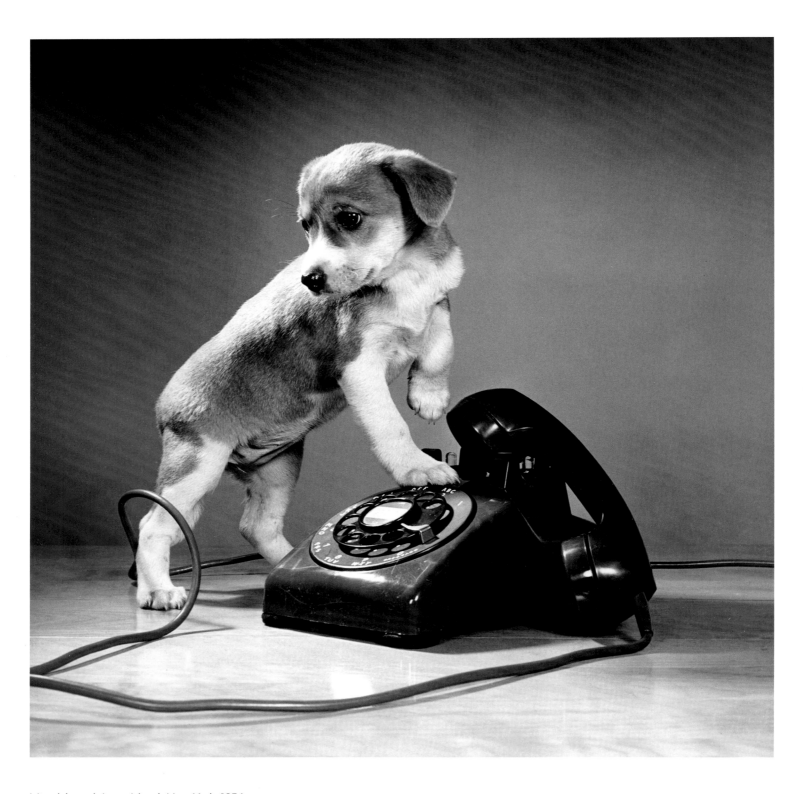

Mixed-breed, Long Island, New York, 1954

Springer spaniel, Long Island, New York, 1954

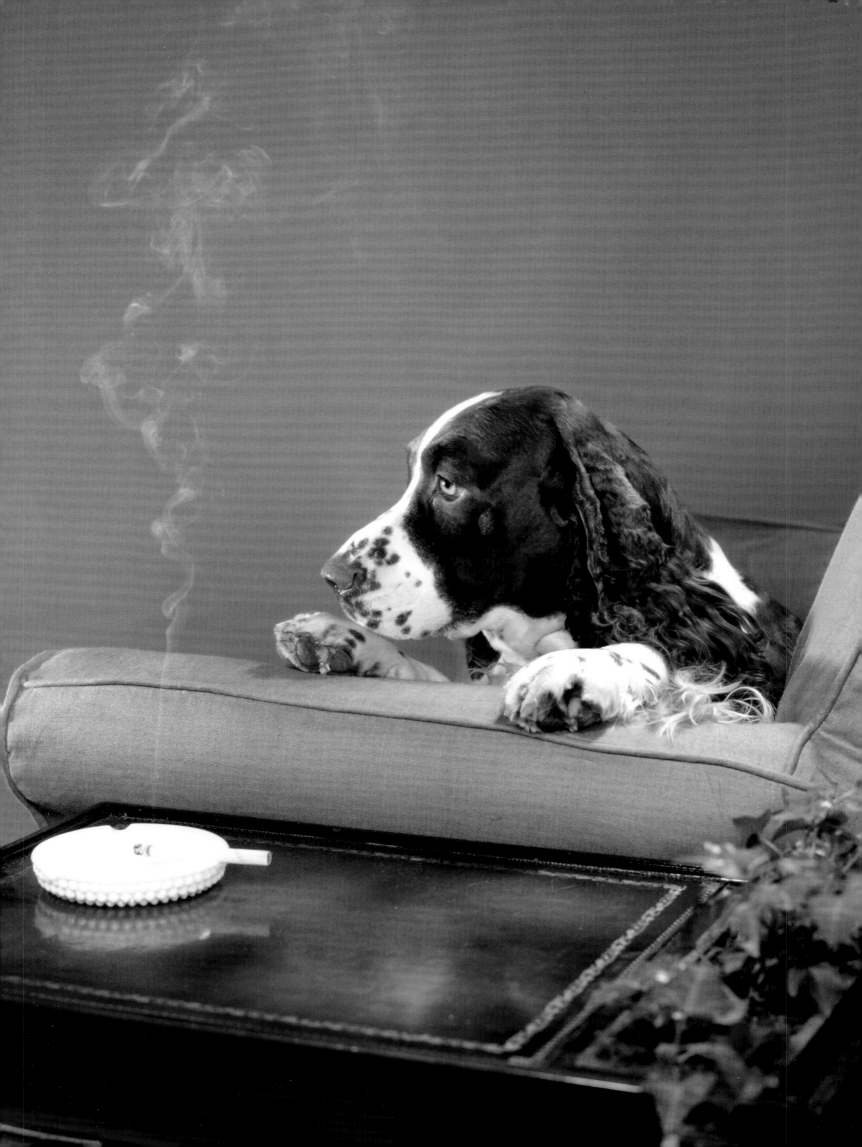

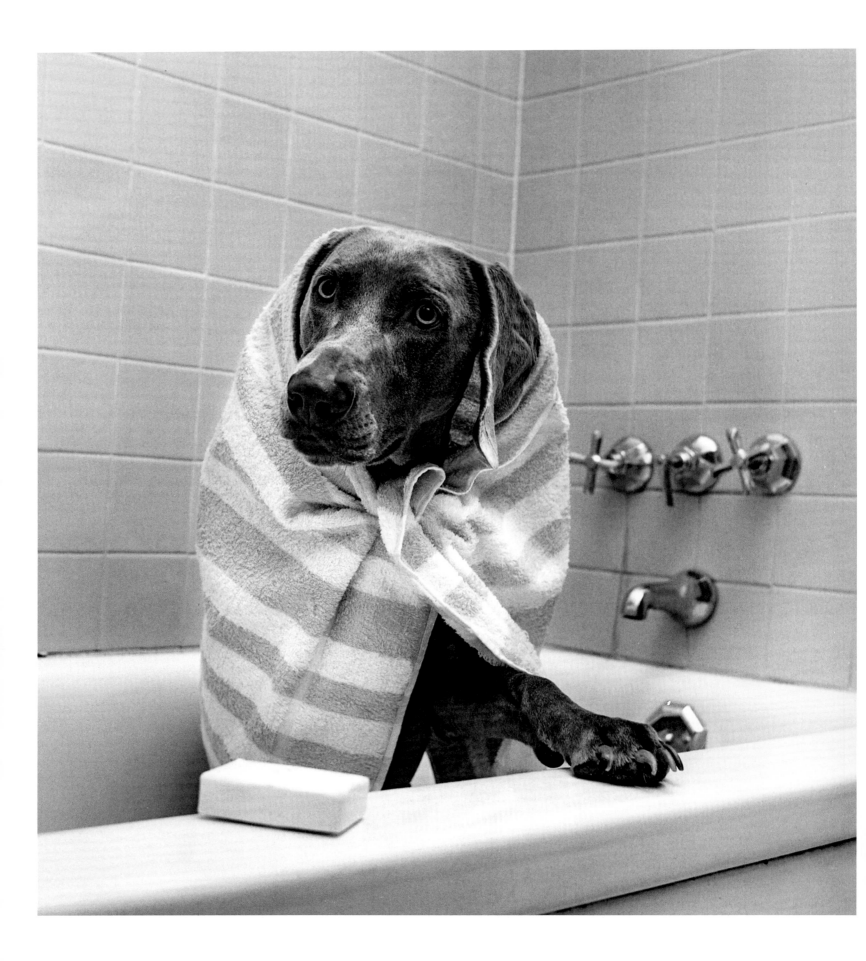

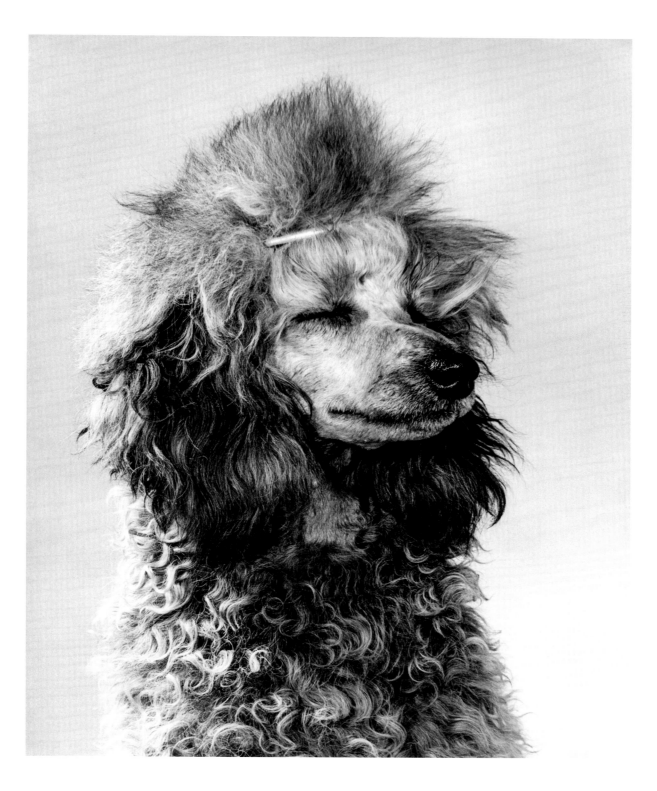

Weimaraner, New Jersey, 1960

Poodle, Long Island, New York, 1953

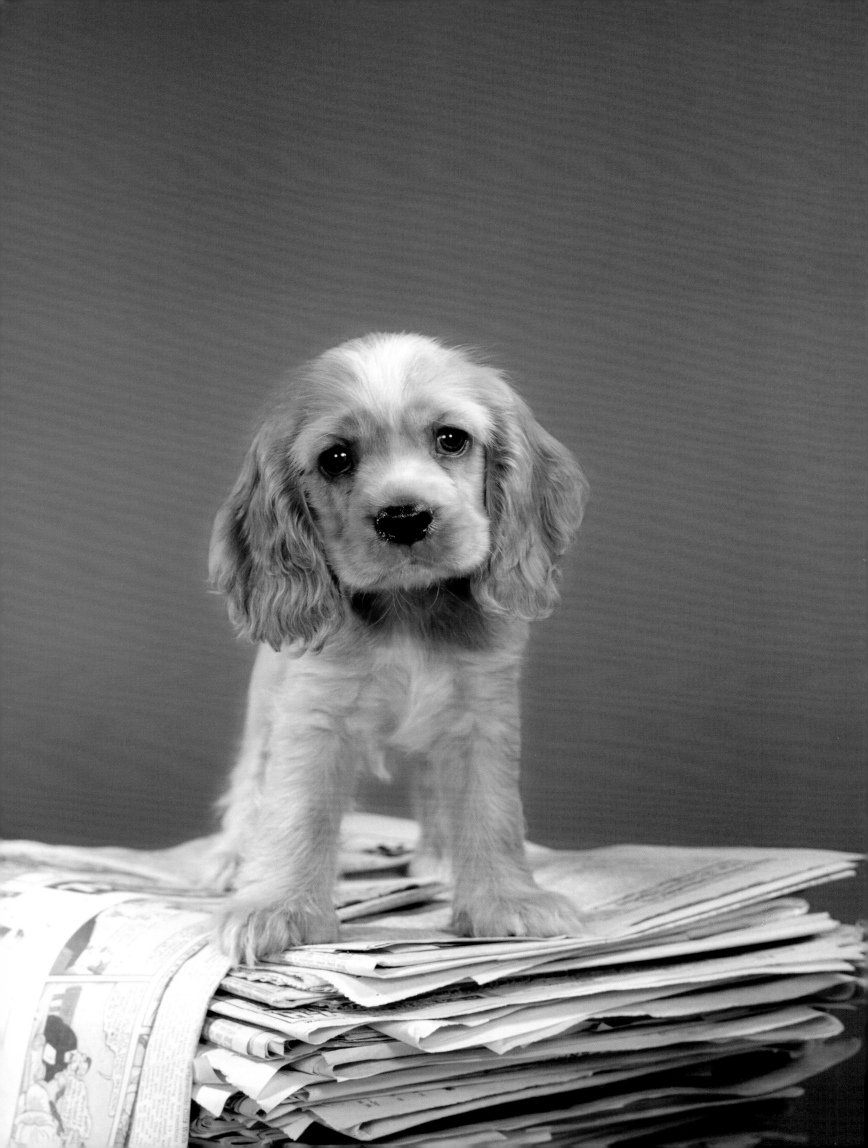

Page 150: Cocker spaniel, Long Island, New York, 1954

Page 151: Toy fox terrier, Long Island, New York, 1957

Chihuahua, Long Island, New York, 1954

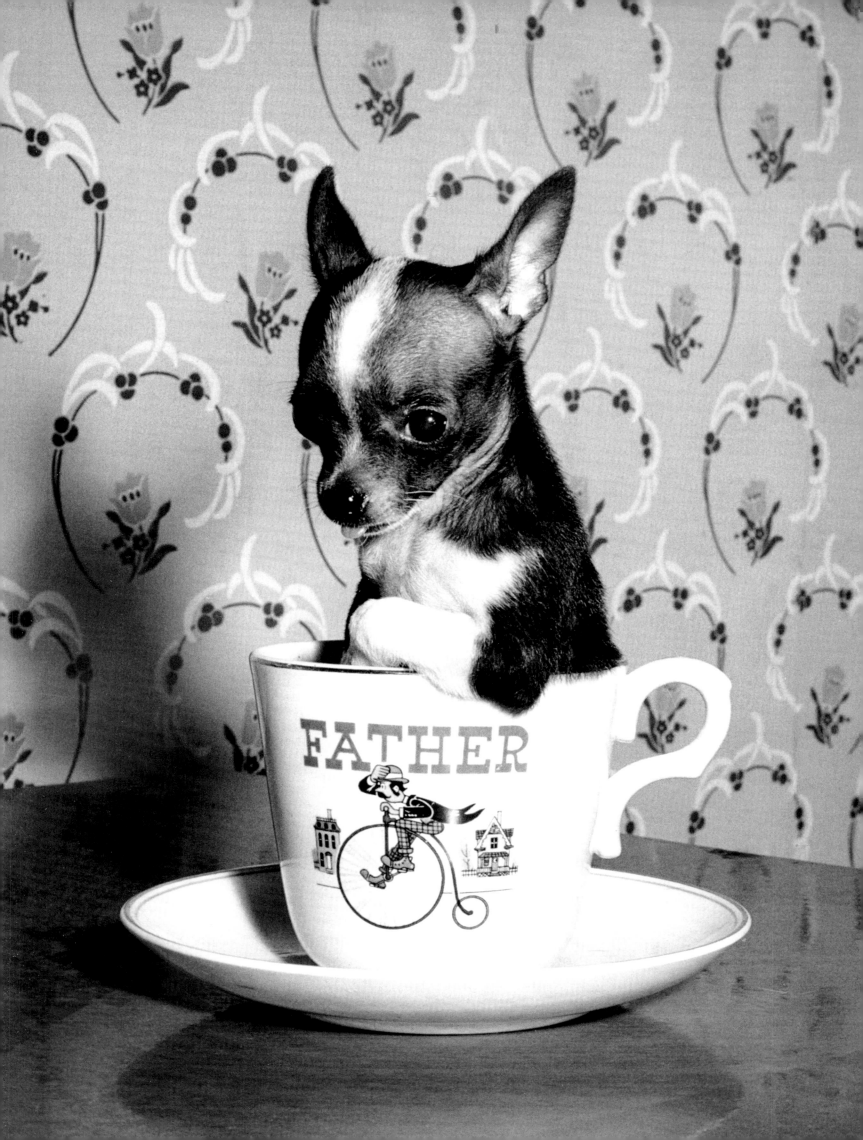

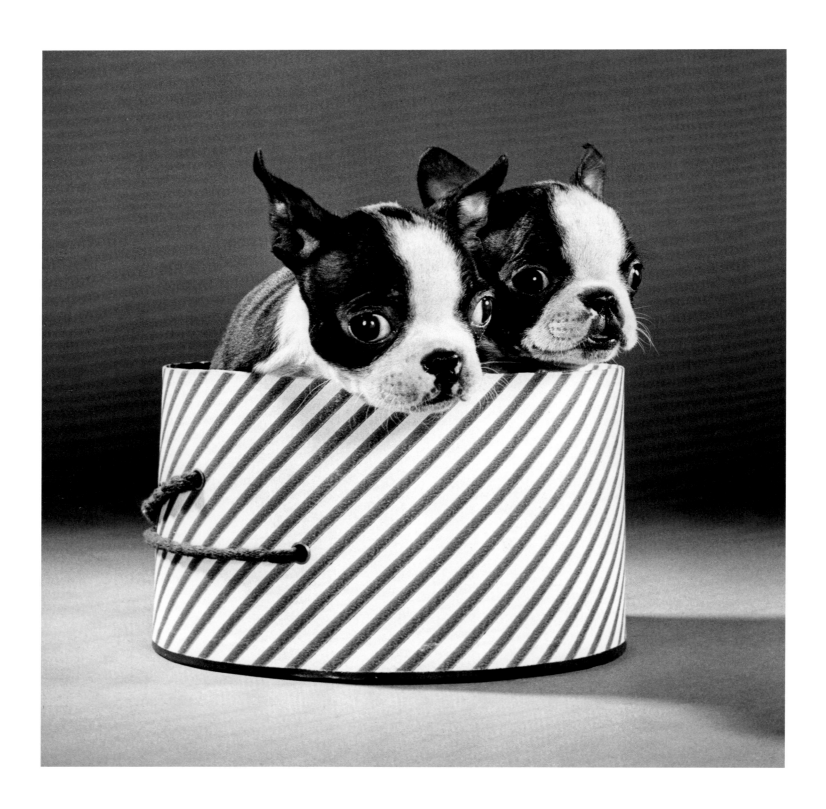

Boston terriers, Long Island, New York, 1955

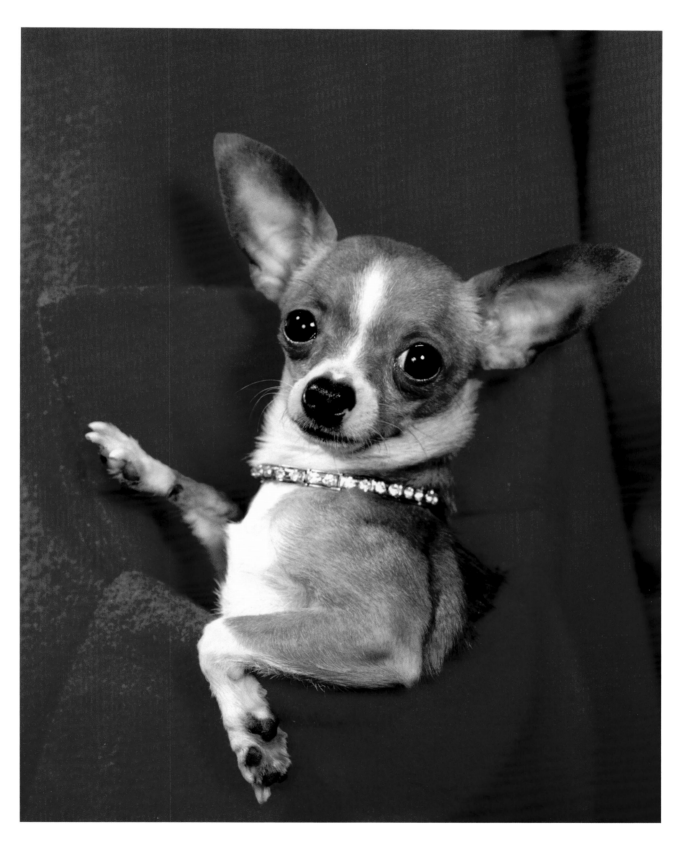

Chihuahua, Long Island, New York, 1953

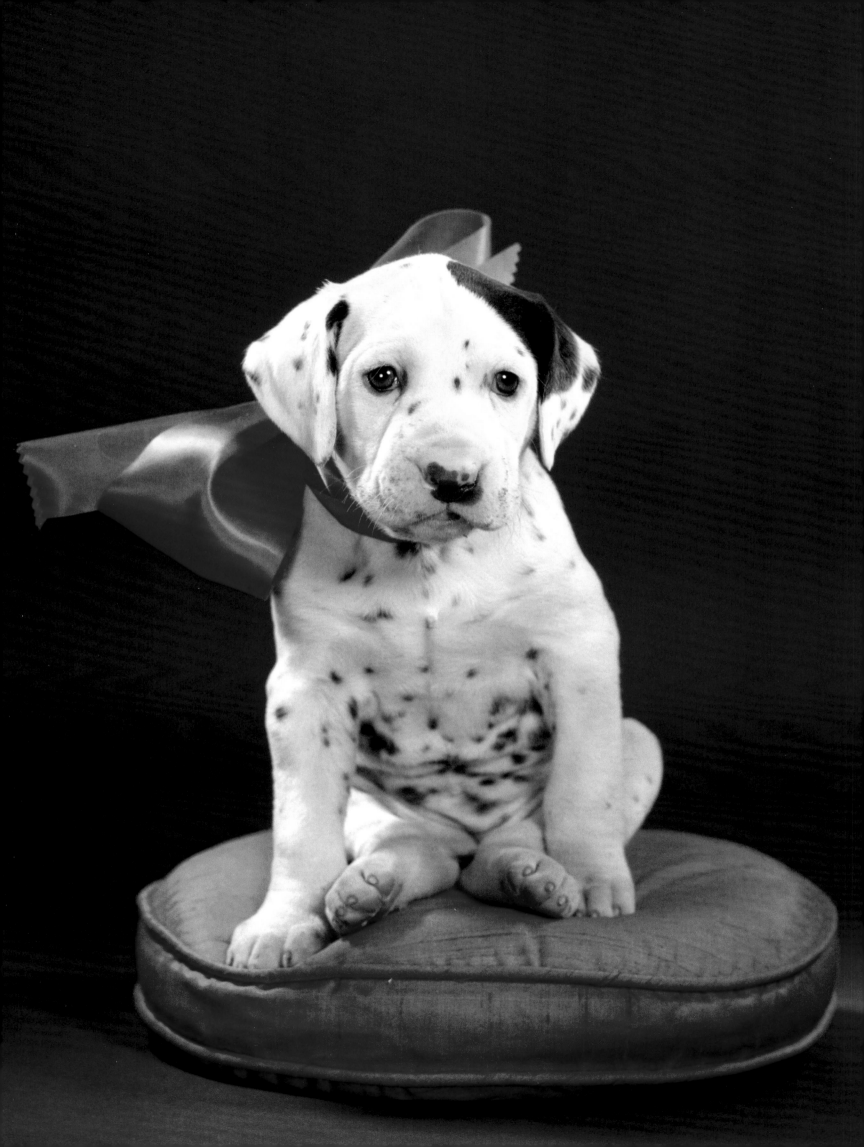

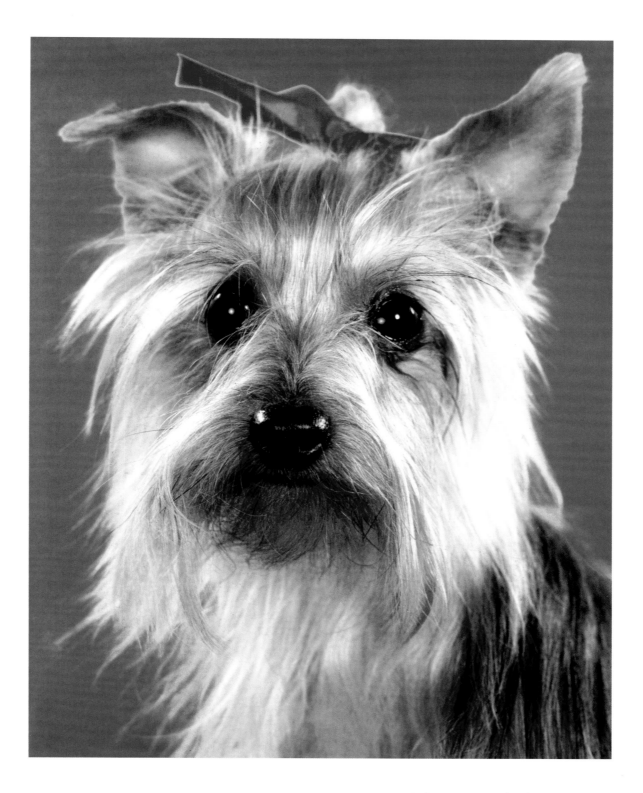

Dalmatian, Long Island, New York, 1957

Yorkshire terrier, Long Island, New York, 1957

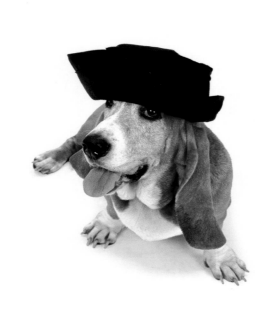
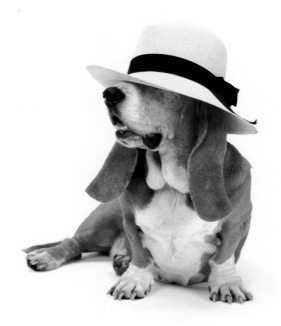
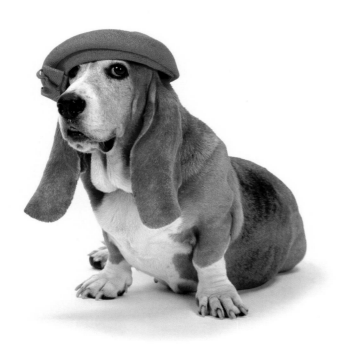
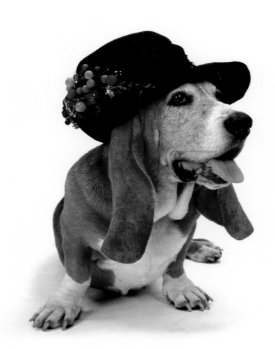

Basset hound, New Jersey, 1975

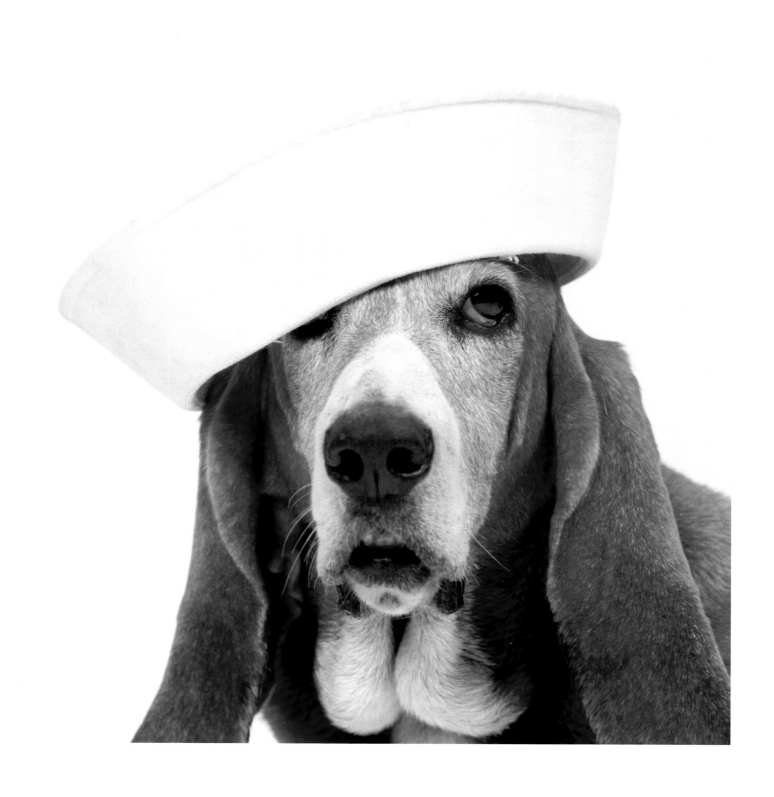

Pomeranian, New Jersey, 1975

Toy fox terriers, Long Island, New York, 1956

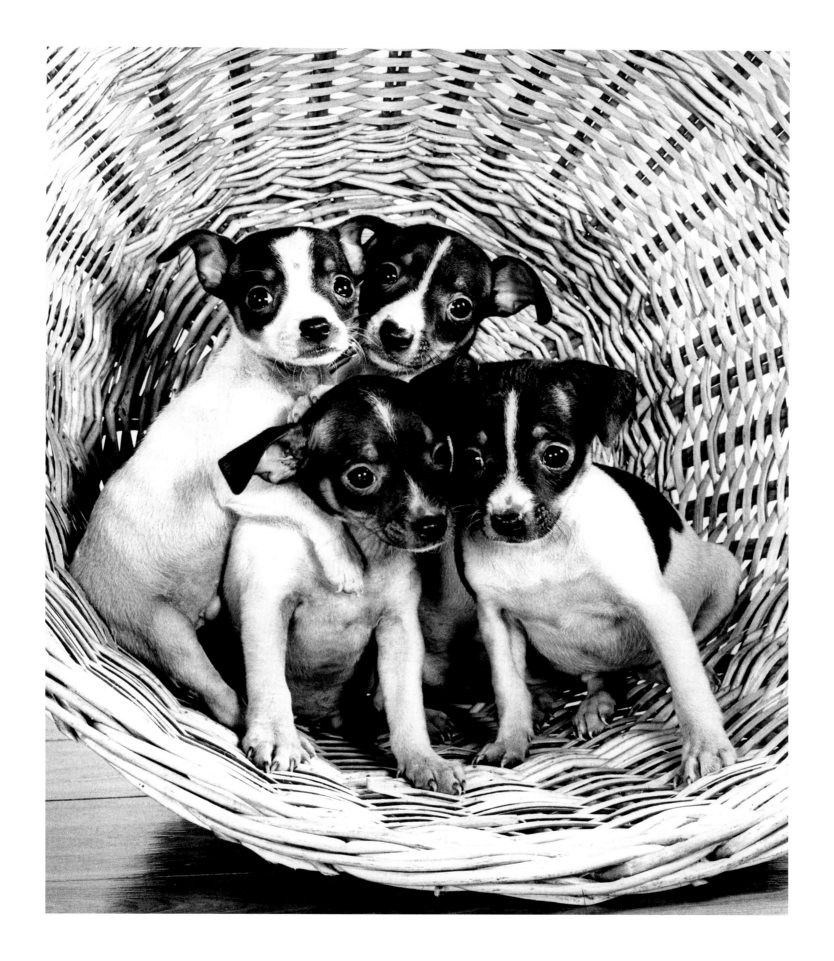

Maltese, Long Island, New York, 1955

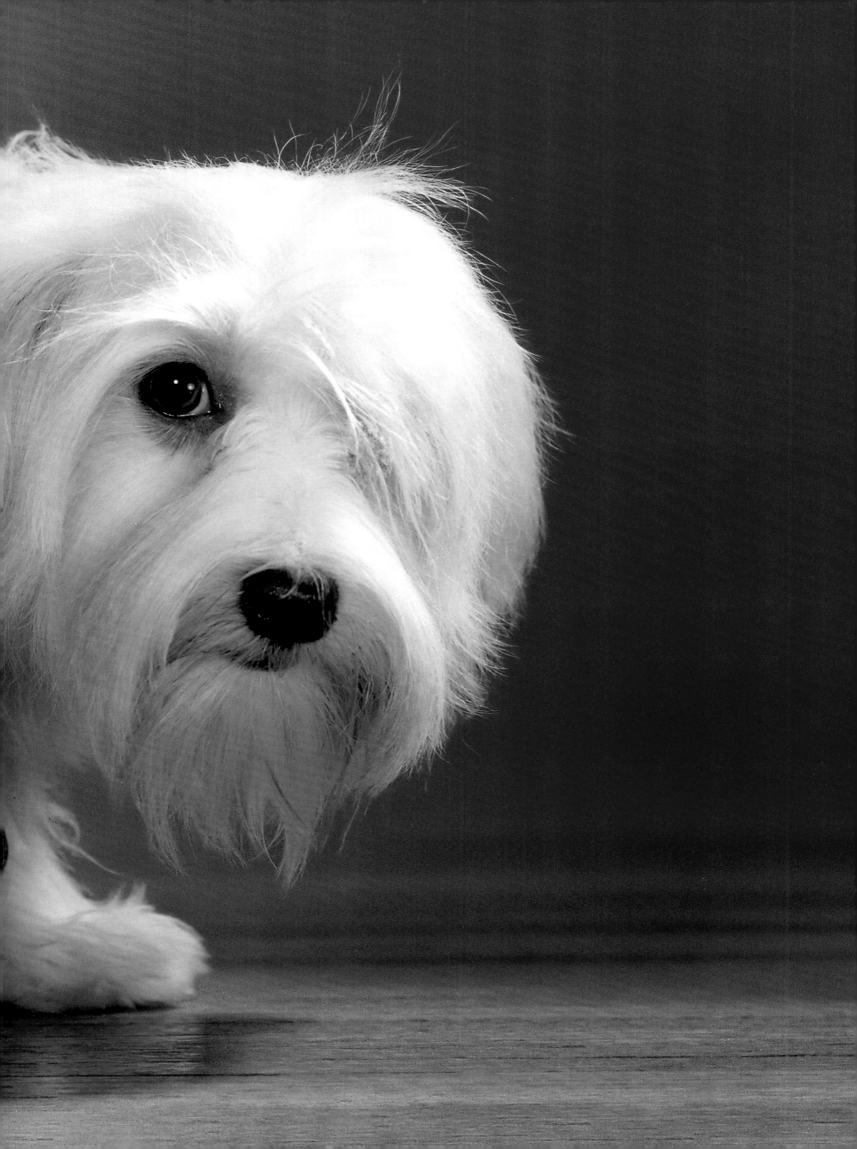

Pug and Maria, Long Island, New York, 1958

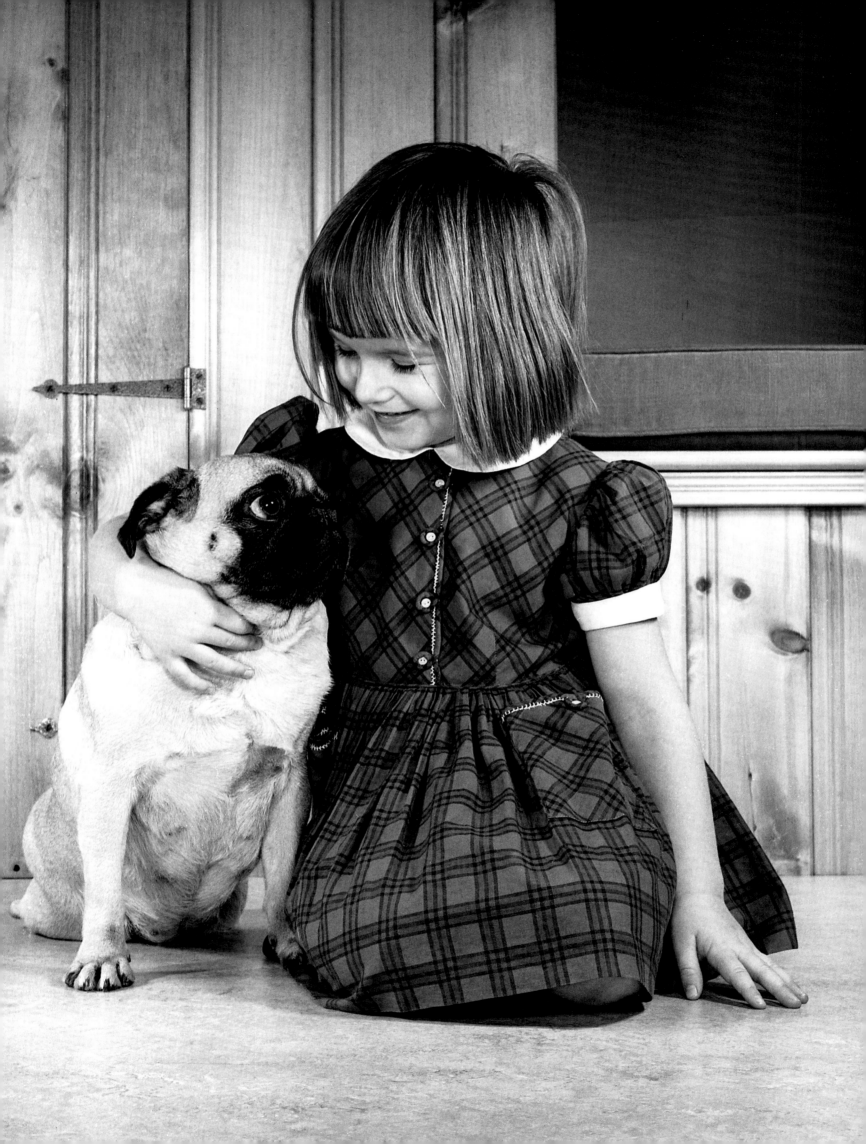

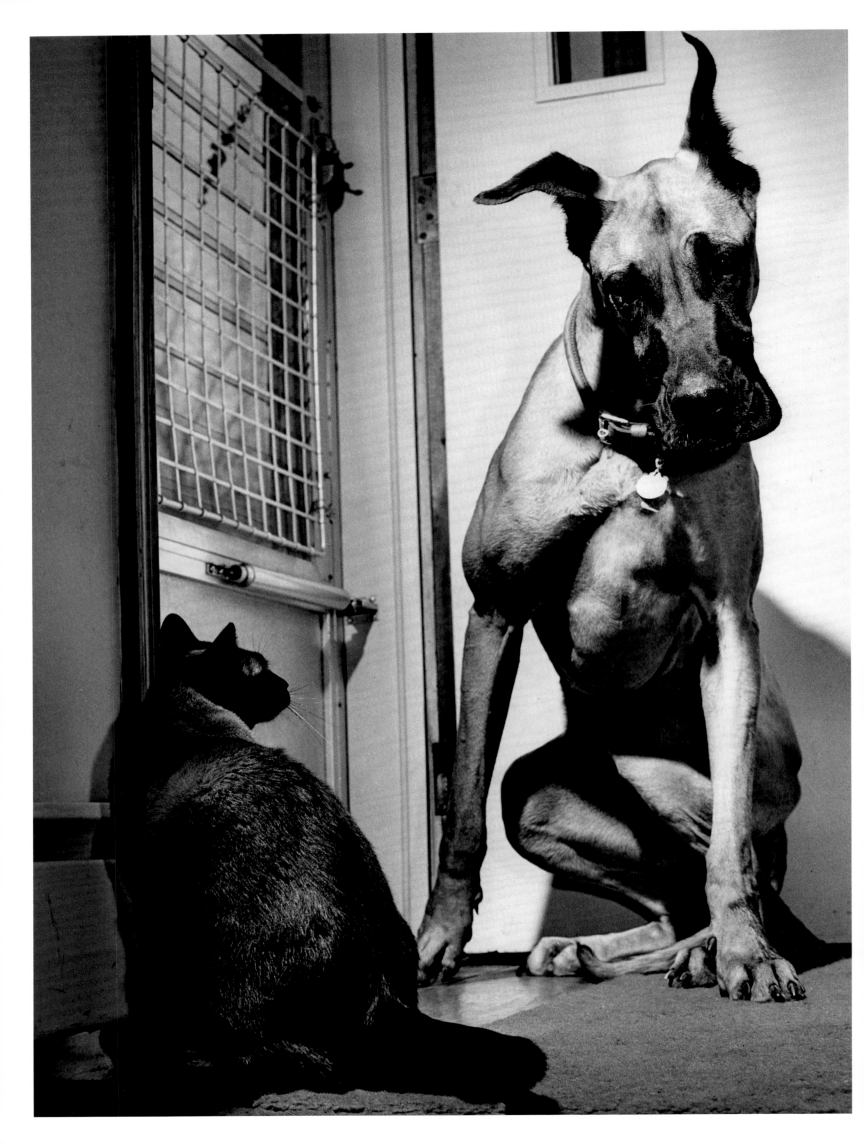

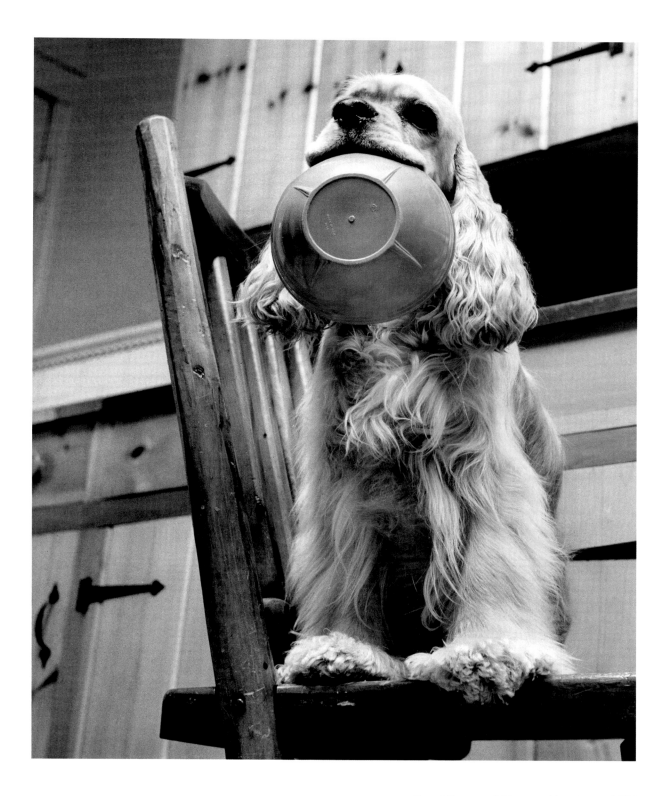

Great Dane and Siamese, New Jersey, 1968

Cocker spaniel, Long Island, New York, 1957

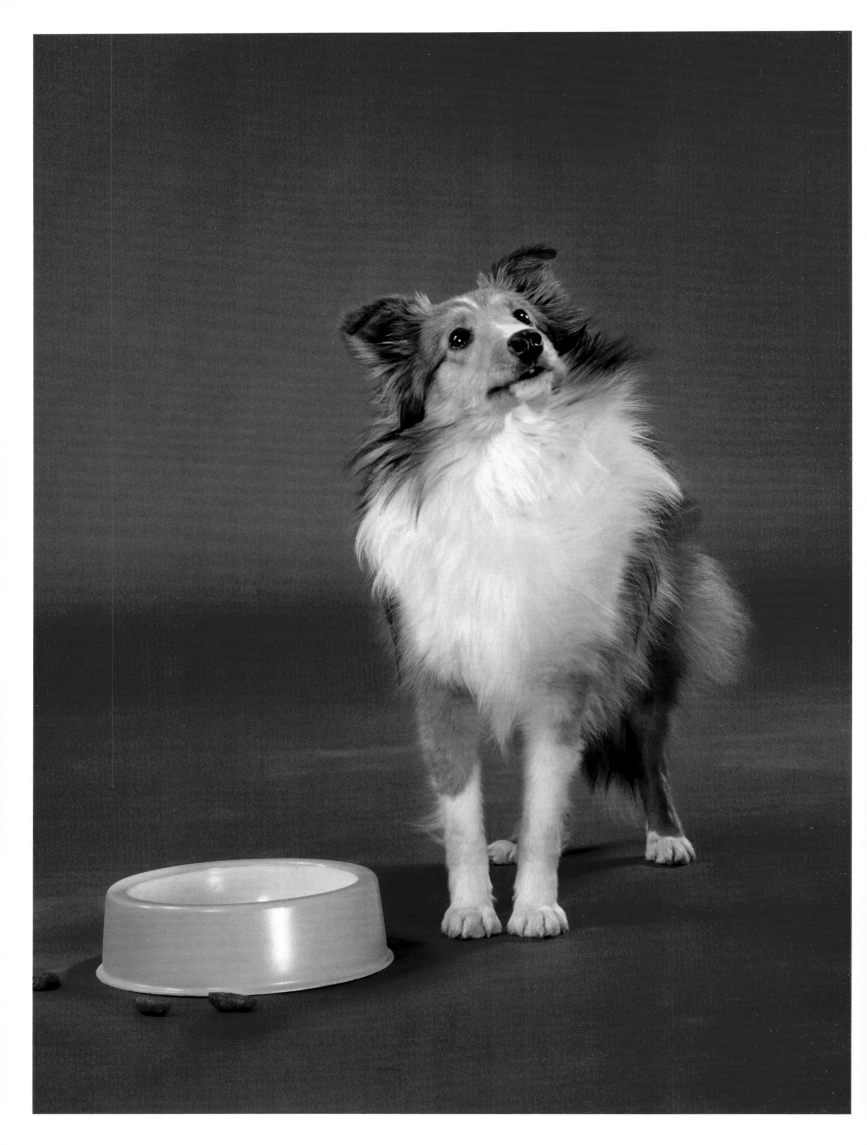

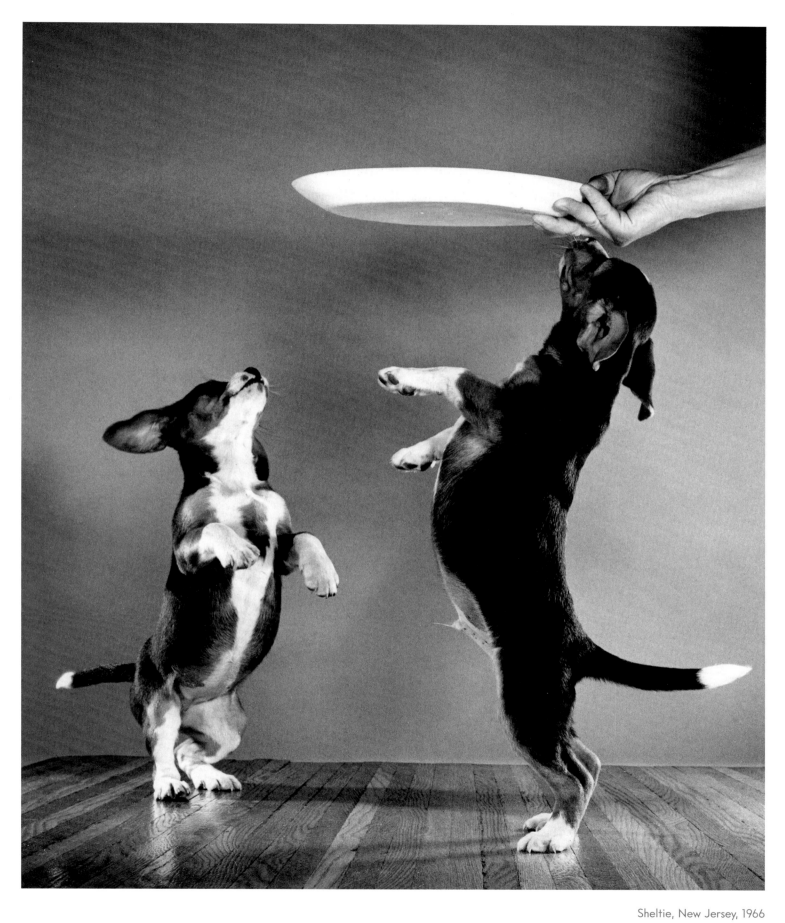

Sheltie, New Jersey, 1966

Beagles, Long Island, New York, 1956

169

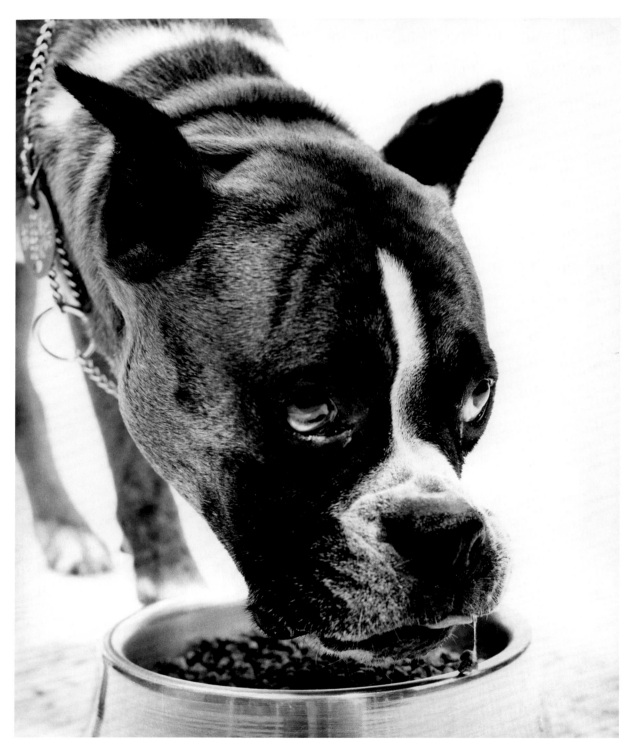

Boxer, Long Island, New York, 1959

German shorthaired pointer,
Long Island, New York, 1953

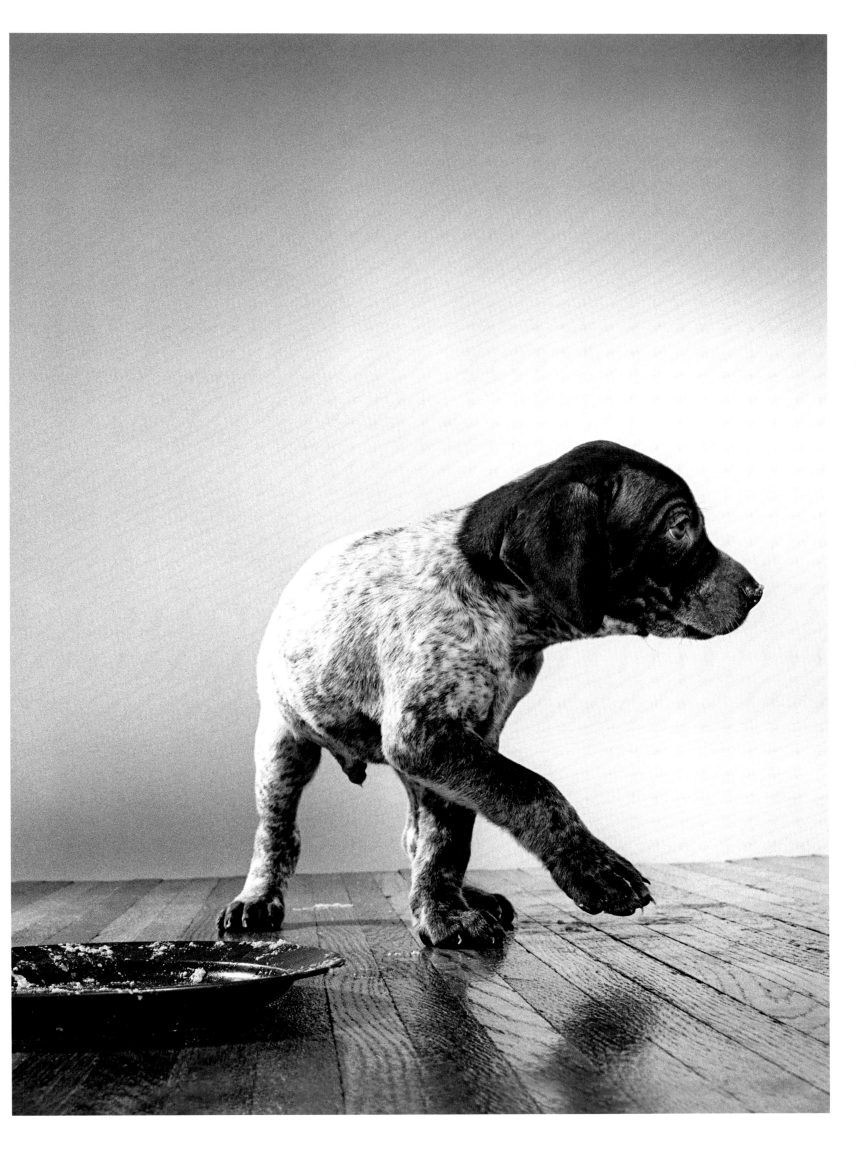

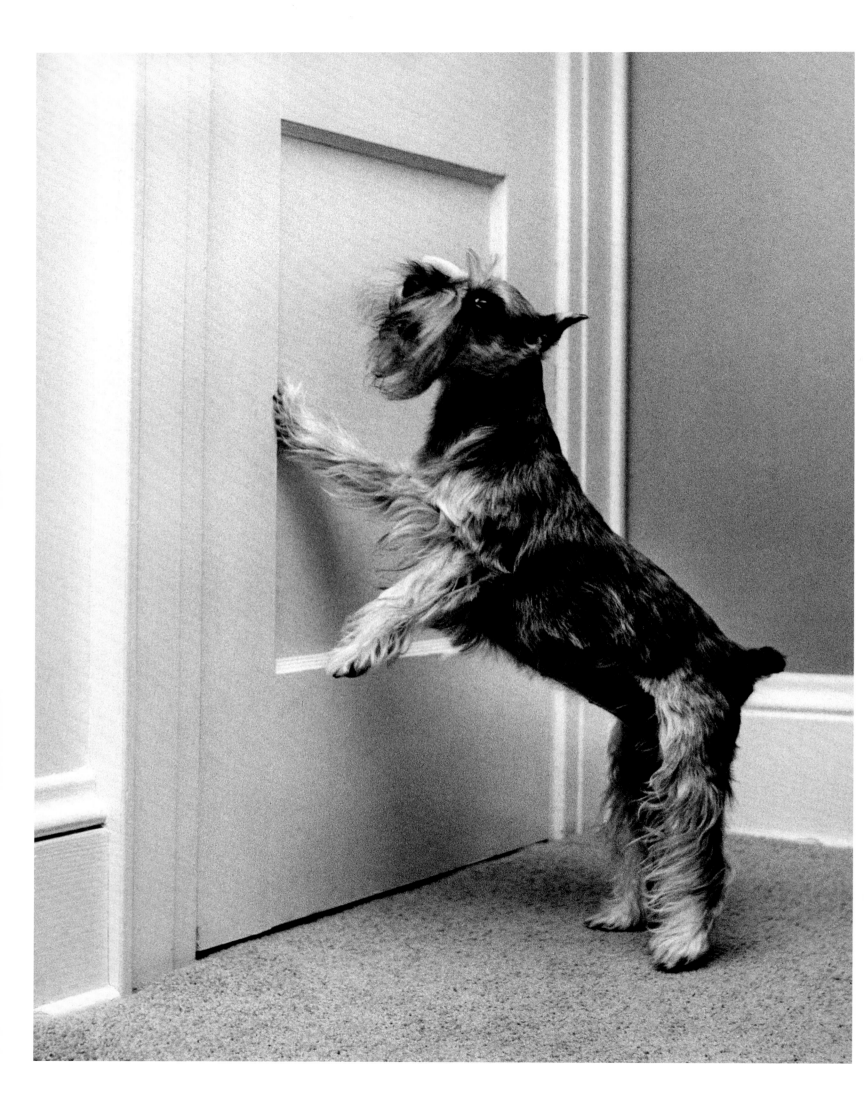

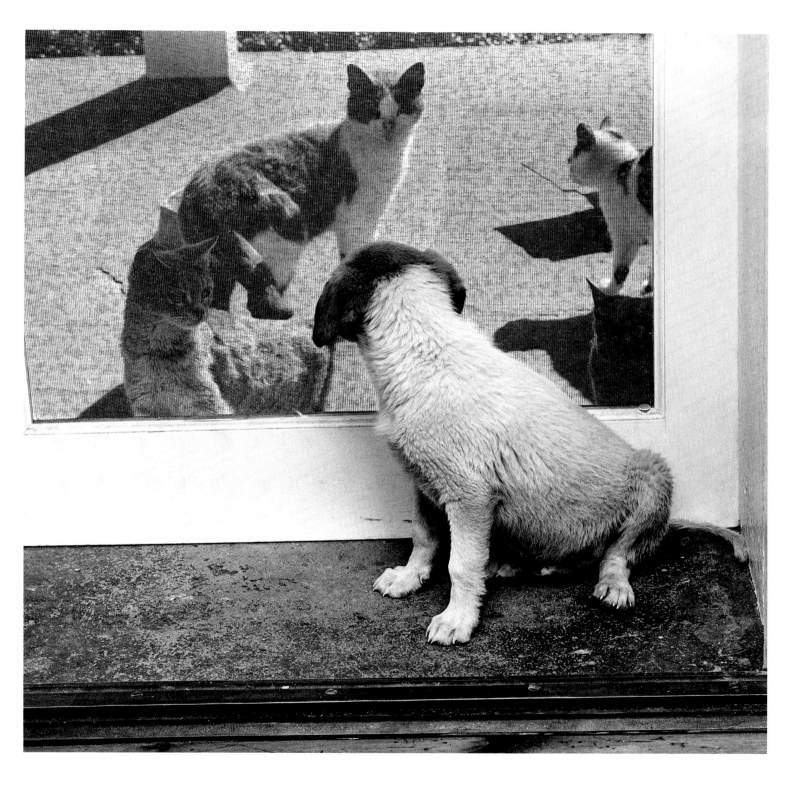

Schnauzer, Long Island, New York, 1959

Mixed-breed and domestic shorthair cats, 1965

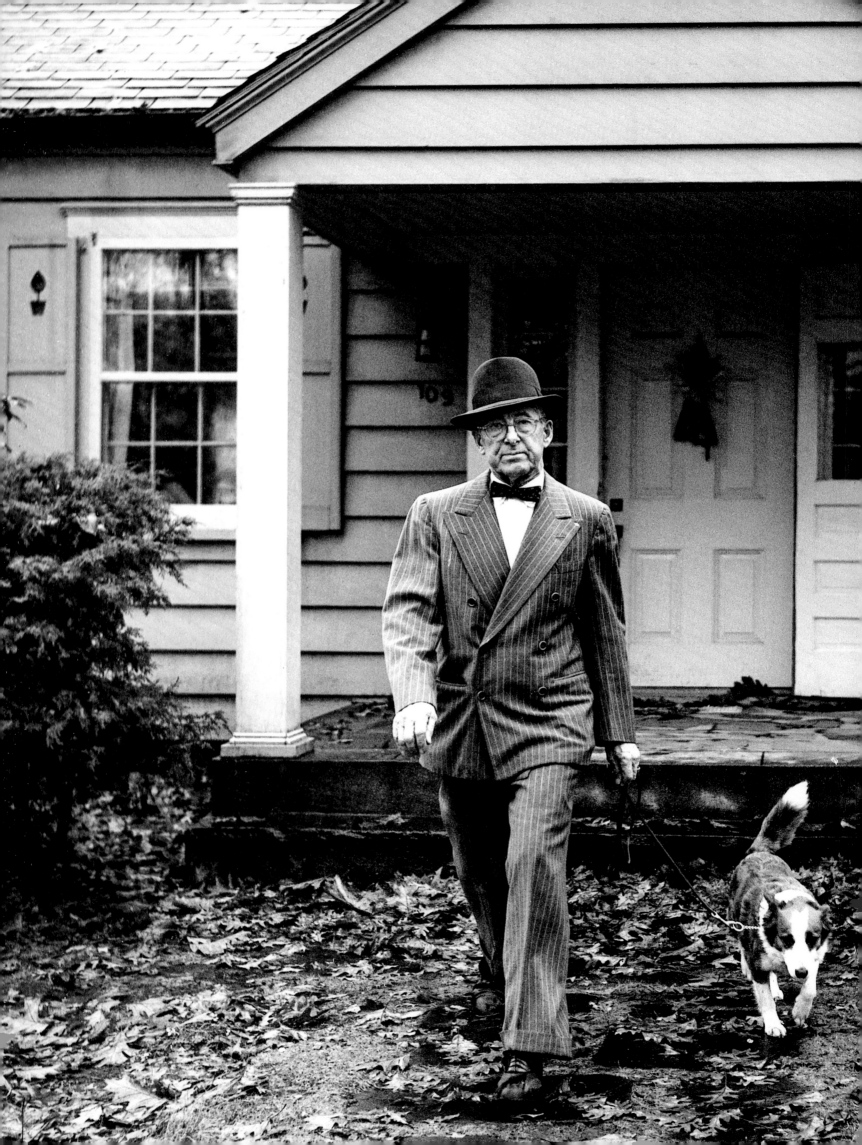

OUT AND ABOUT

Pages 174–175: Mixed-breed,
Long Island, New York, 1954

Pointer, Long Island, New York, 1959

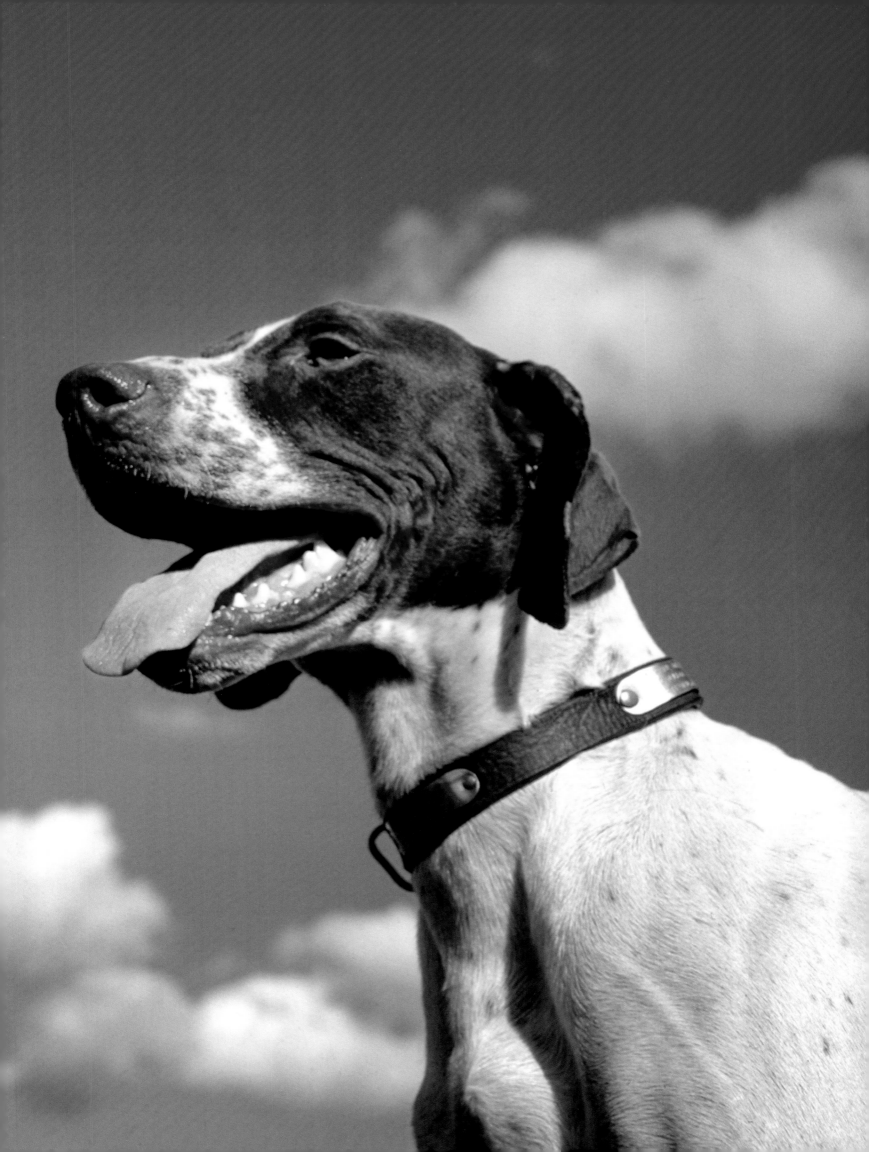

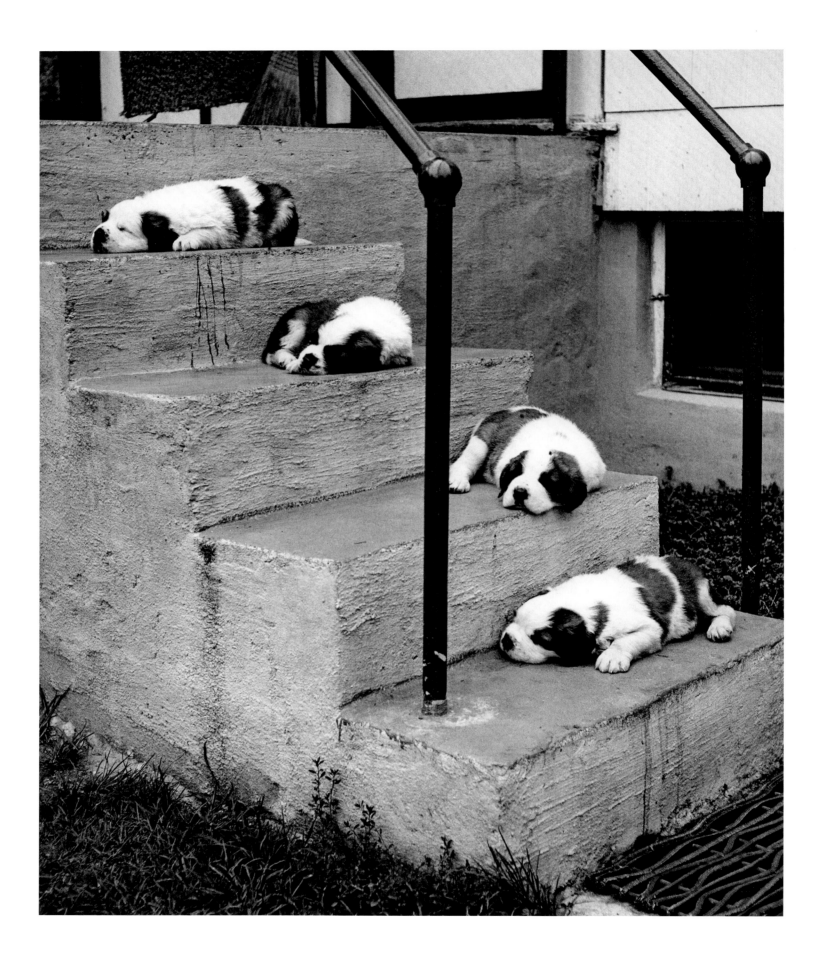

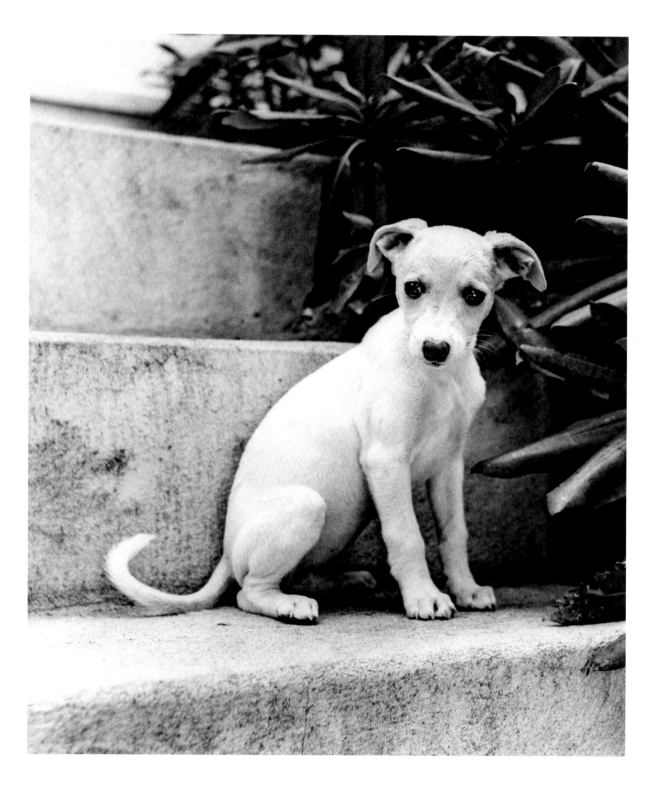

Saint Bernards, Long Island, New York, 1955

Whippet, Long Island, New York, 1953

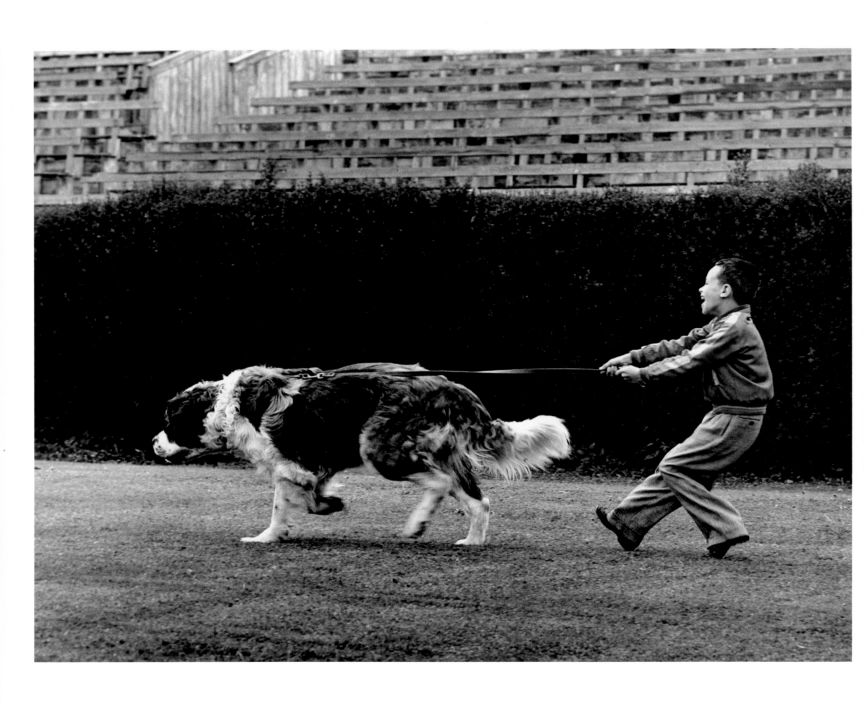

Saint Bernard, Long Island, New York, 1952

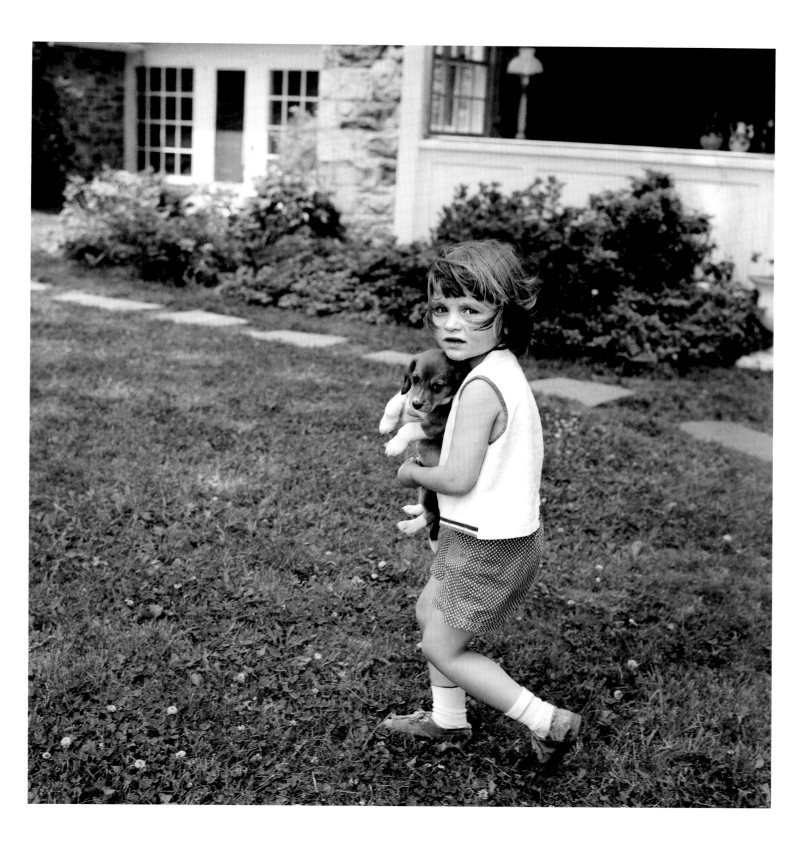

Beagle and Chiara, New Jersey, 1964

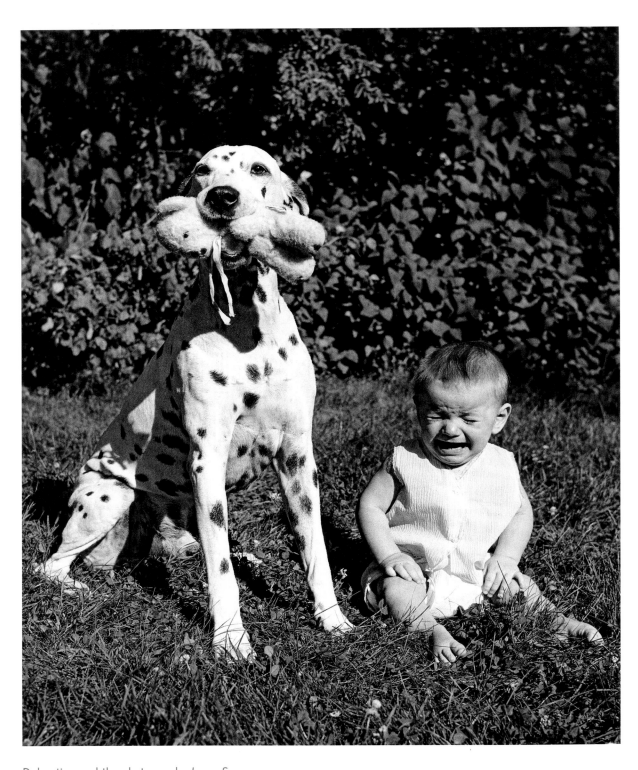

Dalmatian and the photographer's son Sam,
Long Island, New York, 1957

Irish wolfhound and Chihuahua, New York, 1952

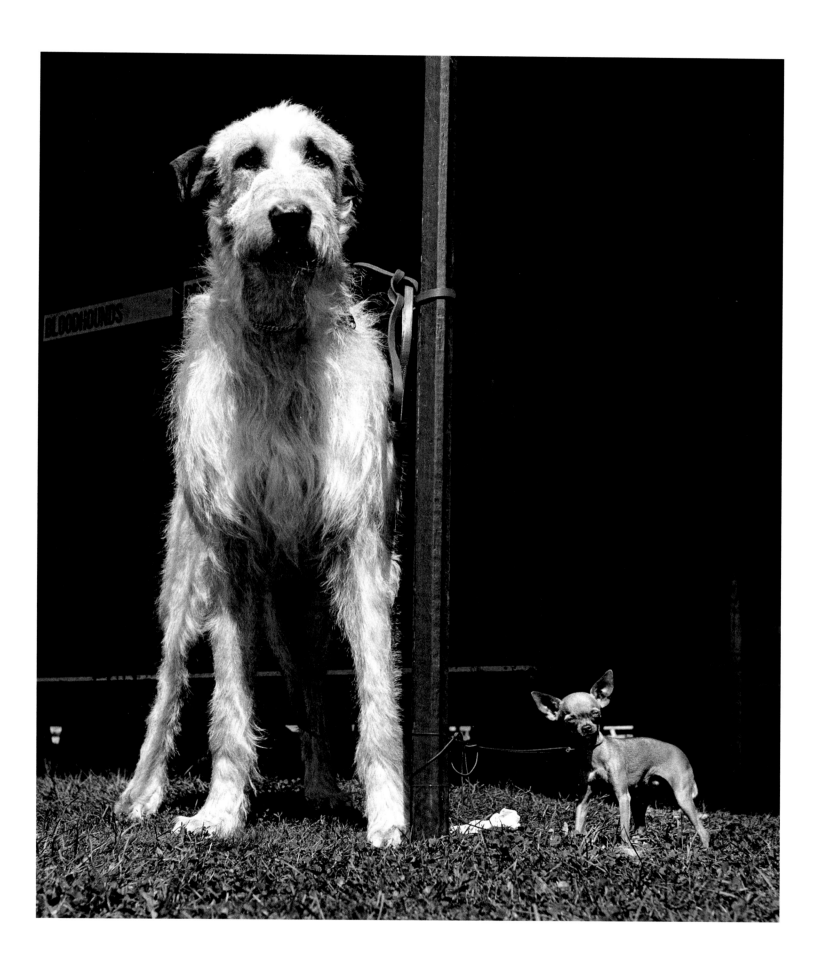

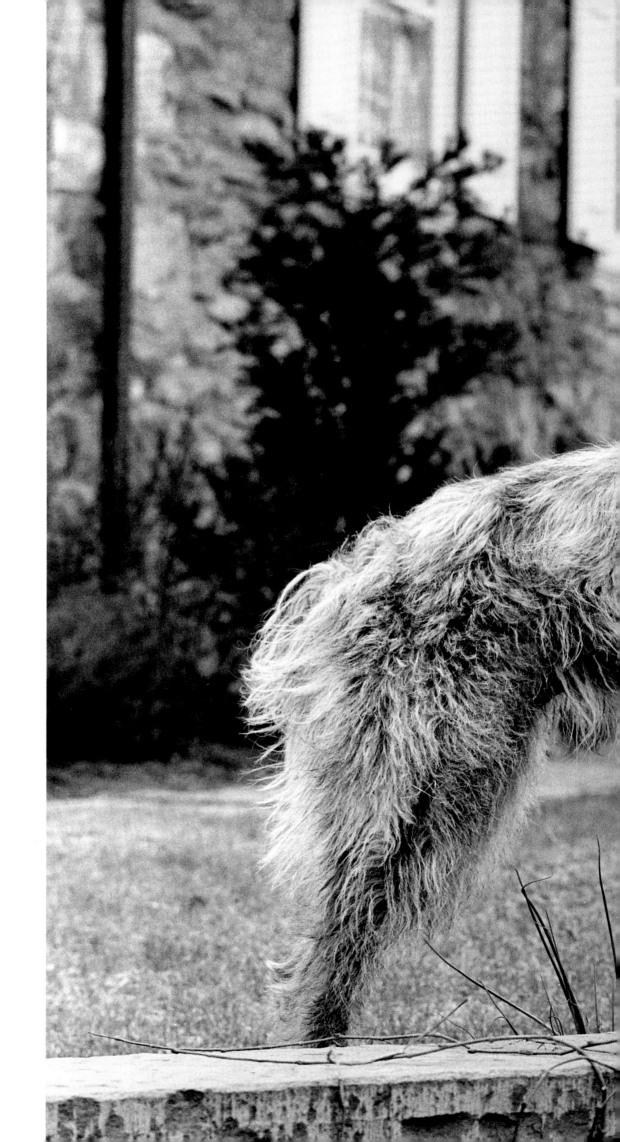

Bouvier des Flandres,
New Jersey, 1962

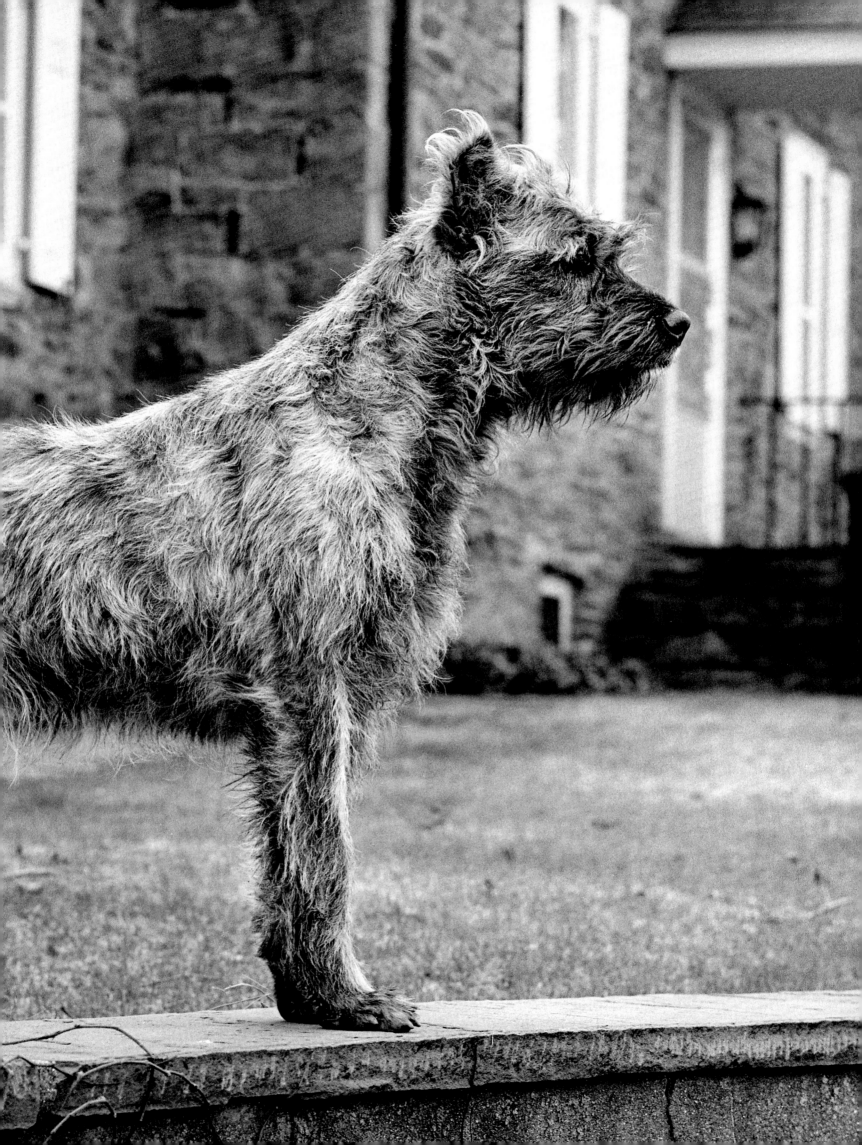

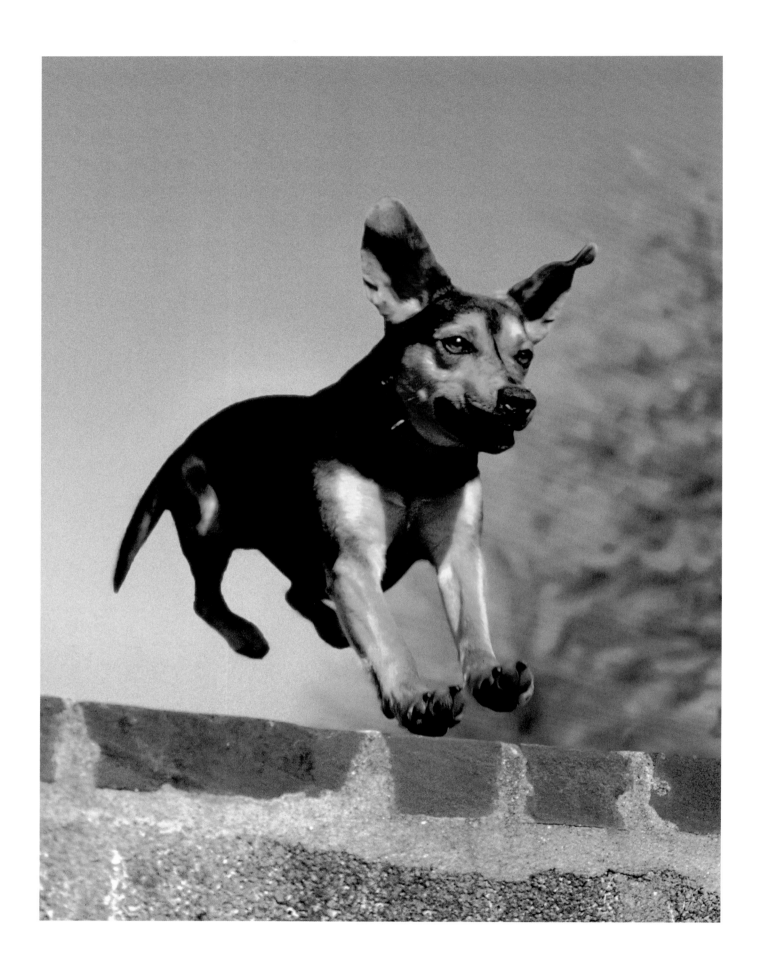

Mixed-breed, New Jersey, 1981

Miniature schnauzer and Paula,
Long Island, New York, 1960

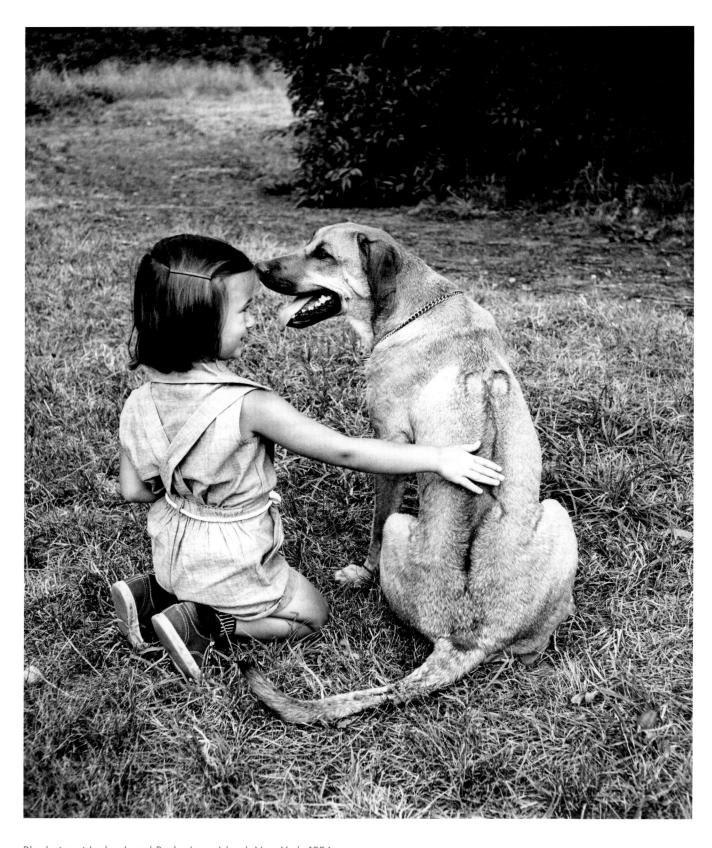

Rhodesian ridgeback and Paula, Long Island, New York, 1954

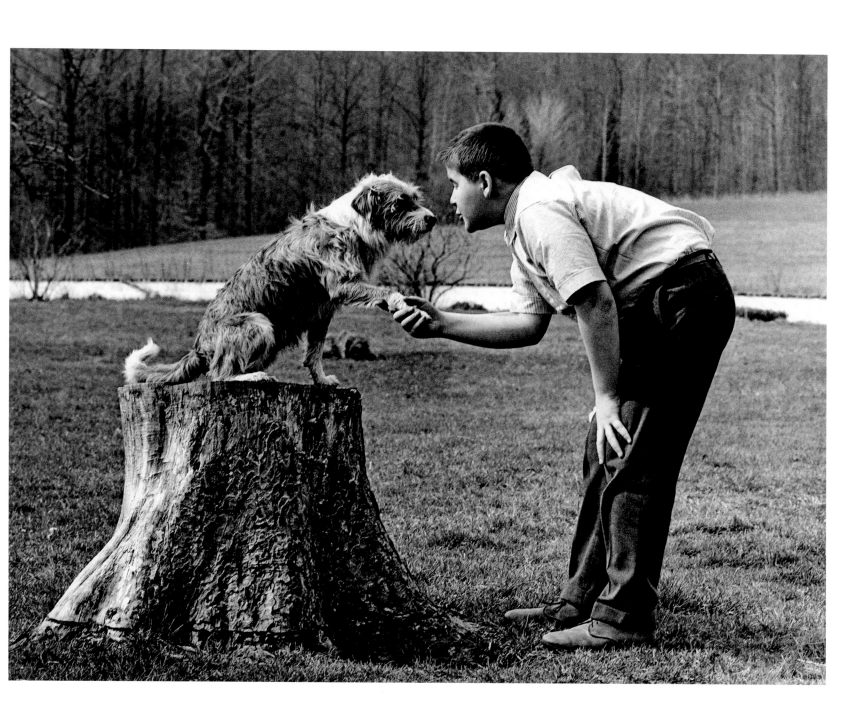

Mixed-breed and Enrico, New Jersey, 1964

Bouvier des Flandres, New Jersey, 1962

Poodle, Long Island, New York, 1958

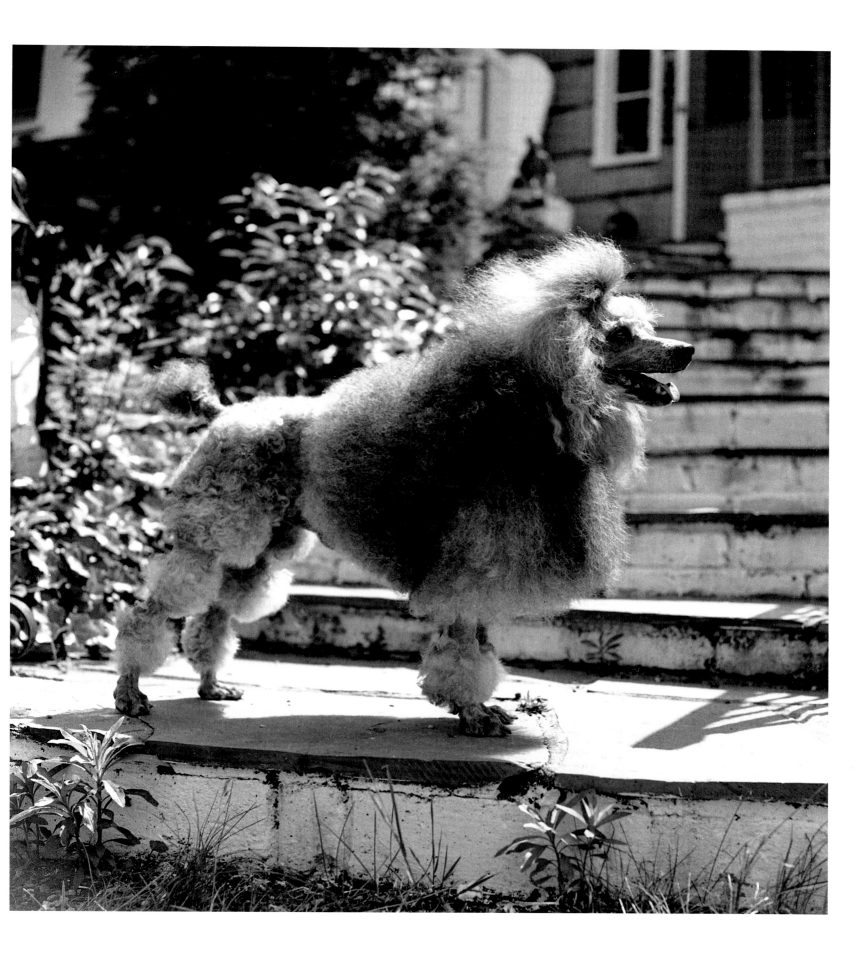

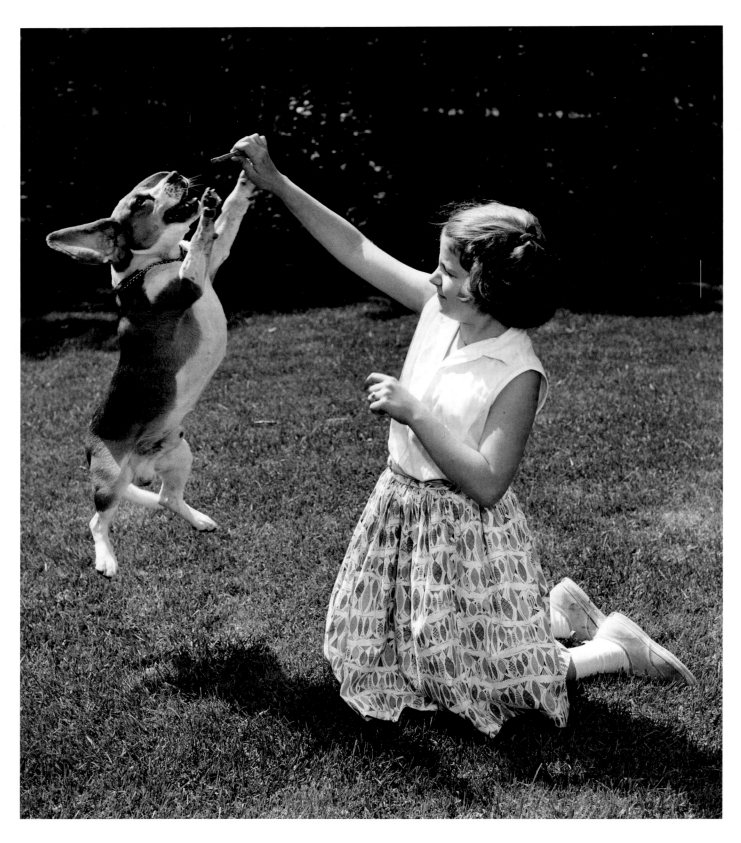

Basset hound, Long Island, New York, 1959

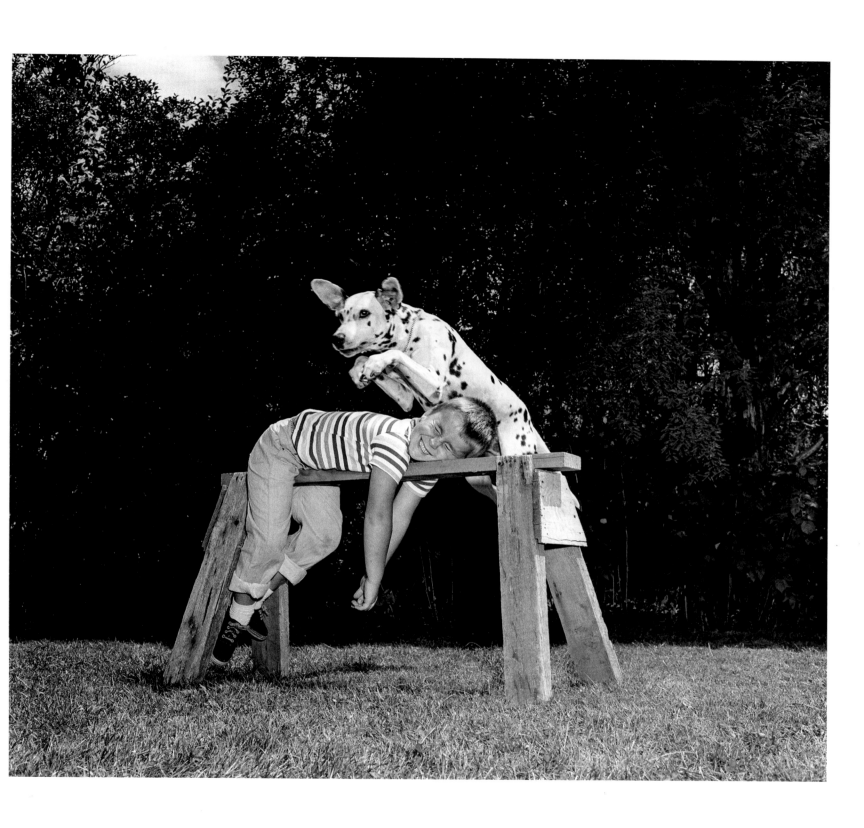

Dalmatian and Enrico, Long Island, New York, 1957

Dalmatian and Enrico, Long Island, New York, 1957

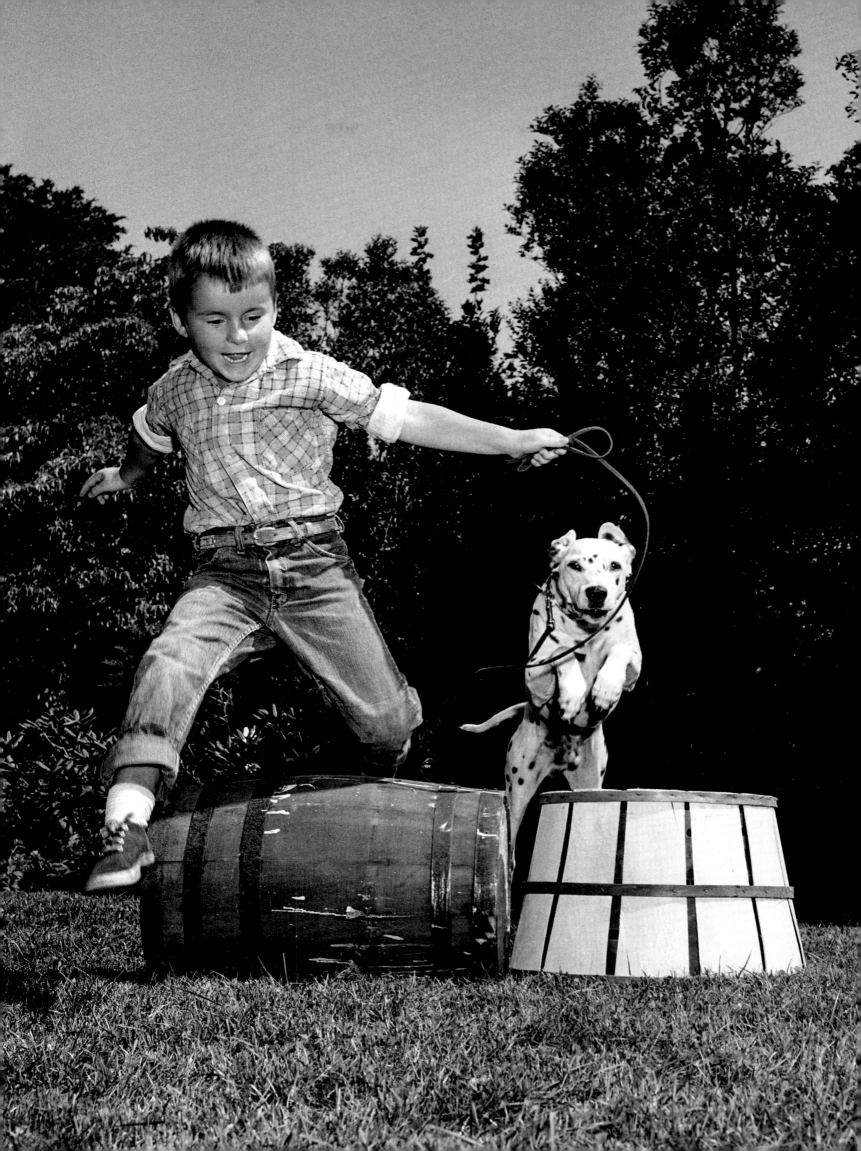

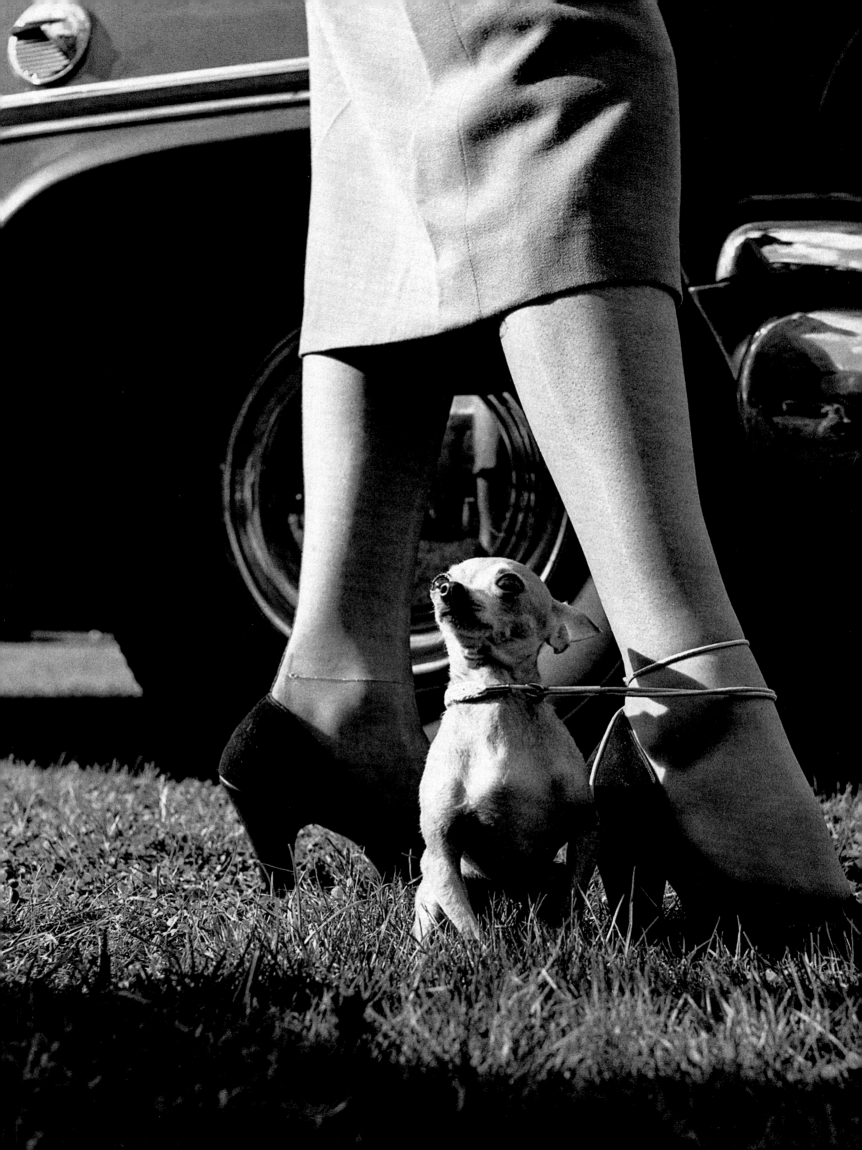

Chihuahua, New York, 1952

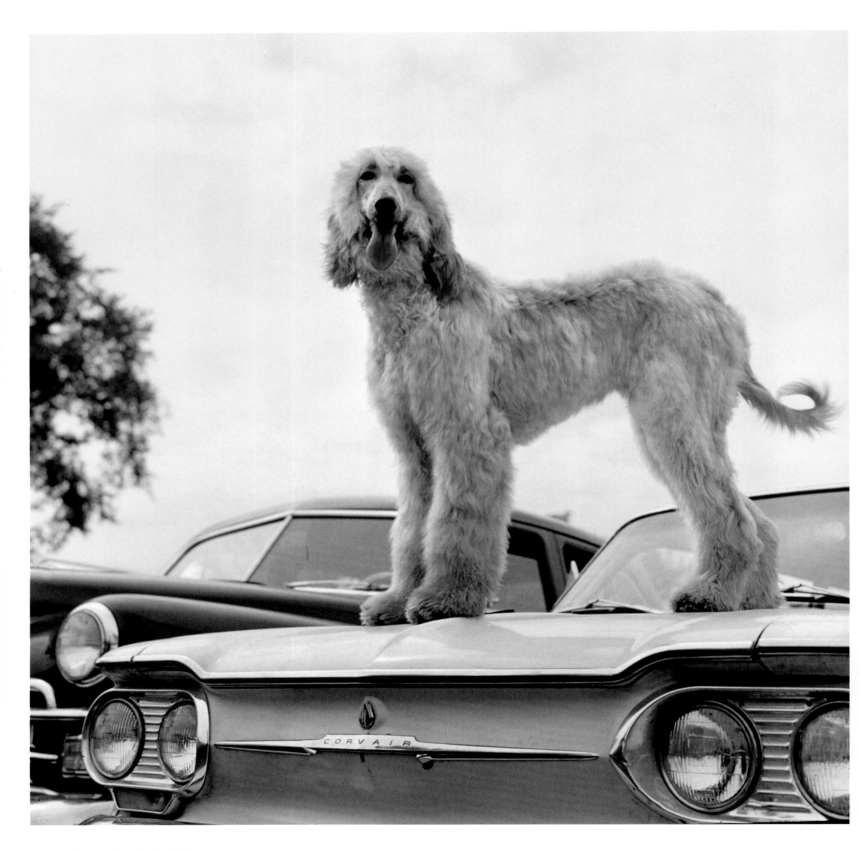

Afghan, New York, 1963

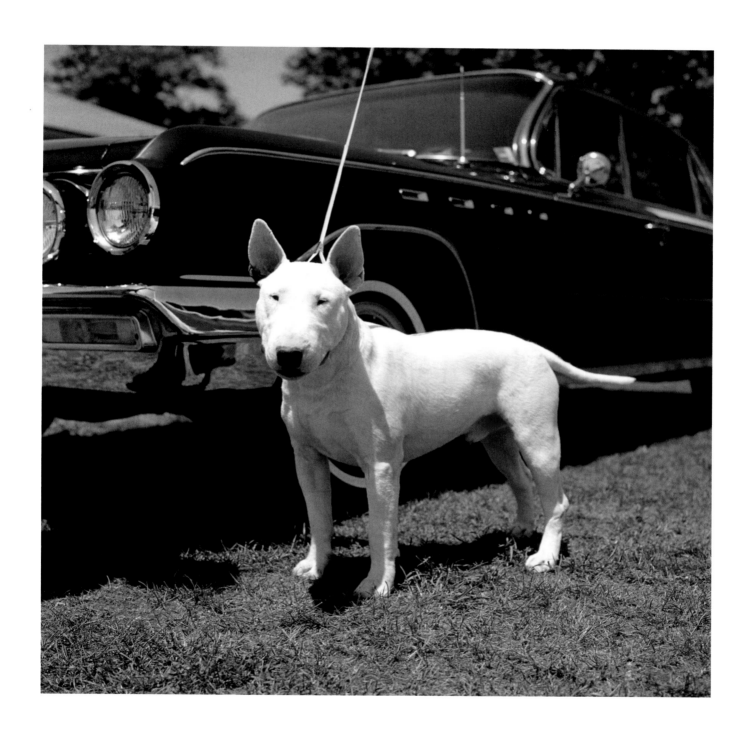

Bull terrier, New York, 1963

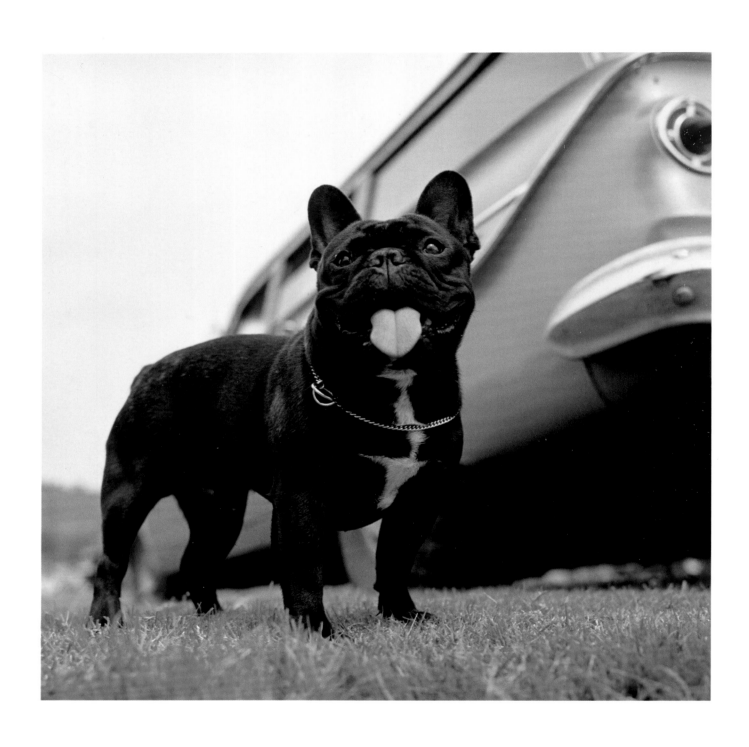

French bulldog, New York, 1963

Dachshund, New York, 1959

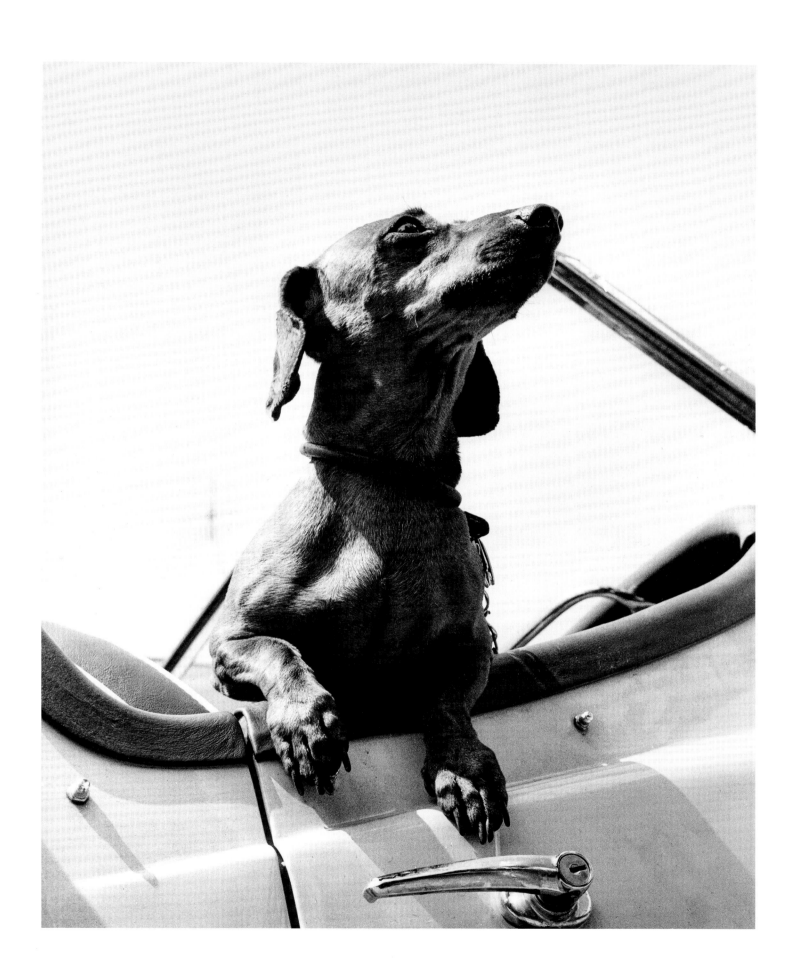

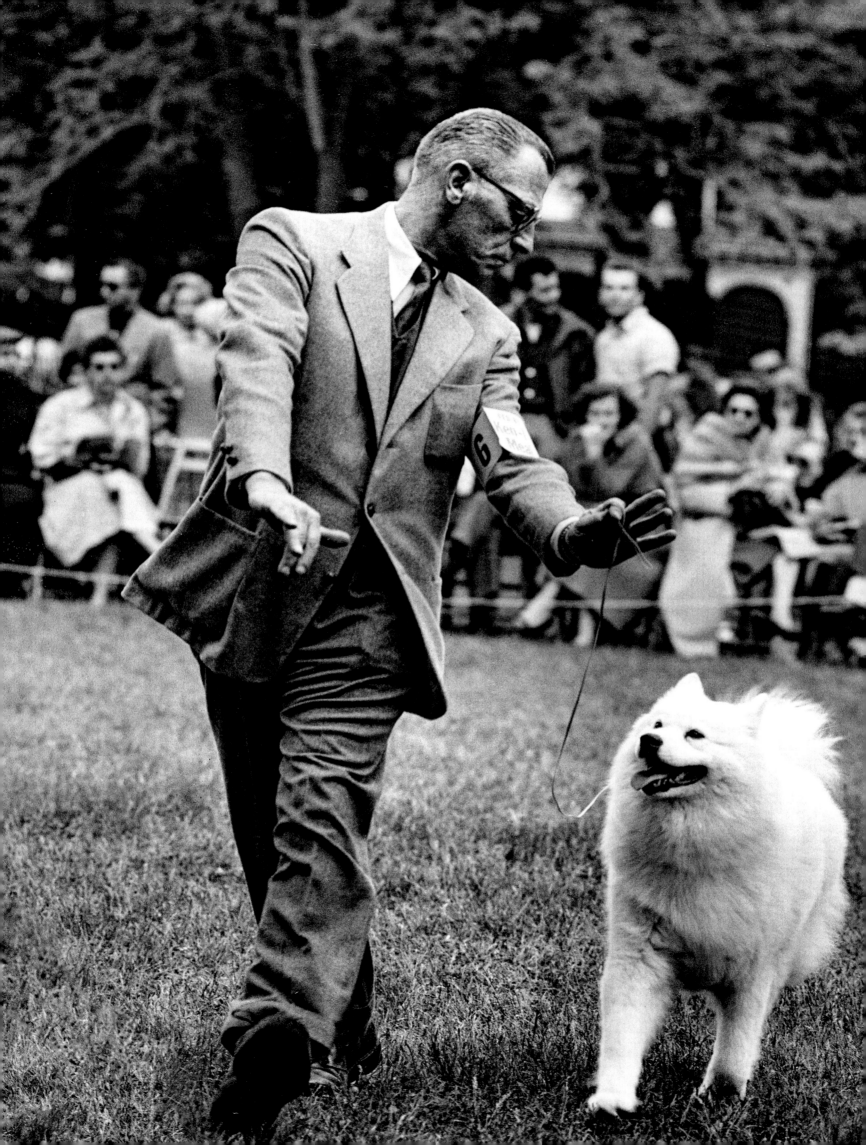

BEST IN
SHOW

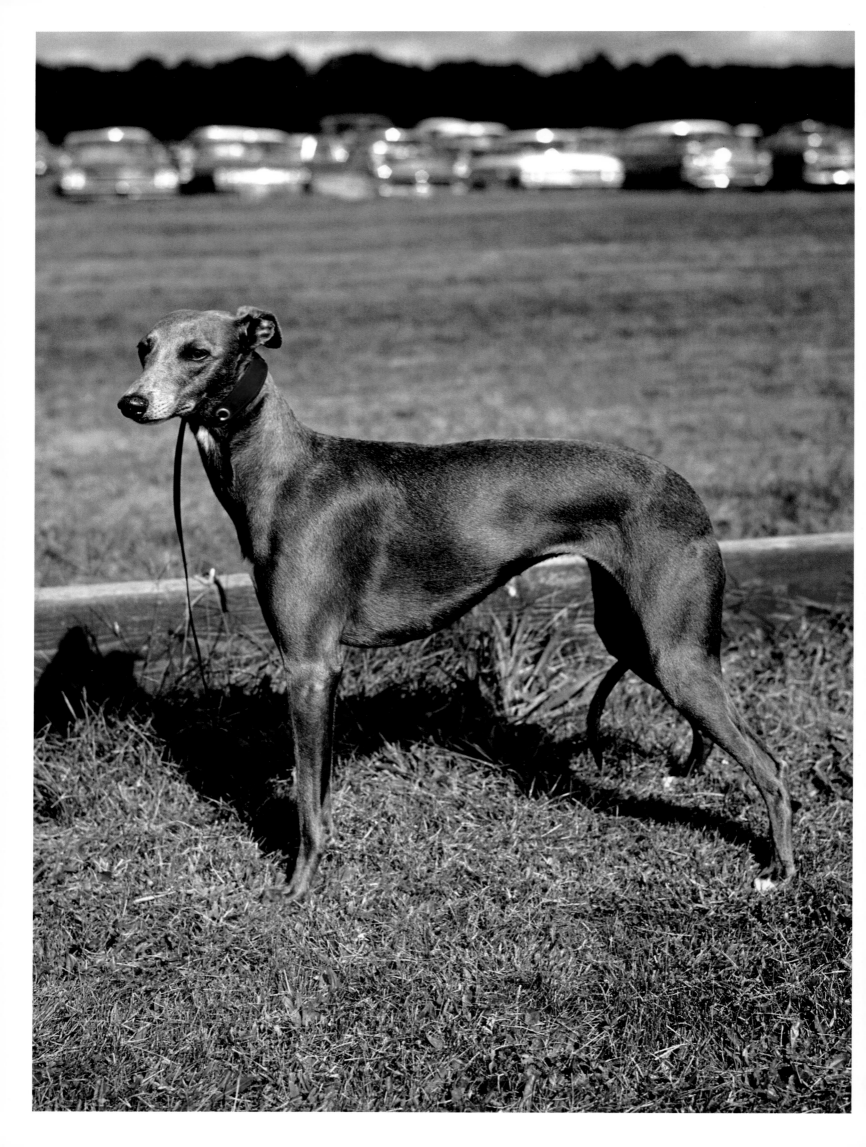

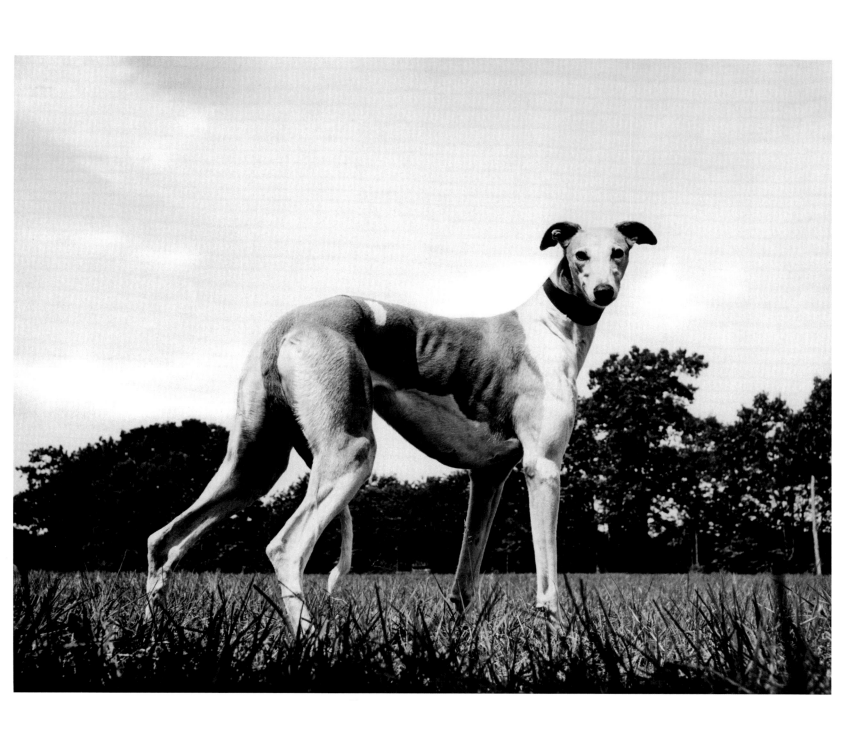

Pages 202–203: Samoyed, New York, 1959

Whippet, New York, 1954

Greyhound, New York, 1954

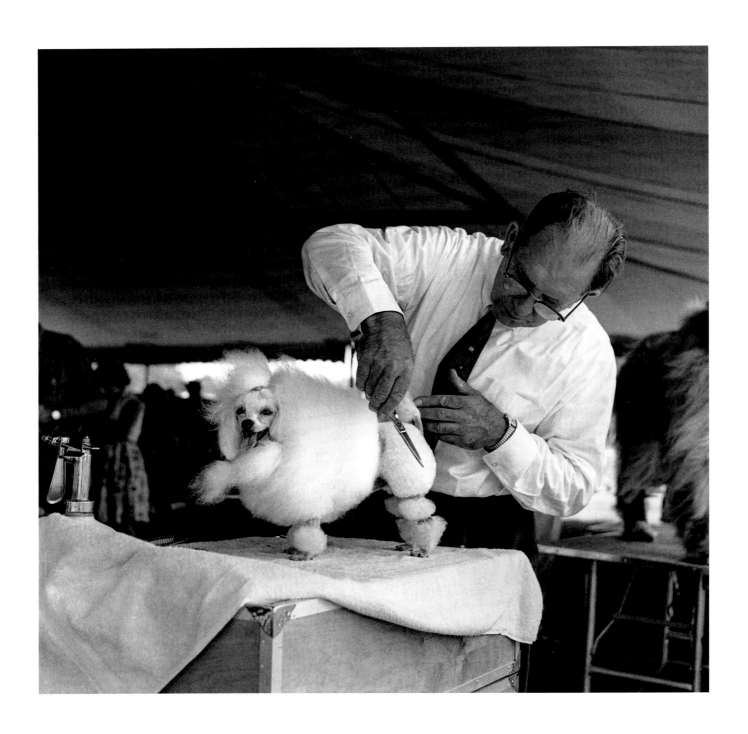

Poodle, New York, 1962

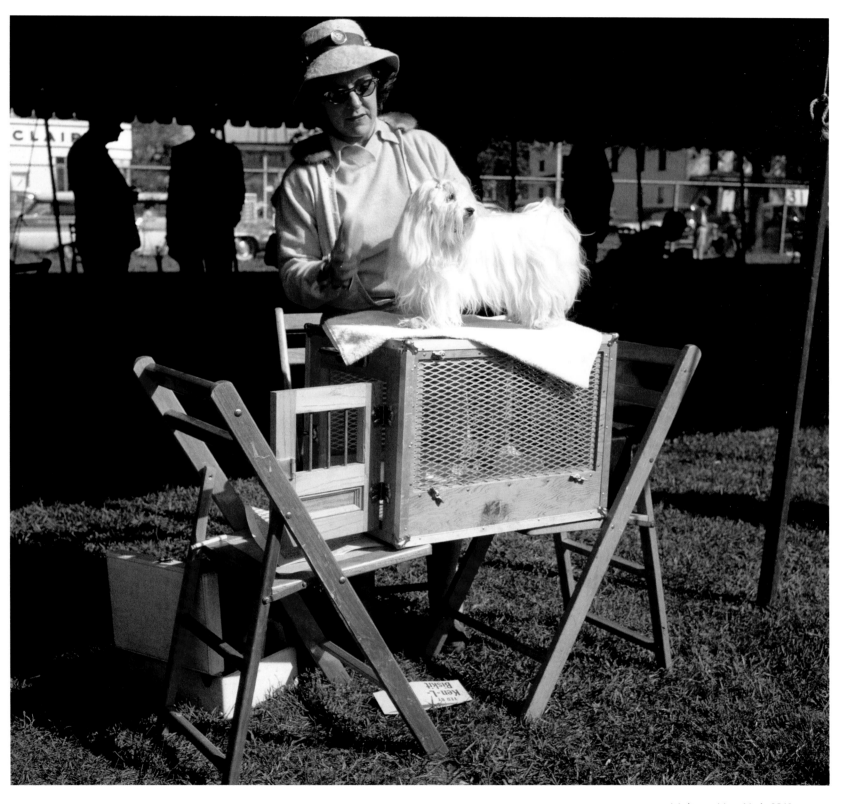

Maltese, New York, 1961

Pages 208–209: Miniature schnauzer,
New Jersey, 1971

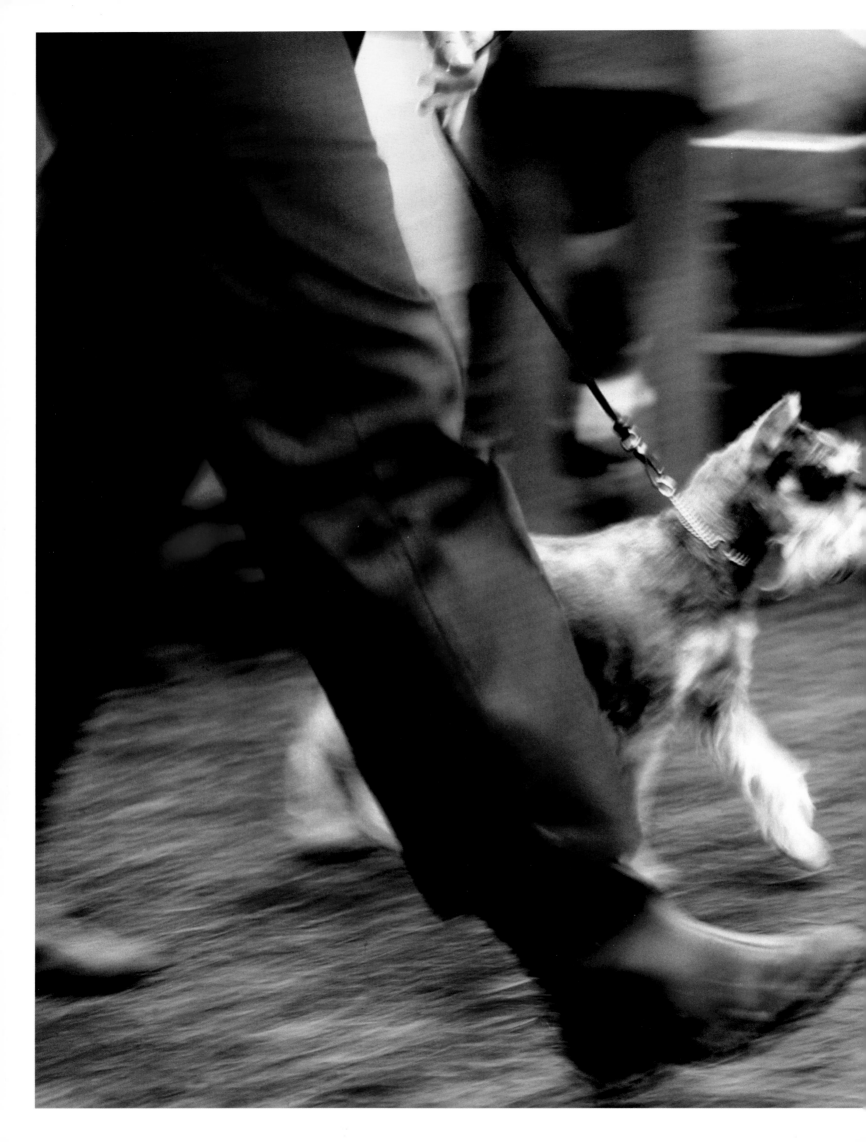

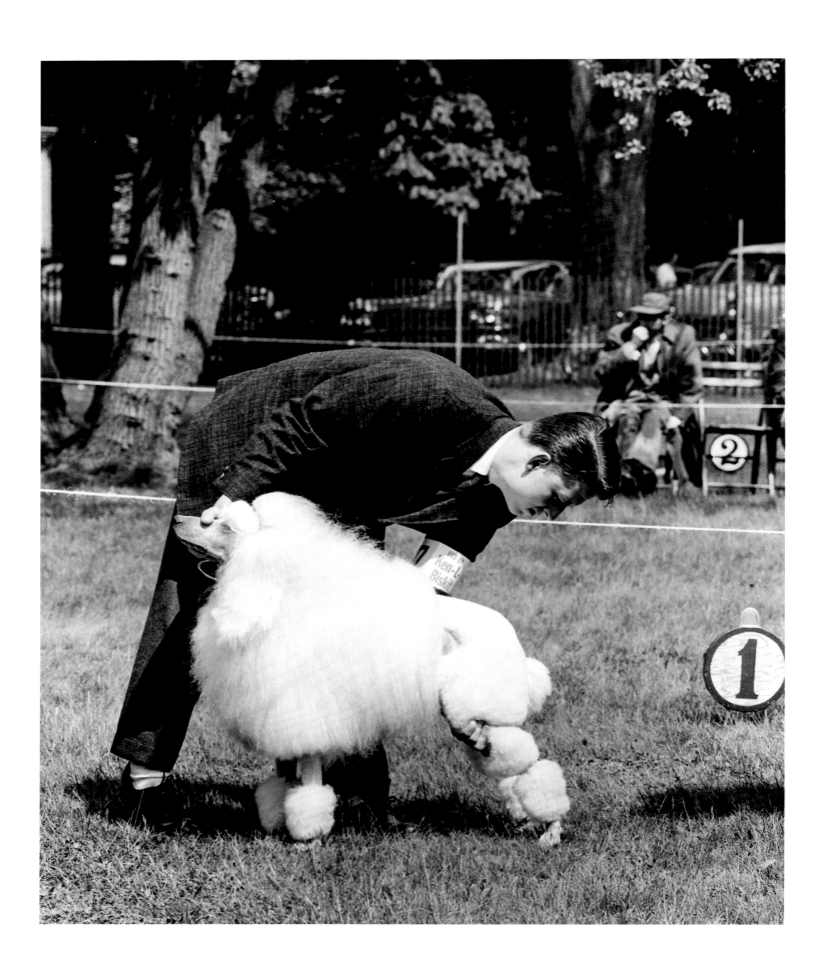

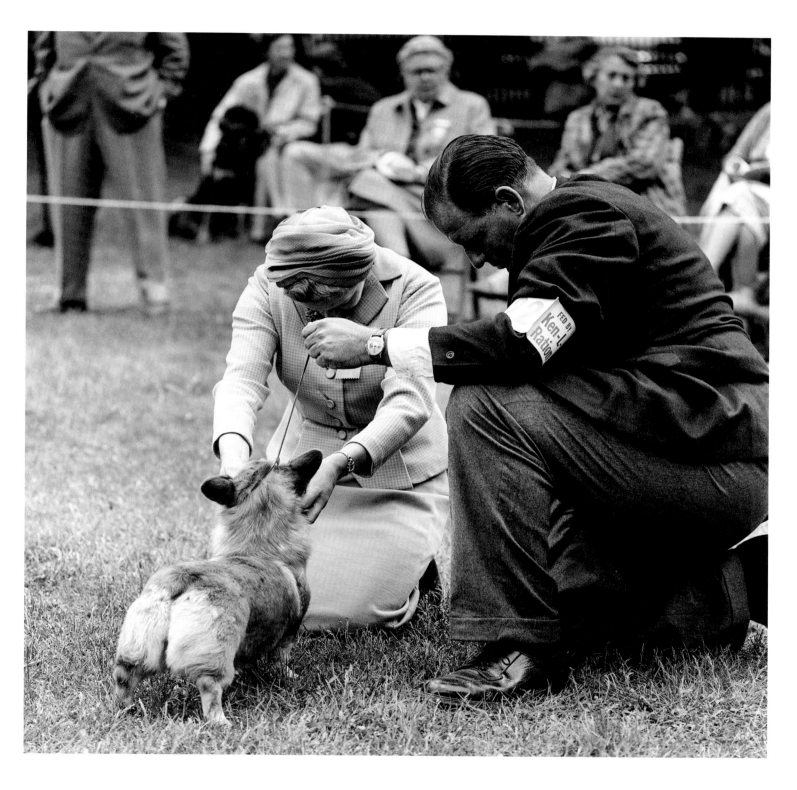

French poodle, New York, 1959

Welsh corgi, New York, 1959

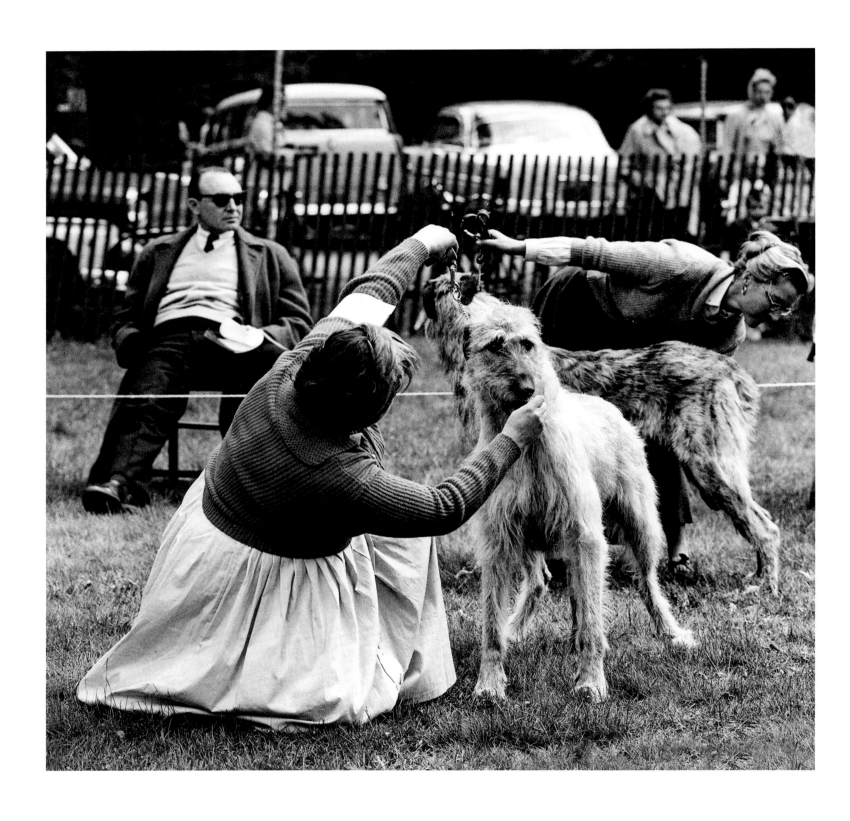

Irish wolfhound, New York, 1959

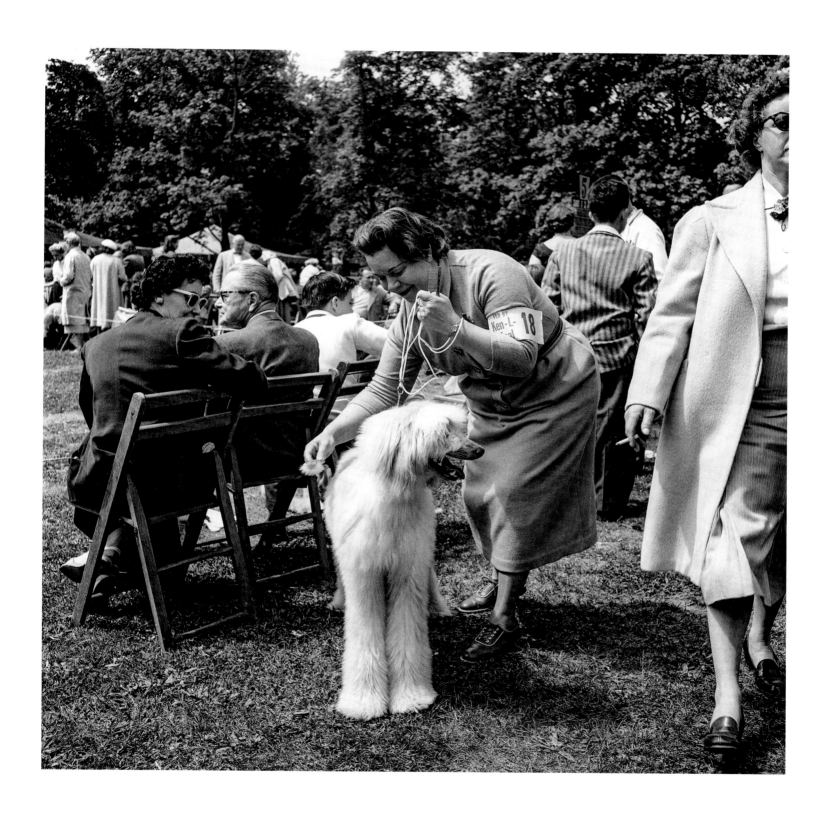

Afghan, New York, 1959

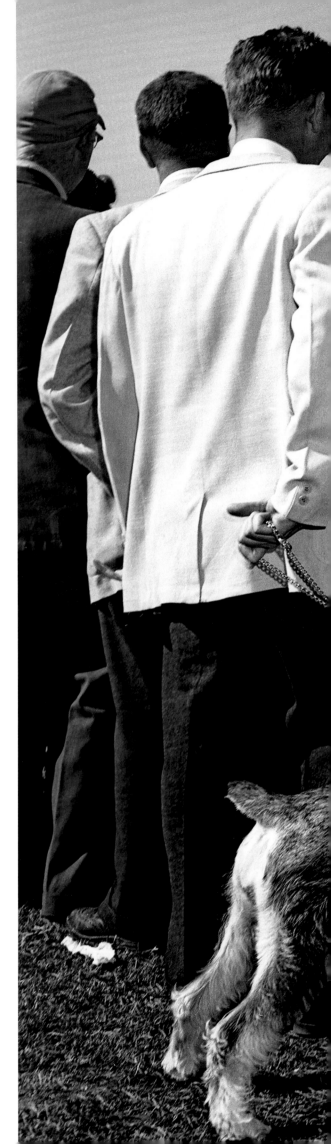

Schnauzer, New York, 1954

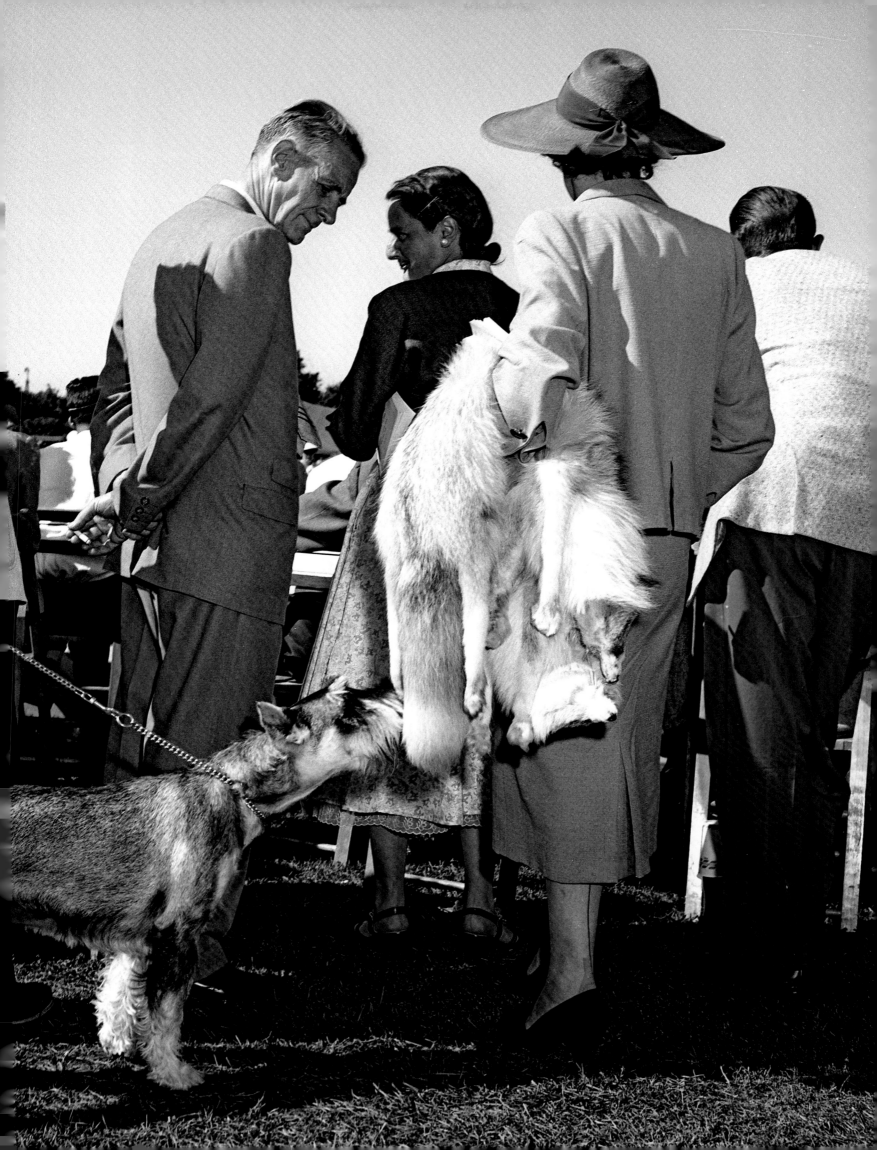

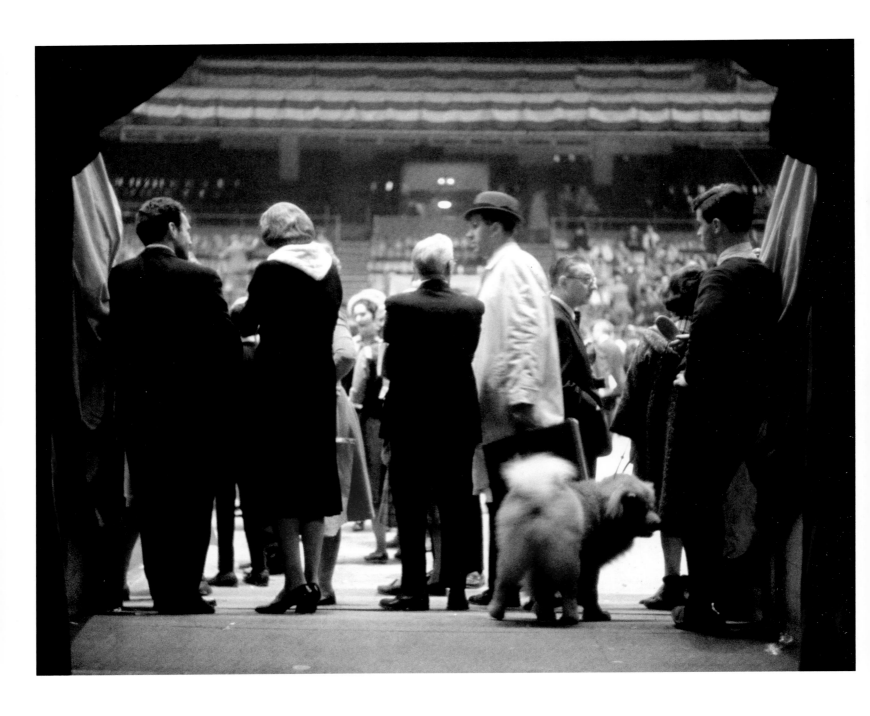

This spread: Westminster Dog Show, New York City, 1972

Pages 218–219: Westminster Dog Show, New York City, 1961

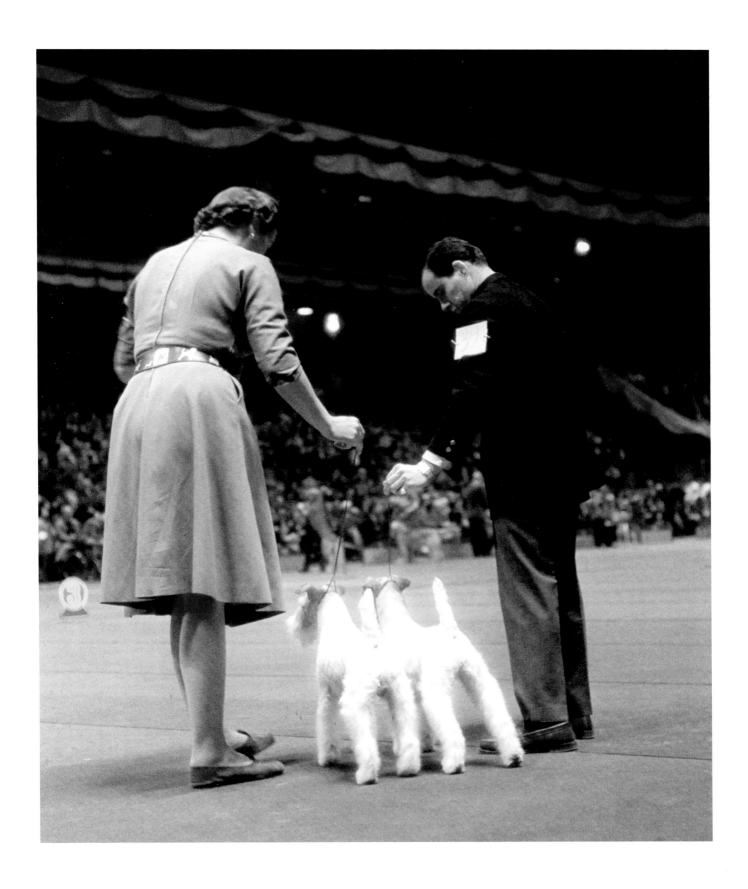

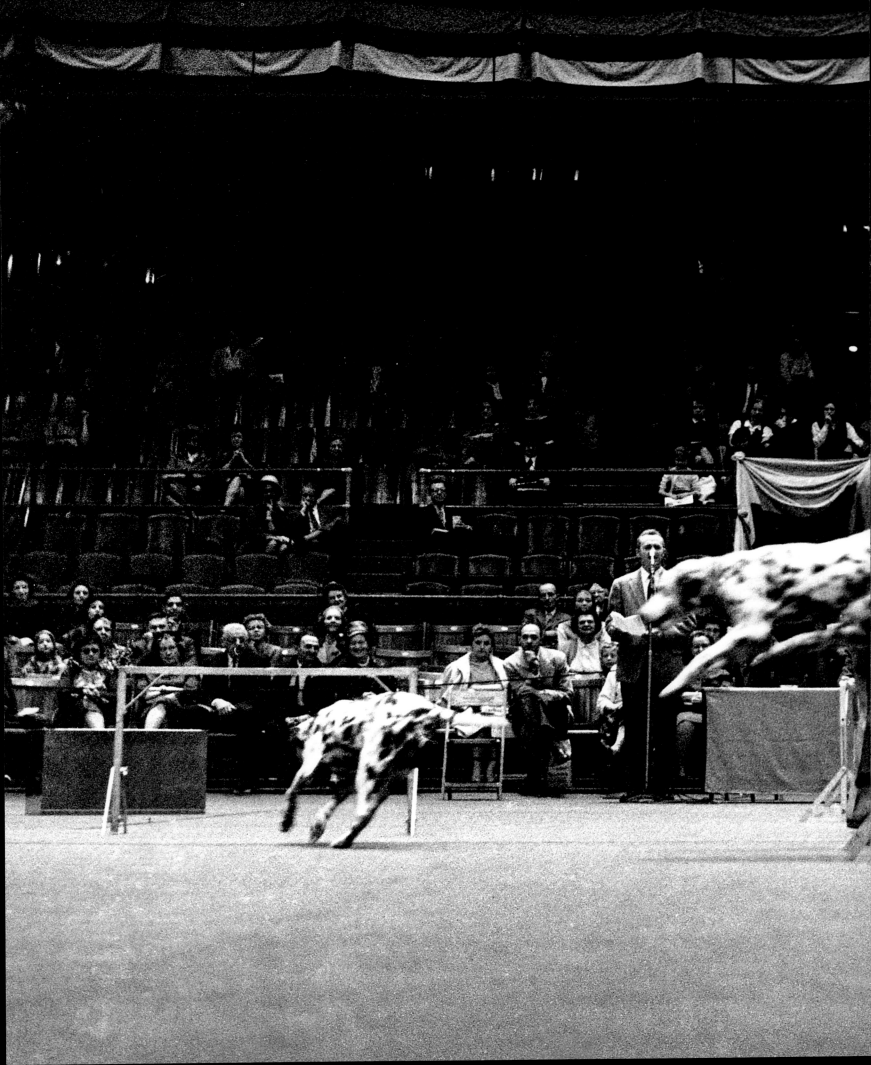

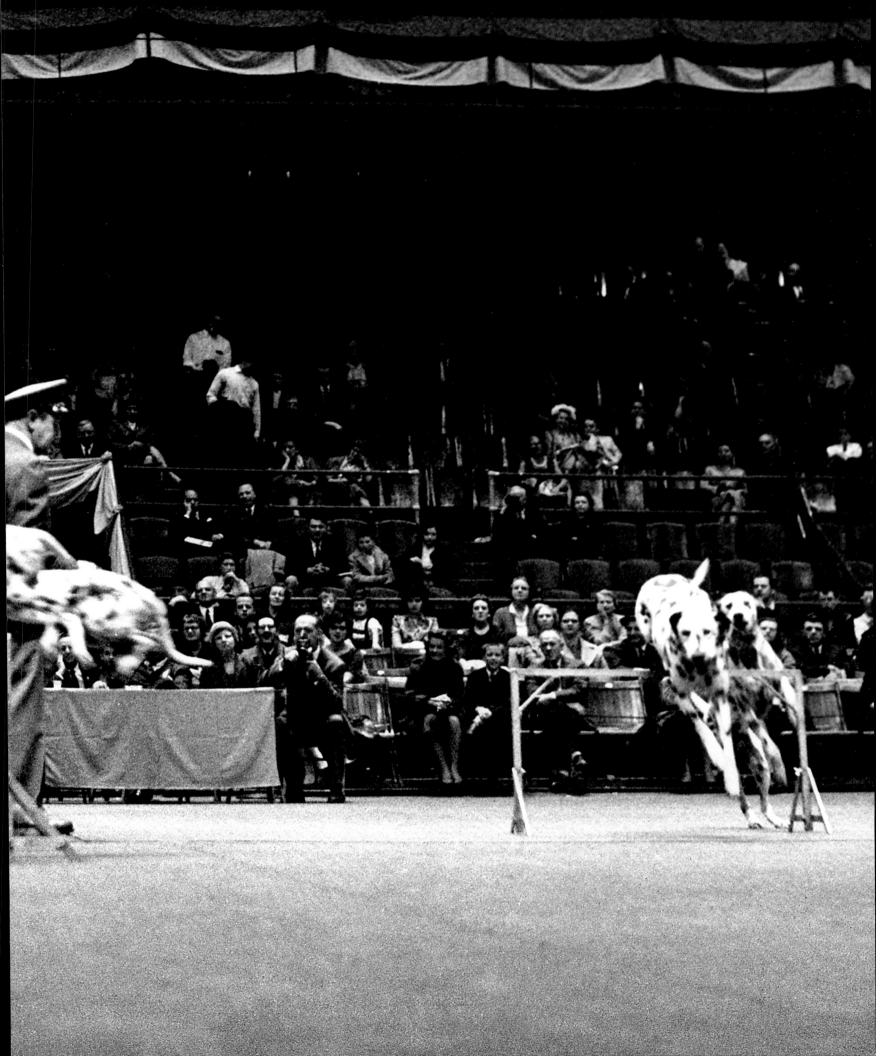

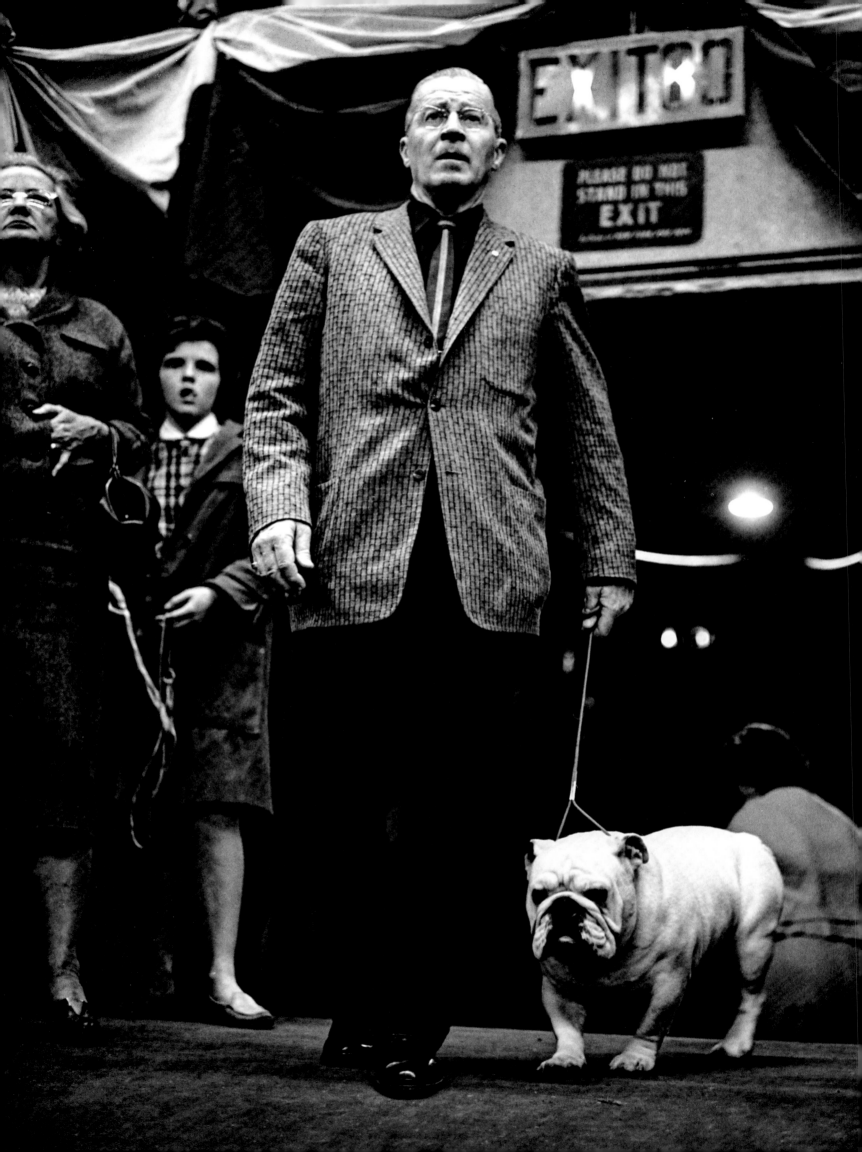

Westminster Dog Show, New York City, 1961

Pages 222–223: Kodak Colorama,
Grand Central Station, New York City, 1956

TAILS FROM THE CITY

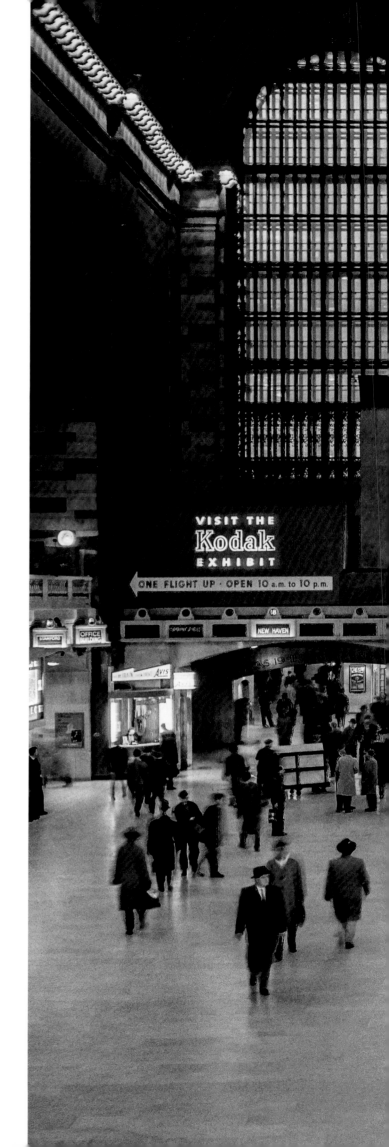

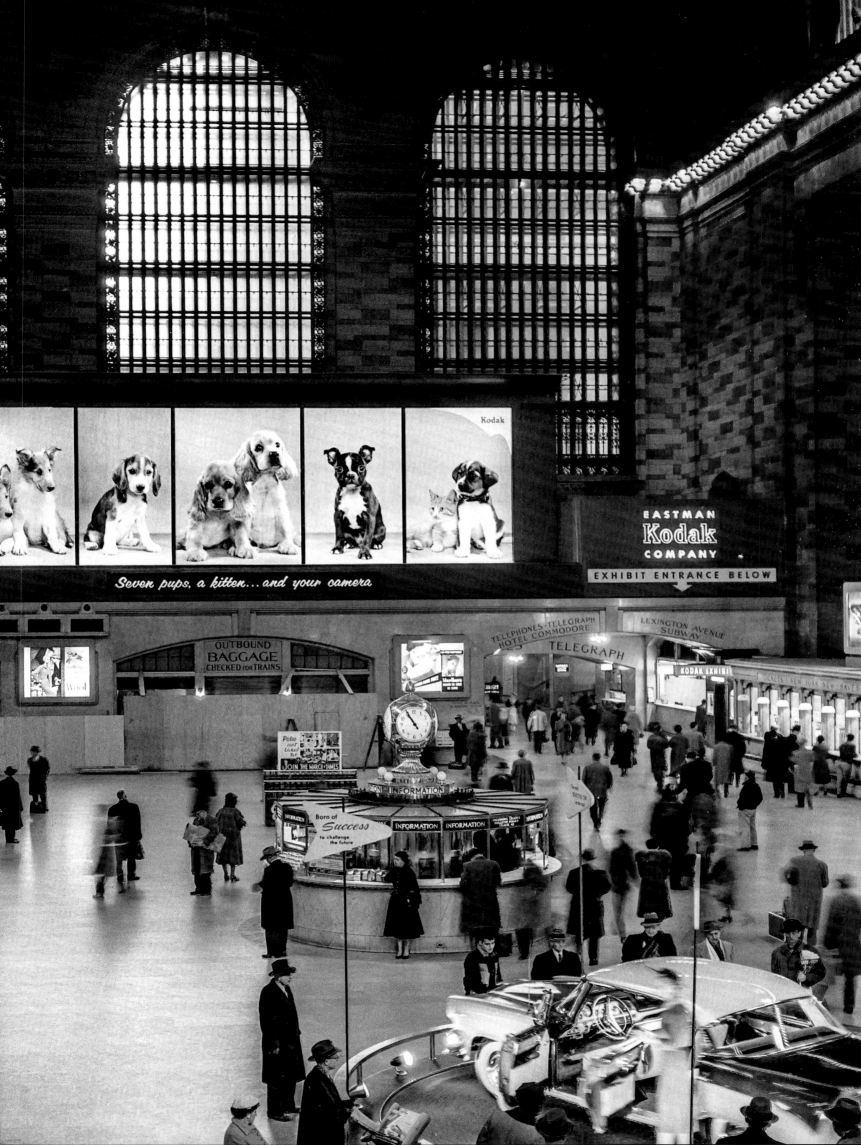

Queens kennels, New York City, 1962

225

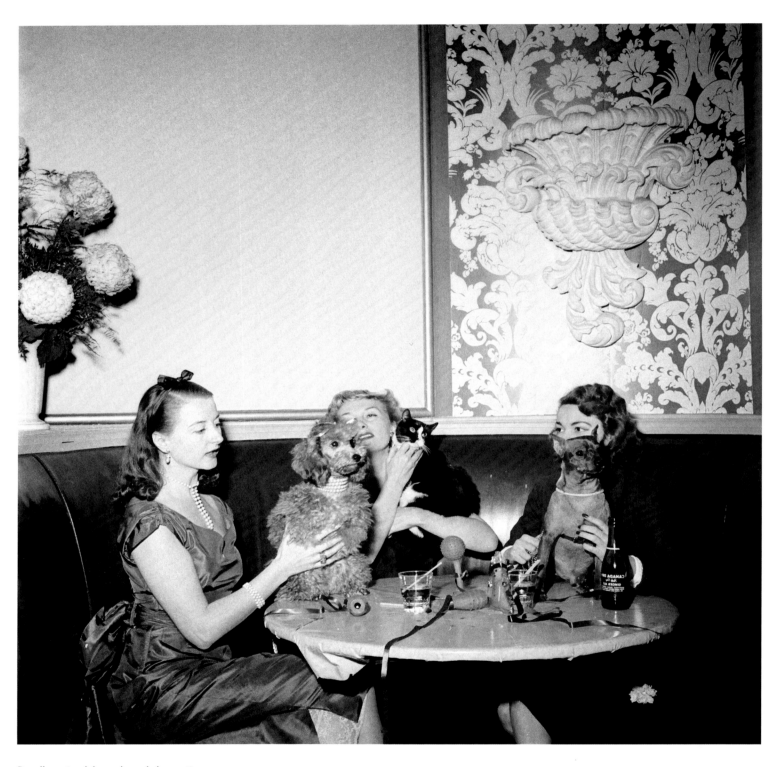

Poodle, mixed-breed, and domestic
shorthair cat, New York City, 1950

Belgian shepherd, New York City, 1949

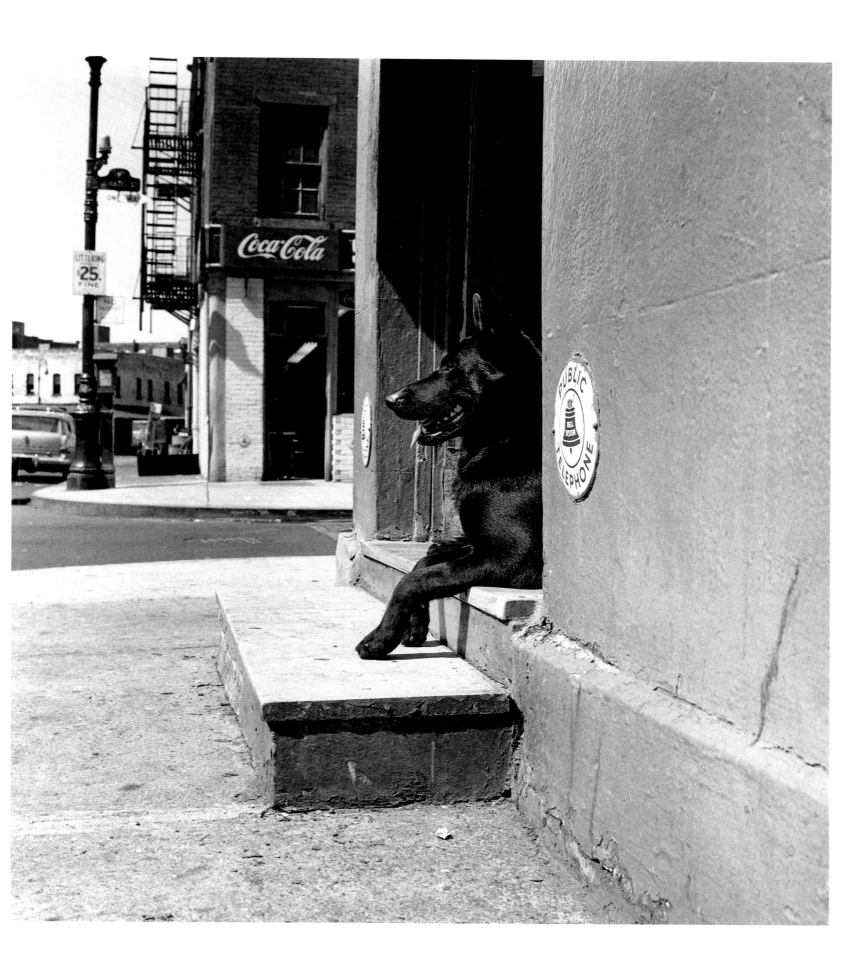

Dachshund, New York City, 1950

Pomeranian and Persian cat, New York City, 1950

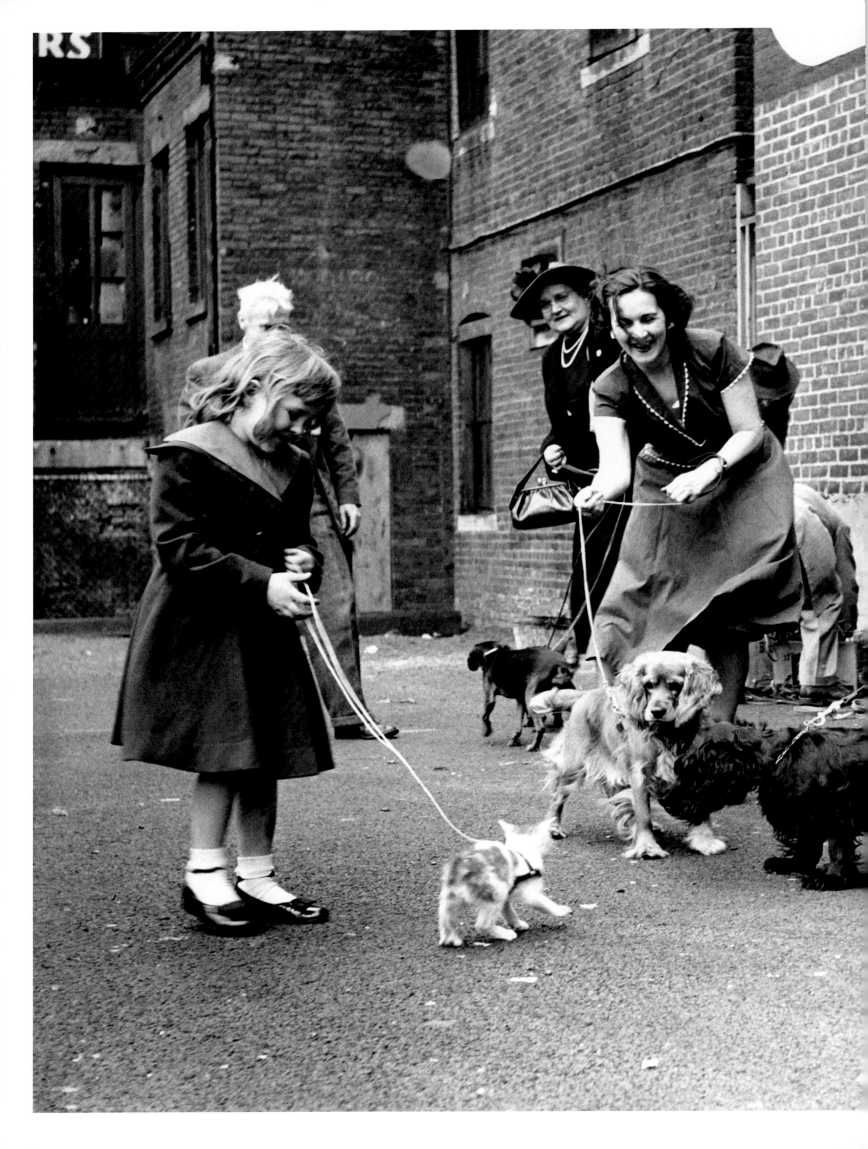

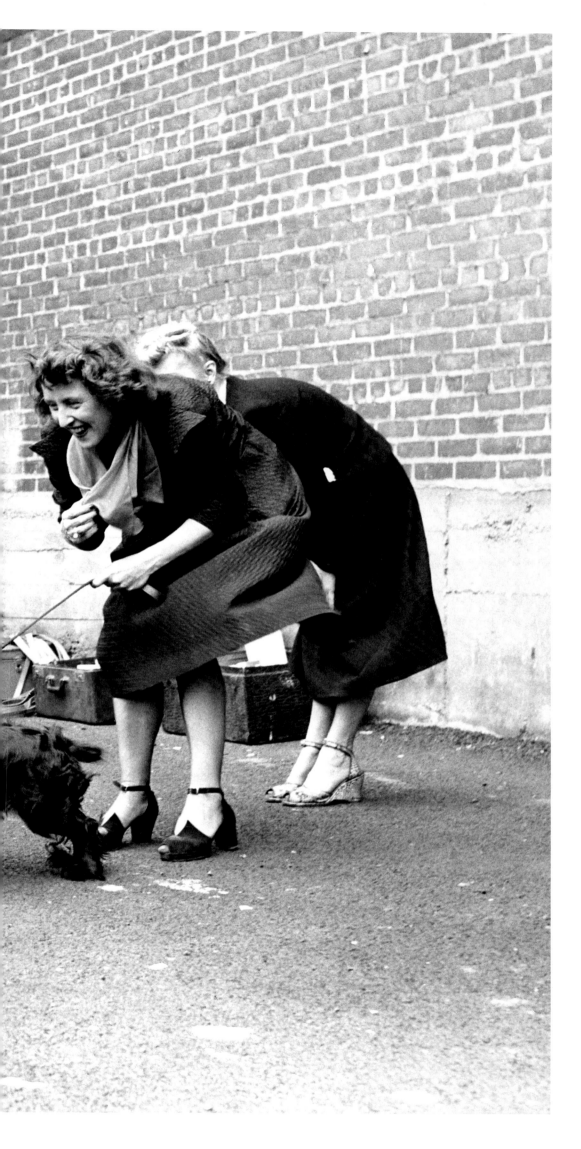

Cocker spaniel, Scottish terrier,
and domestic shorthair cat,
New York City, 1950

Mixed-breeds, New York City, 1949

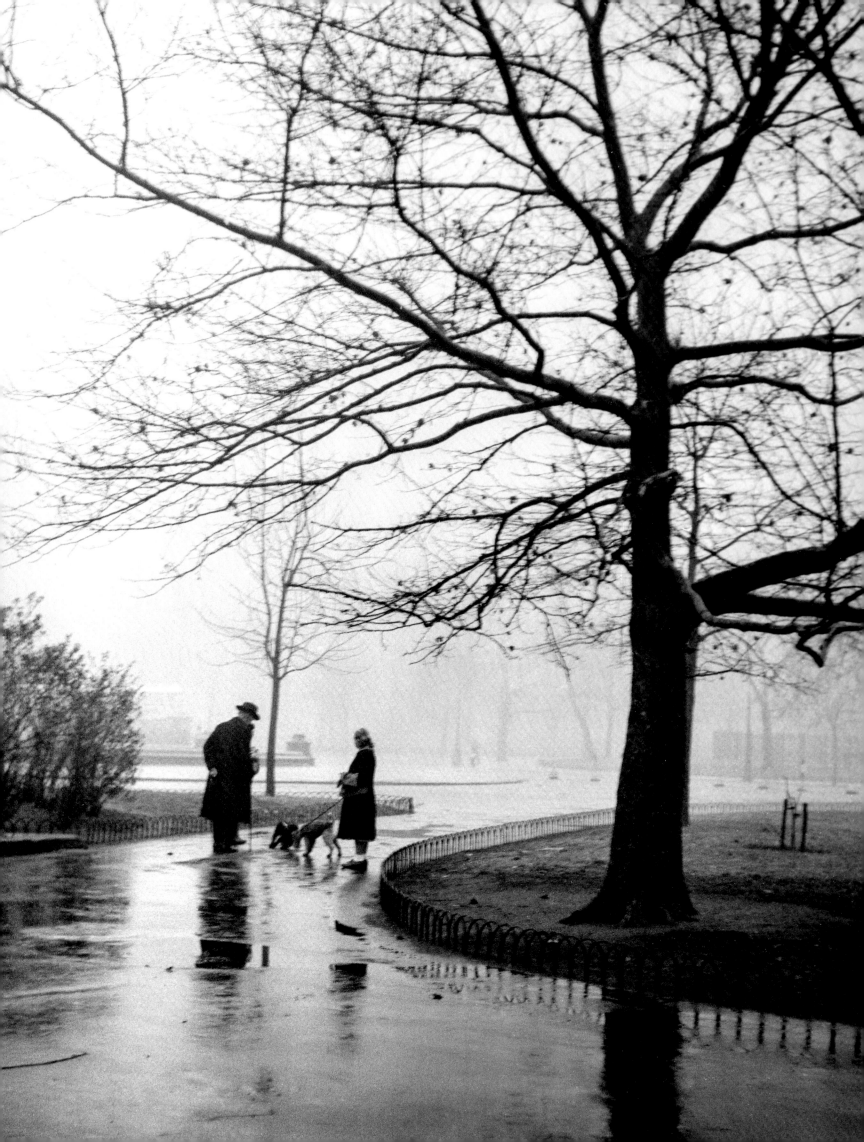

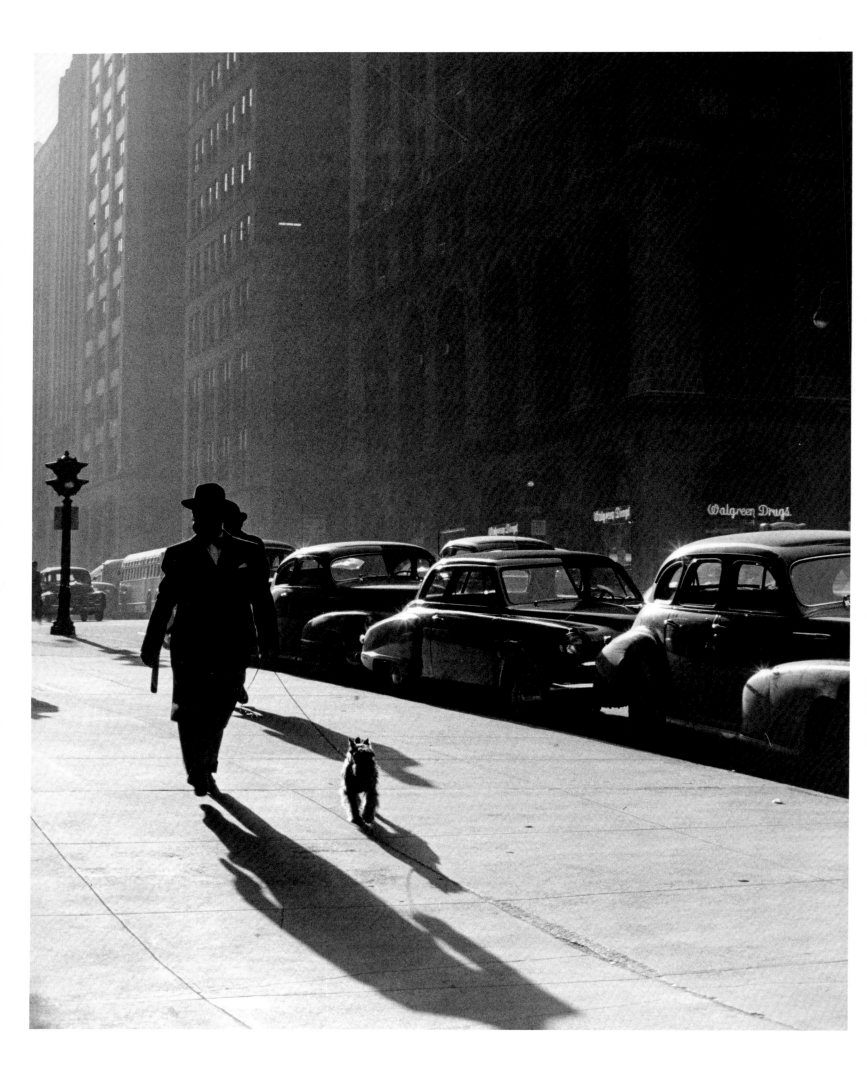

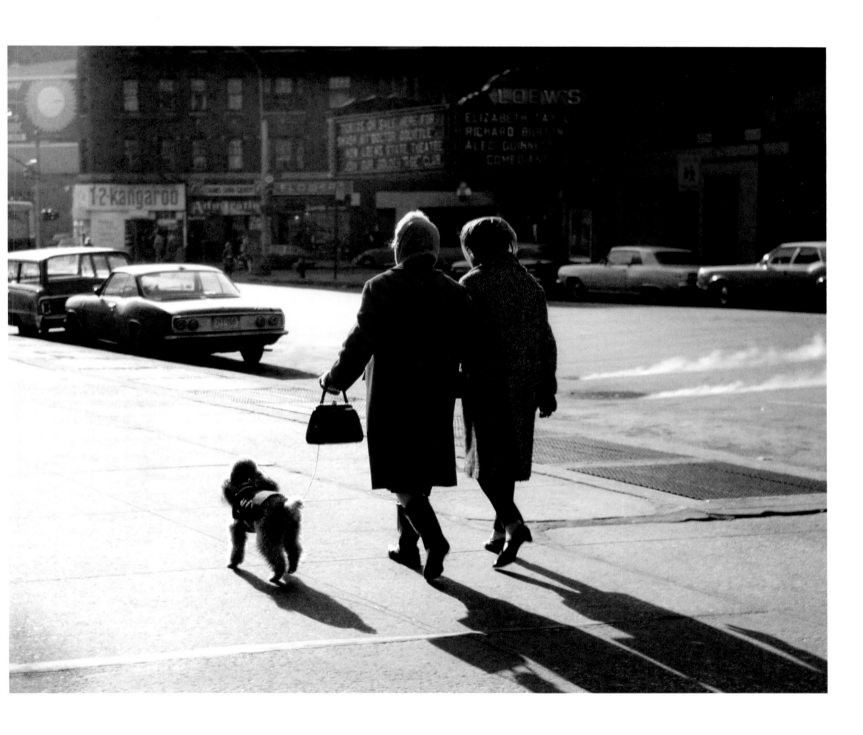

Miniature schnauzer, New York City, 1950

Poodle, New York City, 1968

Pages 236–237: Beagles, New Jersey, 1967

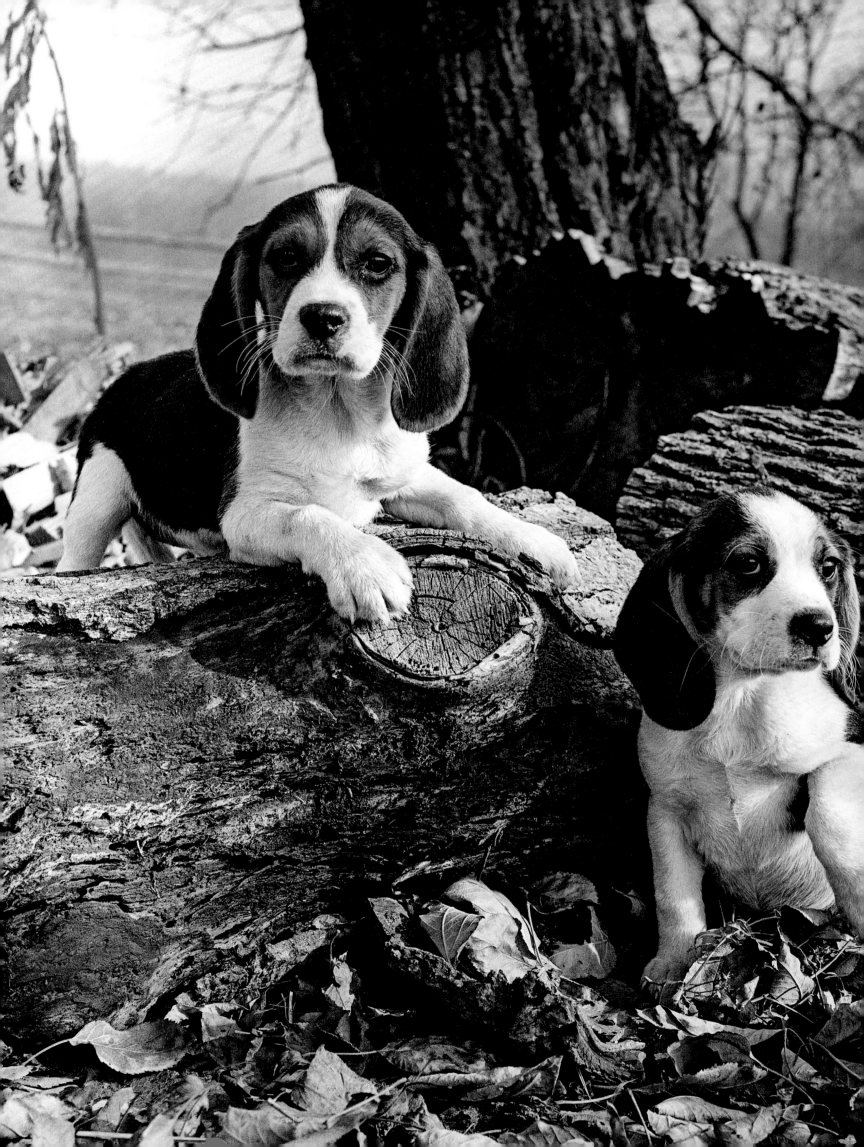

COUNTRY
DOGS

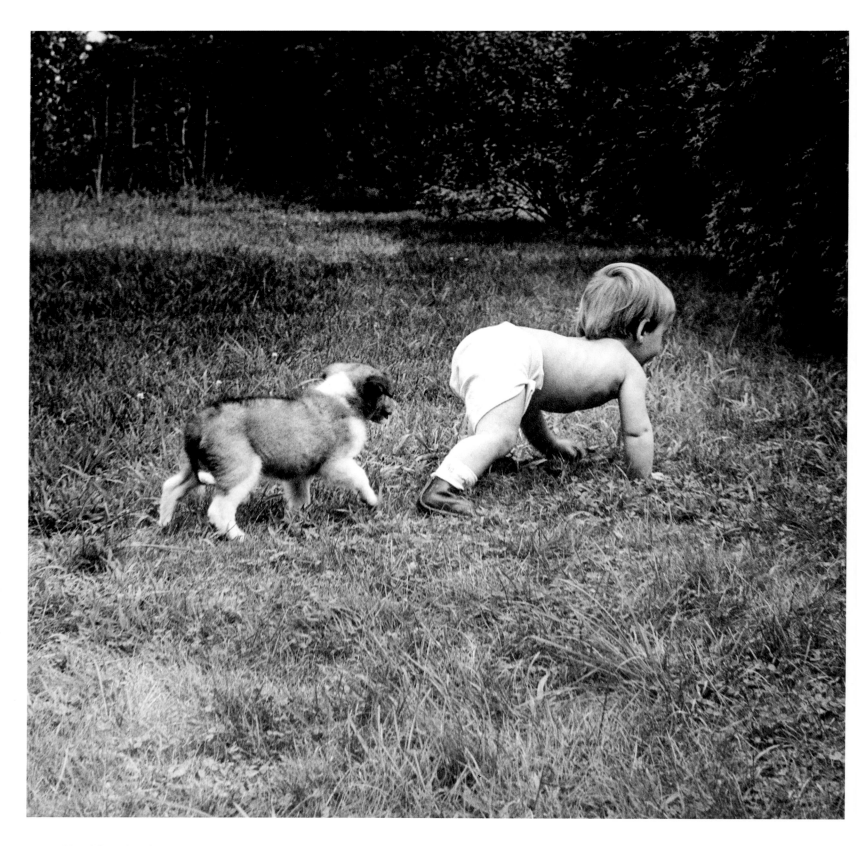

Mixed-breed and Enrico, 1952

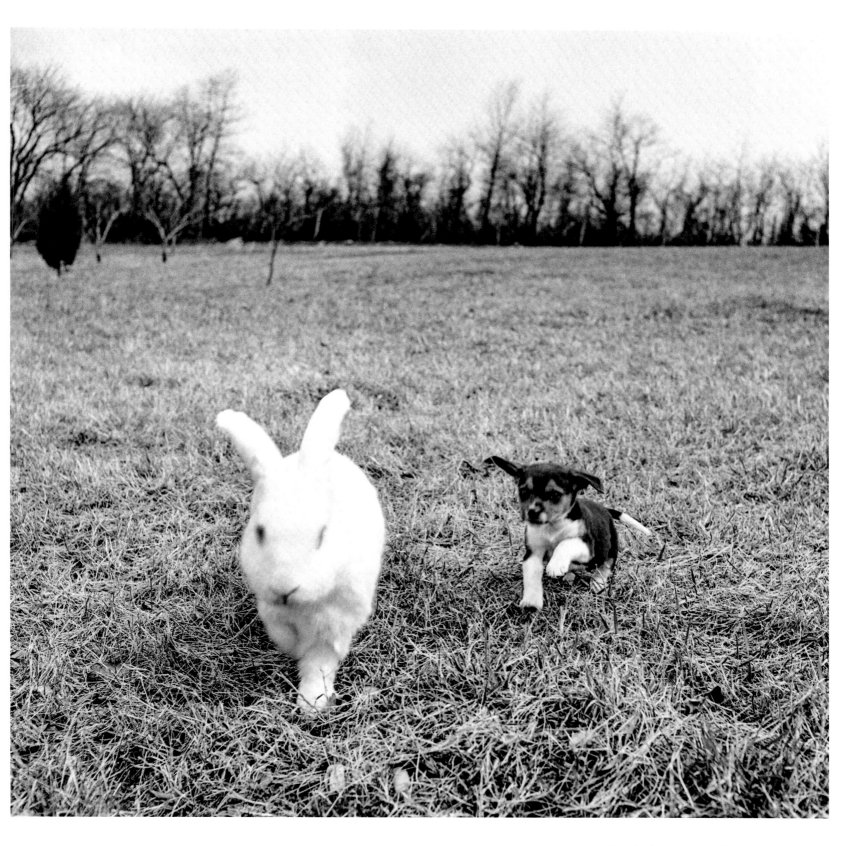

Beagle, Long Island, New York, 1957

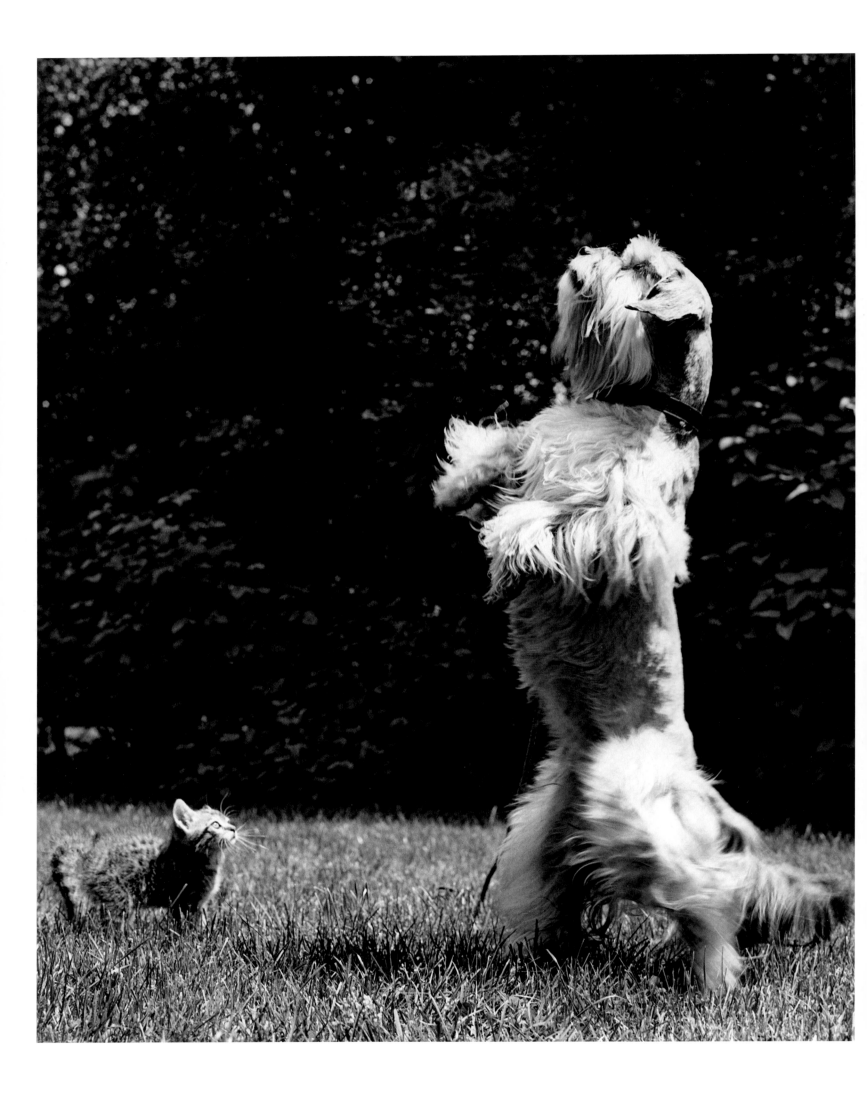

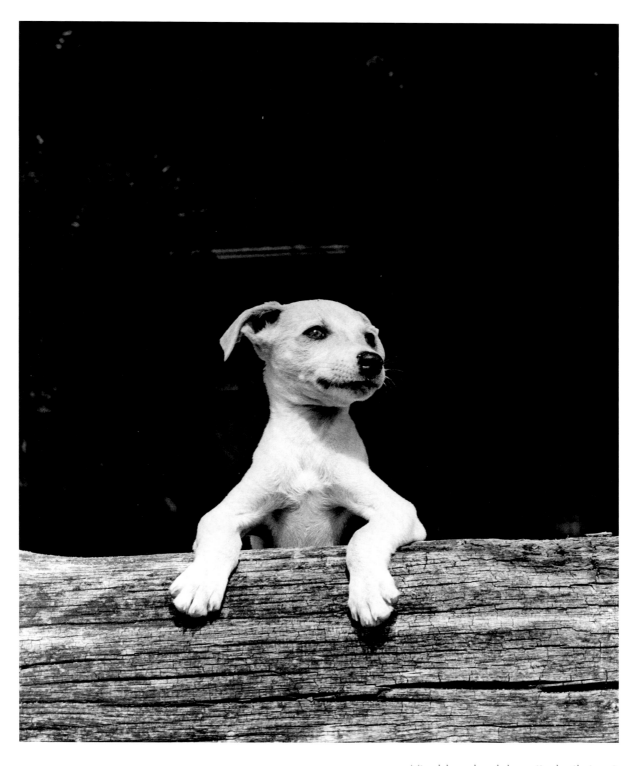

Mixed-breed and domestic shorthair cat,
New Jersey, 1965

Mixed-breed, New Jersey, 1953

Mixed-breed, New Jersey, 1966

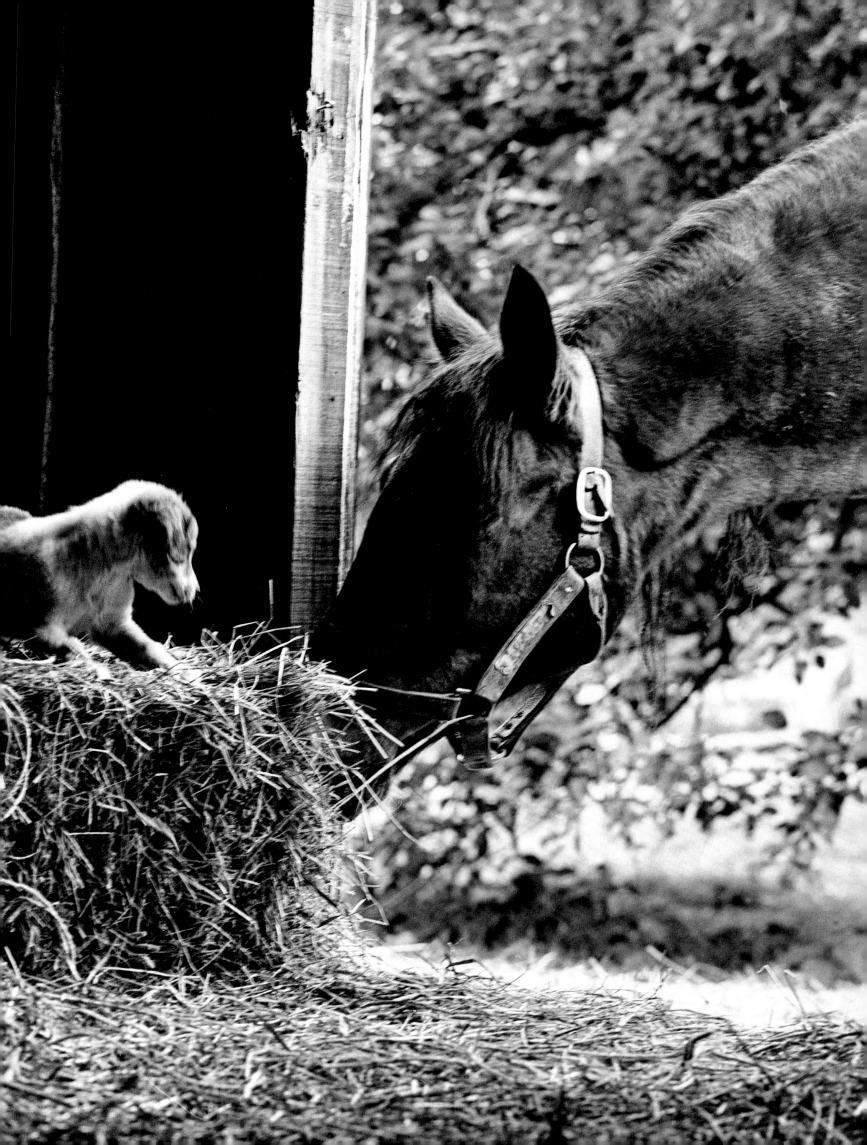

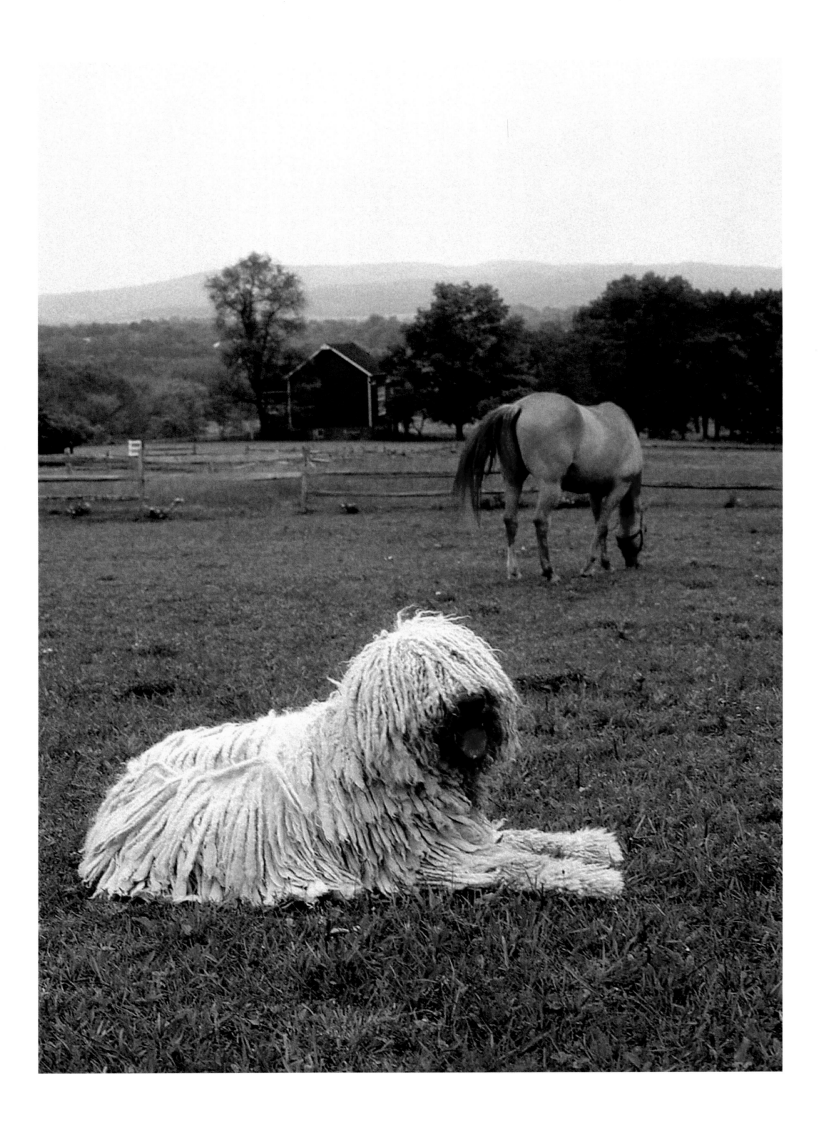

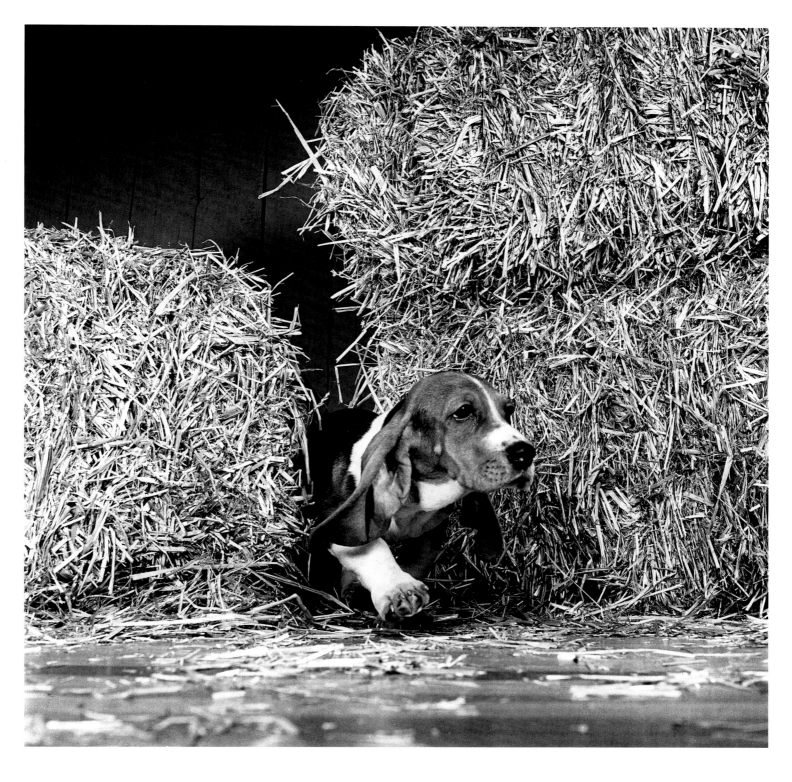

Komondor, New Jersey, 1981

Basset hound, Long Island, New York, 1954

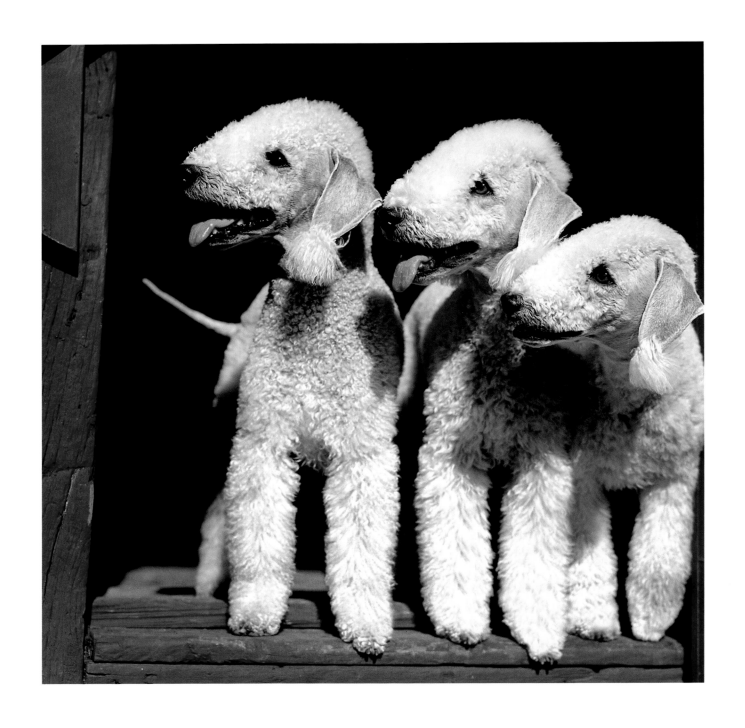

Bedlingtons, New Jersey, 1964

Labrador retriever, Long Island, New York, 1956

246

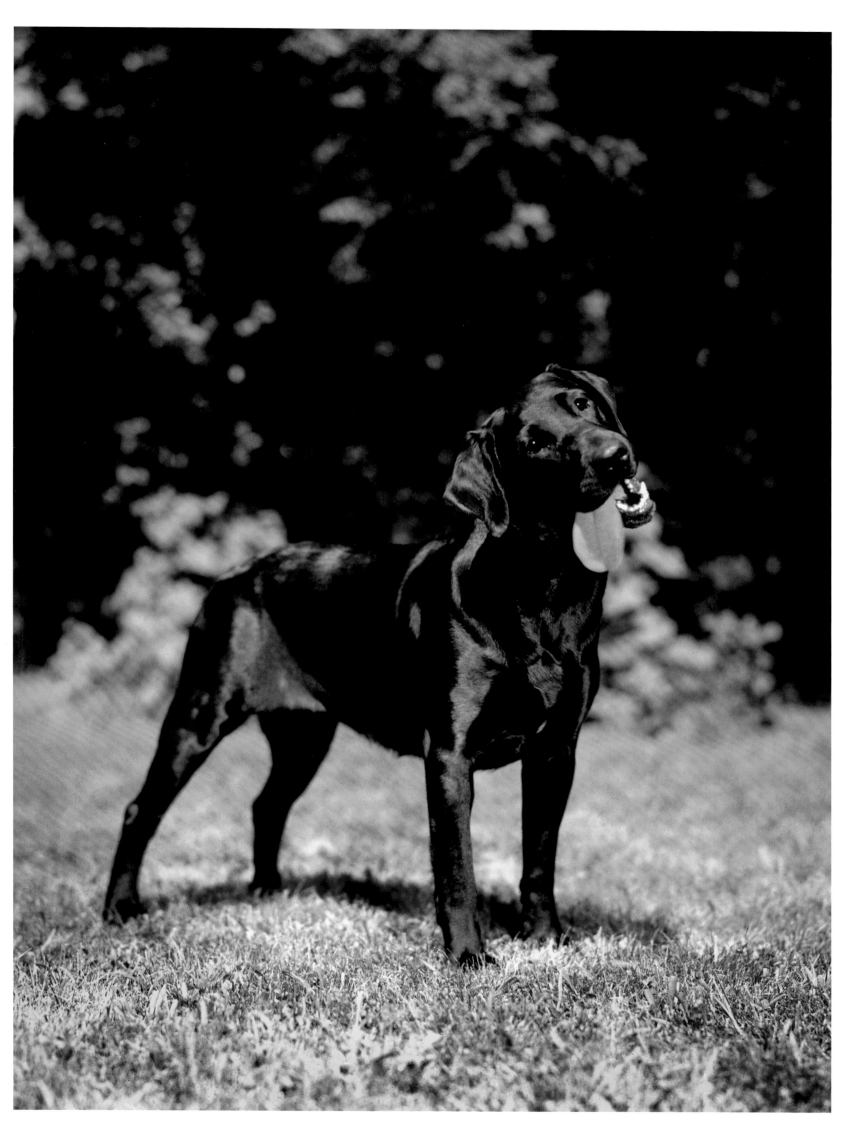

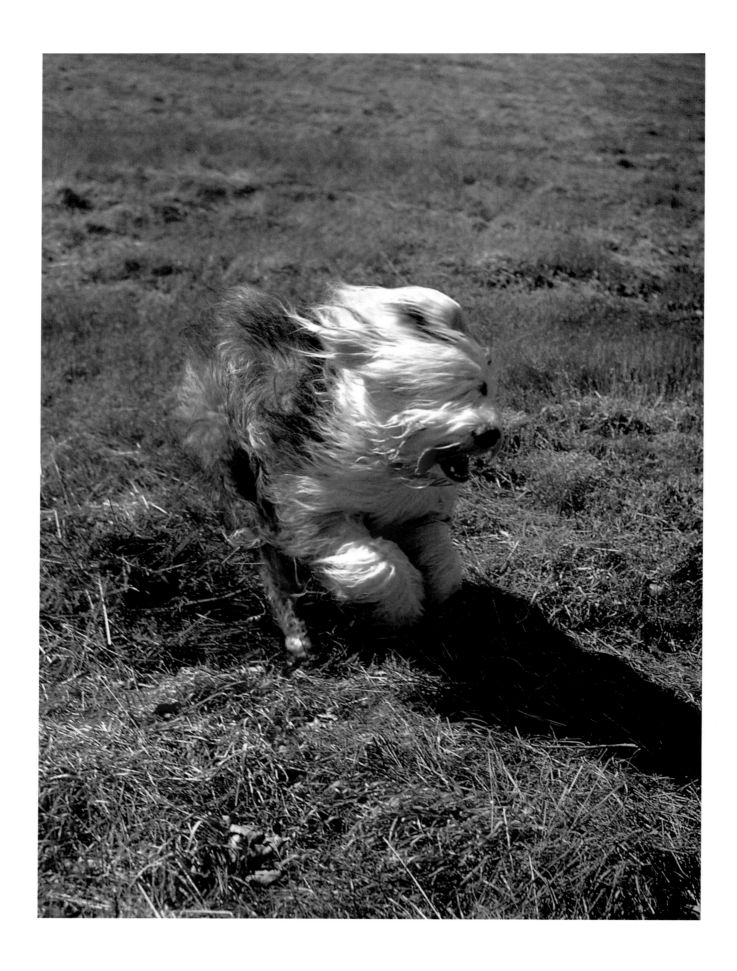

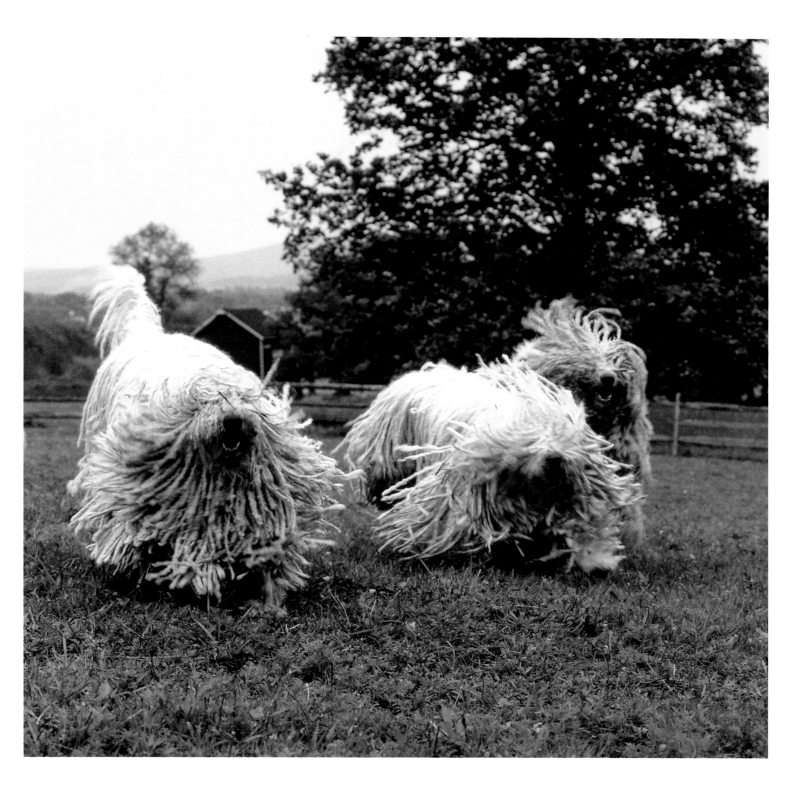

English sheepdog, New Jersey, 1968

Komondors, New Jersey, 1981

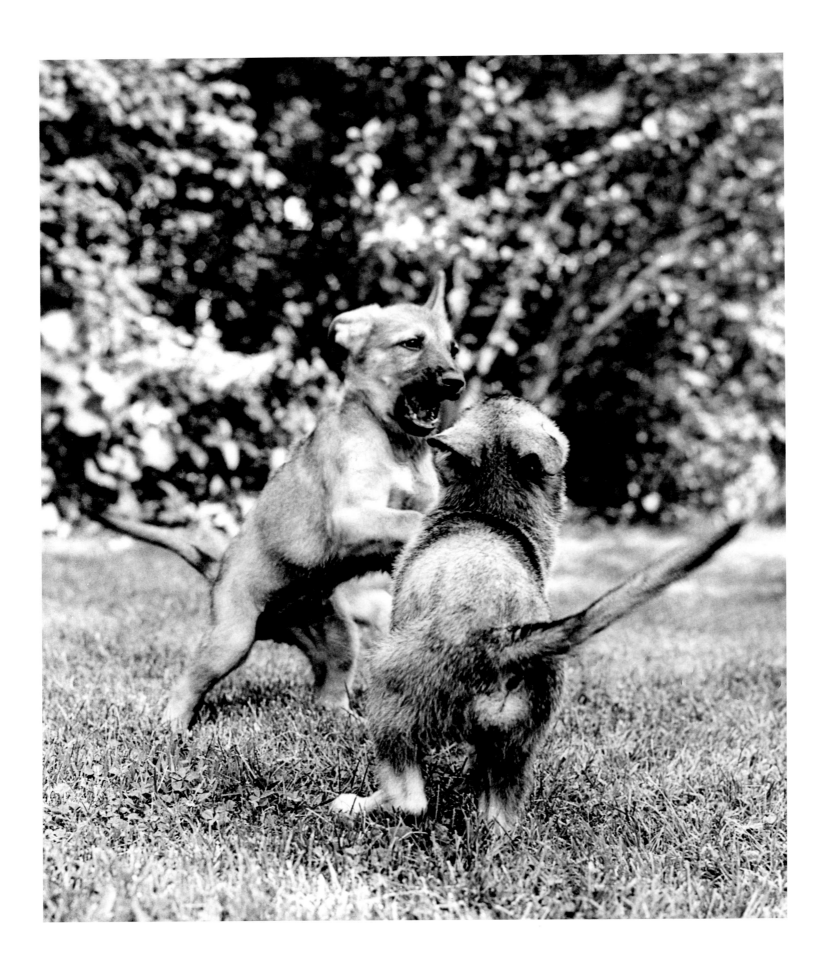

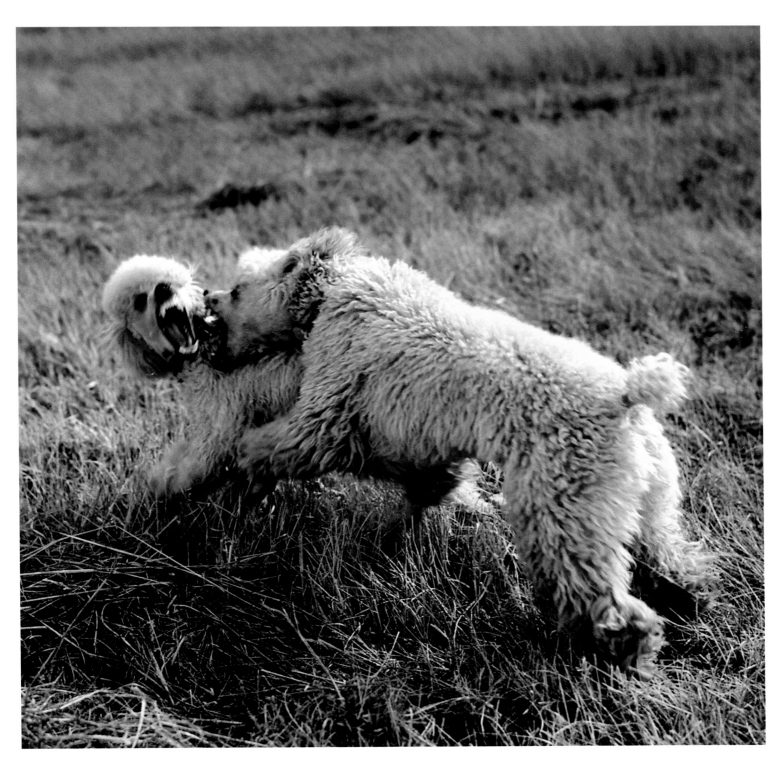

German shepherds, New Jersey, 1960

Poodles, New Jersey, 1968

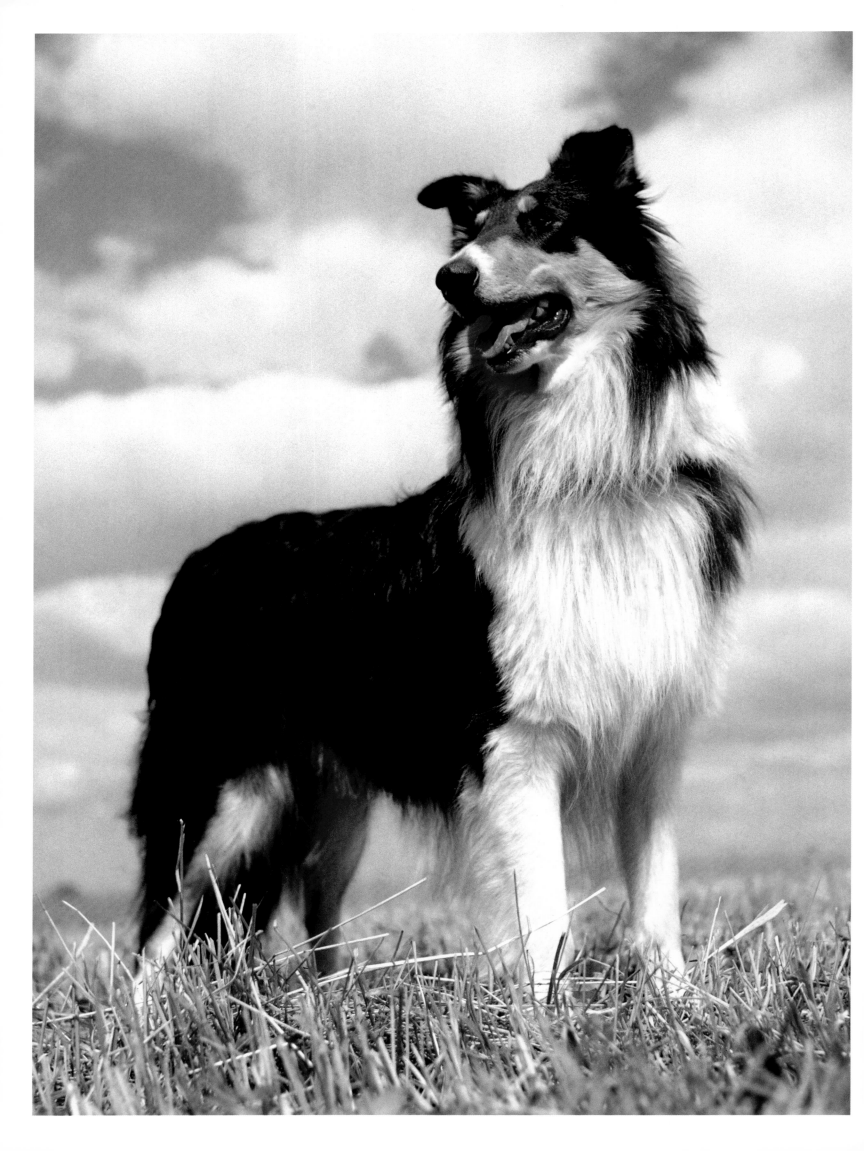

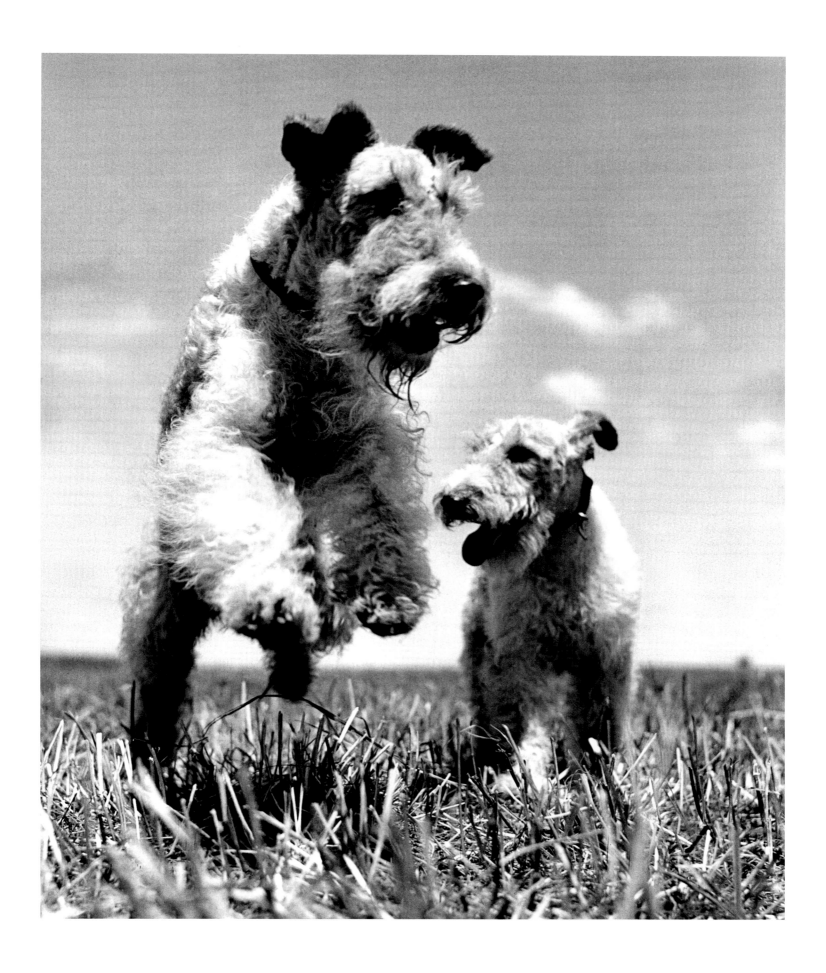

Page 252: Collie, Long Island, New York, 1958

Page 253: Wire hair fox terriers, Long Island, New York, 1958

Scottish deerhounds, New Jersey, 1966

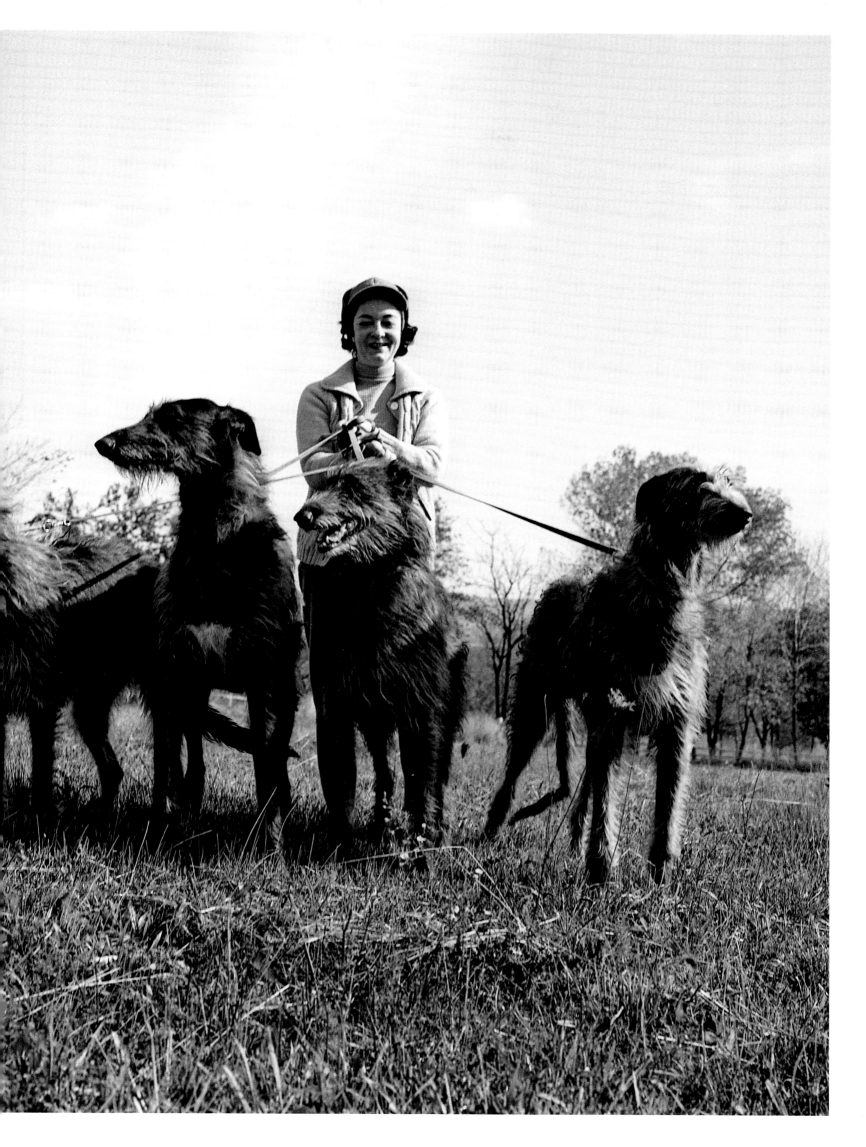

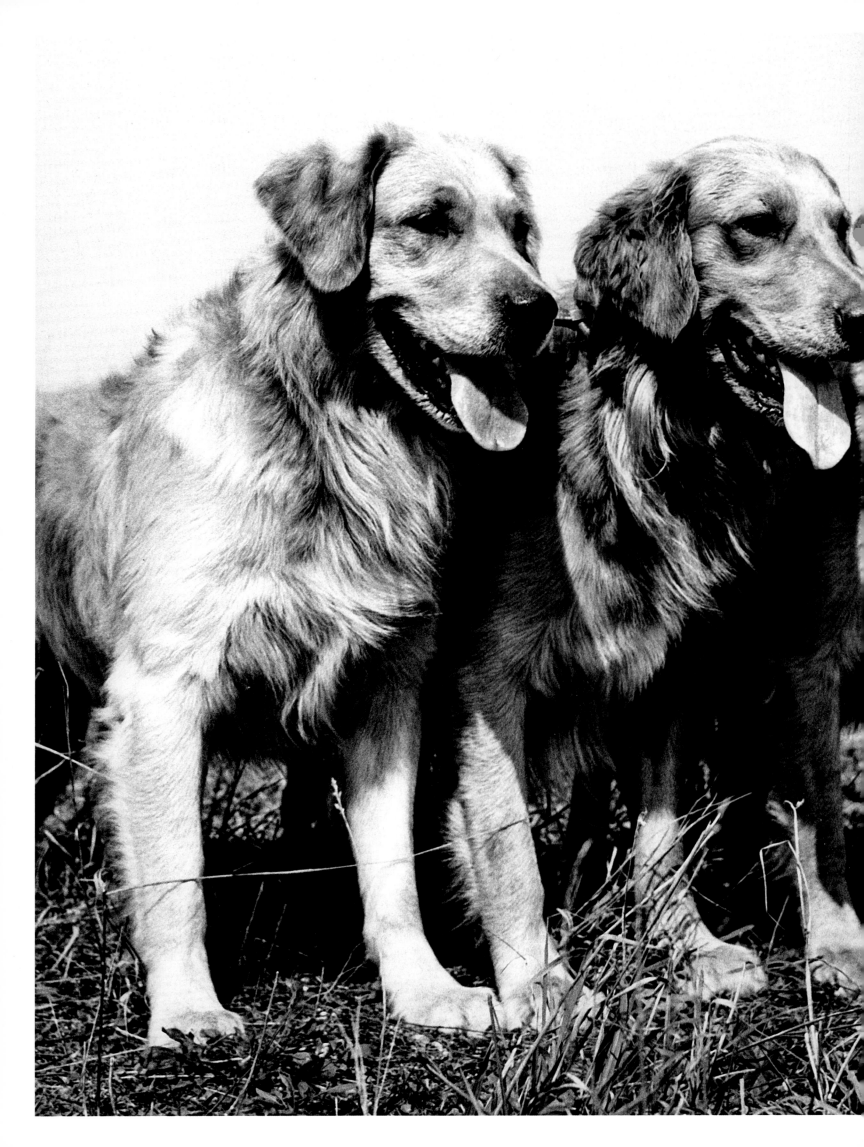

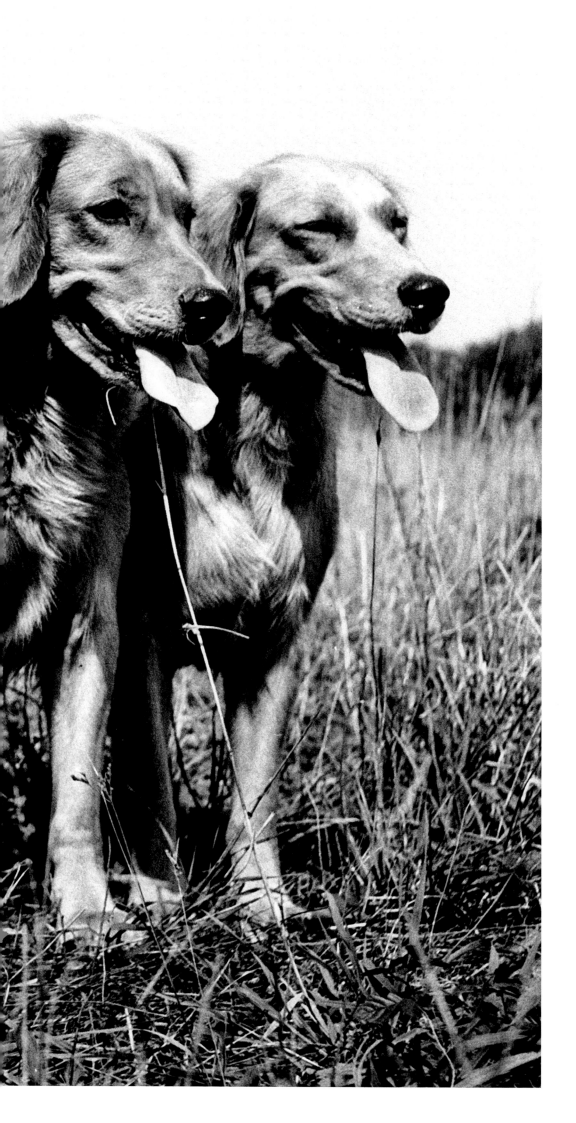

Golden retrievers, Long Island,
New York, 1955

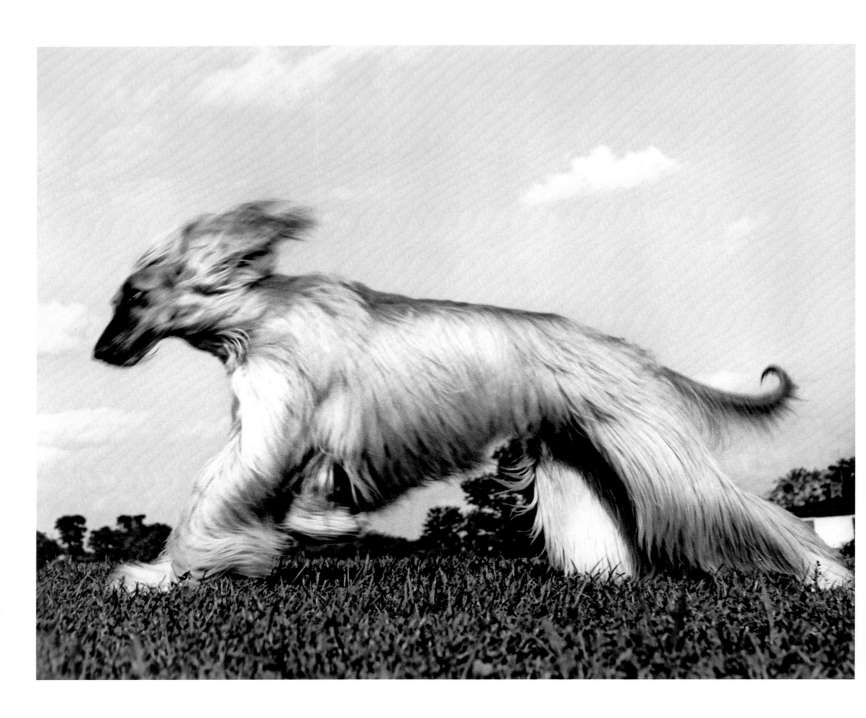

Afghan, Long Island, New York, 1952

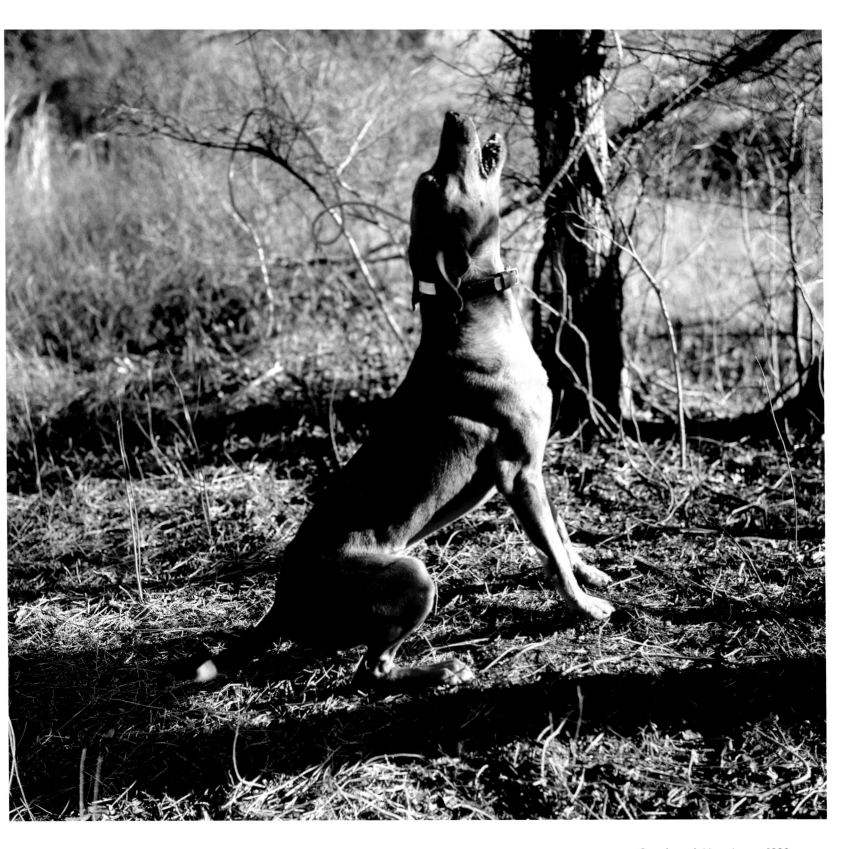

Coonhound, New Jersey, 1980

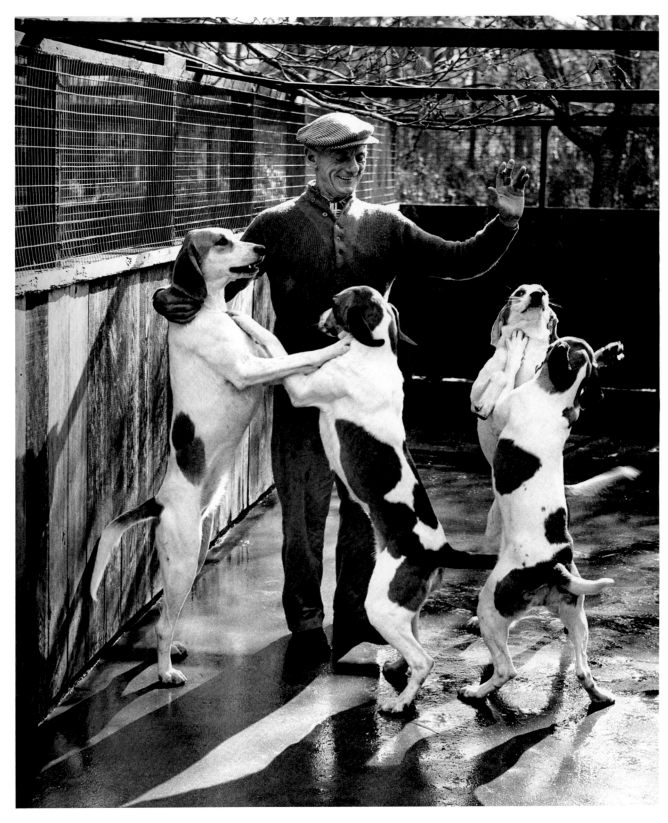

Foxhounds, Long Island, New York, 1958

Golden retriever, New Jersey, 1961

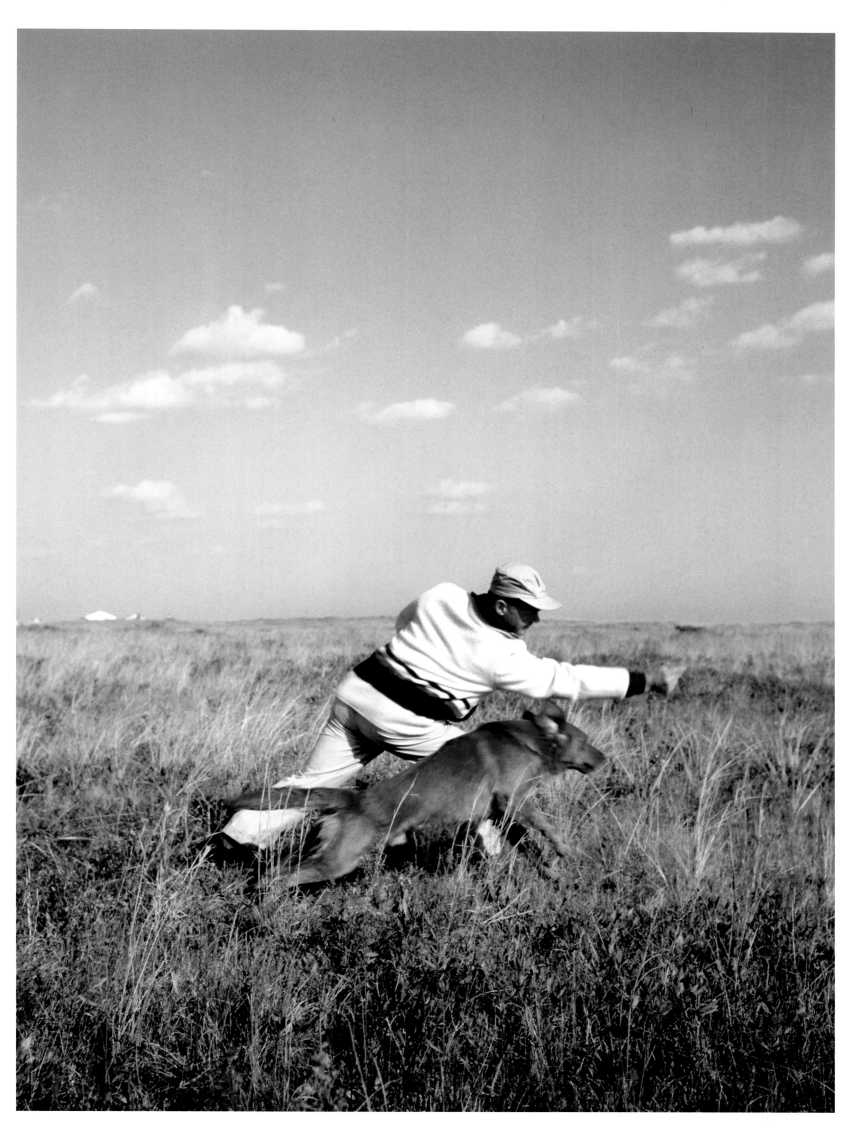

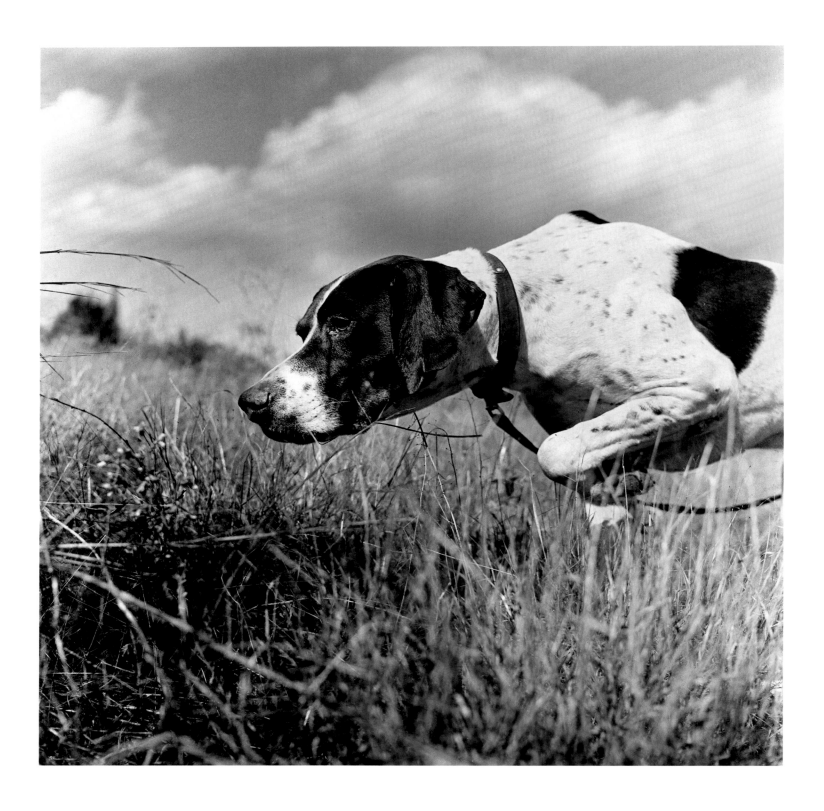

Pointer, Long Island, New York, 1959

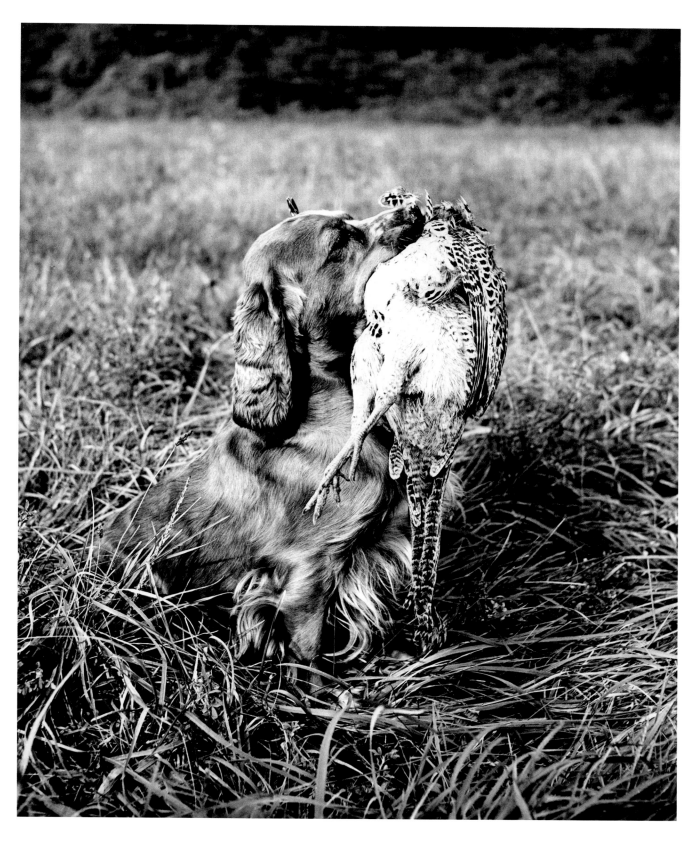

Cocker spaniel, Long Island, New York, 1953

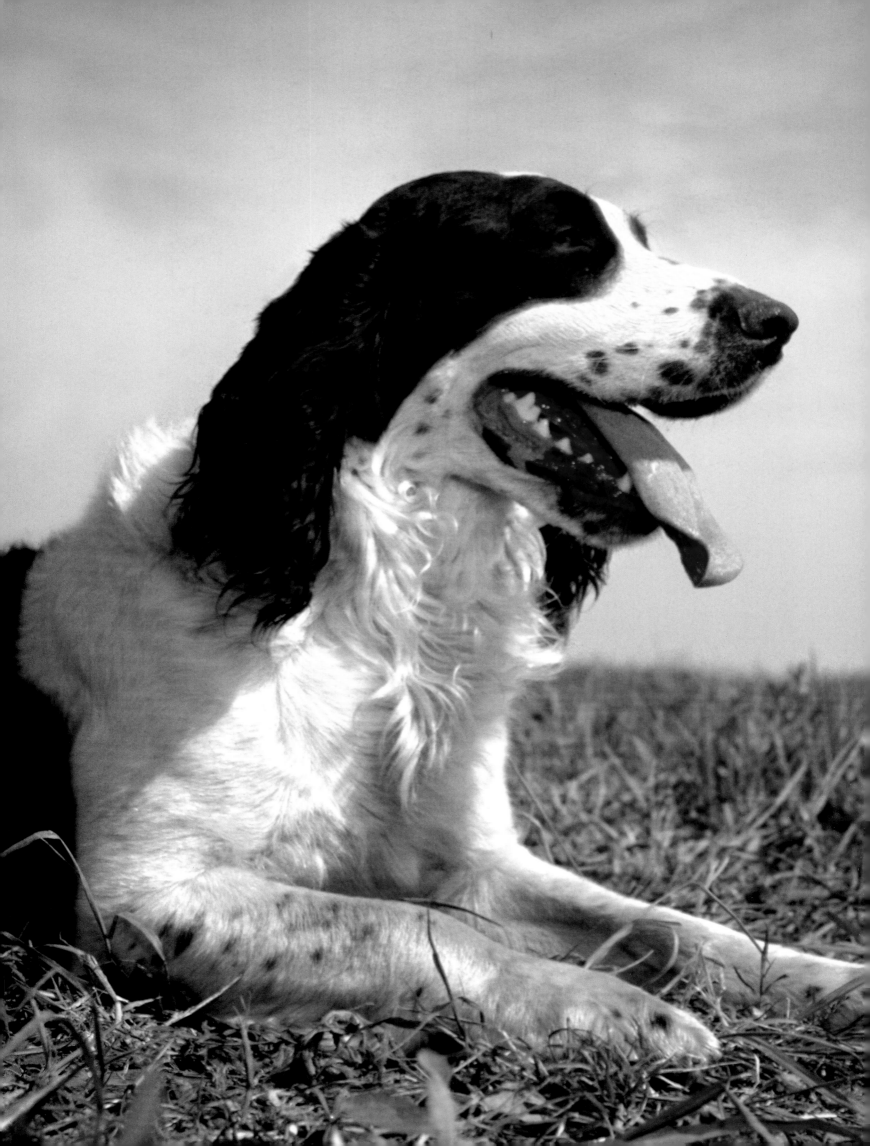

Springer spaniel, Long Island, 1957

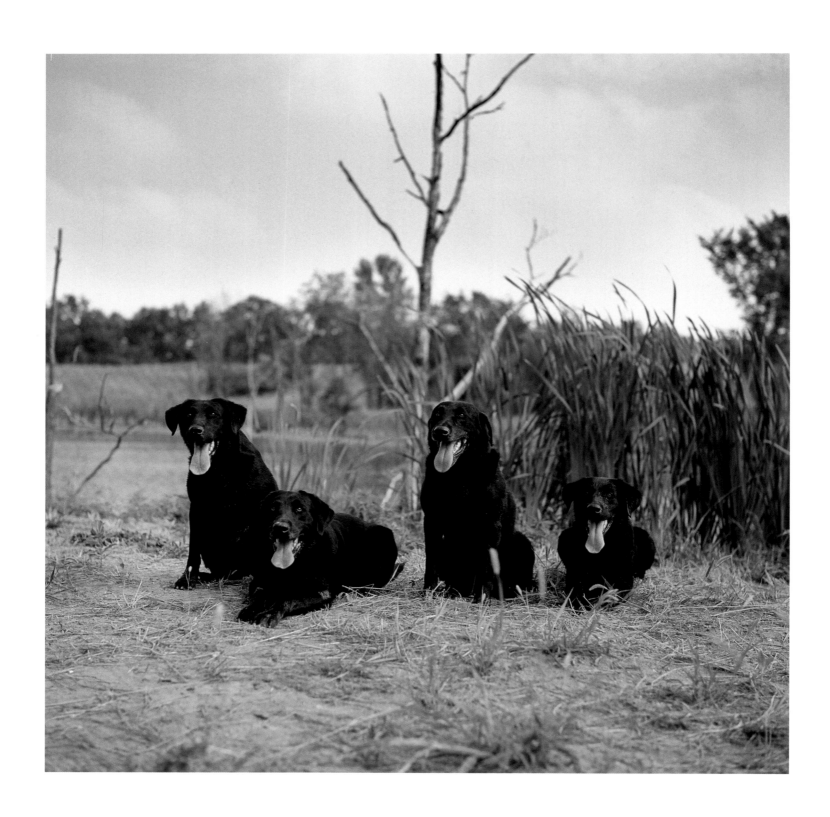

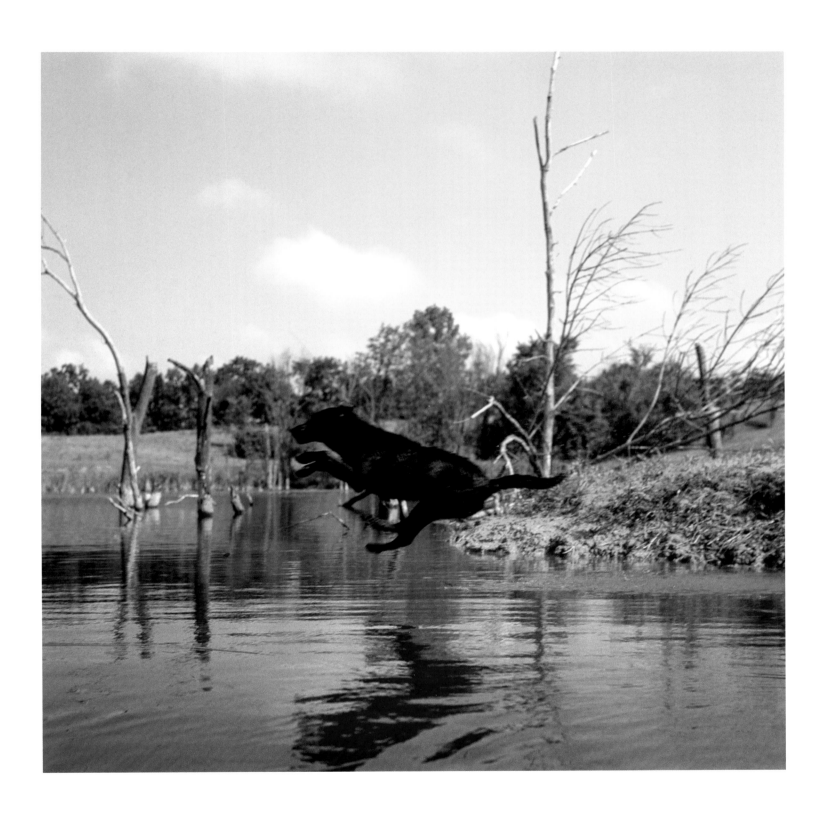

This spread: Labrador retrievers, New Jersey, 1985

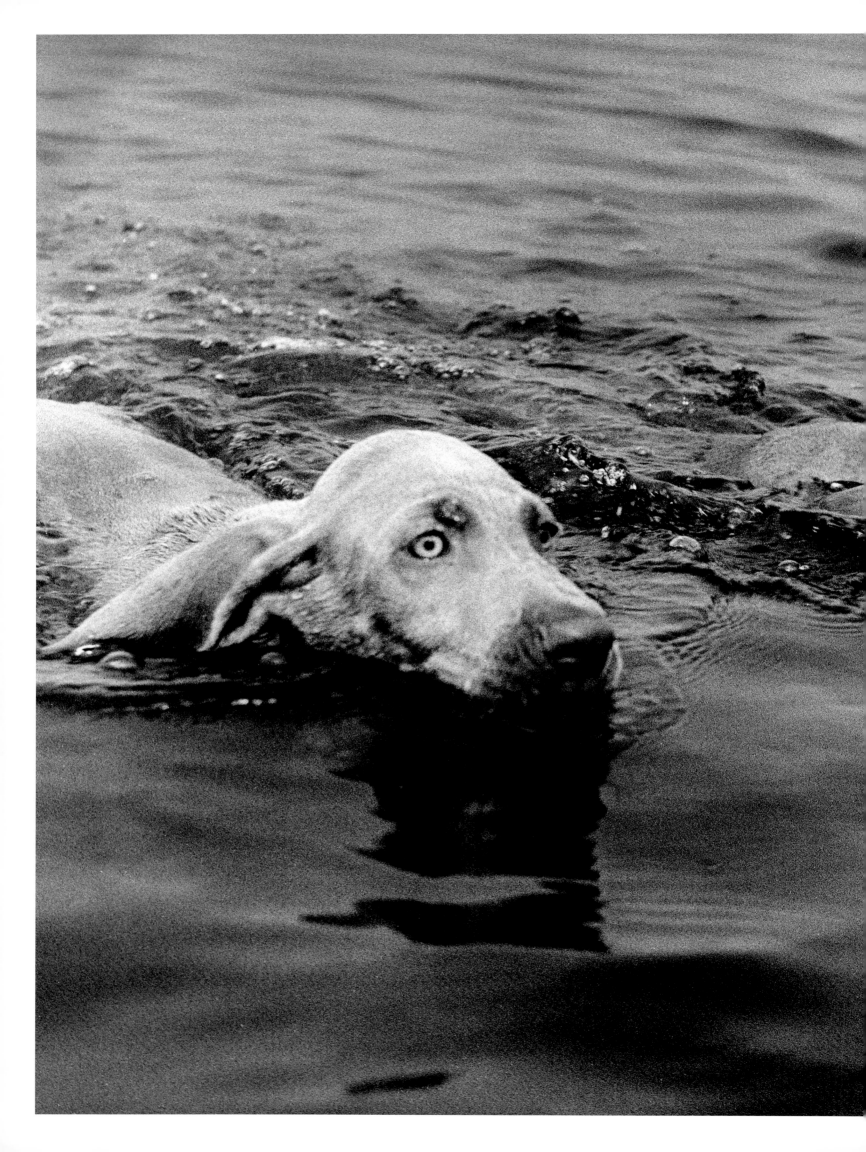

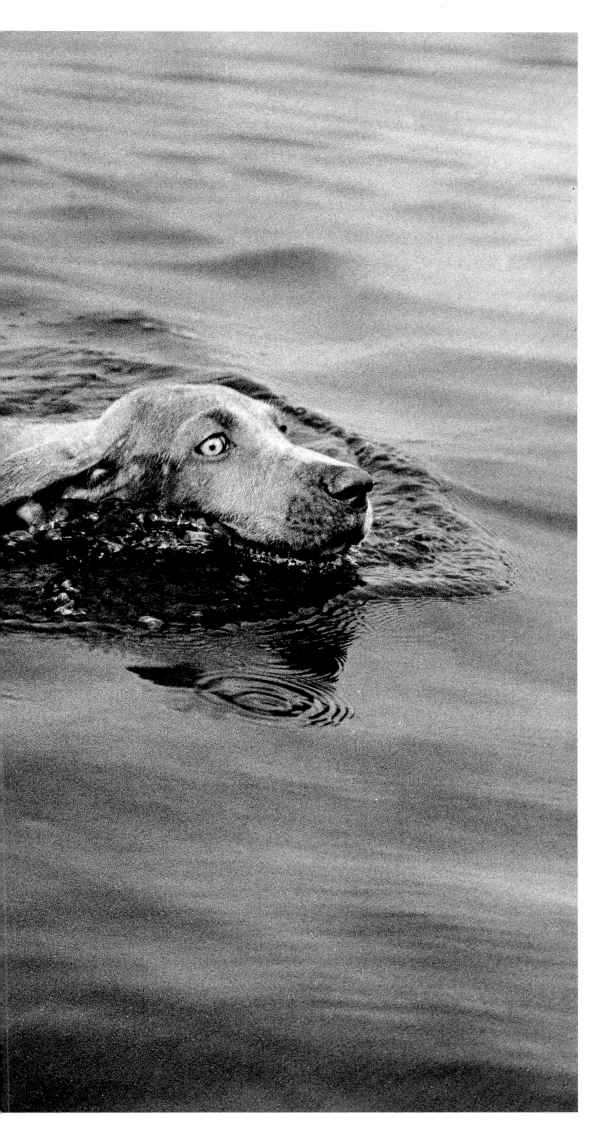

Weimaraners, Long Island,
New York, 1956

Pages 270–271: Collie, Long Island,
New York, 1959

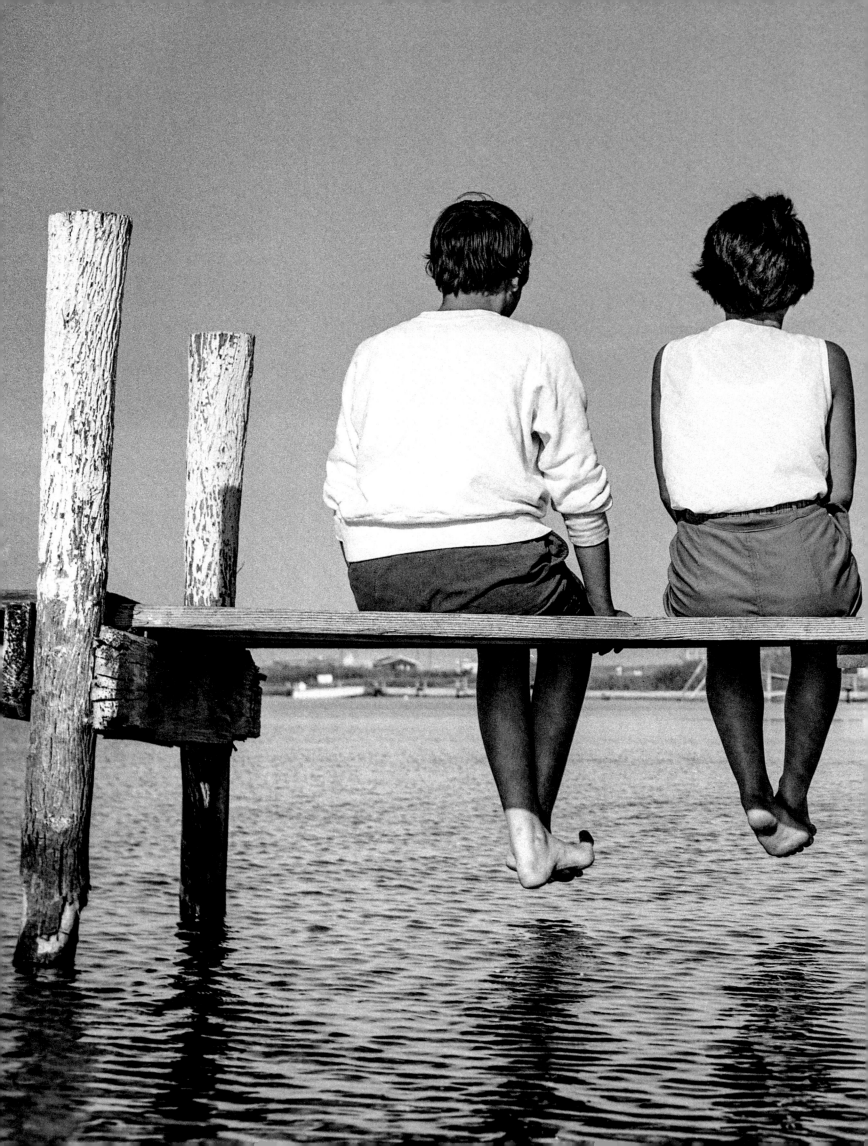

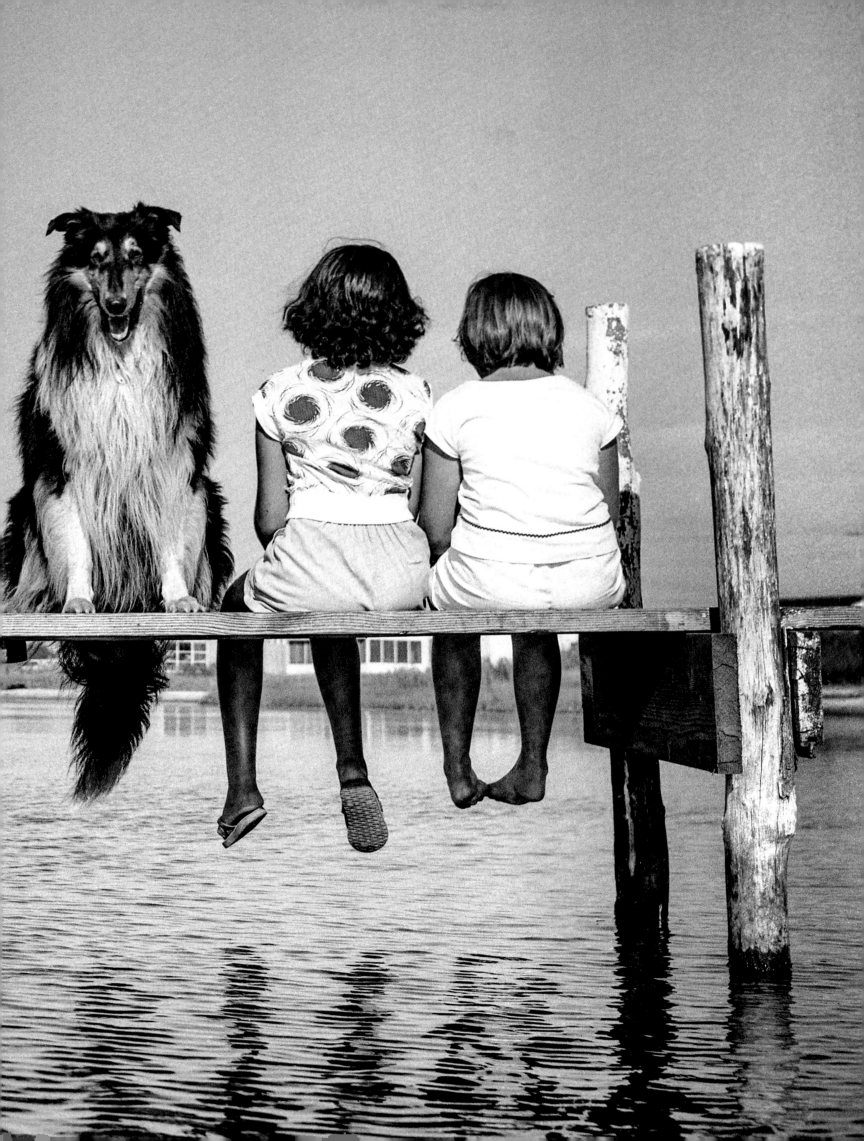

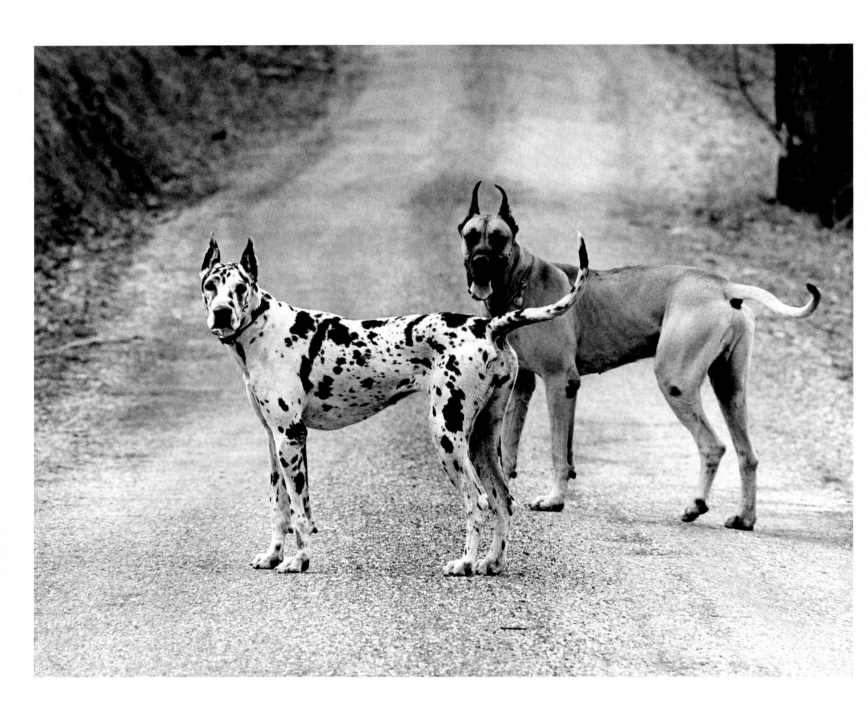

Great Danes, New Jersey, 1964

Mixed-breed, New Jersey, 1957

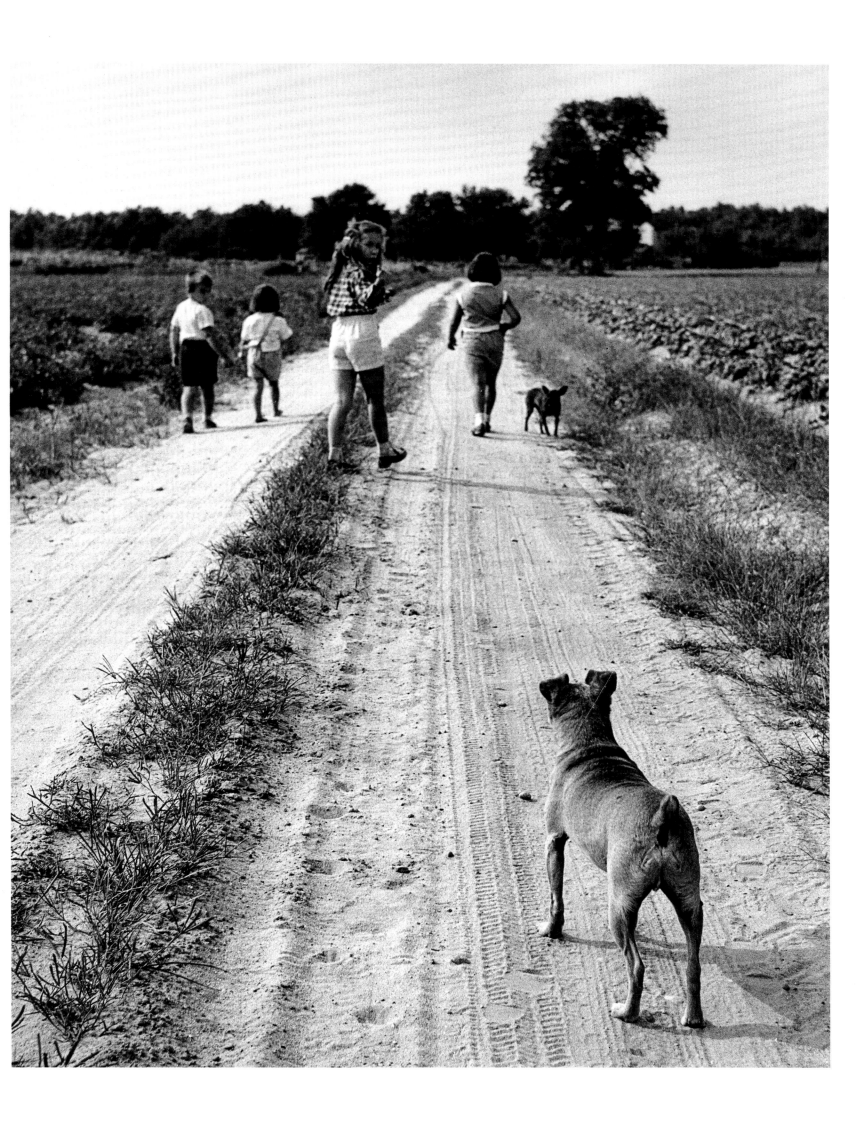

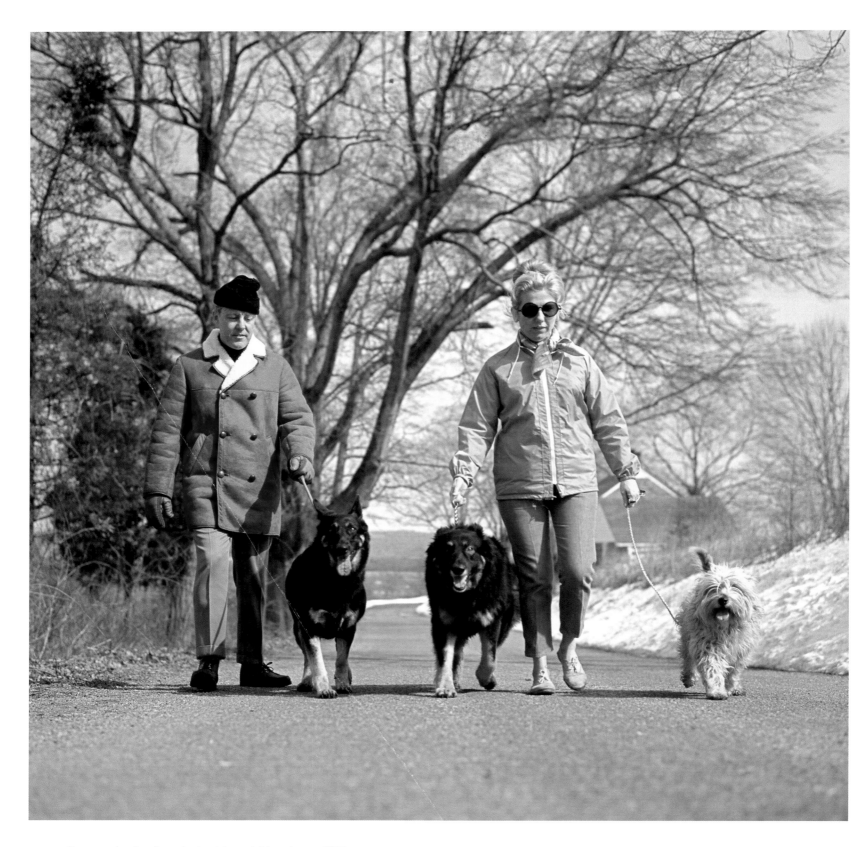

German shepherds and mixed-breed, New Jersey, 1968

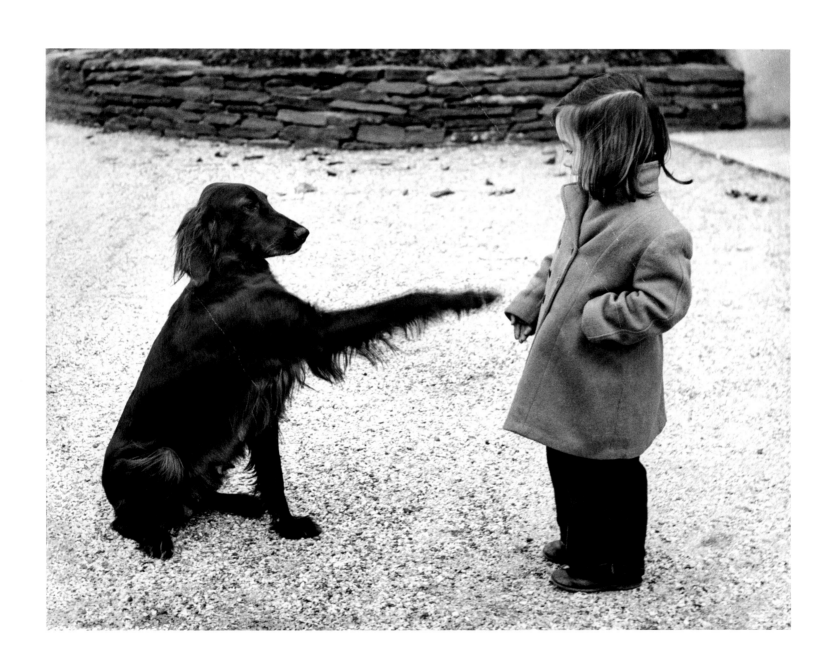

Irish setter and Paula, Long Island, New York, 1953

Pages 276–277: Mixed-breed and Chiara, New Jersey, 1969

Wire hair fox terrier, Long Island, New York, 1959

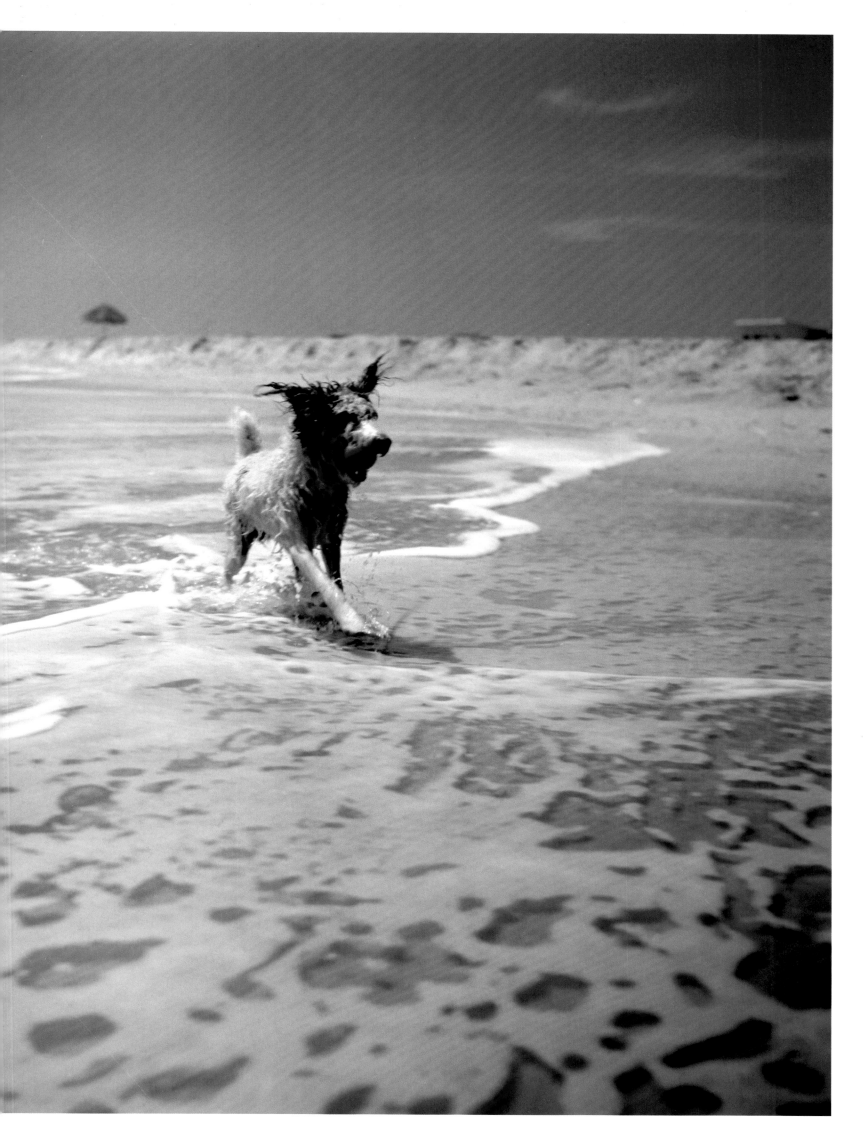

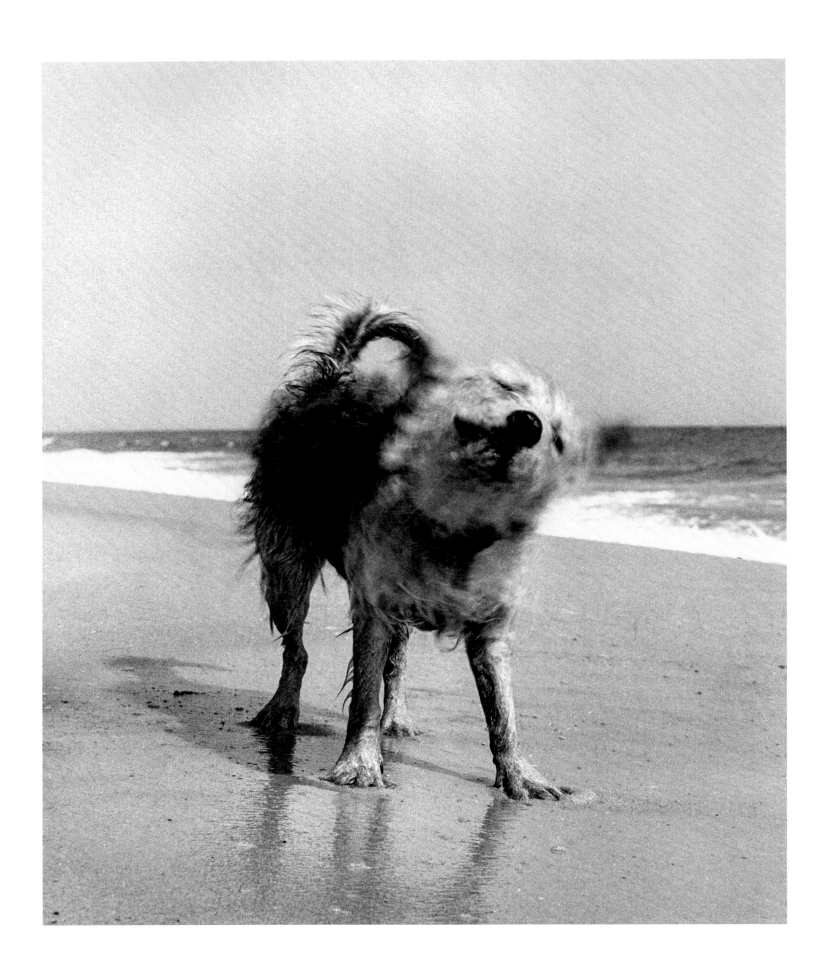

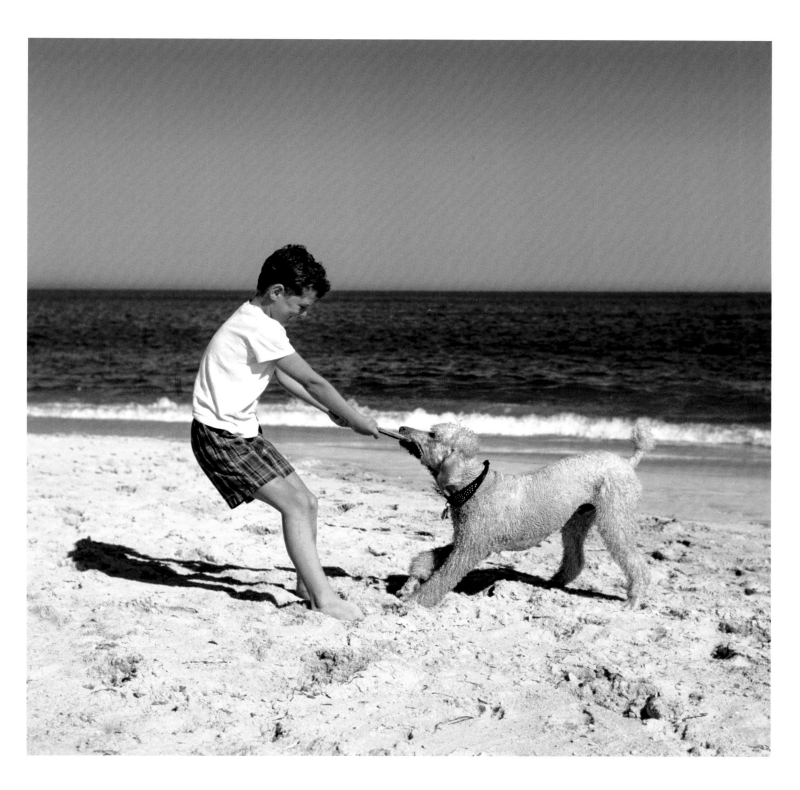

Mixed-breed, Long Island, New York, 1959

Poodle, Long Island, New York, 1959

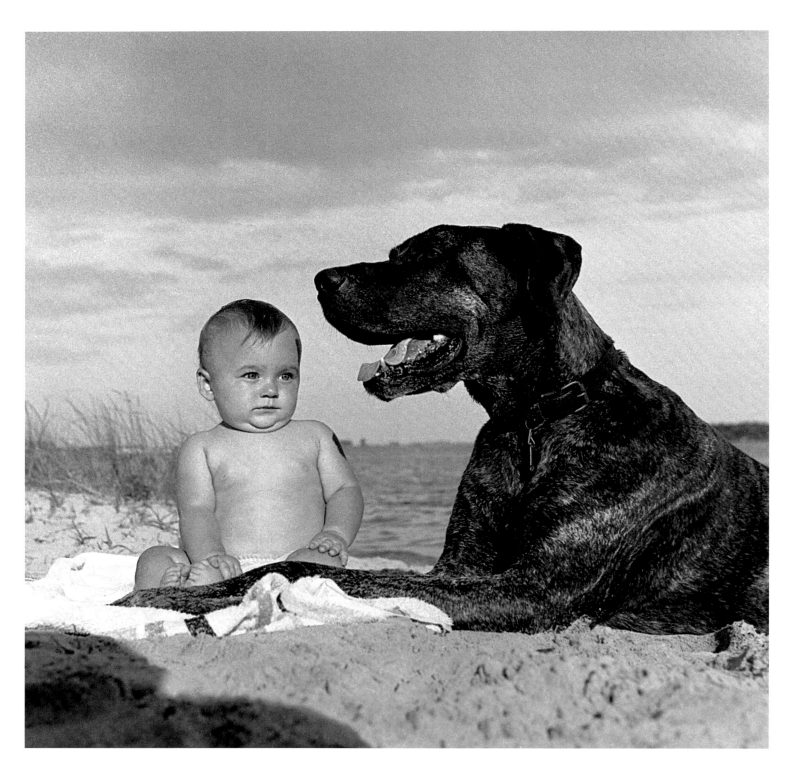

Great Dane and Paula, Long Island, New York, 1950

Saluki, Long Island, New York, 1954

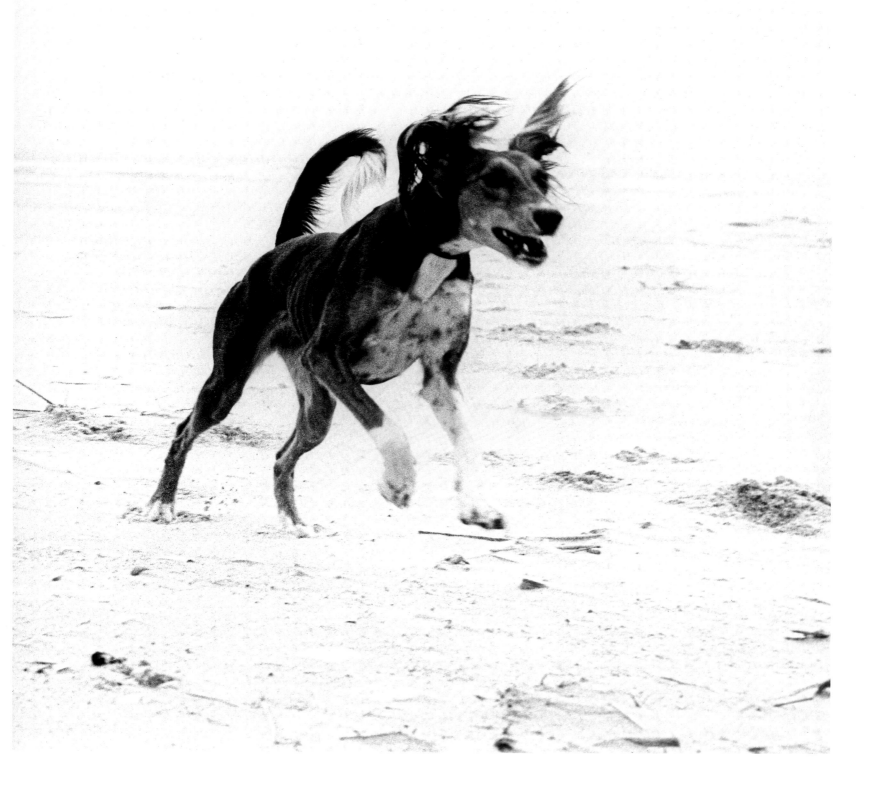

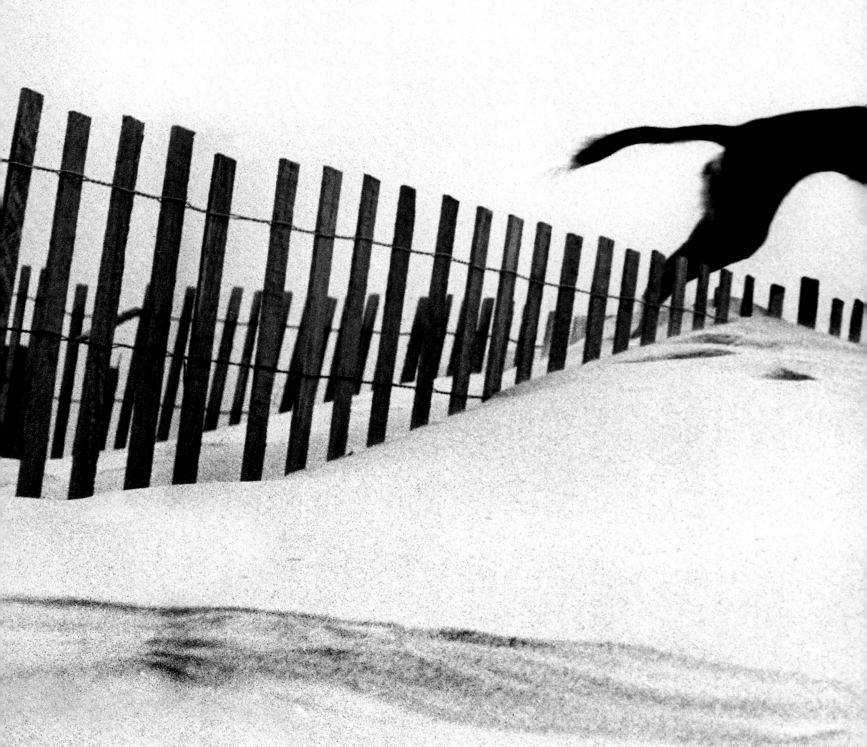

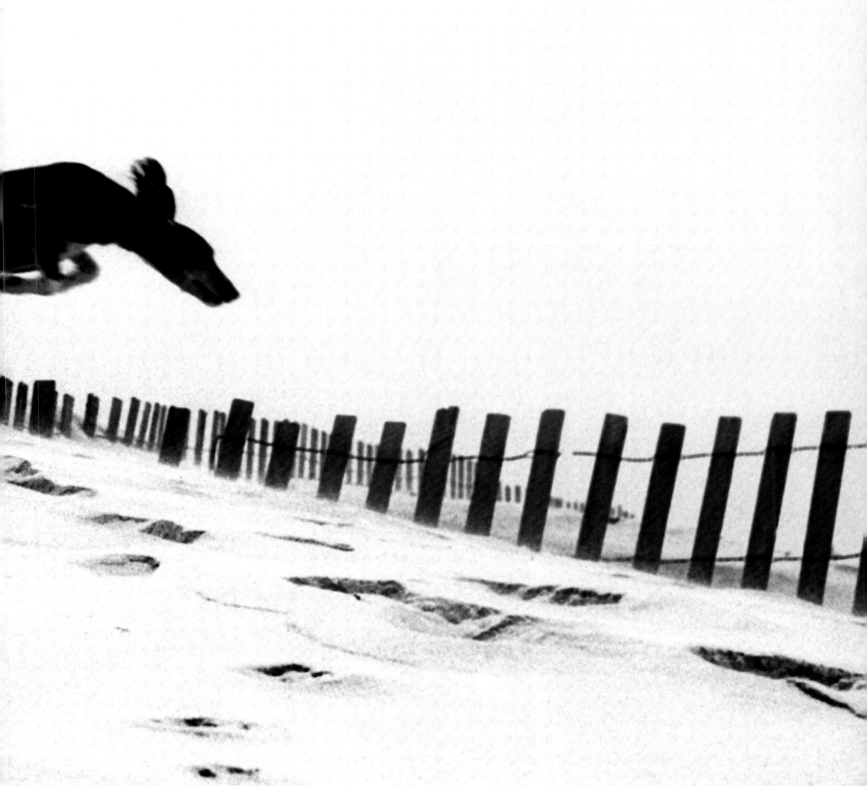

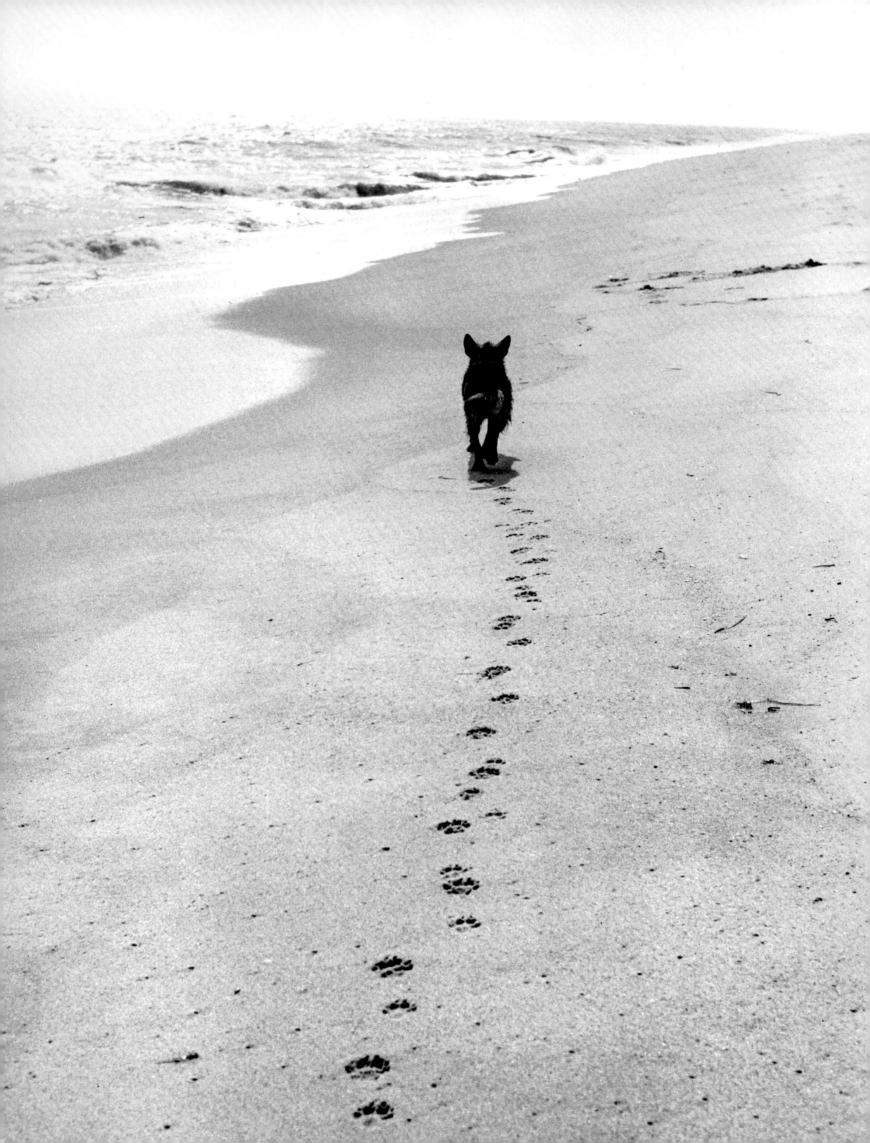

Pages 284–285: Saluki, Long Island, New York, 1954

Mixed-breed, Long Island, New York, 1959

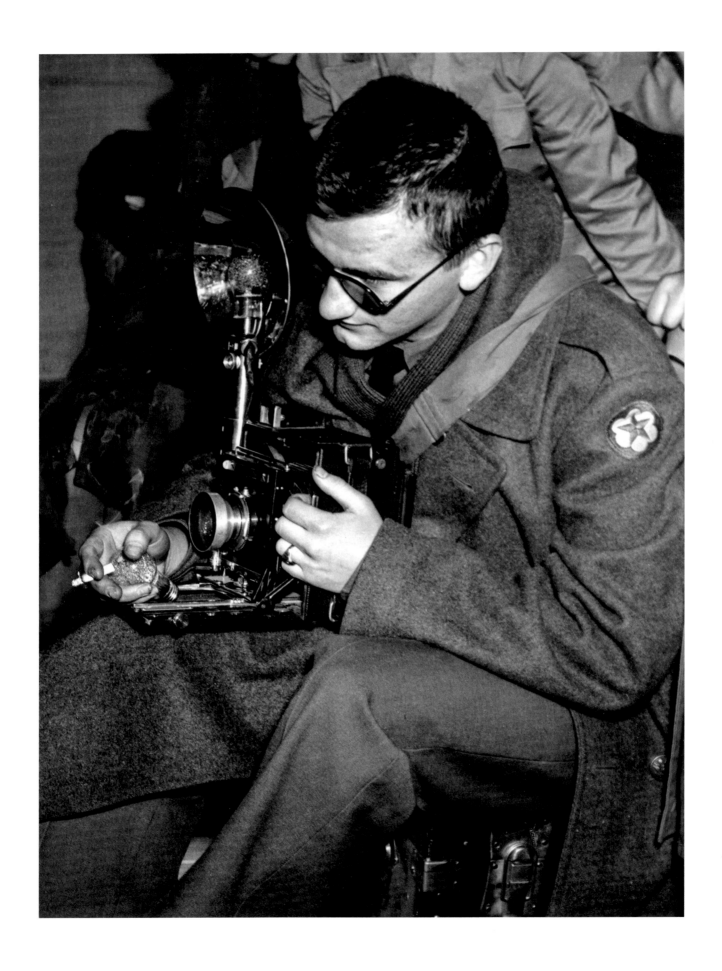

WALTER CHANDOHA
A PORTRAIT

WALTER CHANDOHA (1920–2019) is regarded as the world's greatest domestic animal photographer, with a career spanning more than seven decades and an archive of more than 200,000 photographs. His images have appeared on over 300 magazine covers and thousands of advertisements, packaging, and promotions. From the early 1950s onwards, Chandoha's eminently relatable photographs have been sought after by pet food brands such as Gaines, Milk Bone, Purina, KenL Ration, and Friskies, but also consumer brands as diverse as Old Gold cigarettes, Genesee Beer, Cheerios, American Express, and Ohrbach's department store. His images were regularly featured in picture magazines like *Life*, *Look*, and their equivalents around the world, as well as Sunday newspaper magazines such as *Parade*, *This Week*, and *Family Weekly*. The dominant camera and film companies of the era, including Kodak, Polaroid, Hasselblad, and Graflex used Chandoha and his work to promote their products to both professionals and consumers. His photographs were featured multiple times on Kodak's backlit 18' x 60' Colorama photographic display that towered over the main concourse in New York City's Grand Central Terminal, visited by millions of commuters. 35 books of Chandoha's work have been published since 1951.

Just after he passed away TASCHEN published *Cats. Photographs 1942–2018*.

Born in Bayonne, New Jersey to Ukrainian immigrant parents, Chandoha first became fascinated with photography when he was a teenager. After an apprenticeship with Leon de Vos, a top New York advertising photographer of the era, he served in the US Army during World War II as a combat photographer in the Signal Corp. Upon his return to civilian life in 1946, he lived in New York City and attended New York University on the GI Bill. In between classes, he documented the post-war city, photographing everything from the architectural splendor of the original Penn Station to a Belgian Shepherd eagerly guarding his turf in Greenwich village. Then one snowy winter night during Chandoha's last year in college, he came upon an abandoned kitten in the snow and brought him home to his wife Maria. The couple was captivated by the kitten's nightly antics, and they named the charismatic critter "Loco." Chandoha grabbed his camera and never turned back. It was the early photographs of Loco that garnered worldwide recognition and catapulted Chandoha into a lifetime of animal photography.

Walter Chandoha, US Army, ca. 1944

WALTER CHANDOHA
EIN PORTRÄT

Mit seinem mehr als sieben Jahrzehnte währenden Schaffen und einem über 200 000 Aufnahmen umfassenden Archiv gilt **WALTER CHANDOHA (1920–2019)** als der größte Heimtierfotograf der Welt. Seine Fotos schmückten über 300 Zeitschriftencover, Tausende Werbeanzeigen, Verpackungen und Promotionartikel. Von den frühen 50er-Jahren an waren seine unmittelbar ansprechenden Tierporträts begehrtes Werbematerial für Tierfuttermarken wie Gaines, Milk Bone, Purina, KenL Ration und Friskies, aber auch für verschiedenste Alltagsprodukte wie Zigaretten, Bier, Frühstücksflocken, Kreditkarten oder eine Kaufhauskette. Seine Bilder erschienen regelmäßig in Illustrierten wie *Life*, *Look* und deren Pendants in aller Welt oder in den Sonntagsbeilagen von Zeitungen, etwa in *Parade*, *This Week* und *Family Weekly*. Die führenden Kamera- und Filmhersteller seiner Zeit, unter ihnen Kodak, Polaroid, Hasselblad und Graflex, setzten auf Chandoha und seine Arbeit, um ihre Produkte bei Profifotografen wie Normalverbrauchern zu bewerben. Auf der 5½ x 18 Meter großen Kodak-Colorama-Leuchtreklame in der Schalterhalle des New Yorker Grand-Central-Bahnhofs erstrahlten seine Fotografien viele Male über den Köpfen von Millionen Fahrgästen. Seit 1951 sind 35 Bücher über sein Werk erschienen, darunter der kurz nach seinem Tod bei TASCHEN veröffentlichte Titel „Cats. Photographs 1942–2018".

Chandoha, geboren in Bayonne, New Jersey, als Kind ukrainischer Einwanderer, begann sich als Teenager für die Fotografie zu begeistern. Nach einer Lehre bei dem renommierten New Yorker Werbefotografen Leon de Vos diente er während des Zweiten Weltkriegs als Truppenfotograf der Fernmeldeeinheit in der US-Armee. 1946 ins Zivilleben zurückgekehrt, studierte er mit GI-Berechtigung an der Universität von New York. Zwischen den Vorlesungen dokumentierte er die Stadt in den Nachkriegsjahren und fotografierte, was ihm vor die Linse kam, sei es die glanzvolle Architektur des historischen Penn-Station-Bahnhofsgebäudes oder ein Belgischer Schäferhund, der in Greenwich Village scharf sein Revier bewacht. In seinem letzten Studienjahr stieß er eines verschneiten Winterabends auf ein herrenloses Kätzchen im Schnee und brachte es seiner Frau Maria mit nach Hause. Fasziniert von den nächtlichen Kapriolen des Kätzchens, nannten die beiden das charismatische Tierchen „Loco", also „verrückt". Chandoha griff zur Kamera, und ab dann gab es kein Halten mehr. Es waren diese frühen Fotos von Loco, die weltweit Beachtung fanden und ihn in eine Karriere als Tierfotograf hineinkatapultierten.

Walter Chandoha, Long Island, New York, 1955

WALTER CHANDOHA
UN PORTRAIT

WALTER CHANDOHA (1920–2019) est considéré comme le plus grand photographe d'animaux domestiques au monde, riche de sept décennies de carrière et de quelque 200 000 clichés archivés. Ses photos ont fait plus de 300 couvertures de magazines et illustré des milliers de publicités, d'emballages et d'opérations commerciales. À partir du début des années 1950, les images de Chandoha, qui parlaient à tous, furent très prisées des marques de nourriture pour animaux comme Gaines, Milk Bone, Purina, KenL Ration et Friskies, mais aussi de marques grand public aussi diverses que les cigarettes Old Gold, la bière Genesee, Cheerios, American Express ou le grand magasin Ohrbach's. Ses photos parurent régulièrement dans des magazines prestigieux comme *Life*, *Look* et leurs équivalents dans le monde entier, ainsi que dans des suppléments du dimanche comme *Parade*, *This Week* et *Family Weekly*. Les plus importants fabricants d'appareils et de pellicules photo, notamment Kodak, Polaroid, Hasselblad et Graflex, utilisèrent Chandoha et son œuvre pour faire la promotion de leurs produits, auprès des professionnels et des consommateurs. Ses photos apparurent bien des fois sur le panneau rétro-éclairé en colorama Kodak de 5,5 x 18 m qui domine le hall principal de la gare de Grand Central, à New York, traversé chaque jour par des millions de voyageurs. Depuis 1951, 35 livres ont été consacrés au travail de Chandoha. Juste après son décès, TASCHEN a publié *Cats. Photographs 1942–2018*.

Né à Bayonne, dans le New Jersey, de parents immigrés ukrainiens, Chandoha se passionna pour la photo dès l'adolescence. Il fit son apprentissage auprès de Leon de Vos, photographe publicitaire new-yorkais très en vue à l'époque, puis servit dans l'armée américaine pendant la Seconde Guerre mondiale en tant que photographe de guerre au service des transmissions. À son retour à la vie civile, en 1946, il vécut à New York, où il fréquenta l'Université grâce au GI Bill. Entre deux cours, il immortalisait la ville, photographiant tout ce qui attirait son regard, de la splendeur architecturale de l'ancienne Penn Station à un berger belge protégeant farouchement son territoire à Greenwich Village. Puis un soir d'hiver, pendant sa dernière année de fac, Chandoha tomba sur un chaton perdu dans la neige et le rapporta à son épouse Maria. Le couple fut vite captivé par les facéties nocturnes du charismatique matou, qu'il baptisa « Loco ». Chandoha attrapa son appareil et ne le lâcha plus. Ce sont ces premières photos de Loco qui lui valurent une reconnaissance internationale et le catapultèrent dans une vie entière consacrée à la photo animalière.

Walter Chandoha, Long Island, New York, 1955

The Chandoha family dedicates this book to Walter, Maria and Enrico Chandoha who loved animals as much as animals loved them.

Many thanks to the entire TASCHEN team for their commitment, vision and collaboration.

Very special thanks to Benedikt Taschen, Reuel Golden, Josh Baker, Daniela Asmuth, Kathrin Murr, Sarah Wrigley, Mallory Testa, and Jean Dykstra.

EACH AND EVERY TASCHEN BOOK PLANTS A SEED!
TASCHEN is a carbon neutral publisher. Each year, we offset our annual carbon emissions with carbon credits at the Instituto Terra, a reforestation program in Minas Gerais, Brazil, founded by Lélia and Sebastião Salgado. To find out more about this ecological partnership, please check: www.taschen. com/zerocarbon
Inspiration: unlimited. Carbon footprint: zero.

To stay informed about TASCHEN and our upcoming titles, please subscribe to our free magazine at www.taschen.com/magazine, follow us on Instagram and Facebook, or email your questions to contact@taschen.com.

Edited by: Reuel Golden, New York
Art direction & design: Josh Baker, Oakland
German translation: Julia Heller, Munich
French translation: Alice Pétillot, Bordeaux

© 2020 TASCHEN GmbH
Hohenzollernring 53, D-50672 Köln
www.taschen.com

Printed in Italy
ISBN 978-3-8429-6

Cover: Bassett hounds, New Jersey, 1964

Back cover: Bulldogs, Long Island, New York, 1952

Endpapers: Photo shoots for a Purina campaign, Welsh Springer, and mixed-breed, New Jersey, 1966

Page 1: Basset hound, New Jersey, 1989

Pages 2–3: Bulldog, Long Island, New York, 1959

Pages 4–5: Poodle, beagle, cocker spaniel, and mixed-breeds, New Jersey, 1985

Page 6: Collie, New Jersey, 1961

Pages 294–295: Chandoha in the studio with his rescue dog, 1975

Page 296: Basset hound, New Jersey, 1989

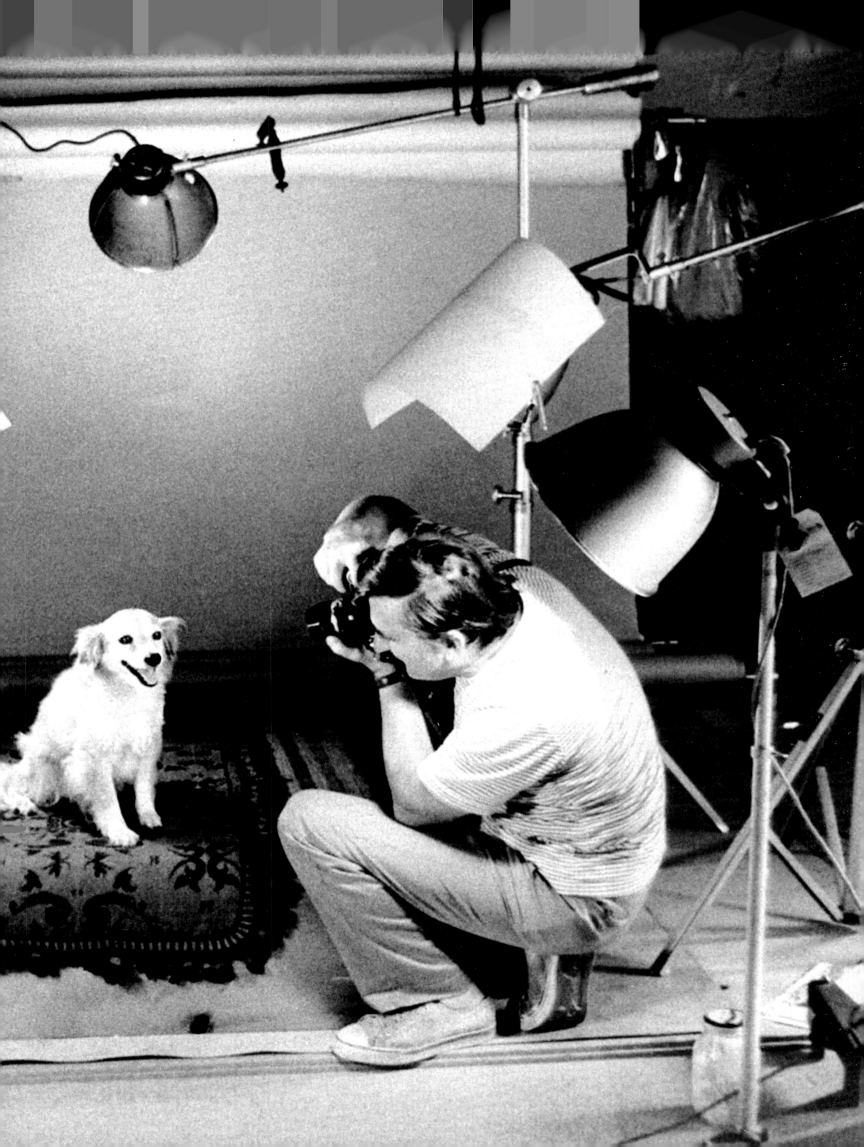

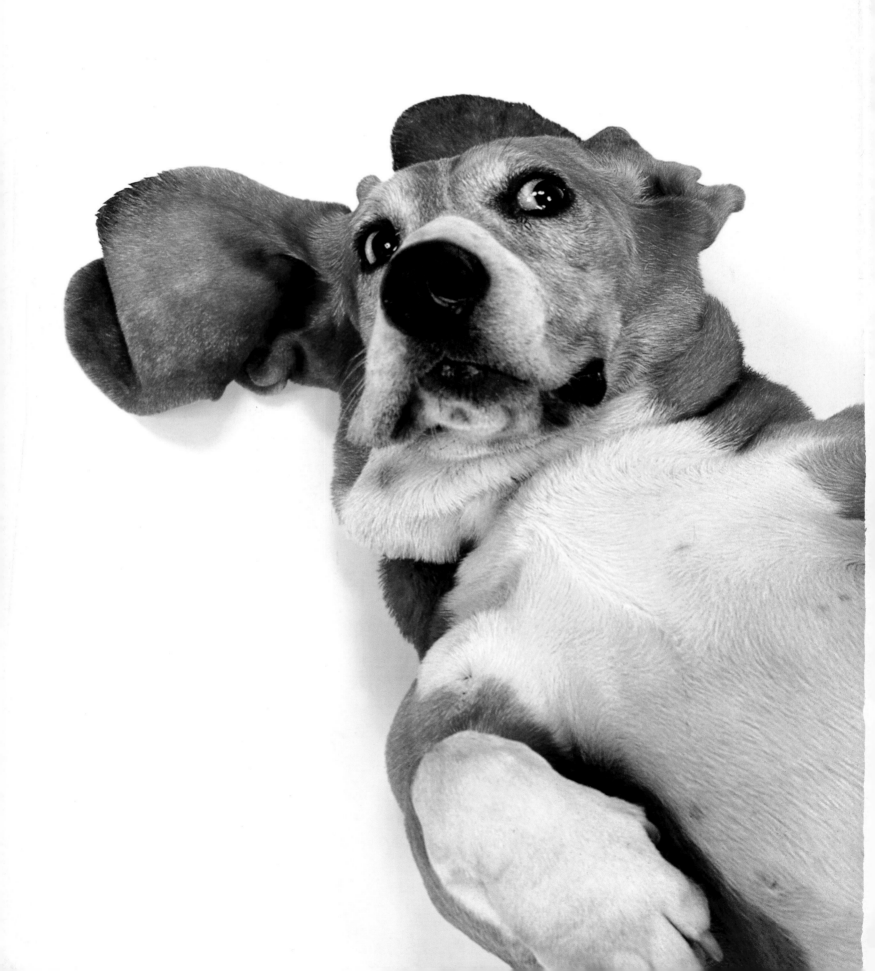

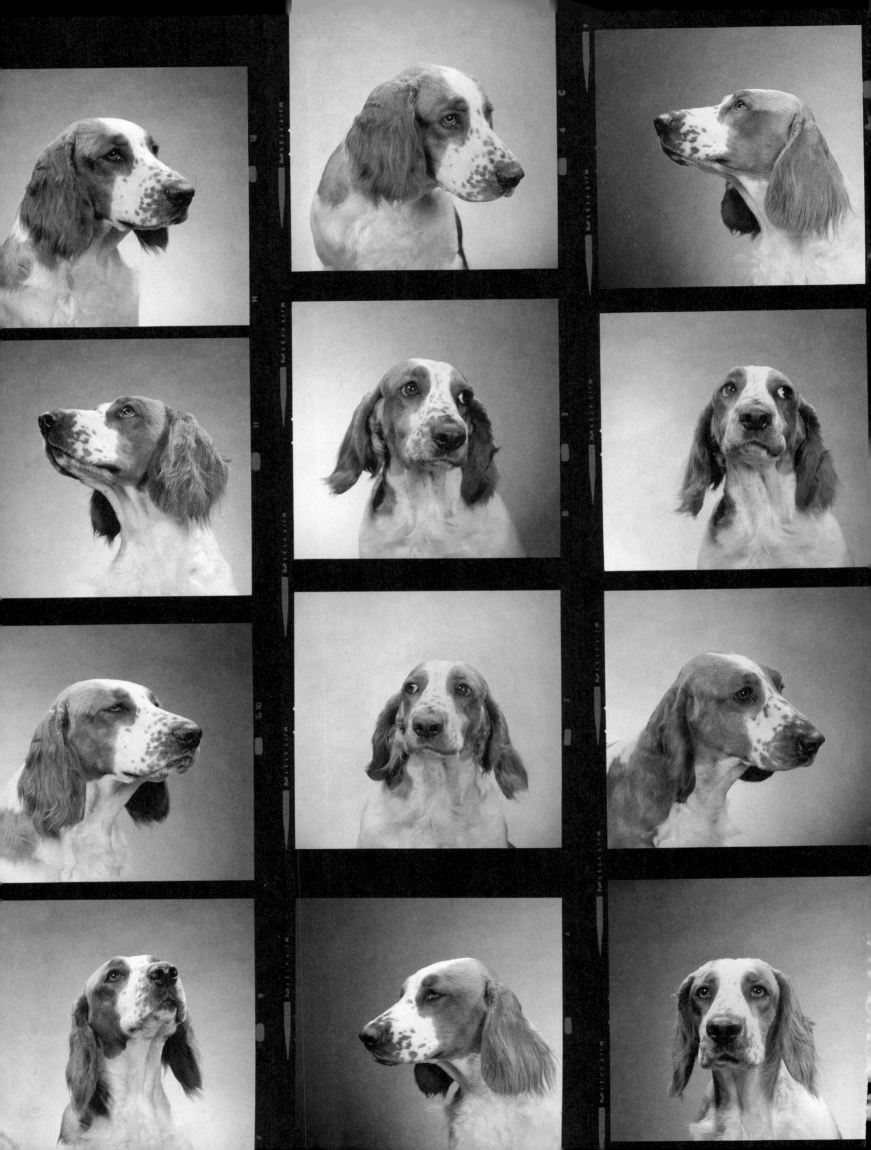